MASTER PRINTS OF JAPAN

UKIYO-E HANGA

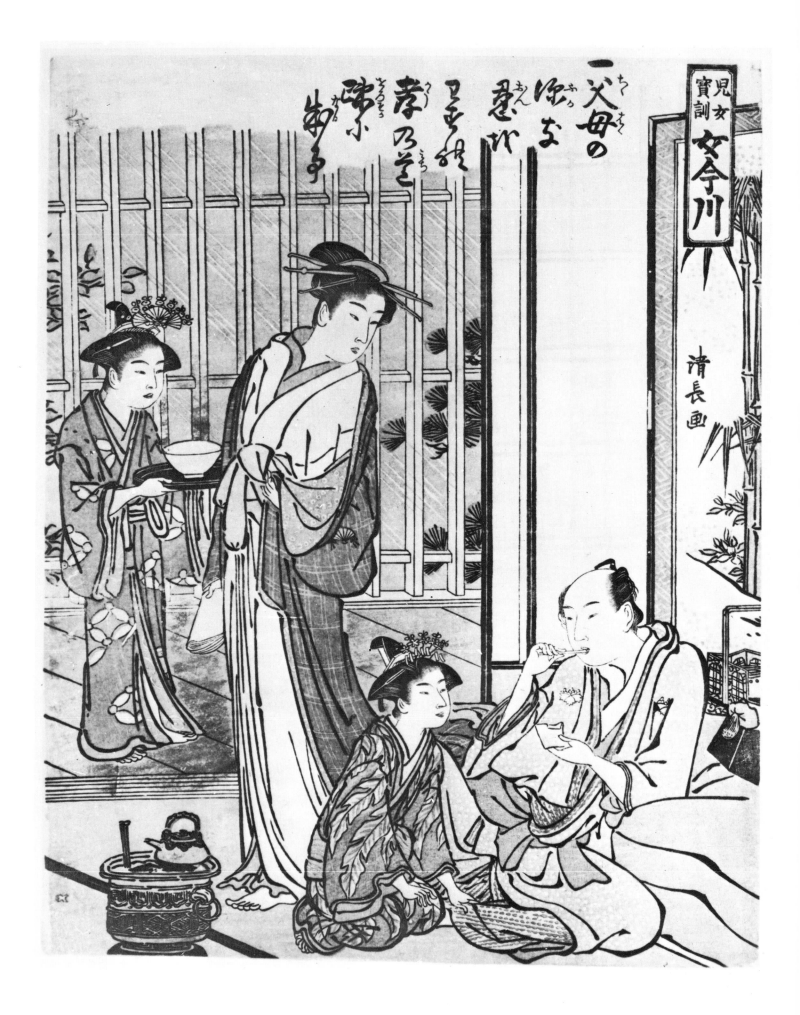

Text by HAROLD P. STERN

Assistant Director, Freer Gallery, Washington, D.C.

MASTER PRINTS OF JAPAN

UKIYO-E HANGA

HARRY N. ABRAMS, INC. Publishers NEW YORK

in association with the UCLA Art Council and the UCLA Art Galleries, Los Angeles

Library of Congress Catalog Card Number: 69–12794

All rights reserved. No part of the contents of this book
may be reproduced without the written permission of the publishers,
HARRY N. ABRAMS, INCORPORATED, NEW YORK

Printed and bound in Japan

CONTENTS

MASTER PRINTS OF JAPAN

UKIYO-E HANGA

INTRODUCTION

THERE IS MAGIC IN THE PRINTS OF JAPAN and their charm grows the more one studies them. I suppose this is true of most things in life to which one develops sentimental attachments. Happily, the old adage that familiarity breeds contempt is untrue. An introduction to Japanese prints might be likened to one's first entry into a cavern lit with mysterious light and filled with ever-changing, glistening crystalline formations. How fascinated we would be as we forgot all else, to plunge further and deeper along on our exploration. One could also liken it to the hypnosis one senses in watching a spider spin its beautiful web. In everything there are features that stand out and have special appeal to one person or another. These compare to the transparent dewdrops radiant in the early morning sunlight, each resting as a masterpiece on the spider's fragile, gossamer web. In like manner, the world of the Japanese print is a vast net, and upon it a number of masters rise and excel. It is about a few of these works of the *ukiyo-e* school that this book is concerned.

The reader may well ask what is an *ukiyo-e*? The word *ukiyo* literally means the floating or transient world, and *e* means picture. It appears that in its earliest form the word was derived from what the Buddhists referred to as the *urei yo* (world of grief). To the devout, man's time on this earth was unhappy and but a stage to be passed through prior to moving along on the road to salvation. Thus, the *urei yo* was everyday existence, and this is the subject matter of the *ukiyo-e*. In the *ukiyo-e* is depicted the parade of life that passed before the eyes of the artists. In particular they loved to portray the pleasures that lightened the burden of their urban existence.

The entire economic and social structure of Japan underwent radical change during the Momoyama period (late sixteenth century), and in the Edo period a new way of life slowly blossomed for the common man. Though the manner of existence was still very highly restricted and regulated, the growth of large cities, such as Edo (now Tokyo), created population pockets which, because of their size and the accompanying economic growth, clandestinely allowed more freedom of expression. It was a simple formula, for the larger the population, the more impossible it was to exercise total dictatorial control over every aspect of urban life. The man in the street was awakening to the world about him, and he cherished the entertainments which brightened his day. He wished to remember them, and what simpler and more beautiful method existed than

through the medium of *ukiyo-e* paintings and prints? He could purchase and own these. Their mere possession implied that he belonged and was part of society. This was slight reward for a social existence that was otherwise forbidding.

A period of relative peace descended upon Japan commencing roughly with the year 1600. It had been brought about through the dynamic personalities of three successive military shoguns: Oda Nobunaga (1534–1582), Toyotomi Hideyoshi (1536–1598), and Tokugawa Ieyasu (1542–1616). It was in the Edo period which they had heralded that towns grew to be metropolises and chattels began their metamorphosis to townsmen, tradesmen, and citizens. At the same time the wood-block prints as the popular art for the masses flourished.

Wood-block prints have a long tradition in Japanese history. The earliest one that survives was of a religious nature and depicts Bishamon-ten. It dates from 1162. Normally on these early prints, the image was repeated many times in rows on a sheet of paper. There is no question that other woodcuts preceded them, for documentary evidence exists, dating from late Heian times, indicating that such prints were used as part of devotional services. The closest parallel to Edo-period Buddhist prints in this book is the representation of the Birth of Buddha (No. 16). The single-sheet secular Edo print, as we know it, is in all likelihood the outgrowth of book illustrations.

During the seventeenth century it was very fashionable to illustrate texts with woodcuts. These were rather primitive in nature, for the artists had not fully mastered the techniques of designing for blocks, nor had the engravers achieved the skill necessary to transfer all of the nuances of the artists' designs onto the wood. The earliest *ukiyo-e* prints were executed only with *sumi* (lampblack ink). We do not know when their manufacture first commenced, but they were common in the late seventeenth century. It was but natural that the artists, or perhaps the owners of the prints, soon took to enhancing them by dabbing on patches of color here and there. Quite a number of men produced these black-and-white prints, called *sumi-e* or *sumizuri-e*. Among the most distinguished were Hishikawa Moronobu (Nos. 2–3), the Kaigetsudōs (Nos. 4–7), and Torii Kiyomasu I (No. 15). In addition there were other great masters, such as Sugimura Jihei and Nishikawa Sukenobu, whose works are not discussed in this volume.

For some unexplained reason the pigments that were most often employed in coloring early prints by hand were *tan* (red lead) and yellow. In all likelihood these colors were selected because of their brilliance and availability. It has yet to be clearly ascertained which yellows were used, but this color was available from *ukon* (saffron), *kuchinashi* (cape jasmine or gardenia), *shiō* (gamboge), or *kiō* (stone yellow compounded from sulfur and arsenic). Prints with orangish red and yellow added by hand are normally called *tan-e*. Many of the artists in this book, from Torii Kiyonobu I through Torii Kiyotada, produced

them. I must warn the reader once again, however, that we have no certainty as to who applied these colors or when they were added. At times there were exceptions and additional colors were touched in. The *tan-e* appear to have fallen from favor about 1715.

There was a steady growth in the decorative quality of the Japanese print. As the *tan-e* was waning, another variety of red coloring was employed in the hand coloring of prints. This was known as *beni* and is a transparent hue extracted from the safflower. The prints on which it was added were called *beni-e* and they were popular from about 1715 until the 1730s. At the same time another coloring technique was employed that produced what came to be known as the *urushi-e* (lacquer pictures). These were in truth *beni-e*, with the refinement, however, that small quantities of lacquer or glue were mixed with the *sumi* to produce a rich, lustrous black. At times these prints were enriched by scattering powdered gold dust, or more often sprinkling cheaper brass filings, over selected areas of the designs. The *urushi-e* often had portions on which embossing or stamping was used. The growth of more elaborate techniques points to a growing desire on the part of the print artists and publishers to make these relatively inexpensive works of art compete with paintings. It is often reported that Okumura Masanobu was the originator of the *urushi-e* techniques; this cannot be substantiated, however, and I would prefer not to quibble or lose myself in an argument that currently cannot be resolved. Many early artists of the Torii school, such as Kiyomasu II, produced *urushi-e*.

Okumura Masanobu is traditionally also credited with the introduction of the first true-color print which was known by the term *benizuri-e*. *Beni* once again refers to safflower red; in these prints, however, red and green are the colors that predominate, and they were all printed from blocks rather than being touched in by hand. Thus, sometime about 1741 the *ukiyo-e* print had taken another major step on the path leading to the full-color print. In addition to red and green, other colors, such as blue, gray, yellow, and purple, were employed by the artists Ishikawa Toyonobu (No. 37), Torii Kiyoshige I (No. 41), Torii Kiyohiro (No. 42), and Torii Kiyomitsu (Nos. 43–46).

Last but not least in the development of the *ukiyo-e* print was the *nishiki-e*, or full-color print. *Nishiki* literally means brocade, and these prints, because of their many rich colors, were named after the fabric. Harunobu is traditionally credited with the introduction of the true full-color print; this occurred around the year 1764. Although it would be difficult to place full credit for this major accomplishment on one man's shoulders, it is clear that Harunobu was the leading developer of the *nishiki-e* technique (Nos. 48–61), and one of the great masters of the woodcut.

One of the most important questions to be answered for the reader of this book is the technical matter of just how a print is produced. One may admire these sheets of handsomely decorated paper; but once we understand the process by which they were made,

one's admiration continues, and to it is added awe and respect. We must now turn to the three basic materials which are all derived from plant life and are thus closely allied. First, to produce a print the artist had to draw a sketch in *sumi* on paper. *Sumi* is a black pigment made from lampblack or soot obtained from burnt fresh pine needles. This is compounded with a small quantity of glue and shaped to form small slabs of ink which are left to dry. These can be rubbed with small quantities of water on an inkstone, or can be crushed and dissolved in water to create the intensity of black desired. Second, the paper used for the production of the sketch for the block, called a *hanshita-e*, was a very thin tissue-like variety made from the fibers of the *kōzo* (paper mulberry) or *mitsumata* (*Edgeworthia papyrifera*) plants. This paper, though it appears to be deceptively fragile, is very sturdy and nobly adapted to its task. A variety called *minogami* is considered to be the best for this purpose. The *hanshita-e* paper is sized with *dosa*, a mixture of alum and glue, and rubbed to prevent it from wrinkling when it is pasted to the block. Third, the selection of the wood block was a matter of great importance. One must keep in mind that completed *ukiyo-e* prints are not the product of a single man. They are the cooperative effort of many hands. The designer is the master who receives the credit for he created the design, but another master, most often unknown, transferred the sketch to a block which he had selected. He also was usually entrusted with incising the design onto the block, as an engraver. Once the block or blocks were carved, another master entered the scene to do the printing. In addition to these men, numerous artisans and disciples were employed to mix and apply pigments, stack paper, as well as to perform other routine tasks. Masterminding the whole project were the publishers, who kept eagle eyes out to delete what they disliked and to alter designs until they had a print in hand which they felt was marketable.

To return to the matter of the block, it was requisite that the wood be without any imperfections and of fine, hard, and uniform texture. One type of wood in Japan qualified nobly for this task, and it is the *yamazakura* (*Prunus serrulata*, mountain cherry) tree. The selector of wood for the block always cut it with the grain and sought to avoid irregularities which would become visible in the printed design. The wood, after selection and cutting, had to be stored for a number of years to season and make certain that no further warping was likely. The blocks were then planed with the greatest of care. An improperly planed block could easily alter the finished product.

Once the *hanshita-e* sketch was completed it had to be affixed to the block. This in itself was a tricky operation, for it required speed to spread the paste properly, and to align the drawing in order to prevent wrinkles from forming in the paper. After this step was accomplished the block was ready for engraving. To do this, normally at least two engravers were employed. One executed the delicate line areas such as head, hands, and

feet, and was called the *kashirabori*; he was highly trained. The other, known as the *dōbori*, was considered less skilled; he engraved the areas of the block thought to be of minor importance. These engravers utilized a full range of chisels and blades to cut away the unneeded areas of the block, leaving only the lines and portions to be printed at surface level. The completed block was known as the key block. In the process of producing the block, it is obvious that the *hanshita-e* was destroyed.

After the design had been transferred onto the wood, the next step was the production of *kyōgō*, which were the initial black-and-white impressions drawn from the key block. The several *kyōgō* drawn from it served as guides for the engraving of the additional color blocks. Great care had to be taken to avoid any shrinkage of the initial or trial impressions, for otherwise the separate color blocks would not fall into register and the print would be a failure. In addition to this, the Japanese developed another guide to keep their prints in register. It was known as the *kentō*. It consisted of two marks carved onto the edge of the block, permitting the maintenance of relatively exact margins. One mark was a small ninety-degree angle and was known as the *kagi* (key); it was normally placed at the lower right corner of the block. The other was known as the *hikitsuke* (draw stop), and it was but a straight flat area carved in exactly same width of the *kagi* and normally placed about two-thirds down along the bottom edge of the block. As long as the printer took care to match his sheets of paper to the *kentō* marks of the color blocks he was using, the print would be in register. One must keep in mind that it was the normal practice to carve a separate block for each color involved in the production of a print.

The next stage in making an *ukiyo-e* print was the selection of the paper for the finished work. Japanese artists normally preferred a paper known as *hōsho* because of its great strength coupled with the proper quality of absorbency. It, like most Japanese papers, is the product of the bark of the *kōzo* (*Broussonetia kazinoki*, paper mulberry). Prior to its use for prints, the paper had to be sized with *dosa* to reduce its absorbency. As a first step to printing, the paper was uniformly moistened to maintain the established dimensions and prevent wrinkling. Following this, a small amount of paste was applied to the block to be used, and the desired pigment, once it had been mixed with the right amount of paste, was also brushed onto the block. The moistened paper was then picked up and set upon the block. It was from the lower right-hand corner that the printer commenced applying his paper. Great caution was necessary to prevent the paper from sagging into the carved-away parts of the block and to guard against the formation of bubbles of air under the areas where the engraving and paper came into contact with each other. Last but not least, the printer would work with an implement called a *baren*, with which he would rub the paper and thus transfer onto it the pigment on the block. The *baren* is an unusual implement, for it is a rubbing pad made up of bamboo cord coiled upon a circular paper pad

and wrapped in a sheath of white bamboo leaf. With the application of proper pressure and movement, the printer could achieve almost any effect he desired.

There is a great deal more to be learned about the technique of producing a Japanese wood-block print, and further information can be found in the handsome volume by Yoshida Tōshi and Yuki Rei titled *Japanese Print-Making*, Charles E. Tuttle Company, Rutland, Vermont, and Tokyo, Japan, 1966. In that volume, formulas as well as technical terms and techniques are discussed. The serious reader would do well to study it.

Collectors, connoisseurs, students, and laymen have access to *ukiyo-e* prints, and no better guide can be found than the study of the prints housed in museums and collections throughout the world. Once one learns the techniques and materials, one can reach guarded conclusions about authenticity and quality. One must train his eyes. This is not something that happens overnight, and the skill can be acquired from no single book. It is the result of work and love, and I feel all of us are equal to the challenge.

In this book I have attempted to briefly unfold the story of the Japanese print. It is not intended to be all-inclusive, and such a volume could never be realized. This book is meant as an introduction to some specific artists and examples of their work. I hope that it will whet appetites and encourage the study and appreciation of the magical world of *ukiyo-e*.

THE PLATES

1

Artist Unknown, Early Fifteenth Century
BISHAMON-TEN
Hand-colored, 31½" × 12¾"
Philadelphia Museum of Art

PRINTING FROM WOODEN BLOCKS is traditional in Japan. The earliest extant examples are some Buddhist charms which were produced on the order of the Empress Shōtoku in A.D. 770. These one million charms were placed in small wooden pagoda-like structures known as the Hyakuman Tō and were distributed to temples. It only follows that the carvers of these charms also realized that designs other than Chinese and Sanskrit ideographs could be carved into wood and then printed. Evidence of the use of related printing techniques can also be found in the patterned fabrics of mid-eighth century date in the Shōsō-in (The Imperial Repository) in Nara.

As time went on Buddhist prints were used as items of devotion and were placed inside wooden images and employed in fulfilling vows. The earliest dated figure prints extant are those representing Bishamon-ten from A.D. 1162 found in an image of Tamon-ten formerly owned by the Jōshin-in, Nakano-kawa, in Nara Prefecture. These early prints were generally of small scale; however, the artisans later learned to use large blocks that resulted in examples such as this picture of Bishamon which in all likelihood is early fifteenth century in date.

Bishamon-ten (Sanskrit: Vaiśravana) is represented as a super being. The name means "the one who hears much" and this deity is used in the Buddhist pantheon in several ways. One is as Tamon-ten, the Guardian of the North Sector of the Buddhist heaven. He is also included as one of the Twelve Heavenly Kings. Bishamon-ten holds a pagoda-shaped reliquary in his left hand and a mace-like implement topped with a lotus and flaming jewel in his right. He wears the costume and armor so often seen in Chinese T'ang-dynasty representations of the Guardian Kings. He stands on a lotus-leaf pedestal and about his head is a halo of flame. His robes and armor are richly patterned and about his waist is a girdle with a stag-head clasp.

Prints of this nature are often difficult to recognize for the printed line serves as but the outline for heavily hand-pigmented areas, and most often they have been mounted as paintings in the *kakemono* manner. The skill of the artisans in designing and printing from blocks of this scale herald what flowered into the golden age of the wood block in Japan and the *ukiyo-e hanga*.

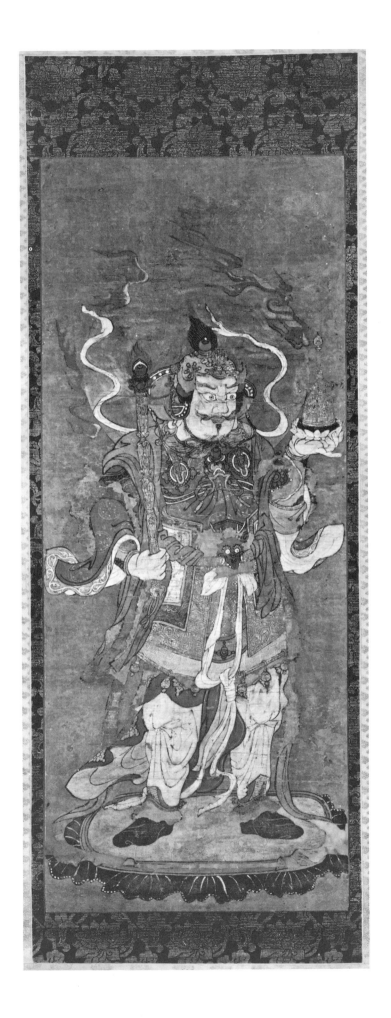

2

Hishikawa Moronobu, ca. 1615–1694
Series: YOSHIWARA NO TEI (Views of the Yoshiwara)
STREET SCENE
Sumi-e, 10½″ × 16¼″, Unsigned
Metropolitan Museum of Art, Dick Fund, 1949 (Ledoux Collection)

THE ARTIST WHO WAS THE GREATEST PIONEER of the *ukiyo-e* style was Hishikawa Moronobu. He is one of the first artists whose work survives in volume and in the past has often been incorrectly termed the founder of the school.

Although the *ukiyo-e* artists are relatively close in time to our modern age, most often little is known or recorded about their lives. One must remember that they were the producers of the popular art of the day and were not closely allied to the upper class or academic world. Biographers rarely took note of them and the little documentation which might have aided scholars has often been lost due to the natural calamities that have plagued Japan.

Hishikawa Moronobu was born sometime between 1615 and 1625, for we know that he died in 1694 in his seventies. He appears to have been born in Hoda-mura, Heguri-gun in Awa Province, the son of a textile designer and craftsman called Hishikawa Kichizaemon Michishige. Although he spent much of his adult life in Edo, he is said to have traveled and to have moved his residence within the city a number of times. There is evidence from his illustrated books, such as *Kosode Gohinagata* (Patterns for Wadded Silk Garments) published in 1677, that Moronobu was also skilled in textile design. Additional support, including his fine sense of color, can be found in a study of any of his paintings, such as the genre scene handscroll in the National Museum, Tokyo, or the *Ueno Park Cherry Blossom Viewing* screens at the Freer Gallery of Art, Washington, D.C.

This print is a *sumi-e*, produced with black ink. At times color was touched in later by hand, although we do not know who added the color or when it was done. In this instance the print survived without such alteration. It is part of a series of twelve sheets usually titled *Yoshiwara no Tei* (Views of the Yoshiwara). Only the last print carries the mark of the publisher, Yamagataya of Tōriabura-chō. The scene is a street

in the Yoshiwara where clients chance upon a courtesan accompanied by two attendants. It is viewed from above much in the manner that an apartment dweller today could glance from an upper story window and scan the parade of life below.

In typical *ukiyo-e* manner he has captured the movement of the meeting between the courtesan and her admirers. She turns her head away from them and looks shyly backward at her two attendants. The figures are spread out along the street and if linked would form an oval which is also characteristic of early *ukiyo-e* compositions. In addition to the courtesan there are three groups for a total of thirteen figures and each group is accompanied by barefoot attendants. To the right of the girl a samurai wearing a straw hat repeats the gesture of the courtesan and shields his face with his raised right arm while his left grasps his extraordinarily long sword. His attendant looks brazenly at the courtesan. Behind this samurai is a large bucket marked "water bucket" with a plank holding seven pails balanced on top of it. This number equates with the seven men (excluding servants) and could have certain erotic overtones. Just beyond the large bucket the composition is divided by a strong diagonal of a fence and gate post. This is matched at the bottom of the print by the rooftop of a house. Three of the samurai in the upper group on the right partially shield their faces with fans, and the fourth hides behind his raised sleeve as though desiring not to be recognized by the lady. The two samurai at the bottom stare openly at her and wear silken tams, while a servant carries the *happi* coat of the foremost figure over his shoulder.

Moronobu has tied the entire composition together by drawing broken horizontal lines along the street to indicate recession into depth and by indicating *kasumi* (clouds) in the sky in the same manner. This device harks back to the eleventh-century *Yamato-e* picture handscroll tradition.

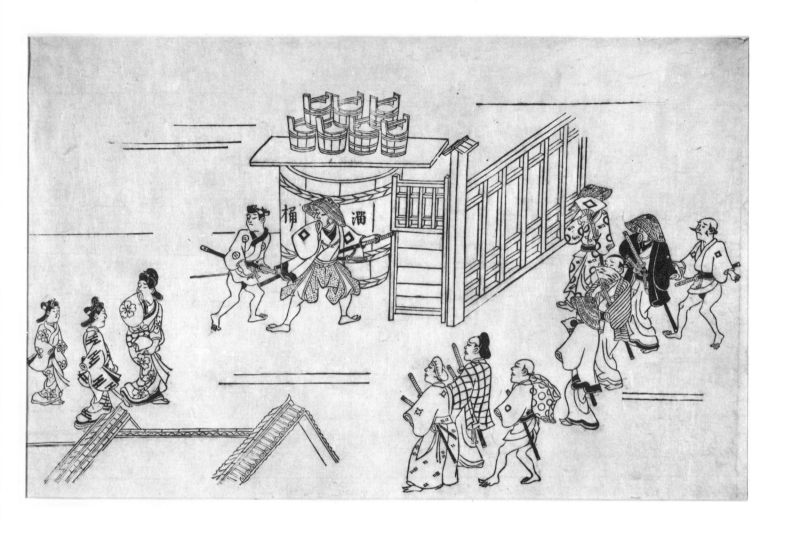

3

Hishikawa Moronobu, ca. 1615–1694

LOVERS (from a set of twelve sheets)

Sumi-e, 9¼″ × 13¼″ (11½″ × 13½″ full-size sheet), Unsigned

Metropolitan Museum of Art, Dick Fund, 1949 (Ledoux Collection)

LOVERS EMBRACING is the subject of this print, which is considered by scholars, such as Dr. Shibui Kiyoshi, to have been from a set of twelve sheets which he calls Series D. In all likelihood each print represents a month and this with *hagi* lespedeza, chrysanthemum, gentian, and autumn grass should be October. The viewer in this print looks from below and a vertical type of composition rises behind. The flowers, figures, rock, sword, and stream all appear as cutouts pasted to the paper, yet one is not troubled by the flatness.

Moronobu balanced the solidity and volume of the rock and water with the lacy net of the flowers, the former male and the latter female. In the center are the lovers, and this full-faced young samurai embraces his beloved. He places one hand inside her robe and the other about her shoulder. The textile pattern on the girl's robe at waist, shoulder, knee, and ankle, while it may be unintentional, resembles and repeats the fingers that embrace her. This pattern is embellished with a coin and a flower design. The pattern on the youth's *haori*, though it could be

a bird in flight or bamboo sprout, might also be interpreted as the ideograph reading *onna* (woman).

One can almost always spot a Moronobu or school work by the treatment of the hair. To indicate depth and its style, he always left blank areas to separate the sections. The mouths of Moronobu's figures are always small and in this example the girl's eyes are almost straight, whereas the young man's eyes curve and repeat the dip of his hair to his shoulder. The crest on his coat has not been identified.

The theme of embracing lovers was often used by later artists. A notable example would be the lovers by Harunobu in the collection of Mr. and Mrs. Richard P. Gale, which was formerly in the Ledoux collection.

Another sheet of this series representing lovers with an attendant is in the collection of the Honolulu Academy of Arts. The upper portion of both of these prints is enclosed in a decorative border. It may be of interest to note that in both, the shell or petal-like corner has nine elements on the right and ten on the left.

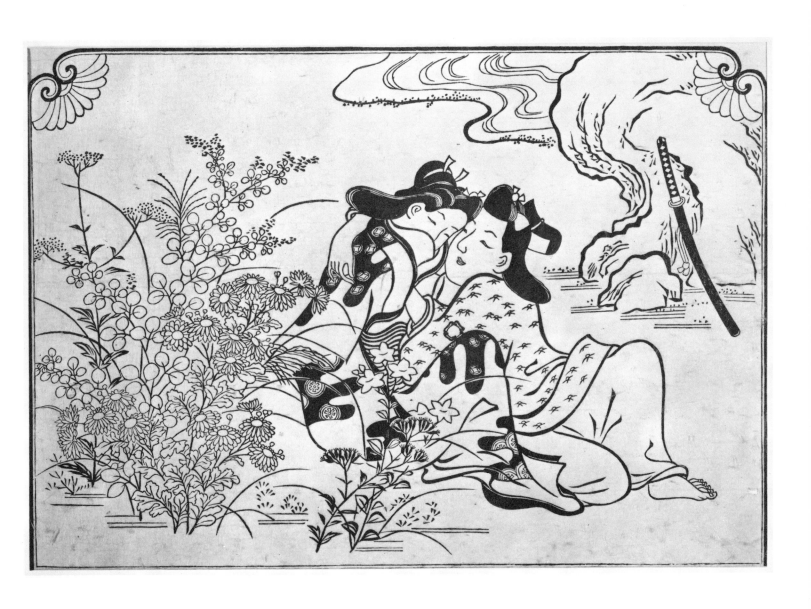

4

Kaigetsudō Dohan (Nobushige), act. 1700–1716
COURTESAN HOLDING POEM SLIP

Large sumi-e, 23½" × 12½"

Signed: *Nihon Giga Kaigetsu Matsuyō Dohan no Zu*

Artist Seal: *Dohan*, Collector's Seal: *Takeuchi Zō In*

Metropolitan Museum of Art, Dick Fund, 1949 (Ledoux Collection)

MORONOBU'S GIRLS PROMENADED or strolled, whereas those by artists of the Kaigetsudō school paraded. There is a majesty and stateliness imparted to them which few other artists achieved.

One of the greatest problems to confront scholars working in *ukiyo-e* studies has been the identification of artists using the Kaigetsudō name. Normally six men are associated with its use. They are Ando (Yasunobu), Doshū (Nobuhide), Dohan (Nobushige), Doshin (Nobutatsu), Doshū (Nobutane), and Anchi (Yasutomo). At times Nori can be substituted for Nobu in reading the second, third, fourth, and fifth names. Biographical data exists only about the first of these and that is brief and vague. Ando is reported to have been active in the first quarter of the eighteenth century. He is believed to have been the founder of the Kaigetsudō group. The only facts readily available suggest that Ando lived in Suwachō at Asakusa and ran afoul of government regulations. He is said to have assisted in arranging for liaisons between the popular actor, Ikushima Shingorō, and a lady at court named Ejima, who is mentioned as being the principal lady in waiting to the mother of the Shogun. As a result, in 1714 he was sent into exile to Ōshima.

Some of the artists using the Kaigetsudō appellation produced no prints. These were Ando, Doshū (Nobutane), and Doshū (Nobuhide). Our great sadness is the lack of any concrete evidence as to the lives of the Kaigetsudō print makers, for their surviving work is very rare, with but thirty-nine impressions of twenty-two subjects recorded.

One of the most skillful was Dohan, who produced this print of a courtesan holding a poem slip. It is physically of large scale and the single figure without background occupies the entire space. This was characteristic of the Kaigetsudōs. The girl is monumental and her kimono is executed in heavy outlines. The line, however, is not static and the figure is alive. This is partially achieved by keeping the view-er's eye alert. One sees the rich and lustrous black hair and then shifts to the delicately patterned outer robe with a design of a bridge, pine boughs, waves, and bamboo set amidst clouds. This is accented by the vertically striped undergarment. The entire figure appears encased as if in a cocoon. She models the height of Edo fashion. The obi is undecorated and the courtesan holds in her hand a love-poem slip. This has been published in the *Catalogue of the Japanese Prints of the Ledoux Collection* as follows:

> *Asa yū o*
> *Sanae ni wakuru*
> *Mitsuru kami*
> *Itsuka–itsuka to*
> *Itsuka–itsuka to*

> *Morning and evening*
> *I part my dishevelled hair*
> *As one would part rice sprouts wondering*
> *When, when will he come.*

This interpretation may be open to question for instead of the word, *ni*, on line two, it should read *to*, and the last two lines read:

> *Sōban–sōban to*
> *Sōban–sōban to*

The basic thought, however, remains unchanged.

Most prints of this large scale were produced on two sheets of paper joined horizontally at the center. Only one other impression has survived and it was formerly in the Vever and later the Matsukata collection, which is now housed in the National Museum, Tokyo. The signature reads *Nihon Giga Kaigetsu Matsuyō Dohan no Zu* (drawn for fun in the Japanese style by Dohan a last leaf [follower] of Kaigetsu). It bears the artist's seal Dohan and that of a collector named Takeuchi.

5

Kaigetsudō Anchi (Yasutomo), act. 1700–1716
COURTESAN FIXING HER HAIR
Large sumi-e, 22¾″ × 12¾″
Signed: *Nihon Giga Kaigetsu Matsuyō Anchi Zu*
Artist Seal: *Anchi*
Collector's Seal: *Takeuchi no In*
Metropolitan Museum of Art, Dick Fund, 1949 (Ledoux Collection)

A SECOND NOTABLE FOLLOWER of Ando was Anchi (Yasutomo). He belonged to the inner circle of artists who considered themselves loyal to their master. They may have been a protest movement on Ando's behalf once he was exiled; however, that is but conjecture.

Anchi was the only pupil to have his own studio name. It was Chōyōdō and hints that he had more independence than the others. Richard Lane, a very able scholar and researcher of *ukiyo-e*, has suggested that he may have been the son of Ando.

His prints are very distinguished. They, like all those of the Kaigetsudō school, represent monumental figures of courtesans. His women have a great deal of grace though are not coy. The Ando formula of wrapping the figure in elegant and handsomely patterned robes is repeated. In this print the courtesan raises her arms to her head and lifts the back knot of her hair as she inserts a pin into place. Her delicate long fingers complement her full face and small features, and contrast with her thick raven hair. The outlines of the robe are heavy. The courtesan's head, broad collar, obi, and underrobe firmly center the composition. Thus, although her sleeves billow out like butterfly wings, she appears firmly balanced.

The robe is handsomely decorated with uncolored chrysanthemum plants above the waist and *sumi* chrysanthemum blossoms floating on waves below. Could it symbolize that these girls were beautiful yet fallen flowers? At her heel one flower turns up and combines with her dark underrobe to balance her hair and thus enclose the figure top and bottom. The textile design was of prime importance and Anchi made no attempt at realism or natural drapery. Where a fold occurs the pattern is uninterrupted almost as though a stencil was used, which in reference to the actual cloth probably was true. It appears to be the type of design and dyeing introduced by Miyazaki Yūzen in the latter half of the seventeenth century.

This print is signed *Nihon Giga Kaigetsu Matsuyō Anchi Zu* and bears his seal Anchi. At the bottom is a seal in red which, as in the case of No. 4, is that of a collector named Takeuchi. It reads *Takeuchi no In*. No other recorded impression of this print survives. It, like the previous one, is composed of two sheets of paper joined together at the bottom of the signature.

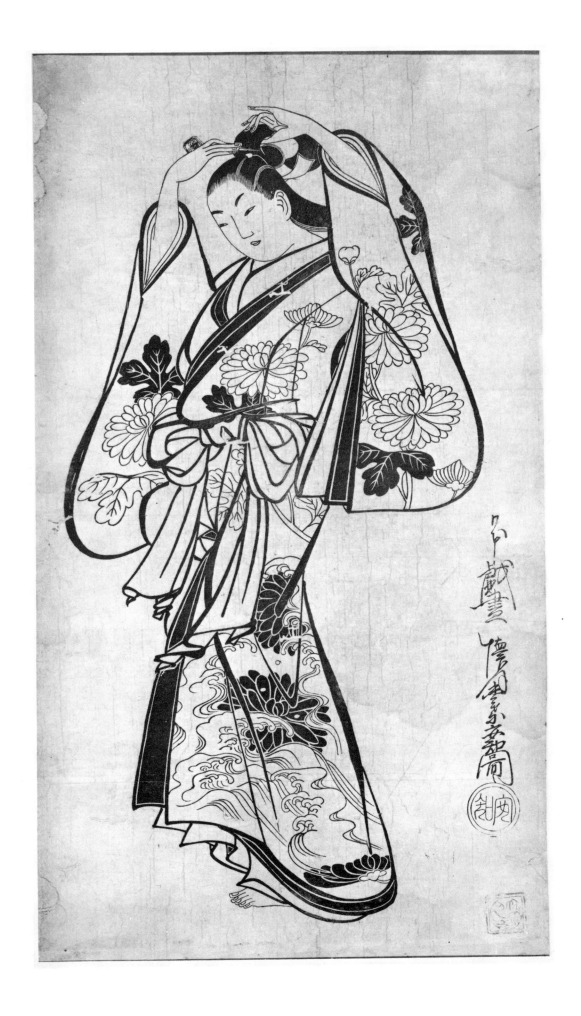

6

Kaigetsudō Anchi (Yasutomo), act. 1700–1716
COURTESAN WALKING
Large sumi-e, 22¾″ × 12¾″
Signed: *Nihon Giga Kaigetsu Matsuyō Anchi Zu*
Artist's Seal: *Anchi*
Publisher's Seal (eggplant-shaped): *Santaya Kihachi*
Collector's Seal: *Takeuchi no In*
Metropolitan Museum of Art, Dick Fund, 1949 (Ledoux Collection)

THIS COURTESAN WHO RAISES HER ROBES as she steps out for a stroll is another design created by Anchi. She more closely resembles the figures in his paintings for her chin is slightly hidden by her collar and her nose is shorter than that of No. 5. In cutting the eyebrows the engraver used two lines rather than a single broad stroke.

Again the figure is all that is shown; there is no setting. Her hair is simple though carefully groomed and a comb holds it in place where a knot twists back almost to form a handle for her head. This adds volume to the upper portion of the print as balance to the heavy robe which dips to the floor. In this instance the outer robe has an iris and cloud pattern, whereas the underrobe is checkered. The dark obi has a reserve cherry-blossom pattern. The broad linings of the outer and inner robes contrast to form a bold design. The presence of iris may indicate that the month is May or June, or could suggest that the courtesan's name was Ayame.

The signature on this print was executed in a heavier hand than Nos. 4 and 5. It is signed and sealed and carries the same collector's seal as No. 5. The publisher's seal, Santaya Kihachi, appears enclosed in an eggplant form. It gives his address as Ōdemma-chō Nichōme Higashi yoko-chō, and his house name Maruya. In the center of the eggplant is the character read *Hachi*, which was part of his name. The print is made of two sheets of paper joined just below the center.

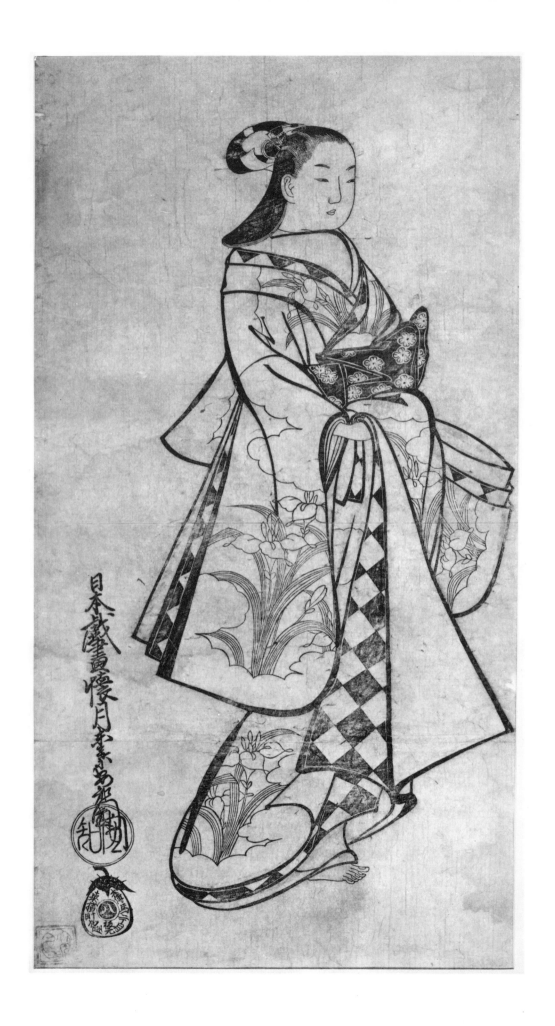

7

Kaigetsudō Doshin (Nobutatsu), act. 1700–1716
COURTESAN
Large sumi-e, 23½″ × 12½″
Signed: *Nihon Giga Kaigetsu Matsuyō Doshin Zu*
Artist's Seal: *Doshin*, Collector's Seal: *Takeuchi no In*
Publisher: *Nakaya of Tōriabura-chō*
Metropolitan Museum of Art, Dick Fund, 1949 (Ledoux Collection)

TAKA MAY WELL BE THE NAME of this courtesan by Kaigetsudō Doshin for her robe is decorated with *taka* (hawk) feathers and silken cords. The pattern is extremely effective for it leads us from her collar to her hem, and although she appears to be standing still the cords and feathers twist and float, creating a sense of great movement. Her obi is diamond patterned. Because of the volume of her robe and its loose fit and pattern, her body becomes unimportant. Only her head and a foot appear. There is no question, however, that this is a woman who enjoys the pleasures of love.

Doshin, in the same manner as the others of the Kaigetsudō school, has adroitly unified the figure by bringing into play complementary tensions. Thus, the slope of the hair, the long sleeve and the hem of the robe on the right are countered by the diagonals of the head, the puffed-out bodice, sleeve, and open robe front on the left. It was all very carefully planned and the slightest change would have made it a poorer print. It is one of the greatest designs of the Kaigetsudō school.

As was the case with Nos. 5 and 6, the signature is in the usual manner. The artist's seal varies from that of Anchi and is placed in a square. Beneath it is a coin-shaped seal of the publisher, Nakaya of Tōriabura-chō, and below that the same Takeuchi collection seal found on Nos. 5 and 6.

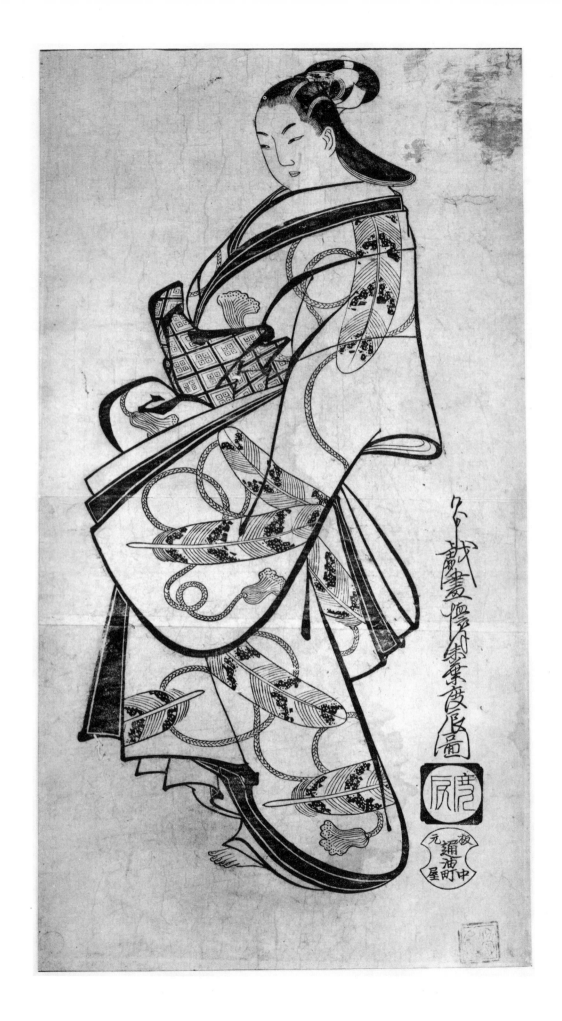

8

Artist Unknown, Early Eighteenth Century
AN ACTOR IN THE ROLE OF YAOYA ŌSHICHI
Chūban, hand-colored, brass powder, 11″ × 8¹/₁₆″, Unsigned
Philadelphia Museum of Art, Given by Mrs. Emile Geyelin in Memory of Anne Hampton Barnes

ŌSHICHI, THE TRAGIC LOVER of Kichisaburō, is the subject of this unusual unsigned print. For some time it was questionable as to whether or not it actually was a graphic work for very heavy pigments and gold were used to finish it. Included were those of a mineral variety which are closer to the ones employed in coloring the fifteenth-century Buddhist votive prints (No. 1). In fact, even the paper ground was sized or painted. Where color has rubbed away, however, one can see the printed design.

Ōshichi was the daughter of a grocer who moved his family to the Kichijōji Temple while his home was being rebuilt following a fire in Edo. The young girl fell in love with Kichisaburō, a youth employed by the Temple, and when her family returned to their restored home felt she could not live without her beloved. To return to him she set her home afire, and as a result of her arson much of the city was destroyed. The authorities executed her and her beloved became a monk and prayed for her soul.

The first actor to play the role of Ōshichi was Arashi Kiyosaburō, d. 1713. From his time on other actors used a folded love-letter crest when portraying this part. The actor's robe is lavishly patterned with combs topped with pine needles and polygons of six sides filled with *tachibana* blossoms while about his shoulders are bamboo leaves. Behind the actor there is a bird in a tall cage with a sprig of plum blossoms tied to the top. These all combine to form the Three Friends, the pine, bamboo, and plum, symbolic of longevity, ironic as far as Ōshichi is concerned. The actor holds in his hand a program which announces the role Yaoya Ōshichi the Lover *(Koi no Sama)*. The second word *Sama* may be misread and could be *sakura* (cherry); thus, Loves Cherry. Also written on the program is the *gidayū* chanter's name Takemoto . . . yodayū. Unfortunately the first part of his name is only partially legible. On the left of the program are the *kana* reading *kyōgen*.

It would be most difficult to assign this print to a specific artist. Stylistically it probably dates from the first quarter of the eighteenth century and is quite unique.

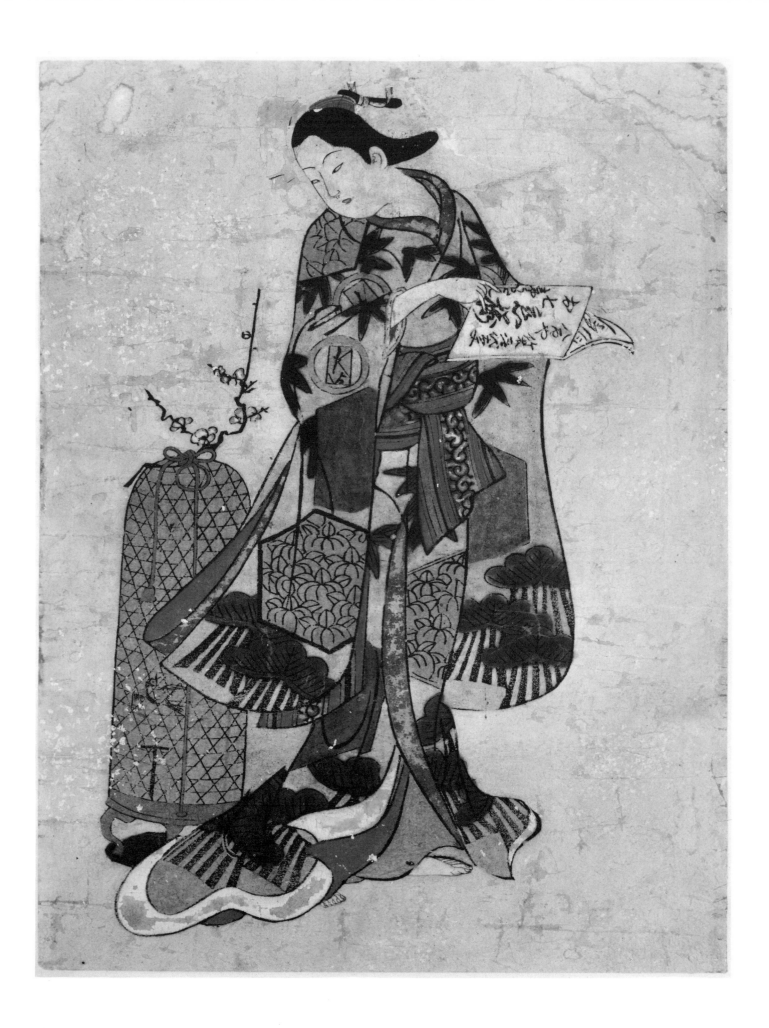

9

Torii Kiyonobu I, 1664–1729

KANAZAWA HAKKEI: ASAHINA UMEJŪ MARU MAI NO DAN

Large panel, tan-e, 12⅜″×21¼″, Signed: *Yamato Gakō Torii Kiyonobu*
Publisher: *Hangiya Shichirōbei Nemoto Hanmoto*
Collector's Seal: *Wakai Oyaji (Wakai Kanesaburō)*
The Art Institute of Chicago

TORII KIYONOBU is generally credited with founding the theatrical print tradition in Japan, although this is not entirely true. He is reported to have been born in 1664 and in the past most authors have considered him the son of Torii Shōshichi Kiyomoto, an Osaka actor and theatrical painter.

In the catalogue of Japanese primitive prints in the Art Institute of Chicago, mention is made that he was adopted by Kiyomoto and in 1661 married his daughter. No evidence, however, is given to support this theory. Kiyomoto moved his family to Edo about 1687 and in 1690 is recorded as having produced theatrical billboards for the Ichimura Theater. His son Kiyonobu used the name Shōbei in signing his early prints, and when Kiyomoto died in 1702 he took charge of the studio. He was steeped in the life of the theater and it is he who promoted and led to the full acceptance of the actor portrait. Needless to say, much of this goes hand in hand with the fact that theater had taken a firm hold in Edo and the demand for portraits of performers had greatly increased. Kiyonobu was a prolific artist though relatively few of his prints have survived the ravages of time. He married in 1693 and his wife died in 1716.

A great deal of confusion exists as to the identity of an artist called Kiyomasu I. At times it has been considered to be but another name adopted by Kiyonobu I. This, however, seems unlikely and the chances are that he was a son. A birth date is given in some references as 1706 but this in all likelihood refers to Kiyomasu II. At the present stage of *ukiyo-e* research it is impossible to clarify the issue and thus I will continue to follow the generally accepted theory that he was a separate person whose work in style very closely resembles that of Kiyonobu who died in 1729.

This large print is rather unusual and the only other copy that has been reproduced is a variation published by Yoshida Teruji in Vol. I of his *Ukiyo-e Jiten*. The theme is not unknown and others at this time had represented the great Shōgun Minamoto no Yoritomo taking a boating excursion past the eight most picturesque spots of the Kanazawa region south of present-day Yokohama. The eight scenic views traditionally are Seto, Uchikawa, Nojima, Shōmyō, Ottomo, Susaki, Koizumi, and Hirakata. The print's title *Kanazawa Hakkei: Asahina Umejū*

Maru Mai no Dan means Eight Views of Kanazawa: the Dance Scene of Asahina and Umejū Maru. The eight adult actors portrayed in the boat in all likelihood equate with the eight scenic views. Seven are identified by cartouches and crests and the Art Institute of Chicago has published them from left to right as follows:

Ichimura Wakadayu as Umejū Maru
Nakamura Denkuro as Asahina Saburō
Takejima Kōemon as Wada Yoshimori
Katsui Chōemon as Hatakeyama Shigeyasu
Murayama Shiroji as Doi no Jirō Sanehira
Murayama Heiemon as Chichibu no Shigetada
The figure in the stern is unidentified
The figure on the dais attended by a youth is
Yamamoto Hikogorō as Minamoto no Yoritomo.

Enoshima and the pine tree where the legendary ninth-century artist Kose Kanaoka discarded his brush when overwhelmed by the scenery are identified immediately above the figure of Yoritomo.

This Kiyonobu representation of the eight views is unusual. The thought is copied from the famous Chinese *Eight Views of the Hsiao and Hsiang Rivers* which became so popular as a theme in Japanese painting of the Muromachi period. The scenic arrangement varies from the standard. From left to right the views are as follows:

	Original Order
Evening Snow	2
Autumn Moon	1
Returning Sails	5
Wild Geese Alighting	8
Evening Glow	3
Night Rain	7
Sunset Sky	6
Evening Bell	4

Based on the actors represented, the scene probably dates from a play of the first decade of the eighteenth century. A search of theatrical records, however, has as yet been unfruitful.

Kiyonobu, like most *ukiyo-e* artists, was proud to be a continuation of the Japanese painting tradition and thus signed this work *Yamato Gakō* (A Japanese Artist) *Torii Kiyonobu*. The print also carries his publisher's seal and slightly to the left and above it the seal of the collector, Wakai Kanesaburō.

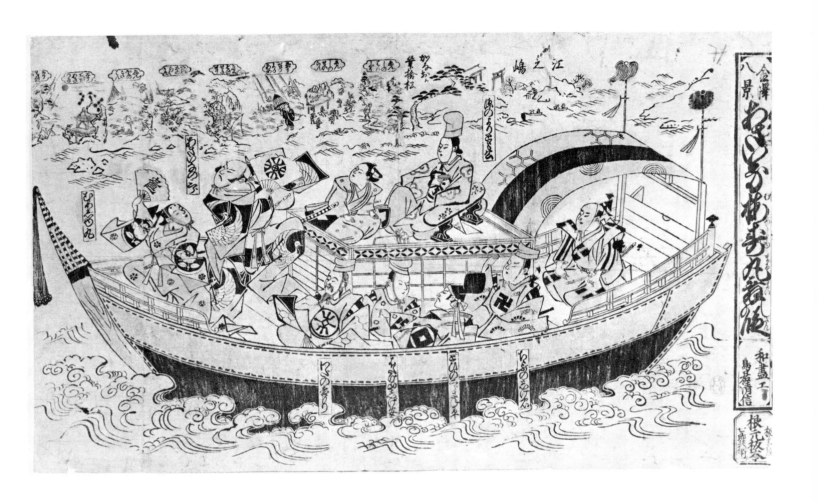

10

Torii Kiyonobu I, 1664–1729

MAN AND TWO YOSHIWARA WOMEN (frontispiece of an erotic album)

Sumi-e, hand-colored, 10¾" × 14½"

Signed: *Kiyonobu*

Seal: *Kiyonobu*

Metropolitan Museum of Art, Dick Fund, 1949 (Ledoux Collection)

IT WAS NOT UNTIL after Moronobu's death in 1695 that Kiyonobu's work began to be recognized. Perhaps it merely marks the conclusion of his apprenticeship as a billboard painter with his father, Kiyomoto.

Most every *ukiyo-e* artist turned at some time during his life to the production of book illustrations and especially to those created for erotic volumes. These illustrations are called *shunga* (spring pictures) and normally the albums opened with a modest scene. This hand-colored signed sheet is believed to come from such an album.

Kiyonobu has portrayed a visitor to the Yoshiwara dozing as he rests his head in the lap of a courtesan. His left arm encircles the waist of another who in turn appears to be plucking hair from his chin with tweezers. This is a theme that appeared very often in the unsigned genre screens prior to the Genroku period. The courtesan on the left somewhat resembles the figures of the Kaigetsudō rather than the Hishikawa school. Her long hair cascades down her back and she wears a tortoise-shell or lacquered comb and a ginko-leaf-shaped hair pin. Her inner collar is white and her underrobe is colored a brilliant yellow and patterned with black and red pine needles; her obi is brick colored and her outer robe has a *sumi* thunderbolt pattern outlining the edge of the sleeves and plum blossoms and swallows set against a delicate blue sky decorate the remaining areas.

The other courtesan is placed in the center of the sheet and acts as a focal point for the composition.

Her robe is black with an overall green bamboo pattern; placed at random on it are large fan designs. The ones at the bottom show a court lady beside a stream and a willow tree, perhaps symbolic of the poetess Ono no Komachi (834–900) or a scene from the Tale of Ise. The fan design on the back of her robe shows a back view of Ariwara no Narihira (825–880) the great poet and lover, the principal character of this same romance. The girl's obi is horizontally striped with five different colors against the black ground.

The dozing gentleman wears a wadded silk tam. His eyes are closed and the courtesan braces his chin with her hand. He wears a simple delicate blue robe with a small floral pattern. Over his knees rests his *haori* turned inside out. It is of a cloud and honeycomb, or tortoise-shell, design with a dogwood-like flowered collar.

Kiyonobu shows his lack of concern for symmetry. Behind the courtesan on the left there is a strong arrangement of diagonals and verticals created by the verandah and the shōji panels. At the back of the print are three folds of a screen with a rustic cottage, trees, and a shore line with waves breaking against small rocky islands. This could be a reference to the noted waves of Matsushima and once again to the *Tale of Ise*. At the bottom of the third panel of this screen Kiyonobu has discreetly placed his name and seal.

In all likelihood the color was added to this print at a later date.

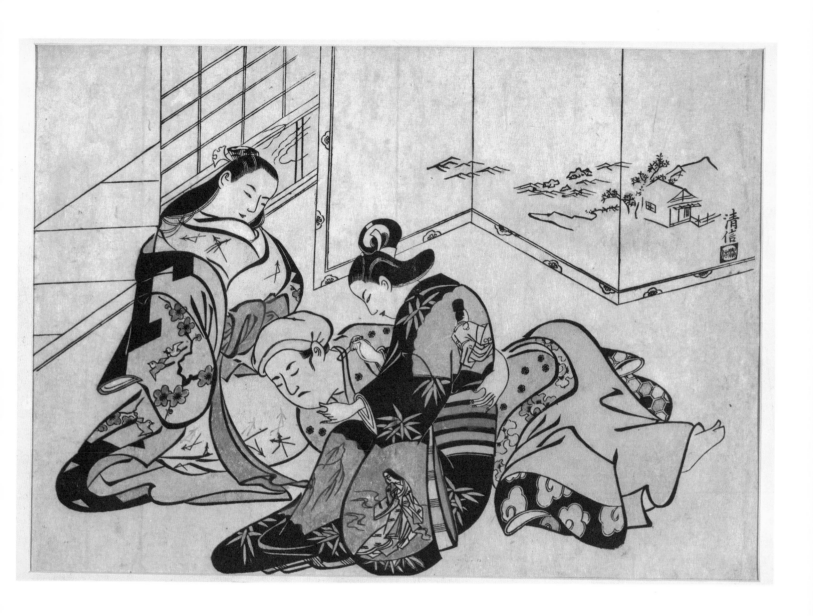

11

Torii Kiyonobu I, 1664–1729

THE ACTORS ICHIKAWA DANJŪRŌ II (male) AND
NAKAMURA TAKESABURŌ (female)

Large panel, tan-e, 16¼″ × 10¾″

Signed: *Torii Kiyonobu Zu*

Philadelphia Museum of Art, Given Anonymously

(To be added to the Henry Le Barre Jayne Collection)

ANOTHER KIYONOBU PRINT which displays his skill at portraying actors is this one which as far as can be determined represents a scene from the well-known *Kyōgen* play *Narukami Shōnin* (The Saintly Priest Narukami). This play was performed at the Nakamura theater in 1715. The great matinee idol Ichikawa Danjūrō is shown in one of his famous roles, Narukami. The story tells how he used magic and a sacred straw rope to halt all rainfall. Princess Taema went to charm him at his mountain lair and cut the rope to release the water and thus save the land.

Danjūrō II shown here was the eldest son of the first actor to bear this illustrious name and succeeded to it in 1705. He in turn passed it along to a pupil in 1735. As the angered monk, his robe is undecorated but for his bold crest of nested boxes. He leans on the verandah rail of his rustic cottage and stares at Princess Taema who at this performance was acted by Nakamura Takesaburō, active in the theater from about 1700 until 1720. In the role he wore a robe decorated with snowy herons set against lotus leaves and water reeds.

Kiyonobu has very carefully organized his space. In the farthest background is a waterfall which provides a strong vertical element; before that is the diagonal of the thatched roof, the latticework window, the verandah, its rail, and the Princess. They in turn are balanced by the diagonal created by the figure of Danjūrō and the edge of the verandah, and to heighten our interest he has placed a number of roughly circular forms into the composition, such as the hole in the rock, the window, the mouth of the bucket, the lotus leaves, and the heads of the actors.

This print must have been handsomely hand colored at one time but has faded a great deal, and all that remains is the faintest trace of what formerly were brilliant yellow, brick red, and orange. It is simply signed *Torii Kiyonobu Zu* and dates from approximately 1715.

[40]

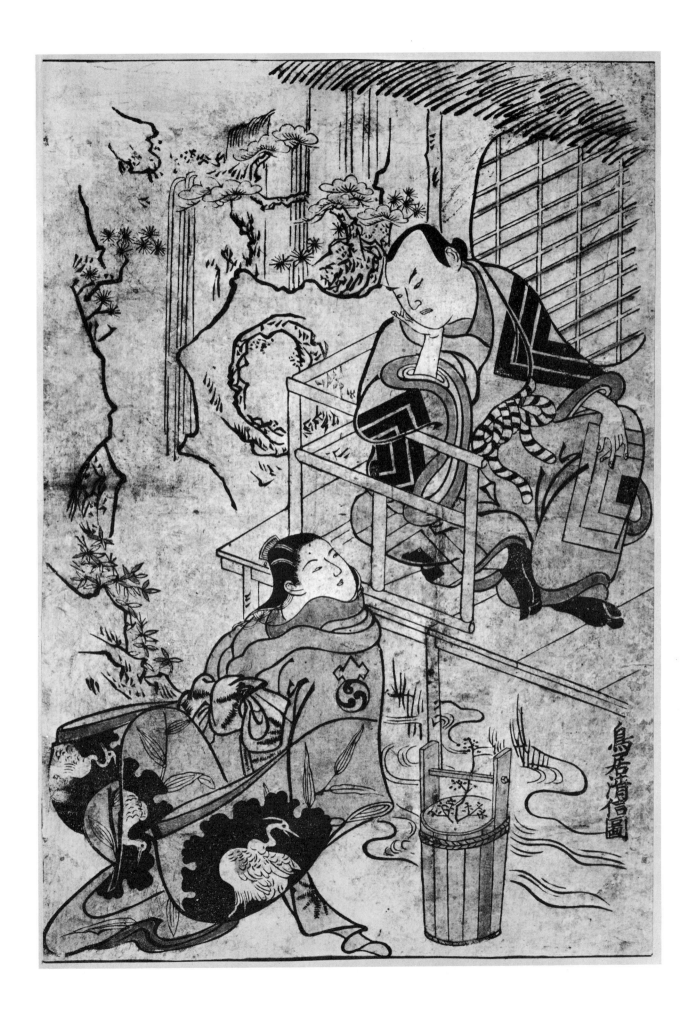

12

Torii Kiyonobu I, 1664–1729 (attributed)
DANCER
Large tan-e, 21¾″ × 11½″
Unsigned
Metropolitan Museum of Art, Dick Fund, 1949 (Ledoux Collection)

ONE OF THE TRULY GREAT PORTRAYALS of a dancer is this large unsigned *tan-e* print. Because of the skillful and monumental arrangement of the figure on the paper as well as the face and textile pattern it can be attributed to Kiyonobu.

The identity of the actor who portrays the role is unknown, although the outer garment is decorated with a *mitsu tomoe* (three comma-shapes placed in a circle) and oak-leaf pattern. When oak leaves were crossed over *mitsu tomoe* it was normally the crest of an actor of the Suzuki family. In this case we are uncertain. When in the Ledoux collection this print was considered to possibly represent the actor

Tsugawa Handayū. The crests, clouds, and movement of the long sleeves add great vitality and keep the figure in motion. The hand which holds a staff is bent at the wrist and leads one to the broad flower-lined hat.

Simple though this print seems, it is one of the most complex designs in which the graceful tension of a dancer's movements are superbly captured. The yellow and orange added pigment further enhance it, but even in black and white the print is magnificent.

It is composed of two sheets of paper joined just at the bottom of the dancer's left sleeve. Several similar subjects exist; however, it is equaled by none.

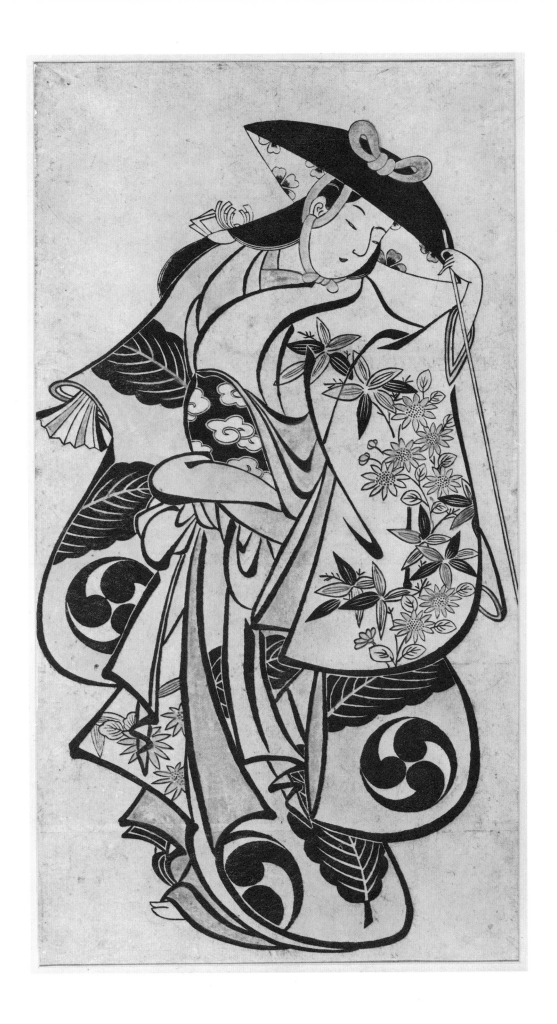

13

Torii Kiyomasu I, act. 1690–1710

THE ACTORS NAKAMURA GENTARŌ AS AN OIRAN AND IKUSHIMA SHINGORŌ AS A MAN

Large tan-e, 20¾″ × 12⅝″

Signed: *Torii Kiyomasu*

Seal: *Kiyomasu*

Metropolitan Museum of Art, Frederick Charles Hewitt Bequest Income, 1912

THE QUESTION OF THE IDENTITY of the artist who used the name Kiyomasu I has already been discussed in commenting on print No. 9. The author continues to prefer to consider Kiyonobu and Kiyomasu as individuals rather than as the same person. It must be admitted, however, that without signatures it would be very difficult to stylistically distinguish the work of one from the other. Some day additional documentation may be found which will answer our questions.

We are also in the dark as to the identification of the play which this large print illustrates. It is a *tan-e* hand colored with red lead and yellow. The scene is one of great charm for the actor Nakamura Gentarō, representing an *oiran* (a higher class of prostitute), has stepped forth from the hanging scroll on the wall and confronts the actor Ikushima Shingorō who is seated on the floor and holds a drum. The composition is somewhat reminiscent of the old New York World's Fair trylon and perisphere, or more accurately a pyramid and Cleopatra's Needle. The corner of the room and floor molding create an inverted Y. To the left flowers hang in the *tokonoma* basket and to the right is the now empty hanging scroll. All that remains of it is the cloud-and floral-patterned mounting and the rough outline of the *oiran*. A jagged line separates the head from the rest of the body.

The ground color of both robes is yellow, while the linings, underrobes, collars, obi, and decorative patterns are orangish red. The man's robe has *tachibana* blossoms set onto an irregular black base. The woman's robe has a plum-blossom design.

The profile of the great actor Ikushima Shingorō is easily identifiable. His features were small and his nose had a marked curvature. His hair style resembles that of a crew cut. The *oiran's* body bends and she lowers her head to look down at the man with the drum. In turn he raises his head to meet her glance. The viewer appears to look up from a level lower than the figures. It is almost as though we view the scene from theater seats. In Japan the stage was raised.

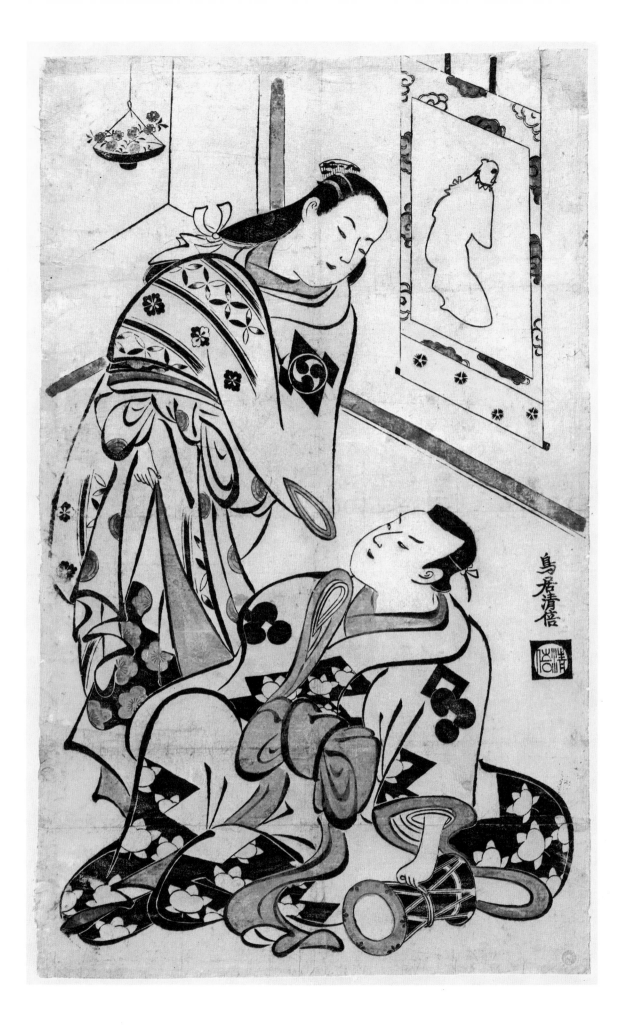

14

Torii Kiyomasu I, act. 1690–1710

THE POET TEIKA (FUJIWARA NO SADAIE) ON HORSEBACK
WITH ŌE SAEMON AND NOWAKE

Large sumi-e, hand-colored, 22⅞″ × 11¾″
Unsigned, Collector's Seal: *Wakai*
Mr. and Mrs. Richard P. Gale, Mound, Minnesota

FROM TIME TO TIME a truly unique print appears.
Such is the case of this large depiction of the great
poet Fujiwara Sadaie, also readable as Teika, as he
rides on horseback accompanied by two other figures
amidst a background of scenes surrounding Lake
Biwa, the Ōmi region of Japan. Kiyomasu I is con-
sidered to be the artist who created this work. It is
a pyramidal composition with Teika serving as the
point and the other figures at each side the base.

The play is not identified, although there are other
treatments of the same theme done by Kiyomasu I.
The identity of the actors is also not known; however,
in the other treatment of the theme Teika was played
by Ikushima Shingorō, Danjūrō played the warrior
labeled here Ōe Saemon, and the female attendant,
labeled Owake in this example, was portrayed by
Arashi Kiyosaburō. As Kiyosaburō died in 1713, it
helps us somewhat in fixing the date of the perform-
ance as ca. 1710; however, the performance, or a
similar one, may have been repeated at a later date.

A number of things in the composition are in need
of further explanation which future research may
provide. The very low-slung belly of the horse with

the character read *kichi* or *yoshi* on its side is unusual
as is the standard appearing behind the horse and
Teika. There is not the slightest trace of a figure
carrying it.

Fujiwara no Sadaie, who lived from 1162–1241,
was a great poet and the leading man of letters in his
day. He served as compiler of some of the most noted
anthologies of poetry, such as the *Hyakunin Isshū*
(Poem of a Hundred Poets) of 1235 and the *Shin Kokin
Waka Shū* (New Anthology of Ancient and Modern
Poetry) of 1205. He was a popular figure and thus
provided a good character for a play. The Teika shown
in this print wears a cloud-patterned traveling robe.

The four sites surrounding Lake Biwa, which are
portrayed, are from left to right: the mountain cot-
tage in which the blind poet Semimaru (897–966)
lived and played the *biwa*—the grandson of the
Emperor Daigo, Minamoto Hiromasa, is shown on
his way to visit him and study music; Mount Hiei;
Sakamoto peak; and the famous Karasaki pine tree.

The print bears the seal of the noted collector
Wakai.

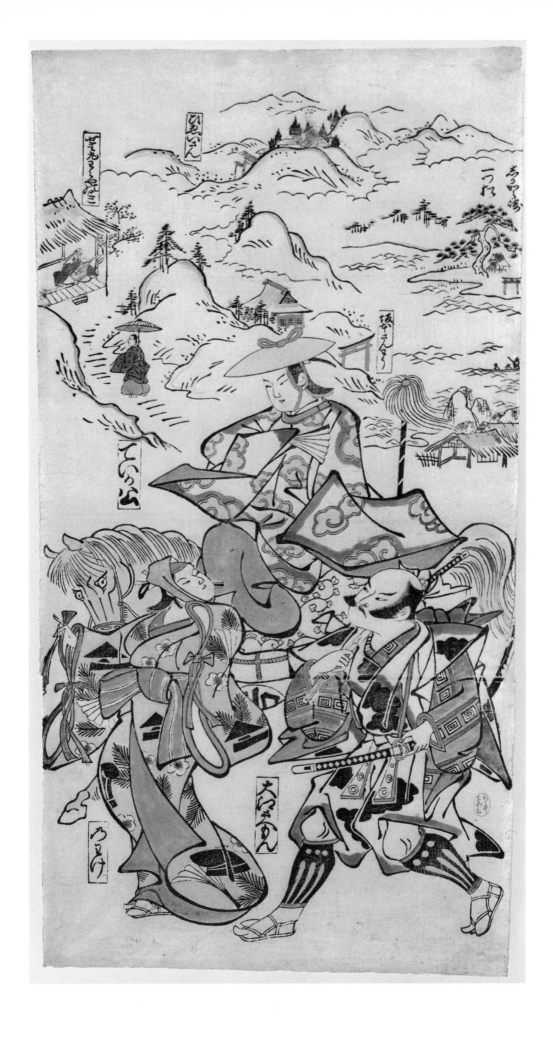

15

Torii Kiyomasu I, act. 1690–1710

THE PUPPETEER (ICHIMURA TAKENOJŌ VIII SHOWING PUPPETS TO A COURTESAN AND TWO ATTENDANTS)

Sumi-e, 11″ × 16″

Signed: *Torii Kiyomasu*

Artist's Seal: *Kiyomasu*

Publisher: *Komatsuya*

Metropolitan Museum of Art, Dick Fund, 1949 (Ledoux Collection)

A STREET THEATRICAL SCENE is the subject of this print by Kiyomasu I. It is a charming setting for in it the artist has represented the actor Ichimura Takenojō VIII in the role of a puppeteer, as the inscription read *kairai shi* in the cartouche on the right indicates. He has stopped on the street to manipulate his puppets for a stately courtesan and her two *kamuro* (young attendant maids). The courtesan who wears a plum-blossom patterned robe leans back, twists her body and head, and watches the performance. Her figure almost forms the letter D. The two *kamuro* look straight on at the performer. Their kimonos are alike, which was the custom of the time, and are decorated with vertical stripes in the *shippō* (coin) and *yotsume nanabishi* (four-petaled flower) patterns. Only the actor is identified by his crest, and the name of the play is not known.

Itinerant street performers were common in Edo in the first quarter of the eighteenth century. Thus, though the print in all likelihood illustrates a play, it is a scene that undoubtedly often occurred in the city. Takenojō VIII carries a box which serves as the stage. His hands are inside it and hidden from view by a cloth. His tiny performers are a fox and a youthful samurai.

The setting for the print points out the continuing influence of Moronobu. Recession in depth is marked off on the street by short parallel horizontal lines. Behind the figures are the curtained entrances of two houses in the Yoshiwara. The one on the left has a pine-tree crest and is probably called Matsuya, and that on the right a wisteria blossom and called Fujiya.

The print is signed and sealed by Kiyomasu and carries his publisher's seal which reads Komatsuya.

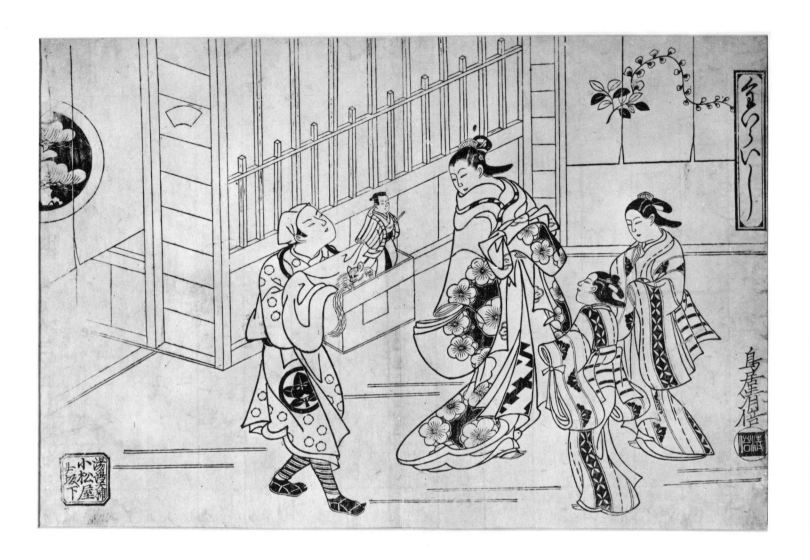

16

Kondō Kiyoharu, act. 1704–1720
THE BIRTH OF BUDDHA
Hoso-e, urushi-e, hand-colored, brass powder, 11⅜″ × 6½″
Signed: *Gakō Kondō Sukegorō Kiyoharu Zu*
Publisher: *Maru ... (?)*
The Art Institute of Chicago

KONDŌ KIYOHARU WAS THE ARTIST who created this rare print. Little is known about his life although he did produce a good number of prints and made many illustrations for popular books of the day, such as the *Kimpira Bon* and *Aka Bon*. There has always been some speculation that he was one and the same person as the publisher Izumiya Sukegorō, for he was also commonly called Sukegorō. Another theory has tried to link him to Torii Kiyoharu. Neither of these has ever been substantiated. The only concrete information that we have is that a man signing in this manner was active during the years 1704–1720.

The subject of the print is the Birth of Buddha and he is the center of the composition. He stands on a lotus which rises from a pond before a thicket of Acoka trees. The infant *Shaka* raises his right hand to heaven and with his left points to earth. Swirling in the sky above are two dragons who spout forth streams of hot and cold water to bathe him. On *Shaka's* left, high in the heaven, is the sun and at his side is his divine father, Indra, whereas on his right is his mother, Maya, and in the sky the moon. Before this group is an assembly of worshipers come to witness the scene. They are foreigners and appear to hold coral and incense on small tables. In the center of this group is a small leaf-bedecked shrine filled with

water. Images of the infant Buddha are placed in these and water is ladled over them in celebration of his birth every April. The ritual is still practiced.

The print is hand colored in orangish red, yellow, and blue (which has since faded). In addition to this a new decorative technique is revealed, for Kiyoharu used imitation lacquer and has sprinkled brass filings over areas to highlight the design. This type of print is called *urushi-e* and glue was the normal binder and substitute for lacquer. I suggest that this was a technique used by print artists of the period to make their work appear richer. The filings served as the poor man's gold and made the print resemble paintings. The subject matter is also especially rare for the *ukiyo-e* school and would fit the votive-print tradition of the thirteenth through fifteenth centuries much closer. An examination of this artist's work reveals that on several occasions he used non-*ukiyo-e* themes. The Art Institute of Chicago also possesses his portrait of Sugawara Michizane (845–903) and the *Battle of Ichi no Tani* of 1184.

This print is signed on the left and in the bottom center is a publisher's seal. Only part remains, signifying that the print has been trimmed. The character read *Maru* appears in a black circle and beneath that *Matsu*.

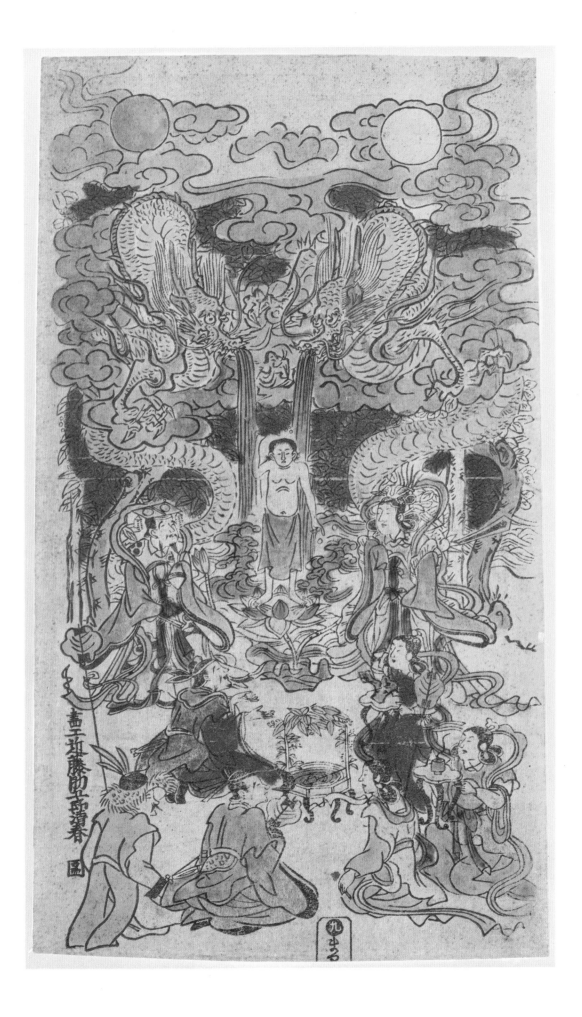

17

Torii Kiyonobu II, act. 1720–1750

THE ACTOR OGINO ISABURŌ IN A DANCE FROM TOKIWA GENJI

Hoso-e, urushi-e, brass powder, 13½" × 6¼"

Signed: *Eshi Torii Kiyonobu Hitsu*

Publisher: *Murata*

Nelson-Atkins Gallery, Kansas City, Missouri (Nelson Fund)

IT IS GENERALLY BELIEVED that the child born in 1706 later called Kiyomasu II may well have been a son of Kiyonobu I. Most scholars also feel that upon the death of Kiyonobu I in 1729 he assumed his father's name. Thus, Kiyomasu II and Kiyonobu II are one and the same person. A second theory, reported in the catalogue of primitive prints in the Art Institute of Chicago, suggests that he was the adopted son-in-law of Kiyonobu I and when his father-in-law retired in 1727 took his name. Though neither theory can be supported by fact, the former is given greater credence.

The subject of this print is the actor Ogino Isaburō dancing in a scene from the play *Tokiwa Genji* (The Eternal Genji) performed in 1726. Dr. Richard Lane, in his *Masters of the Japanese Print*, page 91, points out that this print is one of a pair with the left one showing an actor in a feminine role.

Isaburō is portrayed in violent movement. Only his right foot touches the ground. He holds one sword in his left hand and in rapid gesture moves his right hand holding a fan downward. During this action the right sleeve of his outer robe, which is free of his body, flares out and the two resemble the wings of a butterfly. His features are small and locks of hair swing loose from his head. His determined action

has caused his *naga-hakama* (long culotte-type trouser) leg to fly up as his foot stamps the ground. This type of trouser, which extended behind the foot, always made the wearer appear to be kneeling and in obeisance; at the same time its cumbersomeness restricted the wearer's movement with a sword and thus limited the likelihood that he might draw it. His robes are decorated with a pattern of wisteria roundels, maple leaves floating on water, and a tray and sake cups as a shrine offering. The ideograph in the crest on the sleeve of his inner robe reads *arai* (rough, or in a rage), signifying that he is playing an *aragoto* (vigorous) role. Behind Isaburō is a highly stylized pine tree and to the figure's left is printed his identification, Ogino Isaburō.

The artist's name and the publisher's are at the bottom of the print. The latter is mentioned as living in Tōriabura-chō. The National Museum, Tokyo, impression, published by Lane as plate 37 in his aforementioned book, varies a good deal from the Nelson-Atkins Gallery example. In the former much use was made of orangish red and this is totally absent in the latter in which only black, yellow, brown, and brass filings were employed. It is less busy and bolder.

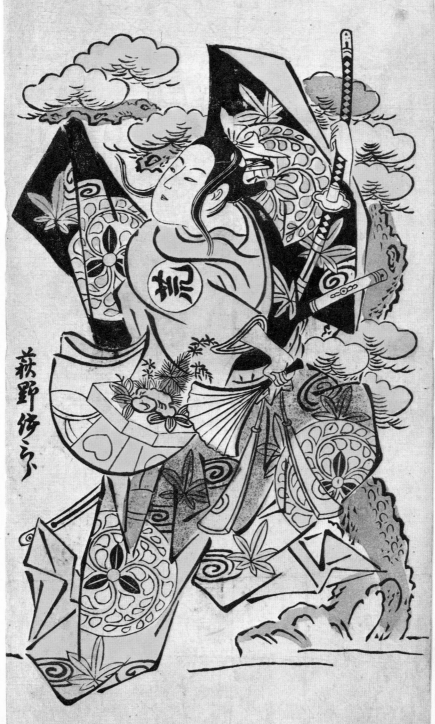

18

Torii Kiyonobu II, act. 1720–1750

THE ACTORS ICHIKAWA DANJŪRŌ II AS FUWA NO TSUZAEMON
AND SEGAWA KIKUJIRŌ AS BUREI NO ICHIRI

Hoso-e, urushi-e, brass powder, 12¾″ × 6″

Signed: *Torii Kiyonobu Hitsu*

Publisher: *Igaya*

Philadelphia Museum of Art, Given by Mrs. Anne Archbold

TWO RATHER VOLUMINOUS FIGURES of actors fill the space of this print by Torii Kiyonobu II. They are shown seated against a roofed fence with slatted openwork in its upper portion. Behind it is a maple tree with its leaves in autumn hues. The fence slopes diagonally from the upper left corner to the right side of the sheet.

The busyness of the composition and the robe patterns, as well as the scale of the figures and less dynamic treatment of the faces, indicates that Kiyonobu II was the artist. The print is an *urushi-e* with glue or very thin lacquer added to the black used for the robe giving it extra sheen. The arrangement reminds us of the two figures in No. 13, a pyramid and a needle, and is viewed from above. Danjūrō II is seated on the ground, his crest of stacked boxes in very large scale is placed at both of his knees almost

like patches, whereas the remainder of his robe is decorated with clouds, wind, lightning, and symbols of a storm. He plays the role of Fuwa no Tsuzaemon, one of the favorite eighteen Danjūrō roles. He looks up and places his hand on the long sleeve of the actor Segawa Kikujirō in the role of Burei no Ichiri. Kikujirō's robe has a rather effeminate floral pattern of *fukujusō (Adonis sibirica)* blossoms and ponds. His hand holds a fan which turns inward to link with Danjūrō's hand and swords, creating a strong diagonal running almost parallel to the fence.

Both actors' names and roles are inscribed beside them. At the lower left is the artist's signature and beneath it the publisher Igaya's seal. The color is brilliant and the left side of the print has been trimmed.

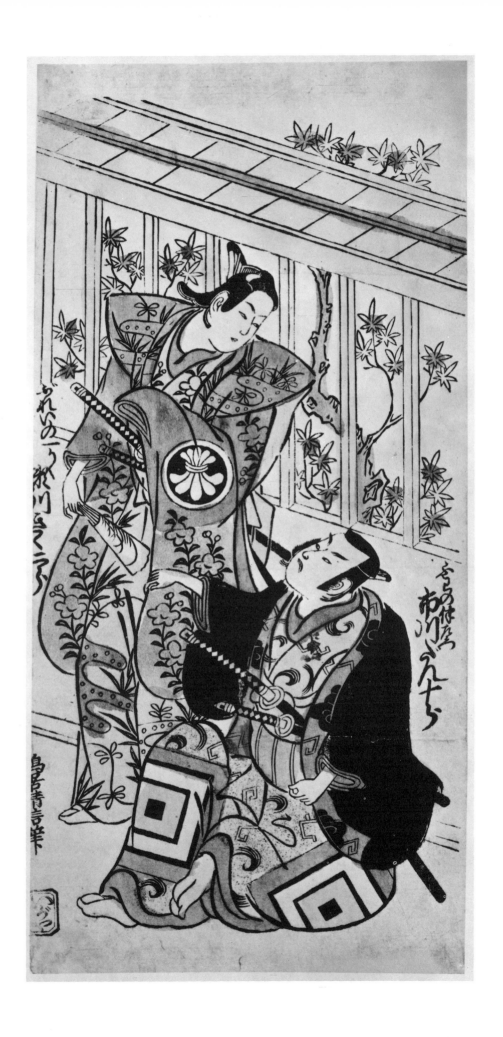

19

Torii Kiyonobu II, act. 1720–1750

THE ACTOR ŌTANI HIROJI I AS ASAHINA

Large pillar print, hand-colored, 27¼″ × 6⅛″

Signed: *Yamato Eshi Torii Kiyonobu Shōhitsu*

Publisher's Seal: *Izumi . . . (?)*

Metropolitan Museum of Art, Frederick Charles Hewitt Bequest Income, 1912

ASAHINA SABURŌ YOSHIHIDE is the subject of this powerful print depicting the actor Ōtani Hiroji I by Kiyonobu II. The theme quite clearly derives from one of the Soga plays in which Asahina took a prominent part. Historically he was the son of Wada Takenori who in 1213 raised a revolt against the powerful Hōjō clan. Asahina was known for his Herculean strength. Kiyonobu has captured his forcefulness. The figure fills the entire space of the large narrow pillar print. No other props are needed. He wears a full brick-colored robe. On it are two crests. The upper one with a crane is that of the role, whereas the lower one is that of the actor Ōtani Hiroji I who lived from 1699–1747. The collar has a narcissus pattern. In the role of Asahina the actor always wore bushy muttonchop side whiskers and his face was heavily and grotesquely made up. He also carried a very long sword, which in this instance rises up beside him as he looks right.

The print is one of the most forceful portrayals of Asahina. He scowls out at his opponents; his eyes are wide open and penetrating. The hand coloring applied to the print has further enhanced it. I do not know of another impression of it. It bears Kiyonobu II's signature proudly signed *Yamato Gashi* (Japanese Artist) in the lower left and that of a publisher, probably Izumi, on the right. The entire composition resembles a theatrical poster.

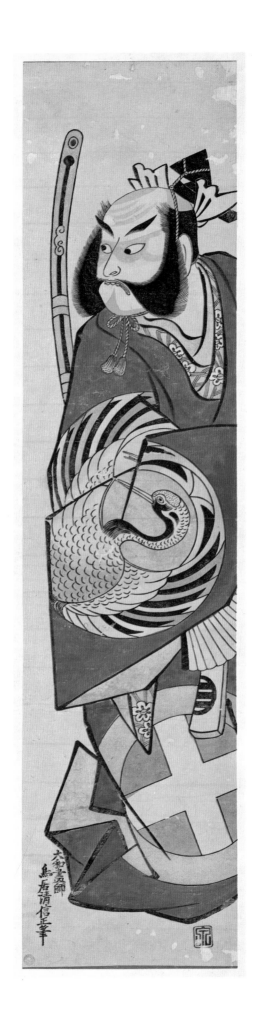

20 21

Torii Kiyomasu II, act. 1720–1750

YAMASHITA KINSAKU AS A COURTESAN AND ICHIKAWA DANJŪRŌ II AS A PORTER

Urushi-e, hand-colored, brass powder, two hoso-e joined, left 13¼" × 6½", right 13¼" × 6¼"

Signed: *Torii Kiyomasu Hitsu*

Publisher: *Igaya Kanemon*

Grunwald Graphic Arts Foundation, University of California, Los Angeles

ALTHOUGH HOSO-E DIPTYCHS were not unknown during the time of Kiyomasu II, few have survived in comparatively good state. Thus the Grunwald Graphic Arts Foundation of the University of California, Los Angeles, is fortunate to have acquired this fine example. It is also an *urushi-e* and was very tastefully hand colored.

The normal procedure would have been to publish the prints signed Kiyomasu prior to those signed Kiyonobu; but since both are the same man, I have arbitrarily reversed the order to indicate the break with Kiyomasu I.

The two prints are in wonderful register. On them is shown the meeting of two figures in front of a house called Hirano-ya, which was probably located in the Yoshiwara or was a tea house. A courtesan, played by Yamashita Kinsaku, standing before the curtained doorway of this establishment is the subject of the left print. Although she faces left, in typical *ukiyo-e* fashion she looks back over her shoulder to the male figure of Ichikawa Danjūrō II, the subject of the right print, who in balance faces right and turns to look back at her.

There is an interesting interrelationship of forms. Associated with the female character are many round, florid, and delicate shapes, such as the grape, star, and floral patterned robe as well as the actor's own crest, and the tea cup, water pot, and fan-shaped stand. In contrast the male figure stands against severe ninety-degree verticals and horizontals created by the house's window and a large box with the character *kotobuki* (felicitations) written upon its side. To his left is a square-shaped lantern which is decorated with a *torii* (Shinto gate) and pine bough and inscribed *inari no mae* (before the fox shrine). The lantern form is a repetition of Danjūrō's crest. He holds an open fan decorated with plover in flight over reeds, and his robe is lavishly embellished with a pattern of floating fans and stripes. He wears a straw hat and his feet pointing in opposite directions anchor him firmly to the ground.

The play has not been identified; however, I feel we are free to speculate that it may be a scene from the same *Bandō Ichi Kotobuki Soga* already mentioned in No. 11. The box with the ideograph in the right print and the robe of the courtesan are indicative of this. A robe like this one is worn by an actor portrayed in a similar role and can be seen in a painting by Okumura Masanobu in the Freer Gallery of Art. A single *hoso-e* print by Okumura Toshinobu with the same actors was published by Fujikake Shizuya as plate 144 in his book *Ukiyo-e no Kenkyū* (Ukiyo-e Studies, Vol. II).

Both of the Grunwald prints are signed respectively on the far left and right *Torii Kiyomasu Hitsu*; and at the bottom of each print in a decorative cartouche is the publisher's seal, *Igaya*, and an inscription which reads *Ukiyo-e sōshi iroiro oroshi* (*Ukiyo-e* illustrated books, various subjects at reduced prices) and *Edo Motohama-chō Igaya Hammoto* (The Publisher Igaya of Motohama-chō in Edo).

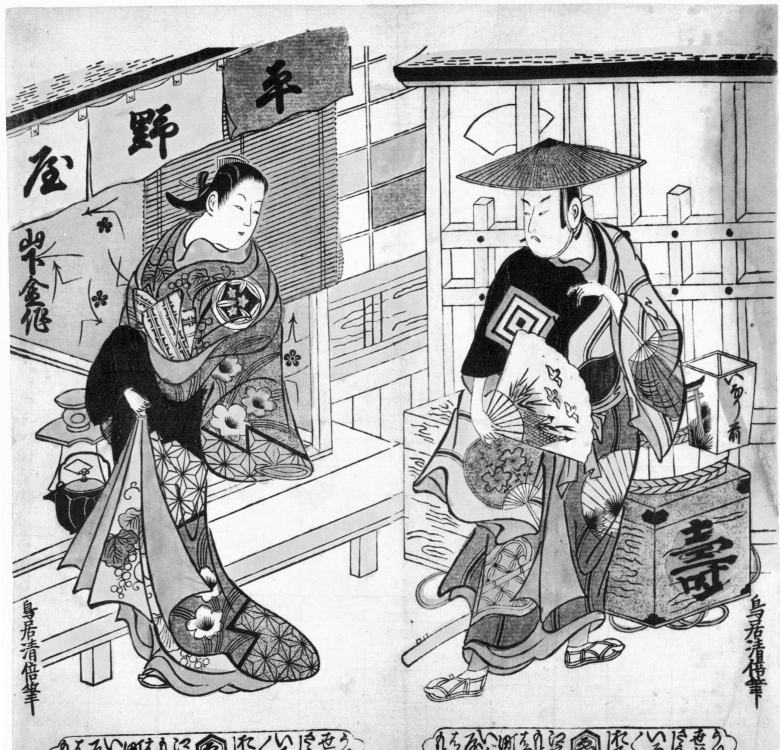

22

Torii Kiyomasu II, act. 1720–1750

THE ACTOR ICHIMURA UZAEMON VIII (Takenojō)

Hoso-e, urushi-e, brass powder, 12⅞″ × 6⅛″

Signed: *Torii Kiyomasu Hitsu*

Publisher: *Emiya*

Nelson-Atkins Gallery, Kansas City, Missouri (Nelson Fund)

ICHIMURA UZAEMON VIII, also known as Takenojō, is shown as a girl leading a bullock laden with bundles of firewood. These simple country girls called *Ōharame* carrying wood on their heads can still be seen in the area of Kyoto; however, their clothing is much humbler than the rather elegant kimono worn by the actor. It is made up of sheaves of rice, cherry blossoms, and flying plover, as patterns, with an obi that imitates a net.

The actor walks to the right and turns to look back at the bullock which, although heading in the opposite direction, turns to follow. Once again we see the almost D-shaped bend of the body so common in the primitive prints and the continued employment of a short solid mass balanced by a slender vertical. The bullock is a rather entertaining and ridiculous-looking beast. The top of its head resembles the

tonsure of our own monks. Behind the figure and animal is a hillock and fence.

Although the play has not been identified, a print closely resembling this one is in the collection of the Art Institute of Chicago (25.1753). It is by Hanekawa Wagen, a pupil of Chinchō, who was active ca. 1716–1735. On it, in addition to Takenojō, the actor Ogino Isaburō I is represented. Both figures carry firewood on their heads and one leads a bullock. They purport to be women of Ōhara. These two actors appeared together in the first month of 1724 in a play titled *Yomeiri Izu Nikki* (The Izu Wedding Diary) in the roles of Oniō and Danzaburō.

The hand coloring is mainly in yellows and orangish red. The print is signed by the artist and also bears the publisher Emiya's seal.

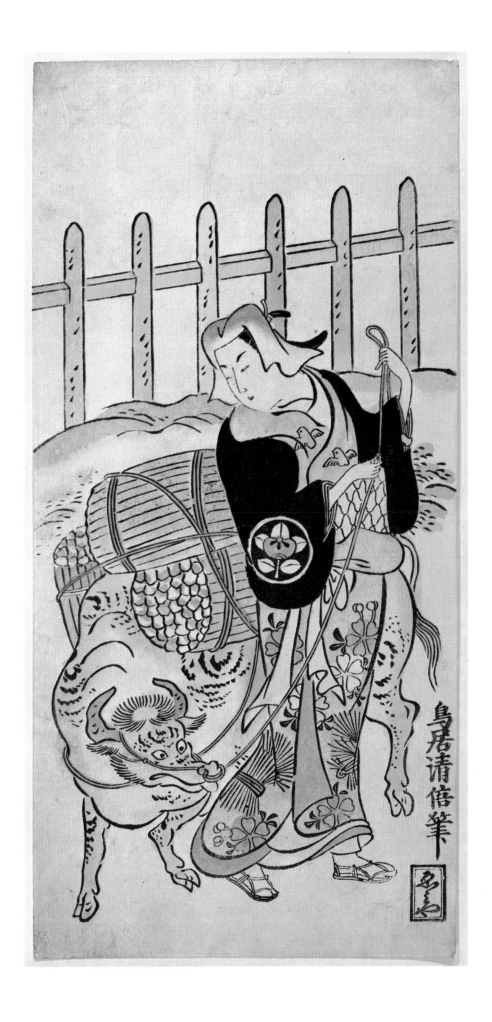

23

Torii Kiyomasu II, act. 1720–1750

THE ACTOR ICHIMURA MITSUZŌ RAISING A DRUM

Hoso-e, urushi-e, brass powder, 12⅛″ × 5¾″

Signed: *Eshi Torii Kiyomasu Hitsu*

Publisher: *Urokogataya*

Metropolitan Museum of Art, Frederick Charles Hewitt Bequest Income, 1912

TORII KIYOMASU II-KIYONOBU II continued throughout his career to produce striking actor portrayals. At times these may appear stereotyped; however, a careful examination reveals fresh qualities in each.

The actor Ichimura Mitsuzō is portrayed as a samurai. His *haori* carries his crest, the character *mitsu*, and is of cherry-blossom patterned silk, whereas his kimono has Ichimura crests, a *tachibana* blossom at knee level, and an overall design of clams and water plants. Mitsuzō raises an hourglass-shaped drum in his left hand. His feet are spread apart and firmly placed on the ground, and his right hand turns in sharply at the wrists as though stiffly frozen to fend off a blow. He almost resembles a football player about to hurl a pass.

The artist has deftly employed hand-applied colors to create interest in the busy robes which aid us in concentrating on the actor's face. Behind the figure is a large wooden tub in which grows a rather stilted palm. One branch curves downward sharply almost echoing the tensely bent wrist of the figure's right hand. The play has not been identified.

At the bottom of the print is a cartouche which contains on the right the artist's name, in the center the publisher's seal, and on the left his name.

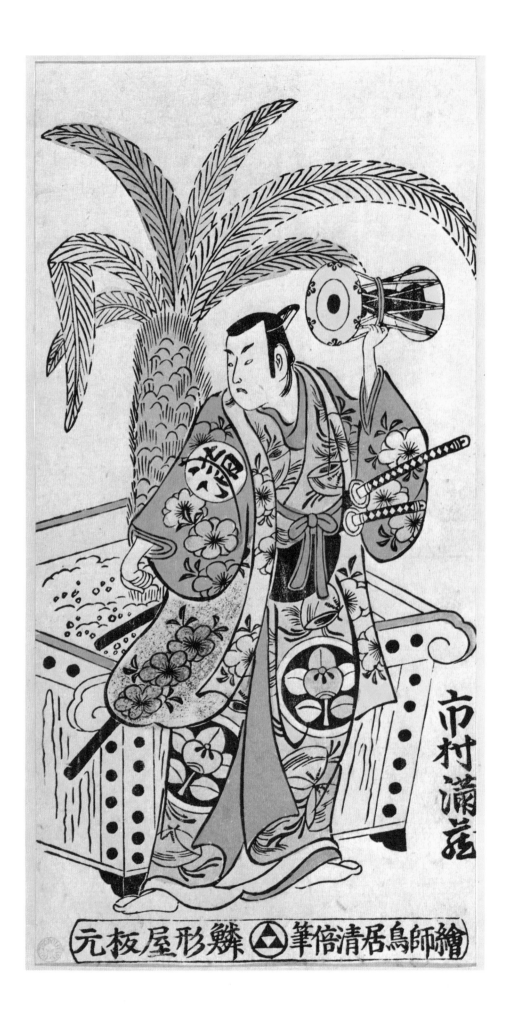

24

Torii Kiyomasu II, act. 1720–1750

Series: ŌMI HAKKEI (EIGHT VIEWS OF ŌMI): NIGHT RAIN NO. 2
AT KARASAKI

Hoso-e, urushi-e, brass powder, 12½″ × 6⅛″

Signed: *Eshi Torii Kiyomasu Hitsu*

Publisher: *Igaya Kanemon*

Metropolitan Museum of Art, Rogers Fund, 1922

IT WAS NOT UNUSUAL for artists in the second quarter of the eighteenth century to produce series of prints. As themes they borrowed from the accepted traditional repertory, but they redeveloped them with *ukiyo-e* flavor. As has already been seen in No. 9, the Eight Views underwent such adaptation for the Kanazawa region. The favorite area for such treatment, however, was that called Ōmi, the name applied to the environs of Lake Biwa. These Eight Views are as follows:

1. *Autumn Moon at Ishiyama*
2. *Evening Snow at Mount Hira*
3. *Evening Glow at Seta*
4. *Evening Bell of Mii Temple*
5. *Returning Sails at Yabase*
6. *Sunset Sky at Awazu*
7. *Night Rain at Karasaki*
8. *Wild Geese Alighting at Katata*

It is the seventh that is represented in this landscape print by Kiyomasu II. Karasaki is located on the southwestern shore of Lake Biwa and is noted for a huge pine tree with a shrine beside it. This is the same site that appears in Nos. 14 and 149.

The three figures who scurry through the rain are of small scale and one carries a torch signifying that it is night. The landscape is sandwiched between two banks of clouds. From the upper one rain pours down drenching the figures and giving needed water to the gnarled and aged pine. An *urushi-e* technique was used in coloring this print, and two heavy dark hori-

zontal bands in the sky symbolize the intensity of the storm and greatly add to the mood. Small patches of brass filings were used on each figure so that they sparkle in the torchlight. The small scale recalls to mind the work of Moronobu and Kiyonobu I as well as book illustrations.

With the series title *Ōmi Hakkei* (Eight Views of Ōmi) No. 2 appears in the cartouche on the upper right, and following that *Karasaki no Yoruame* (Night Rain at Karasaki). It is unusual that the title, normally seventh in the set, is treated by Kiyomasu II as the second. The poem appears to read, and can be roughly translated, as follows:

Yoru no ame ni
Ao o yuzurite
Yūkaze o
Yoso ni nadataru
Karasaki no Matsu

*The night rain obscures
the green.
Indifferent to the
night wind is the
Noted pine of Karasaki*

The cartouche at the bottom of the print, in standard fashion from right to left, contains the name of the artist, the publisher's seal, and his name and location of the shop: Igaya at Motohama-chō. Other prints of this series can be found in the Museum of Fine Arts, Boston, and the Art Institute of Chicago.

[64]

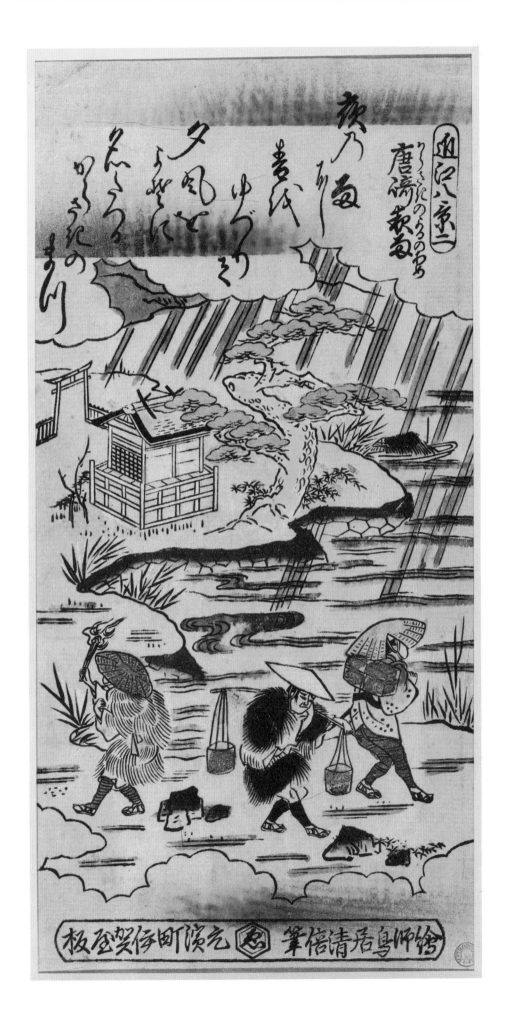

25

Okumura Masanobu, 1686–1764

A PARODY OF YANG KUEI-FEI AND HSÜAN TSUNG:

AGEYA JŪNI DAN (House of Prostitution: Twelve)

Sumi-e, 11⅜″ × 15¾″

Signed: *Okumura Masanobu Zu*

Seal: *Masanobu*

Publisher: *Igaya*

Museum of Fine Arts, Boston, Morse Collection

AN ARTIST WHO VERY MUCH INFLUENCED the entire course of *ukiyo-e* and was considered a great innovator was Okumura Masanobu. He was prolific and we are blessed with many works from his hand.

Masanobu was born in 1686 and died in 1764. His origin is rather obscure, though later in his life he is reported as having established a publishing house for illustrated books and prints located in Tōrishio-chō. This shop was called both Okumuraya and Kakujudō, and a gourd-shaped seal was used as a trademark. Masanobu used many pseudonyms in signing his work, including those of Bunkaku, Tanchōsai, Hōgetsudō, Shimmyō, Genroku, and Gempachi. As many artists of the day, while in his twenties he studied poetry with a noted poet and novelist who used the literary name Shōgetsudō Fusumi Senō. Masanobu is traditionally said to have been the first to use pillar prints and to make use of the *urushi-e* technique. He is also mentioned as one of the first to use mica on prints and experiment with the *ishizuri-e* (stone-rubbing prints). These actually are much closer to rubbings than prints, the lines being in reverse. Credit is also often given to him for the introduction of the *benizuri-e* in which color blocks, usually red and green, were used in the printing. His mark can clearly be seen in the introduction of the *uki-e* (perspective picture) wherein he sought to capture the effect of true perspective. He must have come into contact with this via the growing interest in the Western world.

The works of Masanobu show that he was clearly influenced by Moronobu and Kaigetsudō. In his concern and treatment of landscape, he shows his awareness of the academic Kanō tradition. The fact that his themes are often derived from literature indicates that he was not an ordinary man. He was in close contact with the world about him.

A seated man and a courtesan playing a flute is the subject of this print, which once was part of a set of twelve sheets. This particular one is titled in the cartouche *Ageya Jūni Dan* (House of Prostitution: Twelve). It is a parody of the Hsüan Tsung Emperor and his Imperial concubine, Yang Kuei-fei. The Emperor, who lived from 685 to 762, was the sixth ruler of the T'ang dynasty. He was a great patron of the arts and especially of music, founding an academy to teach it. Unfortunately he fell hopelessly in love with Yang Kuei-fei and she slowly but surely gained more and more control of the political administration through placing her family in key court positions. After a revolution her influence was broken and she was executed before the eyes of the Emperor.

Masanobu has shown an ordinary patron of the red-light district with a quartered-diamond patterned underrobe and striped *haori* as the Emperor. His feet are crossed before him and an upturned sake cup is humorously tied to the back of his head in imitation of a hat of rank. He props up his chin with his left hand and helps the courtesan finger the flute with his right. The courtesan wears a long flowing robe rather ironically decorated with the "Three Friends," *Shōchikubai* (Pine, Bamboo, and Plum) pattern. These are all emblems of longevity, though such was not the fate of the Imperial concubine. The courtesan supports her body with her right hand and holds the flute to her mouth with her left. The way the two figures are arranged should at once bring to mind the Torii Kiyonobu I, No. 10.

Behind the figures are two pairs of sliding doors with each symbolizing a season and inscribed with its character in a circle. From right to left these are as follows:

Haru (spring); a porter has fallen asleep outside curtains enclosing a cherry-blossom picnic.

Natsu (summer); a maid holding a fan is seated outside a mosquito net covering a bed.

Aki (autumn); a man beside a stream gazes at the moon.

Fuyu (winter); a cat sleeps on top of a *kotatsu* (a hearth) covered with a quilt under which people warm themselves.

The artist's signature and seal appear on the print as well as the seal of the publisher.

26

Okumura Masanobu, 1686–1764

AN INTOXICATED SAKATA KIMPIRA

Sumi-e, 9⅞″ × 14¾″

Signed: *Tōbu Yamato Gakō Okumura Masanobu Zu*

Seal: *Masanobu*

Metropolitan Museum of Art, Gift of Samuel Isham, 1914

A VERY STRONG SUMI-E by Okumura Masanobu is this one which shows the famous twelfth-century strong man, Sakata Kimpira, sprawled out on the floor and resting his head against a bucket. A huge sake cup is at his left elbow and in his right hand he holds a Buddhist rosary. Behind him, his sword forms a crescent covering almost the entire width of the paper.

Kimpira was the leading character in many children's stories. Some of the books relating his exploits were called *Kimpira-bon*. He was the son of the even more noted warrior Sakata no Kintoki, also called Kintarō, and served as one of the four faithful henchmen of Minamoto Yorimitsu. Both Kintoki and Kimpira are popular figures at the time of the Boys' Festival on May 5.

There is a wonderful husky sturdiness in Masanobu's portrayal of the figure. Even though having imbibed deeply of sake from the huge cup, he seems packed with vim and vigor, and his bulging eyes stare at the viewer. Kimpira is ready to take on the world.

His chest is bare and his robe is thrown off one shoulder to display his muscular arm and also tell us that he is prepared. The artist has added to the tension of the figure by accordion pleating his robe which rests in his lap.

The setting itself is unusual for Masanobu has made the viewer look down into the room. He has sought to capture space. In the background there is a sliding door with a willow tree, stream, and swallow in flight. The stream design continues into the *tokonoma* (alcove) in which hangs an entertaining painting of Daruma, the patron saint of Zen Buddhism. The Japanese humanized him and *ukiyo-e* artists often treated him in a humorous manner. His bulging eyes and his position in the painting match that of Kimpira. On a table before it is an arrangement of orchids.

The print is signed *Tōbu Yamato Gakō Okumura Masanobu Zu* (A Picture by Okumura Masanobu, an Edo Japanese Artist). It also bears his seal. In the cartouche on the right is the title of the sheet identifying Sakata Kimpira.

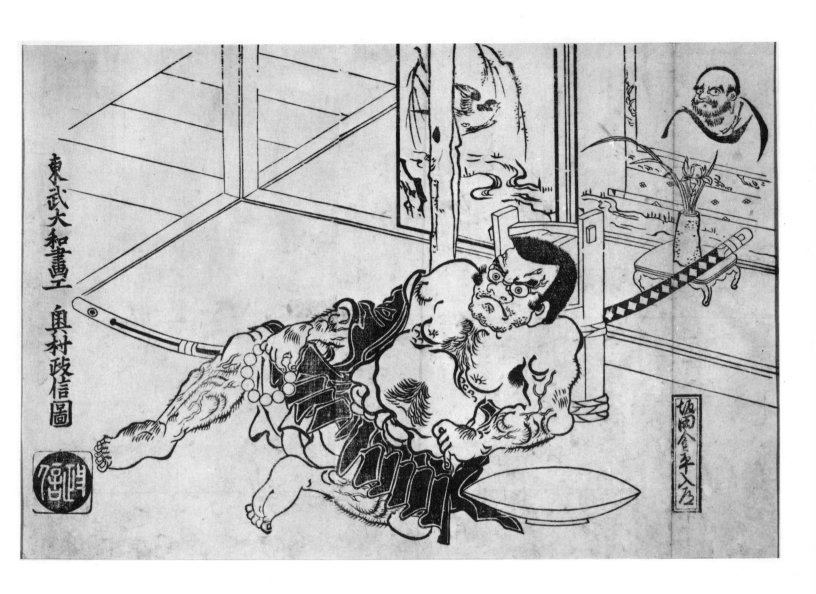

27

Okumura Masanobu, 1686–1764

A MAN AND A COURTESAN WATCHING A YOUNG MAN WRITE

Sumi-e, hand-colored, 9⁹/₁₆″ × 14¼″

Signed: *Okumura Bunkaku Masanobu Zu*

Seal: *Tanchōsai*

Metropolitan Museum of Art, Fletcher Fund, 1929 (Church Collection)

A PRINT THAT IS BEAUTIFULLY EXECUTED and at the same time unusual is this impression of an often published Masanobu theme. Ledoux, Shibui, Noguchi, and others have all reproduced different renderings which they report to be the first picture in an erotic series titled *Someiro no Yama Neya no Hinagata* (Mountain of Dyed Color Specimens of Bedrooms). The one shown here, however, is signed, whereas the others are not. In fact, it is doubly marked for Masanobu's name appears in the upper right on a screen and his gourd-shaped Tanchōsai seal is affixed to the poem on the far left. Perhaps it was one of his literary creations.

The setting resembles in slight manner that of No. 26. The viewer looks down into a room. On the left is a diagonal with a sliding, slatted wooden door behind which stands a framed, floor screen of calligraphy. At the rear of the room is a beautifully executed landscape in the Muromachi period *sumi-e* tradition. Behind the open sliding door is the edge of a screen on which Masanobu has placed his signature.

Three figures are sprawled out on the floor. The central one is a man in a yellow and black striped robe who holds a pipe in his hand. He is looking at a *wakashu* (a homosexual youth) who appears to have started to write a poem. The *wakashu* often frequented the Yoshiwara area and competed for favor, in elegant dress, with the leading courtesans. This one wears

a robe of plum branches, against which are placed petaled roundels of flowers of the twelve months. Also competing for the man's attention and affection is the courtesan who wears a snow-covered pine-patterned robe and rests a hand on his shoulder while slipping the other into his sleeve. Before the group is a smoking tray, pipe, and writing case, while behind them is a sake pot, stand with cup, and tray of food with chopsticks. The print is meticulously hand colored.

Beside the standing calligraphy screen is a poem which may be read and translated as follows:

> *Niō Ume*
> *Aun-no-kuchi no*
> *Hatsu warai*
>
> *The Fragrant Plum (the youth)*
> *Being fond of the same things (being a*
> * a sodomist—this could also be inter-*
> * preted as joining mouths or as the*
> * mouth of one's beloved)*
> *(Produces) the first smile of the year*

It suggests that the man favors the youth. Most poems of this nature are very difficult to translate, and in the past a tendency has existed to make them decent. They were not so and variations can evolve even out of this author's interpretation. The play on words is often deeply hidden.

28

Okumura Masanobu, 1686–1764

THREE WOMEN ENJOYING A MAPLE VIEWING PARTY

Large benizuri-e, 16¼" × 12"

Signed: *Hōgetsudō Tanchōsai Okumura Bunkaku Masanobu Ga*

Seals: *Tanchōsai and Okumura*

Metropolitan Museum of Art, Dick Fund, 1949 (Ledoux Collection)

THE INTRODUCTION of the *beni-e* brought a fresh new excitement to *ukiyo-e* prints about the middle of the eighteenth century. It was a major step in the mechanization of woodcut production, for all prints from a block could now have the same color without having to rely on the time-consuming procedure of hand coloring. In the earliest state the color prints were termed *beni-e* for a red pigment made from *beni* (saffron flowers) was the hue most commonly used, although often in combination with green. Masanobu was a pioneer in this technique.

In this print he shows three girls dressed in the costumes of Imperial guards seated under a maple tree and enjoying the beautiful autumn leaves. Their robes are very busily patterned. The robe of the one on the right writing has a basic peony crest design; that of the central figure holding a sake cup is of cherry-blossom, tortoise-shell, and crane design; and the one playing a *samisen* wears a plum-blossom,

checkered, and chrysanthemum-on-water patterned kimono. The overall effect is one of great richness, and the new use of red and green color is most successful. Before the figures are a rake, a broom, and a sake kettle warming over a blaze made of maple branches and leaves.

The girl writing has started copying a poem by the noted Ki Tsurayuki (883–946), *Kokoroshite kaze no nokoseru* (Mindful of what the wind has left). To the far left is a complete seventeen-syllable poem:

> *Irozuku ya*
> *Momiji o taite*
> *Sake no kan*

This may be translated as "More brilliant become maple leaves burning under sake kettles."

Masanobu has placed on the print a lengthy signature using his many pseudonyms and two seals.

29

Okumura Masanobu, 1686–1764

A YOSHIWARA STREET SCENE

Large uki-e (perspective print)

Sumi-e, hand-colored, 17″ × 25¼″

Unsigned

The Art Institute of Chicago

PRIOR TO THE EIGHTEENTH CENTURY, Japanese experimentation with Western perspective in paintings was very limited. In terms of graphics it was nonexistent. Although there must have been a great deal of curiosity, artists were too tradition bound and did not experiment. It took a man with the inquiring mind of Masanobu to pioneer the *uki-e* (perspective picture).

In this large print he has represented a street in the Yoshiwara. The scale reduces as we recede into space with the fence at the rear center the focal point. Houses on each side of the street serve as a funnel to lead us to it, and the entire scene is framed by an adaptation of a *torii*-type gate which serves as a proscenium. This setting has been published in the past as a street of theatrical agencies; however, it is

more likely the Yoshiwara, though a compressed view. The names of all of the houses are inscribed on curtains which hang from the eaves. A sampling of these produces names such as Tachibana-ya, Fukuda-ya, Azuma-ya, Matsu-ya, Take-ya, Hishi-ya, Edo-ya, Iwa-ya, Imura-ya, and Matsuba-ya. The street is bursting with crowds of people and many of these are Yoshiwara types: courtesans and their attendants, a tobacco vendor, and samurai hiding their faces under straw hats so that they won't be recognized. A supply of the hats is hanging on the wall of a small room to the right of the gate. The entire scene is one of great activity, and, though unsigned, appears to be by the hand of Masanobu. It closely resembles an *uki-e* print by Torii Kiyotada (39.2152) in the collection of the Art Institute of Chicago.

30

Okumura Masanobu, 1686–1764

THE NAKAMURA THEATER, EDO, 1740

Large uki-e (perspective print), hand-colored, 18¼″ × 26¾″

Signed: *Edo-e Ichiryū Kongen Hōgetsudō Tanchōsai Okumura Bunkaku Masanobu Shōhitsu*

Seal: *Tanchōsai*

Publisher: *Okumuraya Genroku*

The Art Institute of Chicago

ONE OF THE MOST EXCITING *uki-e* produced in Japan is Masanobu's depiction of the interior of the Nakamura Theater in Edo in the eleventh month of 1740. During that date the great actor, Ichikawa Ebizō, performed the role of Yanone Gorō in a Soga theme play *Miya Bashira Taiheiki* (The Temple Pillar Taiheiki). As Gorō, Ebizō stands within a small structure and sharpens arrows which he will soon be called upon to use in defense of his brother. He is represented in fierce makeup ready for action.

The theater is shown as a structure of several stories. The stage is built to resemble a Shinto shrine; and an area for actors, chanters, musicians, announcer, and dressing rooms is at its rear. On the right pillar of the stage is written the *Sambasō* dance to be performed, *Okina Chitose Sambasō*; on the left is the name of the role, Yanone Gorō, acted by Ichikawa Ebizō; and on a plaque hanging above the center of the stage *ichimandō narai* (purification ten thousand times). The supporting pillar, which rises from the audience area to a crossbeam, has a sign affixed to it which reads *kido jūroku mon* (price of admission sixteen mon). Along the sides of the theater wall are two tiers of boxes, and in what would equate with our orchestra section sit those who have bought general admission tickets. Even though some two hundred-twenty-eight years have passed, the setting and the action of the audience are familiar. Vendors move amidst them selling food, sake, and tea. Some people intensely watch the scene as others ignore the performance and stop to talk with their friends or gawk at each other. All ages are shown and Masa-nobu truly captured the theater life. The supporting chanters and *samisen* player, as well as others, are seated at the back, and at the far rear left an attendant draws a curtain back and peers out. A painted backdrop of Mount Fuji is at the very rear. From the ceiling hang three rows of lanterns, each bearing an actor's crest. A curtain is pulled up at the left which could be dropped to close off the stage. Because of the fear of fire yet need for light, the top story of the theater was left open and two attendant figures are shown at the rear observing the throng.

This particular impression is the finest the author has seen of the print. It is beautifully cut and even the hand coloring remains fresh. Masanobu's skill in handling the theme and space as it recedes in this print would qualify him as a very competent artist. It is a masterpiece of *uki-e*.

The title of the print is given on the far right as *Shibai Kyōgen Butai Kaomise Ōuki-e* (A Large Perspective Picture of a *Kyōgen* Stage *Kaomise* Performance). Beneath that is the publisher's mark, Tōrishio-chō Etoiya Akaki Hyotan Shirushi Okumura Genroku Hanmoto (Published by Okumura Genroku of the Red Gourd Trademark, Wholesale Merchant, Located at Tōrishio-chō). As Masanobu was both the publisher as well as designer, it becomes even more a work of love. On the left margin is written Edo-e Ichiryū Kongen Hōgetsudō Tanchōsai Okumura Bunkaku Masanobu Shōhitsu (A True Work of Hōgetsudō Tanchōsai Okumura Masanobu, the Originator of One School of Edo Pictures). His gourd-shaped seal read Tanchōsai is beneath this.

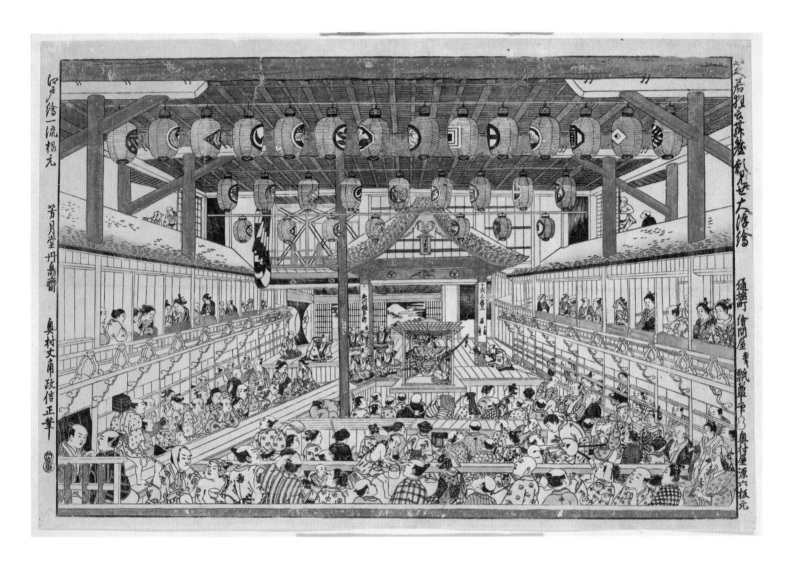

31

Okumura Toshinobu, act. ca. 1717–1750 (attributed)

A YOUNG MAN VENDING LOVE PROPHECIES

Hoso-e, urushi-e, brass powder, 13¼″ × 6½″

Unsigned

Metropolitan Museum of Art, Dick Fund, 1949 (Ledoux Collection)

LITTLE IS KNOWN ABOUT the artist Okumura Toshinobu, who was active from about 1717 until 1750 and is credited with the production of this charming print of a youth carrying two baskets filled with sealed love prophecies. In the past, three theories have been put forth concerning Toshinobu; all relate him to Masanobu. The first is that he was a son and was born in 1709 and died in 1743; the second is that he was a younger brother; and the third is that he was an unrelated pupil. At the present stage of research, the last theory is the only one generally accepted. It is certainly unlikely that he was Masanobu's son for some of his prints carry seals of publishing houses other than that of his alleged father, Okumuraya. His span of active years also is shorter than that of Masanobu. As pseudonyms he used the names of Kakugetsudō and Bunzen.

Toshinobu was noted for the freshness of his prints, and those that have survived appear to be hand-colored *hoso-e*, though at times *urushi-e* techniques were employed. It would be difficult to prove that the print under discussion is by his hand for it is unsigned, carries no publisher's seal, and even the actor's identity is unknown. Ledoux felt that the appearance of the stylized cloud was a mannerism used by Toshinobu, and other prints exist in which he made use of this device. It, however, may also be purely decorative or relate to the name of the actor portrayed. If the crest is examined with care, one will note that it is the left half of Mount Fuji with the same cloud motif at its base. One can only speculate on the existence of an actor or popular youth called Fujigumo (Fuji Cloud). It was also suggested by Ledoux that the actor may be Sodezaki Kikutarō; however, the known Sodezaki crests vary greatly from this one.

The youth faces right and carries over his shoulders two woven baskets containing sealed envelopes believed to be love prophecies. One basket is straight-sided and the other is jar-shaped with handles on the sides. Perhaps one holds prophecies for males, whereas the other contains those for females. The youth's robe has a pine tree, checkerboard, and *jōruri-gidayū* programs pattern. The figure is beautifully contained within the space. The lines are all strong and not fuzzy. The youth's face, although it resembles those of Masanobu, differs in the treatment of the eye and nose, and thus this handsomely colored print is attributed to another artist, probably Toshinobu.

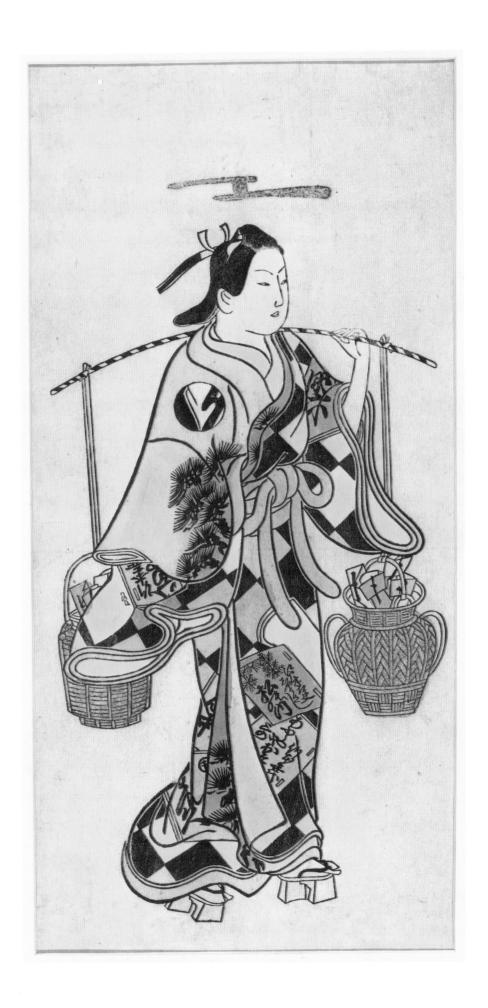

32

Torii Kiyotada, act. 1723–1750
ACTOR DANCING (Ichikawa clan)
Tan-e, hand-colored, 11¼″ × 6″
Signed: *Torii Kiyotada*
Publisher: *Igaya*
Metropolitan Museum of Art, Dick Fund, 1949 (Ledoux Collection)

ONE OF THE GREAT PORTRAYALS OF AN ACTOR in *aragoto* role is that by Torii Kiyotada of Ichikawa Danjūrō II violently dancing. There were four artists who used the name Kiyotada; however, the others were not related to the one considered here and are much later in date. His biography is blank for no documentation is reported. Based on stylistic evidence he was in all likelihood a pupil of Kiyonobu I and was active roughly between 1723 and 1750. Okumura Masanobu also exerted influence on him, as can be seen in his *uki-e* referred to in discussing No. 29.

The figure of Danjūrō is power-packed as he dances away. His right arm, with fingers spread, extends stiffly out from his side and is countered by his left foot which is raised from the nonexistent floor. Only the actor was important and a setting was not needed. The sleeves of his upper robe appear starched as they stand out. He wears a *samurai eboshi* (a black-lacquered, three-cornered-shaped paper hat) on his head and carries two swords, one of which is exceedingly long. His trunk and lower limbs are clothed in *nagahakama*. The position of the figure in an abstract way resembles one of the components from which Japanese and Chinese ideographs are composed, radical 52 (幺). The pattern on the robe consists of four Danjūrō (stacked box) crests placed at the shoulders and knees with horizontal stripes linking them. The *tsuba* (sword guard) is square and repeats the crest shape.

Kiyotada has captured a suspended moment in the dance with great skill. The right arm, stripes, crests, and short sword form one diagonal which is intersected by the long sword and left sleeve, leading the viewer to a horizontal band created by crests and stripes across the knees. In addition to this, the robes and other drapery folds move about wildly in an abstract and very modern manner. There is a sense of cubism and hard edge present, and the masterly application of *tan* (orangish red) and yellow color greatly enhances the print's effectiveness. Torii Kiyotada's name and the seal of his publisher Igaya appear at the right.

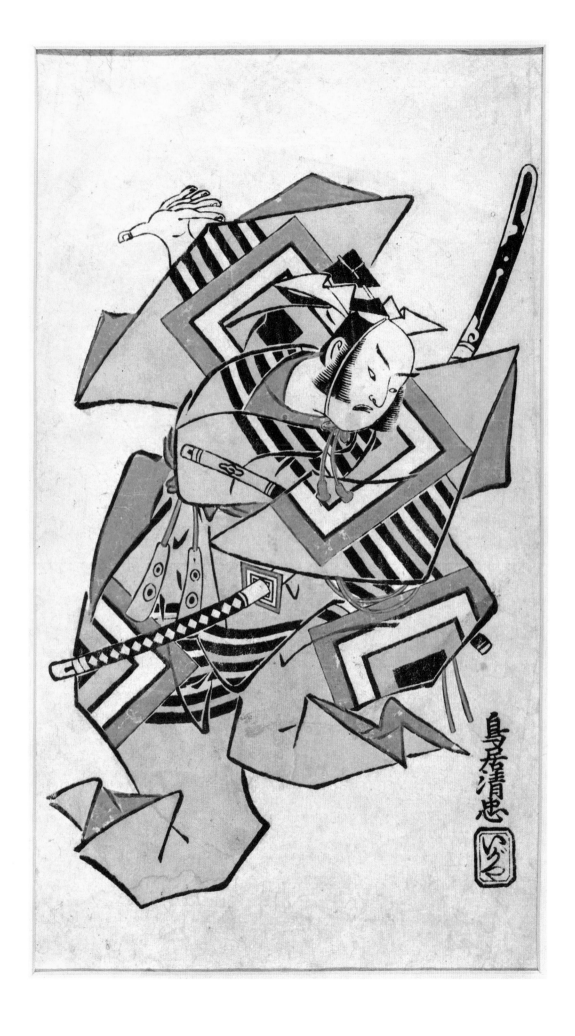

33

Furuyama Moromasa, act. 1712?–1772

SHIN YOSHIWARA ZASHIKI KENZUMŌ (A Game of Hand *Sumō* in the New Yoshiwara)

Large uki-e (perspective print), sumi-e, hand-colored, 13″ × 18½″

Signed: *Furuyama Moromasa Ga*

Seal: *Saihō*

Publisher: *Igaya*

Metropolitan Museum of Art, Frederick Charles Hewitt Bequest Income, 1912

A THIRD UKI-E OF EXCEPTIONAL QUALITY is one in which the interior of a house in the Yoshiwara is shown. It is titled *Shin Yoshiwara Zashiki Kenzumō* (A Game of Hand *Sumō* in a Parlor at the New Yoshiwara) and is signed *Furuyama Moromasa* and appears to be sealed *Saihō*.

Moromasa commenced his artistic career as the son and pupil of Furuyama Moroshige, who in turn had used the Hishikawa name and been a pupil of Moronobu, our first artist. Little is known about Moromasa's career and his work is exceedingly rare. It is believed that at some point in his life he turned to the work of Kiyonobu I, and this *uki-e* points to the influence of Masanobu.

The artist has deftly employed the architectural elements of an interior to achieve spatial depth. The Japanese were not quite ready as yet to try out these effects solely on a landscape. The diminishing, diagonally slanted ceiling beams and the horizontal *tatami* and room partitions lead the viewer back to the rear wall. The figures and objects are also proportionately smaller as one moves from the front edge of the room.

Ukiyo-e artists attempted this variety of print not only out of desire to experiment with new Western-type perspective, but also out of the need to sell. Competition in prints was keen, and something new such as the *uki-e* would guarantee sales.

The foreground group of a maid, servant, and friends is watching a man and courtesan entertaining themselves with a game of hand *sumō*. Two maids look on from another room to the right, and one is about to enter carrying a sake kettle. On the verandah to the left a girl in a thistle-patterned robe arranges her hair. She looks into a mirror and her face can be seen reflected in it. This is further evidence of a growing interest in realistic and natural effects. In the rearmost room of this large house another party is underway. A girl plays a *samisen* while a man with a courtesan at his side claps and sings along as a second male dances.

On the left margin of the print the address and signature of the publisher appears, *Igaya of Motohama-chō*.

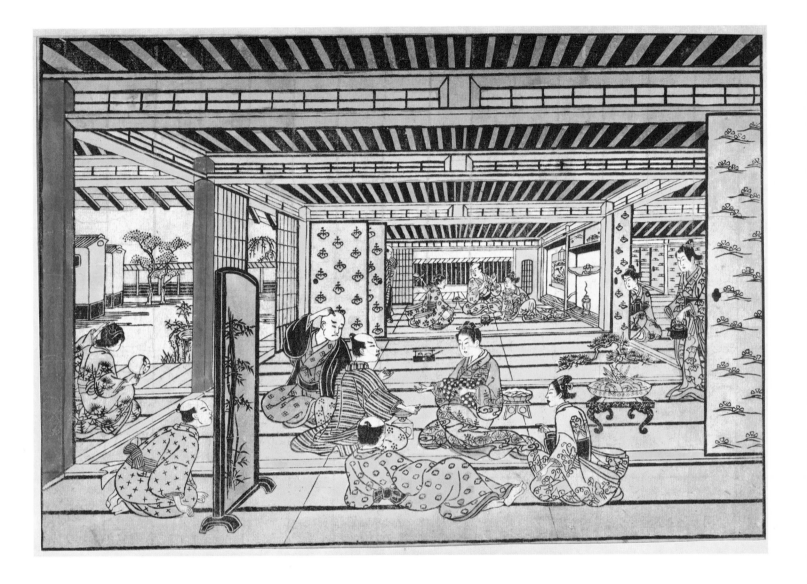

34

Nishimura Shigenaga, ca. 1695–1756

SAMPUKU TSUI CHŪ, KASAYA SANKATSU (The Courtesan Sankatsu of the
House Called Kasaya, the Center Print of a Triptych)

Hoso-e, urushi-e, brass powder, 12″×6¼″

Signed: *Nishimura Shigenaga Hitsu*

Publisher: *Igaya*

Philadelphia Museum of Art, Given by Mrs. Anne Archbold

MANY ARTISTS AROSE IN THE RANKS of *ukiyo-e* though few ever achieved greatness. One must always keep this fact in mind, as well as the realization that for every print that survives today hundreds of others perished. Thus, in reviewing Japanese prints we are restricted. A very capable master who became active during the years ranging from about 1695 to 1756 was Nishimura Shigenaga. His surviving work is rather uncommon, and he is more often thought of not as a great master in his own right but as the teacher of Ishikawa Toyonobu and Suzuki Harunobu. During his early artistic life, Shigenaga is felt to have come under the influence of Kiyonobu I; however, later the style of Nishikawa Sukenobu and Okumura Masanobu captured his fancy. He worked primarily in the *urushi-e* and *beni-e* techniques, and for subject matter he covered the entire range from courtesans and actors to birds and flowers as well as perspective views. Shigenaga is said to have owned property in Edo at Tōriabura-chō and later to have moved and opened a bookshop in the Kanda sector. He made use of the pseudonyms Eikadō and Senkadō and though his exact birth date is unknown it is believed to have been about 1697 for he died in 1756 in his sixties.

Shigenaga tried to follow the lead of Masanobu as an innovator and made use of the *ishizuri-e*. He also was one of the first artists to produce triptychs.

This print, the center sheet of such a work, shows the courtesan Sankatsu of the house called Kasaya standing indoors. It is an *urushi-e* with imitation lacquer and brass filings. Sankatsu looks down at a highly stylized dog with a ribbon about its neck holding a love letter in its mouth. The dog's tail is curled and its feet are humorously non-functional. Shigenaga certainly could not have sketched it from nature. The courtesan in features is a little more reminiscent of Kiyonobu I than his other two inspirers, and thus it appears to be an early work. She wears a robe patterned with baskets of flowers and a *hanaguruma* (floral cart which in form copied the carriages drawn by bullocks). The flowers in the print are symbolic of the three seasons. On the verandah are branches of plum in a bamboo vase, indicating spring. Sankatsu's right sleeve has plum blossoms and camellias, also indicative of spring; the lower front of the kimono, peonies for summer; and the left sleeve, chrysanthemums for autumn. It was often the custom from this period on to depict the beauties of the four or three seasons or of the three great urban centers, Edo, Kyoto, and Naniwa (Osaka).

The print is signed by the artist and carries a six-sided seal of the publisher, Igaya of Motohama-chō.

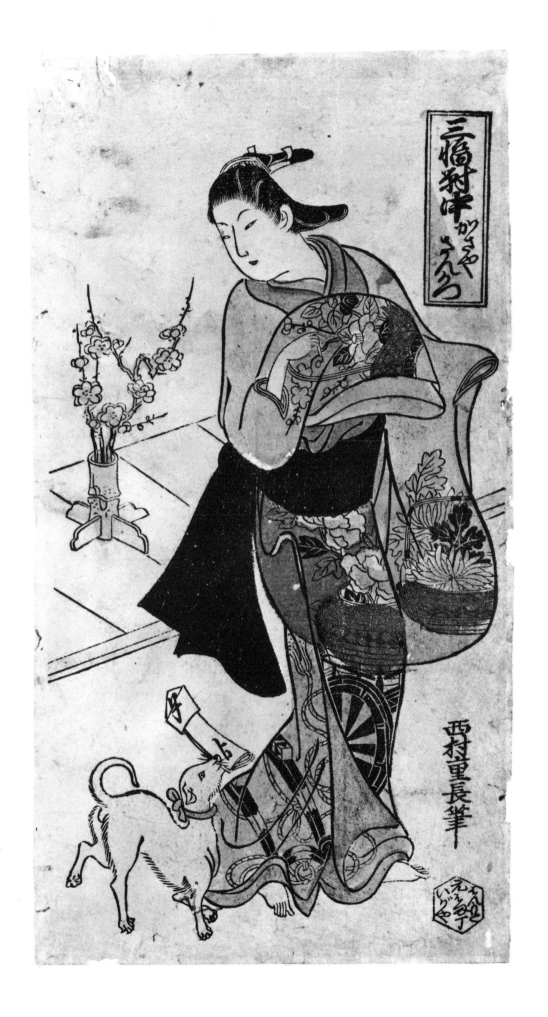

35

Nishimura Shigenobu, 1711–1785

SHIKI NO HANAURI, SAMPUKU TSUI CHŪ (A Peddler of Flowers of the Four
 Seasons, the Center Print of a Triptych)

Hoso-e, urushi-e, brass powder, 13¼″ × 6¼″

Signed: *Eshi Nishimura Shigenobu*

Publisher: *Urokogataya*

Metropolitan Museum of Art, Rogers Fund, 1936 (Mansfield Collection)

AMONG THE SUCCESSFUL PUPILS of Shigenaga was Shigenobu, who borrowed part of his name from his teacher and is believed to have changed it to Toyonobu later in his career. He left quite a number of prints of which the large panel variety (Nos. 38, 39, 40) and *beni-e* (No. 37) are most successful. Those of his early years are, however, primarily of the *hoso-e, urushi-e* variety.

The origins of Shigenobu are rather obscure and some scholars have even kept an open mind as to the Toyonobu relationship. Until contrary documentation can be found, we shall consider them one and the same. He was born in 1711 and said to be of the Ishikawa family. If true, this would mean that his antecedents were of the gentry, for in the Kamakura period they had loyally served the great Hōjō family, the regents. The biographies all state that he was a very handsome young man, although no source for this information is given. Shigenobu married favorably into the family of an innkeeper whose establishment was located in Kodemma-chō. The inn was known as the Nukaya, and Shigenobu using that name at one time called himself Nukaya Shichibei. Upon his father-in-law's demise, he managed the inn. In addition to the other names, he made use of pseudonyms, including Magosaburō, Tanjōdō, and Shūha. He produced many prints and book illustrations, though it was not until the 1740's that the Toyonobu name appeared. As he lived to the ripe old age of seventy-four, dying in 1785, he spanned a period of great activity in *ukiyo-e*. The *nishiki-e* (full-color print) came into use late in his lifetime and the age was marked with major changes in hair styling which aid us in dating prints. About 1776 women's side locks were no longer pulled back but were freed and permitted to extend out from the head supported by artistically decorated pins and combs. The coiffure became more and more complex as time went on, ending up in the elaborate styles illustrated by Kuniyoshi and Kunisada.

This print, showing an actor carrying two stands holding flowering plants symbolic of the four seasons, is an early work for in the cartouche at the bottom it is signed *Eshi Nishimura Shigenobu Hitsu* (Drawn by the Artist Nishimura Shigenobu), and carries the publisher Urokogataya's trademark and name. It was obviously executed while he was still strongly under Shigenaga's influence. This is reflected not only in the actor figure and his features but also in the fact that it is the center sheet of a triptych, a form that his teacher favored. The sheet is titled A Peddler of Flowers of the Four Seasons. The actor turns his head to look back over his right shoulder. The plants framing the figure on the left side are chrysanthemum . . . autumn, and plum. . . winter; whereas on the other side are a cherry tree in bloom. . . spring, and peony. . . summer. The actor has a very full face and a band tied about his head. His kimono is lavishly decorated with a pattern containing stripes, plum blossoms, cloth-covered *heiji* (bottles), and what appear to be kites. He has not been identified for his crest is a combination used by two actors. The Art Institute of Chicago relates it to that of Ogino Isaburō and Sodezaki Kikutarō. They own another impression of this print as well as the left sheet, and Boston possesses the right one.

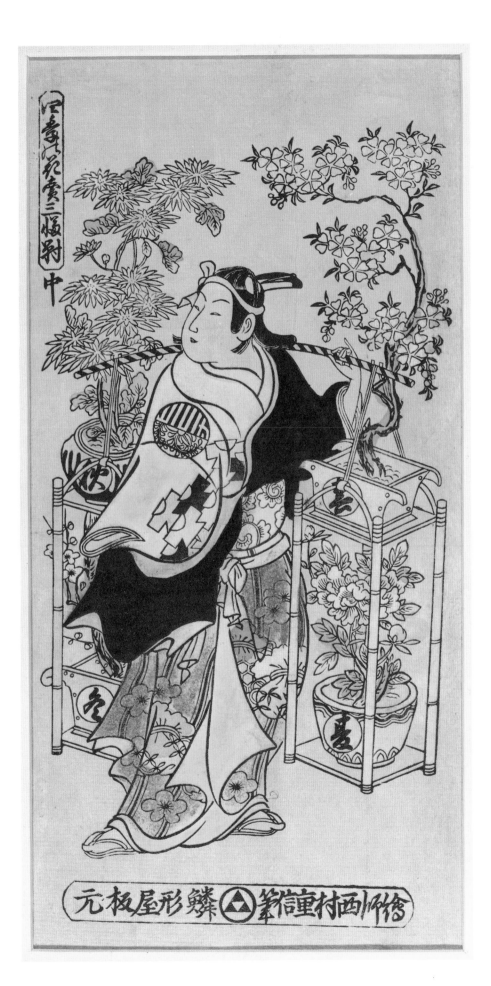

36

Ishikawa Toyonobu, 1711–1785 (attributed)
A FEMALE IMPERSONATOR
Hoso-e, hand-colored, brass powder, 12½″ × 6″
Unsigned
Metropolitan Museum of Art, Dick Fund, 1949 (Ledoux Collection)

THE IDENTIFICATION of unsigned prints has always presented a challenge to the art historian. One usually tries to search out any clue that might stylistically relate a work to a master. Such is the case as regards this extremely handsome design. Ledoux attributed it to Toyonobu and the author is inclined to agree. The careful placement of the figure on the paper is superbly handled. It represents a *wakashu* corresponding in character to No. 27. The effeminate youth wears a raincoat decorated with the crests of various actors. He balances on high *geta* (clogs) in order to keep his feet and robe dry and unsoiled. His face is quite typical of those drawn by Toyonobu. It is rather delicate with a relatively straight nose executed by a single hooked stroke. Toyonobu in his early days, while the spell cast by Shigenaga was still strong,

favored this method of depiction. A cloth covers the shaved forelock of the youth, though it hasn't lessened his use of feminine trappings, for he has copied the popular courtesans and placed a comb in his impeccably groomed hair. His wrist is very delicate and almost fragile in appearance, yet it supports an oiled, paper umbrella. On the umbrella is the character read *kotobuki* (felicitations) and it may indicate that the youth is paying his New Year calls. The graceful curve of the body, high *geta*, and perfect positioning of the umbrella recall to mind a tightrope walker. Nothing is out of balance in this great hand-colored *urushi-e*. Prior to passing into the Ledoux collection, the print was in the Jaeckel collection and attributed to Masanobu. In the author's opinion this *wakashu* has more character than Masanobu's.

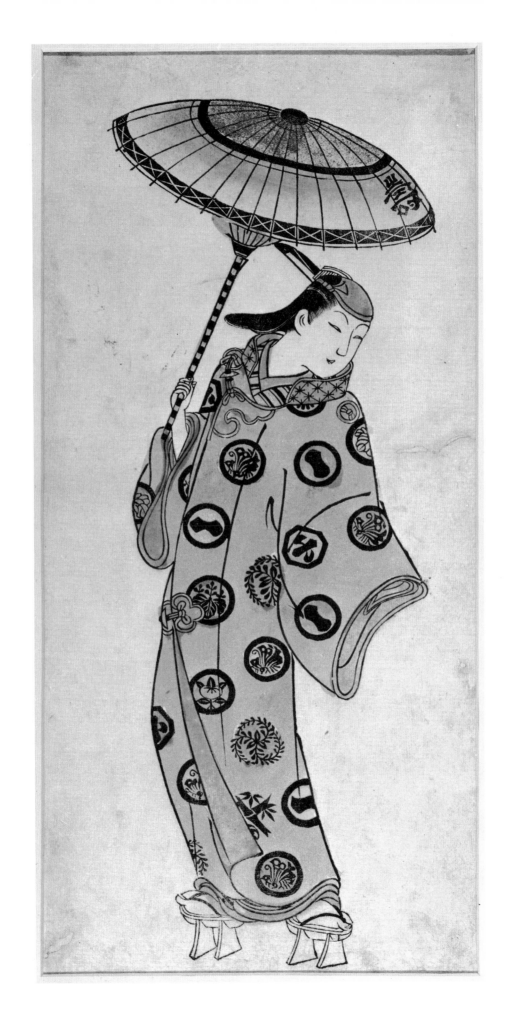

37

Ishikawa Toyonobu, 1711–1785

NAKAMURA KIYOSABURŌ AND ONOE KIKUGORŌ AS LOVERS
 PLAYING A SAMISEN

Large benizuri-e, 17⅜" × 12³/₁₆"

Signed: *Tanjōdō Ishikawa Shūha Toyonobu Zu*

Seals: *Ishikawa Uji and Toyonobu*

Publisher: *Urokogata*

Grunwald Graphic Arts Foundation, University of California, Los Angeles

A THEME THAT APPEARS AGAIN and again in prints is the representation of two lovers seated on a bench playing a *samisen* together. The extremely handsome red and green color of this *beni-e* makes it a notable example of both this theme and Toyonobu's work. The two figures are actors; the male wears the crest of Onoe Kikugorō, and the one in the female role that of Nakamura Kiyosaburō. The play has not been identified. Kikugorō gently supports and fingers the *samisen* while Kiyosaburō uses a plectrum to produce the sound. It is a joint effort and, as in love, the two harmonize.

The girl shyly bows her head, her hair almost ap-pears to brush the cheek of the young man. Her outer kimono is richly patterned with maple leaves (nor-mally symbolic of Takao, a noted beautiful courtesan) and hats worn by the *Gagaku* (Ceremonial Court Musicians). Her obi is striped and her right foot is raised, as is the left foot of the love-smitten youth. He wears a *haori* of a Naritakōshi (Narita lattice) design closely resembling a plaid, and his kimono is sprinkled with the same kite pattern we saw in No. 35. Though the perspective of the bench is naive, we should feel privileged in being permitted to look down upon this sentimental and tender scene.

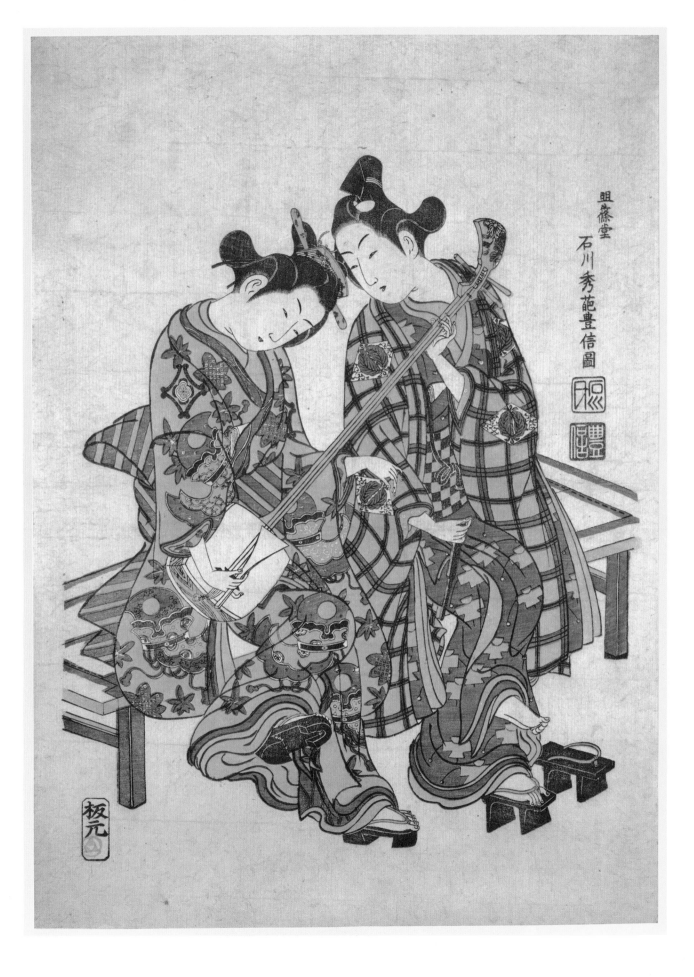

38

Ishikawa Toyonobu, 1711–1785

A YOUNG MAN OPENING AN UMBRELLA

Large panel, hand-colored, 25½″ × 6″

Signed: *Tanjōdō Ishikawa Shūha Toyonobu Zu*

Seals: *Ishikawa Uji and Toyonobu*

Publisher: *Murataya*

Metropolitan Museum of Art, Dick Fund, 1949 (Ledoux Collection)

THE LARGE PANEL-SHAPED DESIGNS of Toyonobu were especially successful. He was endowed with a rare gift of composition and his figures, although large, do not crowd the space. They fit it to perfection and indicate his genius. The young man depicted on this print has just put his left foot forward, while his other foot and shoulder are outside the composition. There is a moment of action as he prepares to open his umbrella, and the absence of the full figure adds to the effect of the gesture. He has just come upon the scene and a shower is about to begin. It is alive and free rather than formal and stiff.

The hand color of the print has been beautifully preserved save for the background color of the raincoat, which has a simple stylized floral pattern. His robe on the other hand is a complex arrangement of designs. It resembles a patchwork of different elegant cloths pieced together. Sacred jewels, snowflakes, waves, phoenix, ivy, clouds, and *tatewaku* stripes all

are represented. The youth wears a single sword and stands on high *geta*. These appear to have been in vogue during the time that Toyonobu worked for he often showed them. The youth's head is bent forward as he concentrates on opening the large umbrella. The solid black of his hair, bands on the umbrella, and *geta* stand in stark contrast to his garish garments.

A seventeen-syllable poem appears in the upper right corner, and it reads and may be freely translated as follows:

> *Heyazumi ya*
> *Shubi o kufū no*
> *Tsuyu shigure*
>
> *A young man still residing in his*
> * parents' home*
> *In autumn showers contrives*
> * opportunities (to rendezvous with*
> * his beloved)*

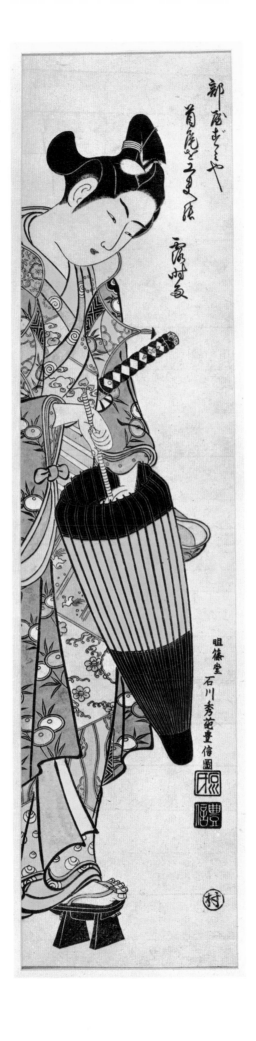

39

Ishikawa Toyonobu, 1711–1785

A YOUNG LADY STANDING ON A VERANDAH

Large panel, hand-colored, 19¾" × 9"

Signed: *Tanjōdō Ishikawa Shūha Toyonobu Zu*

Seals: *Ishikawa Uji and Toyonobu*

Publisher: *Urokogataya*

Metropolitan Museum of Art, Dick Fund, 1949 (Ledoux Collection)

THE SUMMERS OF JAPAN are hot, and prior to the advent of air conditioning one would seek to capture and enjoy a breeze wherever it could be found. A print of exceptional beauty and quality is this one in which Toyonobu has portrayed a woman standing just within the verandah of her home as she seeks to escape the heat. She carries a small lantern in her right hand and a bamboo-decorated fan in her left. The air is still for the branches of the willow tree outside her window hang limp, the drapery of her night robe is motionless, and even the smoke rising from her lantern barely moves. Her head is bent forward emphasizing the calm and lack of action, and her large knotted sash sags. It is a very languid setting, and the only elements of movement and lightness can be found in the background stream and the bold-patterned, though delicately colored, translucent robe which hangs loosely about her neck.

Not only is this print a masterpiece in composition but also in execution. The carver of the block must have lavished love as well as skill on it. Not a line is out of place. Toyonobu appears to have had a penchant for using the same kimono and figure over and over. He probably soon realized that a popular theme could stand repetition. The Art Institute of Chicago and the Honolulu Academy of Arts have similar treatments of this girl. As to this print, "its loveliness increases ever."

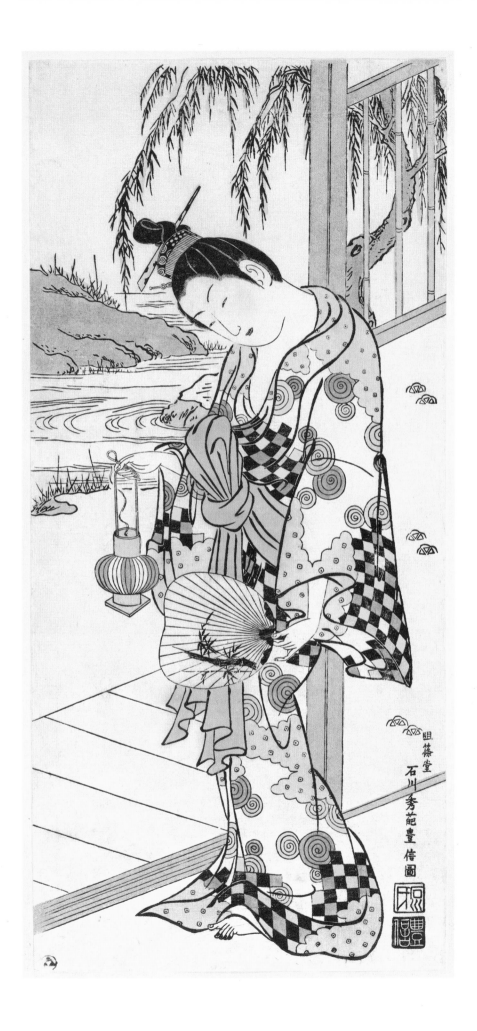

40

Ishikawa Toyonobu, 1711–1785

THE ACTOR SANOGAWA ICHIMATSU I

Large panel, hand-colored, 24″ × 9¾″

Signed: *Tanjōdō Ishikawa Shūha Toyonobu Zu*

Seals: *Ishikawa Uji and Toyonobu*

Publisher: *Urokogataya*

Metropolitan Museum of Art, Dick Fund, 1949 (Ledoux Collection)

A THIRD LARGE-PANEL hand-colored print by Toyonobu is that showing the actor Sanogawa Ichimatsu I holding a letter in his left hand and turning to look backwards. Although the Art Institute of Chicago's impression is some four inches taller, this one is equally imposing. Ledoux believed the actor was portraying the role of Hisamatsu in another of the Soga plays titled *Kado Midori Tokiwa Soga* (The Eternal Soga of the Green Gate). It is a fusion of the star-crossed lovers' (Osome and Hisamatsu) story with the Soga legend and other popular tales. The play was performed at the Nakamura Theater during the first month of 1743.

James Michener in *The Floating World*, p. 308, relates that this portrayal of Ichimatsu was so popular that the print was repeated several times. The Art Institute of Chicago owns Shigenaga's design which his pupil Toyonobu copied. The head of the Toyonobu version was apparently preferred and the publisher, Urokogataya, had the Shigenaga head removed and

replaced by it. Documentation to substantiate this story is unavailable; however, there is no question that portraits of Ichimatsu I had great appeal and several versions exist.

In this print formerly in the Ledoux collection, he is shown wearing a checked brown and black *haori*. The pattern became so closely associated with this actor that it was soon called Ichimatsu. The kimono conceals two underrobes and is decorated with seals placed against an overall pattern of blossoming plum. Although his left foot is firmly placed on the ground, his right heel is raised and only his toes can be seen. The black hair and bold *haori* form a striking contrast to the elegant kimono. From the quality of the carving and coloring, one can conclude that the relationship between Toyonobu and his publisher, Urokogataya, must have been one of great respect. All parts of the team had to work in close harmony to maintain such standards of excellence and beauty.

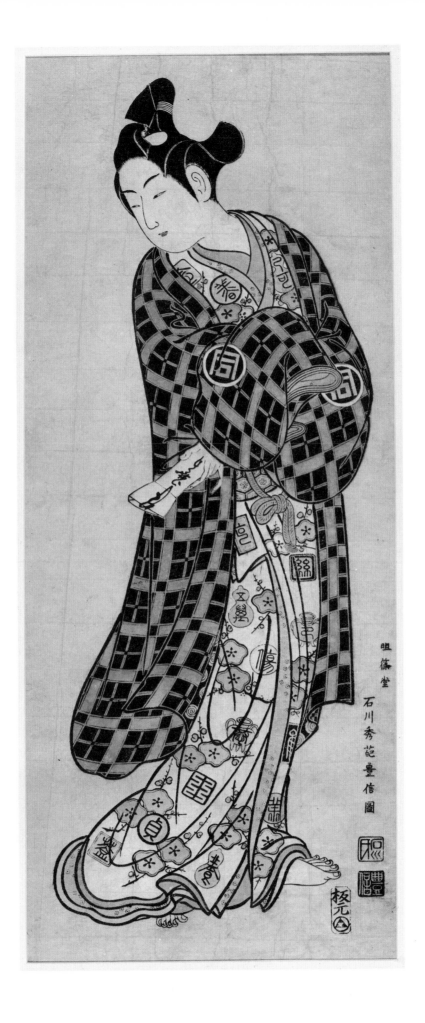

眠篠堂

石川秀範豊信圖

41

Torii Kiyoshige I, act. 1730–1760

THE ACTOR BANDŌ SAMPACHI AS HEIKYŪ

Hoso-e, benizuri-e, 14⅞″ × 6⅞″

Signed: *Torii Kiyoshige*

Seal: *Kiyoshige*

Publisher: *Yamamoto*

Metropolitan Museum of Art, Bequest of Henry L. Phillips, 1940

THE ACTOR BANDŌ SAMPACHI I, who died in 1770, is the subject of this striking print by the artist Torii Kiyoshige I. Unfortunately we must once again repeat that often used phrase, "little is known about this man." The biographical data is very sparse and the only information that we can extract is that he was evidently a pupil of Kiyonobu I, was active in the second quarter of the eighteenth century, and produced prints of actors and beautiful women. We also know that he used a pseudonym, Seichōken, and lived in Edo at Koami-chō.

This work by Kiyoshige is rather distinctive for the figure occupies the space more fully than those of his contemporaries. Sampachi I, who was a disciple of Ichimura Uzaemon and acted in the Ichimura theater, is shown with a shaved head and wearing muttonchop whiskers. His face very closely resembles the standard portrayals of Danjūrō II or Ōtani Hiroji I as Asahina. He wears two swords and is shown in an *aragoto* role with his left foot raised in action. Though the wrong foot is raised, the stance somewhat resembles that of the Shinto Buddhist deity Zaō Gongen. Sampachi's hands are inside his robe and the right one is held against his chest. The print is a *beni-e* with the pink and green colors skill-

fully employed to indicate the textiles. The *haori* has a magnificent pattern of a crane with spread wings set against a ground of blossoming plum, whereas the kimono is decorated with a tortoise swimming in the sea. The patterns are bold and highly stylized abstractions. Both are symbolic of longevity and indirectly relate to Sampachi's role. The inscription at the top reads: *Isagiyoshi Kobayashi-mura Bandō Sampachi Ede Kobushi Heikyū* (A Portrayal of the Gallant Bandō Sampachi I of Kobayashi-mura as the Old Warrior Heikyū). The characters used for his role may be translated as "eternal calm" which is what the crane and tortoise symbolize. His action, however, certainly is the antithesis of this.

A puzzling feature of this print which has not as yet been explained is the presence of the two superimposed wedge-shaped elements beneath his left knee.

In the past, through error, this portrait has been catalogued as representing Nakamura Nakazō. Bandō Sampachi, however, used a very similar crest and the print is clearly identified in the inscription. It carries both the artist's name and seal as well as that of the publisher.

[98]

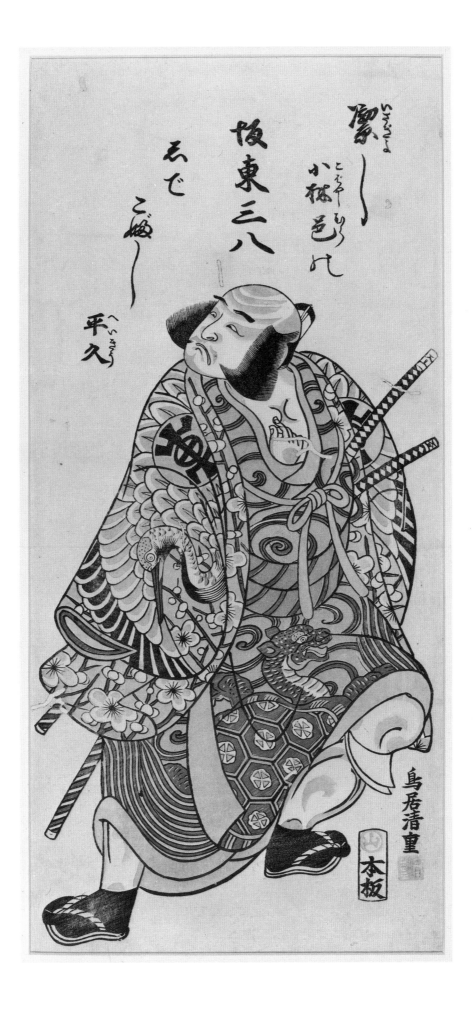

42

Torii Kiyohiro, act. 1737–1766

THE ACTOR NAKAMURA TOKUJŪRŌ AS MUSUME YOKOBUE IN THE PLAY MUSUME DŌJŌJI

Large benizuri-e, 17⅛" × 12¼"

Signed: *Torii Kiyohiro Hitsu*

Seal: *Kiyohiro*

Publisher: *Tōriabura-chō Hōsendō Maruya*

Publisher's Seal: *Maruko Han*

Nelson-Atkins Gallery, Kansas City, Missouri (Nelson Fund)

A SCENE FROM THE GREAT LEGEND of the tenth-century monk Anchin and Kiyohime at the Dōjōji Temple is the subject of this print. Kiyohime fell hopelessly in love with Anchin and tried unsuccessfully to lure him. He hid from her under the bell of the temple, whereupon she danced before it and caused it to crash to the ground imprisoning and killing the monk. Not able to receive his affection, she slowly transformed into a serpent and wound herself about the bell with such fervor that she perished as flames enveloped her and melted the bell.

The actor performing the *onnagata* (female) role titled Musume Yokobue is Nakamura Tomijūrō and the play appears to be *Musume Dōjōji*. He is shown in great action with one foot raised, his body bent and hands holding peony branches extended as he performs a *shakkyō* (lion dance). Tomijūrō wears a long red flame-like unruly wig covering most of his hair. His head is turned to the left and he looks at the temple bell suspended from a cherry tree. In his hair he wears two fans instead of the *tate eboshi* (tall golden hat) usually worn by the dancer in this role. The figure is clothed in four robes, and the patterns, as well as the green, pink, and black color, are captivating and refreshing. The outer robe covering the upper torso has an iris-and-cloud pattern and bears his crest of eight feathered arrow shafts pointing inward to form a circle. A second robe has a phoenix design, a third is flower patterned, and a fourth has a tortoise-shell motif. There is some confusion as to how they are worn and which layer is bottommost.

The print is a typical example of the craftsmanship of Torii Kiyohiro. He excelled in *beni-e* and especially in those of large scale. There is a good likelihood that he was a pupil of Torii Kiyomitsu and most of his prints seem to date from the Hōreki period (1751–1763). At times he used the pseudonym Shichinosuke, and is reported to have dwelt in Sakai-chō. The *Ukiyo-e Ruikō* states that he died of measles in 1777; however, this cannot be confirmed. His ability as a designer is demonstrated here and certainly compares favorably with the work of Toyonobu who obviously influenced him.

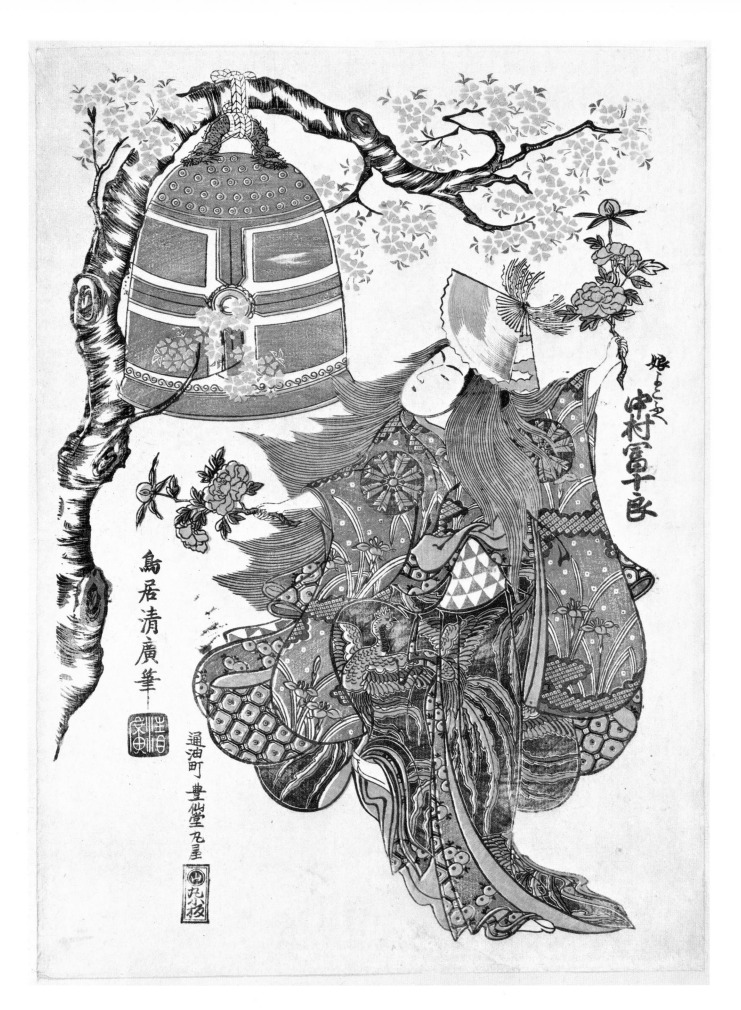

43

Torii Kiyomitsu, 1735–1785

BANDŌ HIKOSABURŌ II AS HACHIMANTARŌ YOSHIIE

Hoso-e, benizuri-e, 15″ × 7″

Signed: *Torii Kiyomitsu Zu*

Seal: *Kiyomitsu*

Publisher: *Tōriabura-chō Hōsendō*

Publishers' Seals: *Maruko* and *Yōzen*

Metropolitan Museum of Art, Dick Fund, 1949 (Ledoux Collection)

TORII KIYOMITSU was a very prolific artist and fortunately many of his prints have survived. This makes a comparison with his contemporaries Kiyoshige and Kiyohiro both unfair and difficult. He is recorded as having been born in Edo at Naniwachō in 1735 as the second son of Torii Kiyomasu II (Nos. 20–24). He married in either 1752 or 1754, depending on which account one accepts. The former date is important for some scholars believe it was the year Kiyonobu II died. His demise gave great impetus to Kiyomitsu's rise in the Torii family ranks, for his own father was no longer active and Kiyonobu's son had died young. Thus, Kiyomitsu is normally considered the third-generation Torii master. He used Kamejirō as his personal name and had two children, a boy and a girl, although the son is said to have died in 1772. Kiyomitsu must have been a very precocious child, for in 1747 when but thirteen he produced illustrations for a *kuro-bon* (black book) titled *Furisode Semimaru Taimen no Biwa* (Long Sleeves, Semimaru Face to Face with a Biwa). In addition to being a musical instrument at which the poet Semimaru was skilled, the Biwa suggests that the poet lived in the environs of Lake Biwa. As an artist he was a great experimenter and promoted the development of the *nishiki-e* (full-color prints), and even when using the *beni-e* technique a third or fourth color was often added by afterprinting. Kiyomitsu's primary involvement was with the theater. He not only executed portraits, but also produced sign boards, programs, and books. In a true sense one could designate him the third Torii artist by appointment to the Kabuki theater until his death in 1785.

The actor Bandō Hikosaburō II, in the role of Hachimantarō Yoshiie, from the play *Kogane no Hana Gaijin Aramusha* (The Golden Flower, Triumphal Return of a Fierce Warrior), performed at the Nakamura-za in the eleventh month of 1766, is the subject of this print.

The name he used in composing poetry, Shinsui, is given just beneath his theatrical name. Hikosaburō II is shown facing left with his head turned in the opposite direction. The *ukiyo-e* print masters relied on this device to heighten the sense of action. He holds arrows in his right hand and a bow in his left. His handsomely patterned robe is decorated with white and red *chidori* (plover) flying over waves. Five different colors were used in the printing—black, red, green, blue, and purple—an advance far beyond the two-color *beni-e*. In all likelihood the two light olive bands were originally blue and have faded, thus they are not counted as a separate color.

The poem is a rather complex pastiche of puns which may be read and very freely translated as follows:

> *Nageire ya*
> *Yunde ni*
> *Suisen*
> *Nete ni*
> *Ume*

> *In a free-style flower arrangement*
> *Narcissus is on the left (bow hand)*
> *Plum on the right*

The poem is signed Jōa. The only recorded master using this name was a priest of the Namboku-chō period who composed *renga* (linked verses). This specimen must be by a later poet, due to the flower arrangement references. David B. Waterhouse in his work *Harunobu and His Age*, p. 182, identifies the poet as Kansuidō-Jōa, (act. 1750–70), who wrote *kusazōshi* (novelettes).

44

Torii Kiyomitsu, 1735–1785

THE ACTOR ICHIMURA UZAEMON IX IN THE ROLE OF NITTA YOSHISADA

Benizuri-e, 14⅜″ × 6⅝″

Signed: *Torii Kiyomitsu Zu*

Seal: *Kiyomitsu*

Publisher: *Yamamoto (Maruya Kohei)*

Metropolitan Museum of Art, Rogers Fund, 1936 (Mansfield Collection)

AFTER LOOKING AT A NUMBER OF PRINTS by Torii Kiyomitsu, one recognizes a slight monotony in them for the artist skillfully and frequently reworked poses and themes. This is especially notable in the case of this example and No. 45. As chief artist of the Torii atelier, Kiyomitsu must have been very popular and pressed and thus at times compromised on originality.

The actor shown here is Ichimura Uzaemon IX, in the role of the great warrior Nitta Yoshisada (1301–1338). Although originally loyal to the Hōjō cause, Yoshisada split with them and joined the southern forces at the time of civil strife. He captured Kamakura and brought an end to the Hōjō dictatorship. Later he battled with Ashikaga Takauji and after many successful ventures was defeated and lost his life. Yoshisada is known in Japanese history as one of the great defenders of the legitimate dynasty during the wars of the Namboku-chō period.

Uzaemon IX was the son of Uzaemon VIII and nobly represented the Ichimura line of great theater proprietors and actors. As a child he was called Kamezō and ascended to his theatrical name in 1755. After a long and brilliant career he died in 1785. In

this portrait the artist has placed to the right of the actor's shoulder his pen name, Kakitsu. Uzaemon's feet are spread wide apart as he looks over his right shoulder. His *haori* projects outward to his side and is draped over two swords. His right arm is bent at the elbow and supports an umbrella from which hangs a rolled scroll. The perspective is unusual for the structure of the umbrella is important to the design, and thus it is slightly tilted so that we look up into it. Uzaemon IX's features are typical of Kiyomitsu. The hair is orderly and almost helmet-like against the head. Two locks curve behind the ears and project forward. The eyebrows and eyes slant upward, whereas the mouth has a definite downward curve.

The robes that Ichimura Uzaemon IX wears are very handsome. They carry his *tachibana* (orange-like fruit) crest as well as an overall pattern of the same design. The underrobe decoration resembles concentric rings of a whirlpool. As in No. 43, Kiyomitsu made use of more than the traditional *beni-e* colors, although the strong red and green are dominant and striking.

45

Torii Kiyomitsu, 1735–1785

ONOE KIKUGORŌ I AS TAWARA MUSHANOSUKE

Hoso-e, benizuri-e, 12″ × 5¼″

Signed: *Torii Kiyomitsu Ga*

Publisher's Seal: Unidentified

Nelson-Atkins Gallery, Kansas City, Missouri (Nelson Fund)

THE RESEMBLANCE OF THIS PRINT to No. 44 is immediately apparent and need not be treated further here. In this handsome presentation the actor is Onoe Kikugorō I in the role of a samurai, Tawara Mushanosuke. He was born in 1717 in Kyoto, the son of Otowa Hanbei, a constable in the Shijō Mandayū theater. In 1730 he was playing youth roles and in 1735 had advanced to feminine portrayals. Kikugorō I moved to Edo in 1742, and sixteen years later took charge of the Ichimura Theater. During a trip to Osaka in 1783 he died.

Three basic colors in addition to black are used in this print: yellow, red, and a delicate purple. Kikugorō I wears his fan-shaped crest with crossed oak leaves on the sleeve of his wisteria-patterned *haori*. His kimono is striped and his underrobe has a *shippō* motif. In his right hand he holds a partially closed floral-decorated fan and in his left a *kammuri* hat worn by elder civil officials.

The inscription on the upper portion of the print states that he was from the Hayakumo Chōdayū theater. The remaining portion may be read and translated as follows:

Azuma kiku no
Na mo
Sue-hiro shi
Miyako dori

The Edo chrysanthemum's
(China aster's) fame is comparable
to that of the Kyoto bird (gull)

A second interpretation would revolve about the interpretation of the word *sue-hiro* as fan, for that is Kikugorō's crest and also what he holds. Thus, the chrysanthemum of Edo is the same as the warrior with the fan, the bird of Kyoto.

This publisher's seal has not been identified previously; however, in searching through manuscript notebooks of the eminent late scholar of *ukiyo-e*, Dr. Fritz Rumpf, I have found an entry establishing it as a firm called Harumaya. It consists of an inverted V over a dot. It is to be hoped that at a future date additional unpublished research by Dr. Rumpf may be brought to light.

46

Torii Kiyomitsu, 1735–1785

THE ACTOR SEGAWA KIKUNOJŌ I WEARING A SILK BONNET

Hashira-e, benizuri-e, 25⅞″ × 3⅞″

Signed: *Torii Kiyomitsu Ga*

Seal: *Kiyomitsu*

Publisher: *Yōzen Tōriabura-chō Hōsendō*

Publisher's Seal: *Maruko* Bottom Seal: *Fuji*

Museum of Fine Arts, Boston, Special Funds

SEGAWA KIKUNOJŌ I, the noted actor of feminine roles, is portrayed in this handsome *hashira-e* (pillar print) by Torii Kiyomitsu I. The subject is very well adapted to fit the narrow format. Kikunojō's name appears in the upper right as well as his pen name, Rokō. He began his acting career in Osaka where he was a pupil of Takenojō. In 1712 he first assumed the name of Kikunojō and frequently appeared on the stage. As was the practice, he traveled to Edo in 1730, settled in that bustling city, and performed at the noted Nakamura Theater. After seven years there, he traveled back to the Kyoto and Osaka area where he remained for four years prior to returning to Edo in 1741. His death date is reported as 1749.

Facing left, Kikunojō is shown in a three-quarters stance. He appears to wear four robes: an under one that is tie dyed; over that a *yuiwata* (cotton cloth tied like sheaves) patterned garment; on top of that a robe covered with flowers and bearing his crest on the collar; and last but not least, one with an overall chrysanthemum-on-water motif. Although he acts a woman's role, he wears two swords and upon his head is a wadded silk hat which resembles those worn by men seen in the early Moronobu and Kiyonobu prints Nos. 2 and 10. His wig is ornamented with tortoise-shell combs and pins.

A careful study of this print brings to light the developing trend of mid-eighteenth-century *ukiyo-e* artists to make the hands and feet of their figures incredibly delicate. They are totally out of proportion and unfunctional. The extreme of this is visible in this print where the fingers of the right hand, if it can be called that, touch the ribbons of the opposite sleeve and the fingers of the left hand delicately peek through the sleeve opening. The foot also is incapable of supporting anything. The handsome format, face, and pattern of the robes, however, mask that weakness.

The second half of the inscription at the top is another poem by Jōa (No. 43). It is a love poem and reads:

> *Fure ya Yuki*
> *Tsumoru Omoi no*
> *Segawa wata*

> *The fallen snow*
> *Piles up, resembling Segawa's*
> *wadded silk hat*
> (*Thus one's love is like the snow*
> *accumulating in depth resembling*
> *Segawa's hat*)

Two unusual seals are placed on the print, the first immediately beneath that of the artist appears to be another seal of the publisher, Hōsendō, and may read Tsūsen (No. 43). The second at the bottom of the print reads Fuji and is unidentified.

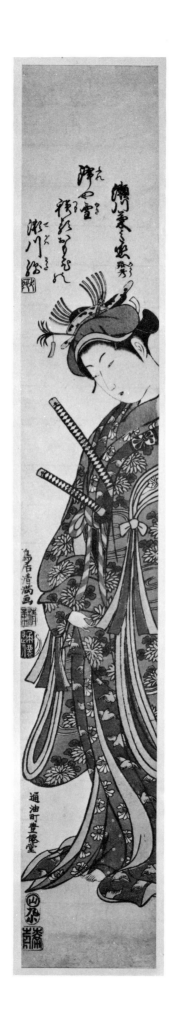

47

Torii Kiyomitsu, 1735–1785 and Torii Kiyotsune, act. 1757–1779
MATSUMOTO KŌSHIRŌ IV IN HIS SEMBEI SHOP
Chūban, nishiki-e, 11″ × 8¼″
Signed: *Torii Kiyomitsu Ga* (right), *Torii Kiyotsune Ga* (left)
Nelson-Atkins Gallery, Kansas City, Missouri (Nelson Fund)

IT SHOULD BE OBVIOUS that the artists of the Torii school who all engaged in the portrayal of theatrical themes collaborated at times to produce works of art. This print of the actor Matsumoto Kōshirō IV and possibly Osagawa Tsuneyo II in a *sembei* (rice cake) store is the combined effort of Torii Kiyomitsu and a student, Torii Kiyotsune. Very little is known about Kiyotsune. He is reported as having been the son of Nakajima Izaemon, a publisher of theatrical prints. An examination of his work establishes the fact that he was greatly influenced by Harunobu who had ascended and was changing the nature of prints.

An actor wearing the crest of Matsumoto Kōshirō IV is seated in the open doorway of a shop that sells rice cakes. Two signs flanking two chests at the rear of the shop identify the business. The one on the right announces *Kōrai Sembei* (Kōrai Rice Cakes), and that on the left *gozen masu tsutsumi* (food wrapped to take out). Resting on the chest are the four-blossom crest of Kōshirō IV and the stacked-box crest of an Ichikawa actor. The Art Institute of Chicago has published this actor as being Ichikawa Komazo I; however, this is unlikely, as the crest is atypical. The actor is seated between a *suzuribako* (ink-stone case) and hibachi and is inscribing a poem on a fan. The right side of the print is signed Torii Kiyomitsu Ga and the male figure appears to be his contribution, for the face is almost a facsimile of No. 45.

Seated on the doorstep is an actor in feminine role who chats with Kōshirō IV and will, in all likelihood, be the recipient of the fan. This figure has never been properly identified, though the crest on the kimono is composed of an element found in that used by Osagawa Tsuneyo II. The left side of the print is signed Torii Kiyotsune and he may be credited with the female figure, as well as the Harunobuesque setting. There is a general sense of calm and dignity about this multi-colored print. It is not garish and only delicate green, yellow, salmon, and tan were used by the artist. The scene is intimate and due to the setting we are made a part of it rather than merely looking in a detached way at a portrait. The growing Harunobu influence can be seen, not only in the subdued colors and lack of posturing, but also in the *chūban* format and the use of gaufrage which he favored.

At the top of the print, floating in a cloud band, is a poem:

> *Gohiiki no megumi ya*
> *Hiraku Fukujusō*

> *Because of kind patronage*
> *We prosper*

The poem contains a play on words, for *hiraku* means to open and *fukujusō* is the name of the *Adonis Sibirica* plant, which is symbolic of prosperity and longevity.

The verse is introduced by a tiny brush that points to it and gives the name of its composer, Kinkō, perhaps a pen name for Kōshirō IV.

48

Suzuki Harunobu, 1725–1770

TWO YOUNG WOMEN: PARODY OF KANZAN AND JITTOKU

Chūban, nishiki-e, gaufrage, 10⅞″ × 8¼″

Signed: *Suzuki Harunobu Ga* and *Kyosen Kō*

Seal: *Kyosen no In*

Miss Edith Ehrman, New York, N.Y.

THE REFINEMENT OF UKIYO-E had no greater champion than the artist Suzuki Harunobu, who was the unchallenged master with the delicate touch. His men and women have an extremely fragile, almost porcelain appearance. One must marvel that their diminutive ankles can support their bodies and their thin wrists their hands, which appear to be purely decorative. They are delicate and doll-like and their features are rarely grotesque, for Harunobu portrayed a world of love and home life, rather than concentrating on actor portraits and the theater. Although others preceded him, Harunobu is credited with being the innovator of the *nishiki-e* (the full-color print) and his use of color was exquisite. Regardless of his role as an innovator, he brought the color print and gaufrage technique to a level rarely to be surpassed. Considering his work, one must remember that his delicacy, not unlike that of the Victorians, did not stop him from producing quantities of erotica. It may seem shocking but he, was what we could term both an arbiter of taste and a prominent pornographer.

An ironic situation exists in studying Harunobu, for although he was very prolific, almost nothing is known of his life. His origin and training are clouded and though he used the Suzuki family name, it may have been adopted. He also used Suiseki, Jihei, and Chōeiken as names and dwelled in Edo in Ryōgoku at the corner of Yonezawa-chō, and later in the Kanda area at Shirakobe-chō. Scholars have established that the Osaka artist Nishikawa Sukenobu influenced him and slight touches of the Torii style appear in Harunobu's work; however, he created his own idyllic world, a paradisaical Edo.

A second problem in studying the prints of Harunobu is the appearance of a signature and seal reading Kyosen. This was once considered to have been either one of the artist's names or that of an engraver or craftsman. It is now clear, however, that the name is the pseudonym of a man who headed a group of ama-

teurs and connoisseurs who commissioned *surimono* (presentation prints), *e-goyomi* (calendar prints), and full-color prints. Kyosen is considered to have been a wealthy gentleman in the service of the Shogun.

Two young girls, one standing and one seated, have unrolled a long love letter. The seated figure intently reads it while the other inserts a hairpin into her elegant coiffure. The composition closely resembles the needle-and-pyramid-like duos such as Kiyomasu I's No. 13. The girls are fragile and their kimonos are elegantly patterned though colored with great restraint. White flowers done in gaufrage and gray streams decorate the light pink silk of the standing figure's robe, which is tied with a white obi having a *mietasuki* (stacked diamond) design. The light pink kimono of the seated girl is patterned with folding fans, red clouds, and white gaufrage flowers. Her red obi is of a pattern called *sayagata*. On the floor beside her rests a rush broom. Harunobu has made us look down into the room and indicates depth by the diagonal floor mats and by a background of massive *fusuma* (sliding interior doors) with embossed uneven lines decorating them discreetly. Although several colors have been used, they are understated and the overall effect is one of great elegance.

The two young women are actually a parody of Kanzan (Chinese Han Shan) and Jittoku (Chinese Shih-te), hermit legendary poets, who scorned worldly things. Jittoku was a scullion and is usually shown with his broom as well as admiring his own verse. Kanzan often sought his company and the humble food and drink that his kitchen provided. They were favorites of the Japanese who often treated them in a frivolous manner. Their scorn for action and the positive has been humorously transferred by Harunobu to the two girls in this print of mid-eighteenth-century Japan.

49

Suzuki Harunobu, 1725–1770

Series: THE MARRIAGE CEREMONY—KOSHI-IRE: THE BRIDE'S
TRIP TO HER HUSBAND'S HOUSE

Chūban, nishiki-e, gaufrage, 8″ × 10⅞″

Signed: *Harunobu Ga*

Collector's Seal: *Hayashi Tada [masa]*

Miss Edith Ehrman, New York, N. Y.

THE JOYS OF LIFE appear time and again in the work of Harunobu. It is difficult to explain his break with the *ukiyo-e* theatrical tradition, although it may have been the result of patronage from the upper levels of society which, though tempted by it, frowned upon the plebeian world of the theater and brothels. They were more interested in the pleasantries of life as distinguished from the pleasures.

Seven prints were designed by Harunobu about 1768 to illustrate a traditional marriage ceremony. *Koshi-ire* is the moment when a bride travels from her family home to that of her husband. The artist has indicated this by showing a procession of figures accompanying her palanquin. It is a night scene and thus they carry lanterns, and Harunobu has daringly made the street black. The fourteen figures are almost like dolls. They closely resemble the people seen in screens called *Rakuchū Rakugai* (Scenes in and about Kyoto), which were popular in the seventeenth century. Instead of just showing a formal procession, the artist relaxes the composition by having figures turn and relate to each other. The lantern bearers, porters, escorts, and maids, all seem earnest to deliver their precious cargo.

A factor that added to the success of Harunobu's prints was his unbelievable sense of color. The orange, brick red, gray, yellow, green, and pink of the robes stand out against the gray stone wall and delicate pinkish fence of the background. It is a toyland where nothing can go amiss.

The print carries the Hayashi collection seal in the lower right corner.

50

Suzuki Harunobu, 1725–1770

Series: THE MARRIAGE CEREMONY—TOKO SAKAZUKI: THE
SAKE CUP BEFORE BED

Chūban, nishiki-e, gaufrage, 8⅜″ × 10⅞″

Signed: *Harunobu Ga*

Collector's Seal: *Hayashi Tada[masa]*

Miss Edith Ehrman, New York, N.Y.

ANOTHER PRINT of the *Marriage Ceremony* series is
that called *Toko Sakazuki* (The Sake Cup before Bed).
Before retiring after the ceremony the bride and
groom share a cup of sake. The same cloud band that
appeared in No. 49 masks the top of the print and
Harunobu has lifted the roof to permit us, as on-
lookers, to partake in the scene. The spatial effect is
achieved by the diagonals of the mats and the sliding
doors. In the inner room on the left the newly wedded
couple sit facing each other. The groom holds the
cup in his left hand. Before him is a cup stand and
on his left is a tray with a plate containing a *tai*
(a sea bream). Ebisu, the deity of wealth, one of the
seven gods of good fortune, is normally shown with
this fish under his arm. Thus it would be a wish that
the couple prosper. At the same time it indicates
congratulations, *medetai*, for the term is pronounced
in the same manner as the second half of this word.
On his right are lacquer boxes and a plate of food.
His bride has covered her hands with her sleeves
and bows her head. Her underrobe is of a red tie-
dyed fabric, whereas the outer one is decorated with
what appears to be jets of water and diamond-shaped
crests of two cranes, symbolic of longevity. The bride
is chaperoned by an older woman with shaved eye-
brows, wearing a maple-leaf patterned robe. Behind

them is a folding screen and the two visible folds
depict a pine-covered beach, and thus the longevity
theme comes into play again. Waiting in the next
room a young maid seated before a floor screen looks
backward at an older woman who has caught her
sleeve with a pipe to get her attention and gestures
to her. The maid's robe is patterned with origami
boats and before her is a sake pot. A winter scene with
a pair of mandarin ducks, symbolic of conjugal bliss,
decorates the screen, which carries Harunobu's
signature. Behind it, farther back in the room,
futon (bedding) and pillows are stacked before a
chrysanthemum-decorated screen. In front of this a
liaison is taking place. A standing youth wearing
striped trousers passes a love letter to a seated young
lady. His extended right hand, holding a candle
snuffer, reaches for the floor lamp, while his left
relays the note.

Once again the many colors are expertly handled,
as is the difficult technique of printing from many
blocks. Orange, yellow, gray, and soft green are the
tones that predominate. The composition is clever,
for it is closed, depth is indicated, and the figures
actively relate to each other. The seal in the bottom
right corner is that of the Hayashi collection.

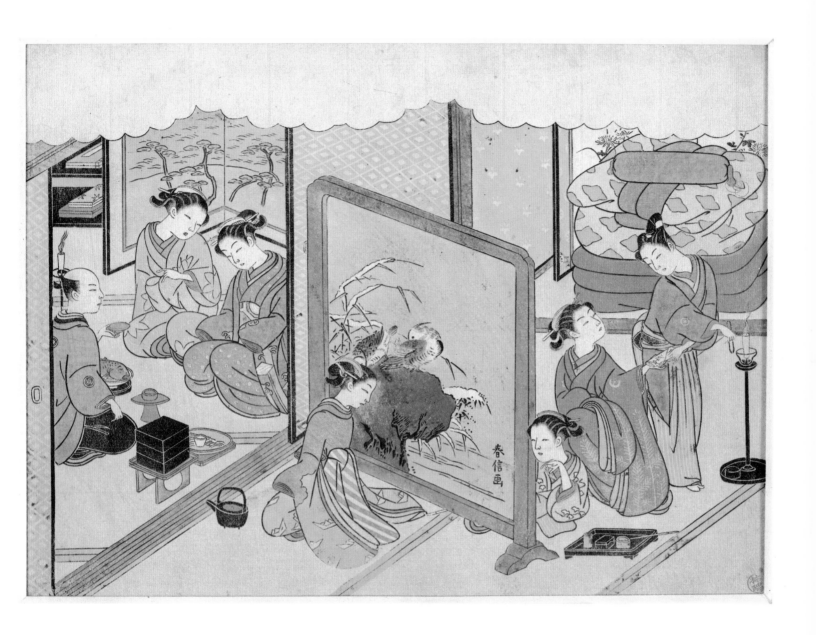

51

Suzuki Harunobu, 1725–1770

LOVERS AND SLEEPING CAT

Chūban, nishiki-e, gaufrage, 11¼″ × 8¾″

Signed: *Harunobu Ga*

Miss Edith Ehrman, New York, N.Y.

IF ONE WERE TO EVER TRY to summarize the work of Harunobu he would more than likely comment on the preponderance of full-color *Chūban* prints in which two figures, not actors, are shown in an interior or exterior setting. In this example, the artist uses the strong vertical post parallel to the left edge of the print to establish the spatial relationship. From that point the viewer is carried back into space and around the corner of the L-shaped room. The lines of the mats and the slatted doors at the rear assist in establishing depth. In the upper left portion of the print there is a screen with two folds visible. Painted on it are two snowy egrets standing in a stream beside reeds. Harunobu's signature is unobtrusively applied to the end panel. The screen's ninety-degree fold is also a relative indicator of depth, for it almost parallels the L-shaped edge of the room.

Artists often were prone to rework or readapt a theme once they found it to be popular and salable. Harunobu's prints appear to have been very much in demand and thus he often felt the need for this. He has depicted a young man seated on the doorstep talking to a girl who is seated indoors shaping floss silk (*mawata*) over a lacquered dryer (*nurioke*) while a cat dozes in the background. The theme is readily recognizable from the "Snow in the Dusk" print of the famous *Zashiki Hakkei* (Eight Views of Parlors) series, where two women are seated shaping silk in the same manner. The important variation is that the single print is more erotic in nature. The presence of the youth who wears a gray-and-white striped robe, tied with a purple sash over green and purple underrobes, establishes a male and female balance. In addition to that the lacquer dryer is phallic-shaped, whereas the unbound cloth before it resembles a radish, which was considered by the Japanese a feminine symbol. The two rolls bound together in the foreground are indicative of the union of the lover and his beloved. An examination of Harunobu's erotic prints also reveals that he often used cats or miniature figures as commentators on the action taking place.

The youth and girl are enthralled with each other. Her kimono, underrobes, and obi are all in purple and purplish-red tones. The lovers are not only linked to each other by the exchange of glances but also by the sleeve and edge of her robe. The colors beautifully relate the figures to the surroundings, and the charming red-ribboned dozing cat, probably meant to symbolize a weary chaperone, make this a noteworthy print.

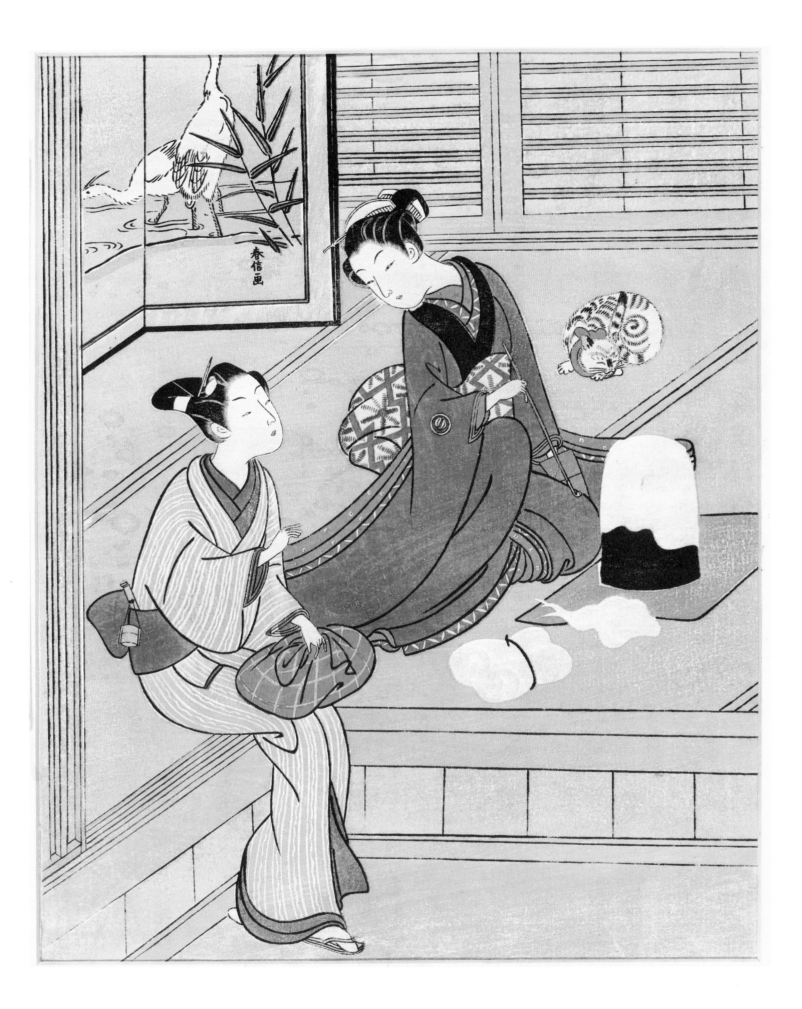

52

Suzuki Harunobu, 1725–1770
Series: THE FIVE CARDINAL VIRTUES
GI: JUSTICE, RIGHTEOUSNESS
Chūban, nishiki-e, 11¼" × 8½"
Signed: *Suzuki Harunobu Ga*
Miss Edith Ehrman, New York, N.Y.

THE FASCINATION OF CREATING series of prints lured Harunobu as it had many *ukiyo-e* artists prior to him. In all likelihood it was an outgrowth of doing illustrations for books which had a common theme. These, however, were not as grand as the single sheets. An extremely beautiful print is that titled *Gi* (Justice, Righteousness) from the *Five Cardinal Virtues* set. It had become highly fashionable to illustrate educational readers. Harunobu, following Sukenobu's lead, did illustrations which were to serve as etiquette guides for the daughters of his patrons. A young lady wearing an orchid-patterned red robe tied with a black obi is seated on a window ledge. Before her a young man, whose forelock has not as yet been shaved, is seated on the floor reading a book. He wears a comb in his hair as did the *wakashu*, No. 36, and his robe resembles the gray-and-white striped one appearing in No. 51. There is actually some conjecture as to whether this is truly a male figure, for the obi has tassles, an uncommon feature in men's wear of the day. The book is open to a scene from a tale showing a warrior before a bridge rending a robe with his sword while a mounted warrior and attendant carrying a lance look on. The two figures exchange glances as though love smitten. Before the youth is a small red lacquer stand and sake cup, as well as two books, perhaps of the same series as the one he holds. They are titled *Ehon Utsushi Takara Bukuro* (Picture Book Copy of a Treasure Bag), which in its original state was a reader for girls. It is a night scene, for in both visible rooms candles are lit and a snuffer rests on one candle stand with a scroll of paper beside it. The sliding door panel separating the two rooms is decorated with a mandarin drake in a snowy setting. This painted wooden door bears the artist's signature. Mounted above the doorway is a panel of calligraphy signed by Rinsen, which was the pen name of Soseki (1271–1346), a noted Zen priest and poet. On it are written the characters *Jun Yoku* (Obedience and Order), which served as an additional admonition to the young.

The cartouche in the upper right corner contains the following poem:

> *Nanigoto mo*
> *Mi o herikudari*
> *Ri o wakachi*
> *Itsuwari naki o*
> *Gi towa iu beki*

> *Be humble in all things,*
> *Follow reason and do not deceive;*
> *That is righteousness.*

The color of this impression of the print, which formerly was in the Ledoux collection, is incredibly well preserved. The reds, yellow, orange, and gray are fresh and the oxidized pink and white add an antique charm to it. While studying it with care I noticed a character which reads *Tora* (Tiger) on the youth's left shoulder. Although it is not the ideograph normally associated with calendar prints, one wonders if other characters possibly aiding in accurately dating the print may not be found on other impressions.

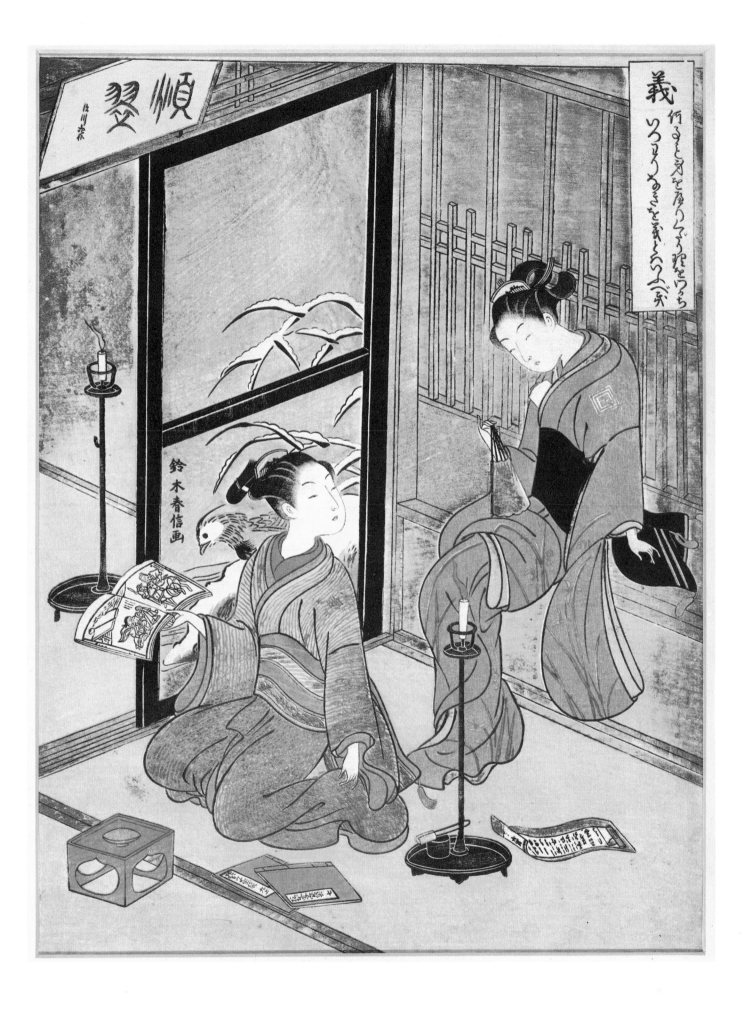

53

Suzuki Harunobu, 1725–1770

GIRL READING A LETTER WHILE BEING MASSAGED BY A MAID

Chūban, nishiki-e, gaufrage, 10⅞″ × 8¼″

Signed: *Suzuki Harunobu Ga*

Miss Edith Ehrman, New York, N.Y.

ALL OF THE ELEMENTS requisite for a fine Harunobu print are present in this example in which he has depicted a young girl reading a love letter while being massaged by her maid. The composition involves the multiple use of right angles as seen in the matting, window slats, floor boards, sliding door, folding screen, and smoking tray. Also evident is the pairing of things, such as the figures, boats, bedding, and aforementioned sliding door and screen.

The many colors employed in the print, as well as its state of preservation, enhance its beauty and importance. The girl pointing with her pipe kneels and reads a letter resting on the floor. She wears a deep purple kimono patterned with white plum blossoms having pink centers. These are interspersed with what are traditionally called snowflakes colored grayish green. Her underrobes are gray, white, and red, and her sash is the same color as the snowflakes. Her maid wears a red striped robe tied with a brown

and grayish green striped sash. At their side is a smoking tray decorated with two openwork cherry blossoms. The mats on which the figures sit are a bright green, and in the interior room red comforters rest against a screen decorated with lespedeza indicating that the season is autumn. The flooring of the verandah is a bright yellow and through the slatted open window two boats are visible, adding a sense that she longs for her absent lover. The sliding door is decorated with alternating horizontal bands of waves and so-called "TLV," geometric patterns done in gaufrage.

The top of the print has a cloud band which, in addition to linking *ukiyo-e* to traditional *Yamato-e* artistic style, was intended for a poem. Many of the artist's prints were designed in this manner and I feel that it indicates that Harunobu at one time had seen paintings by and possibly studied with a Tosa school master.

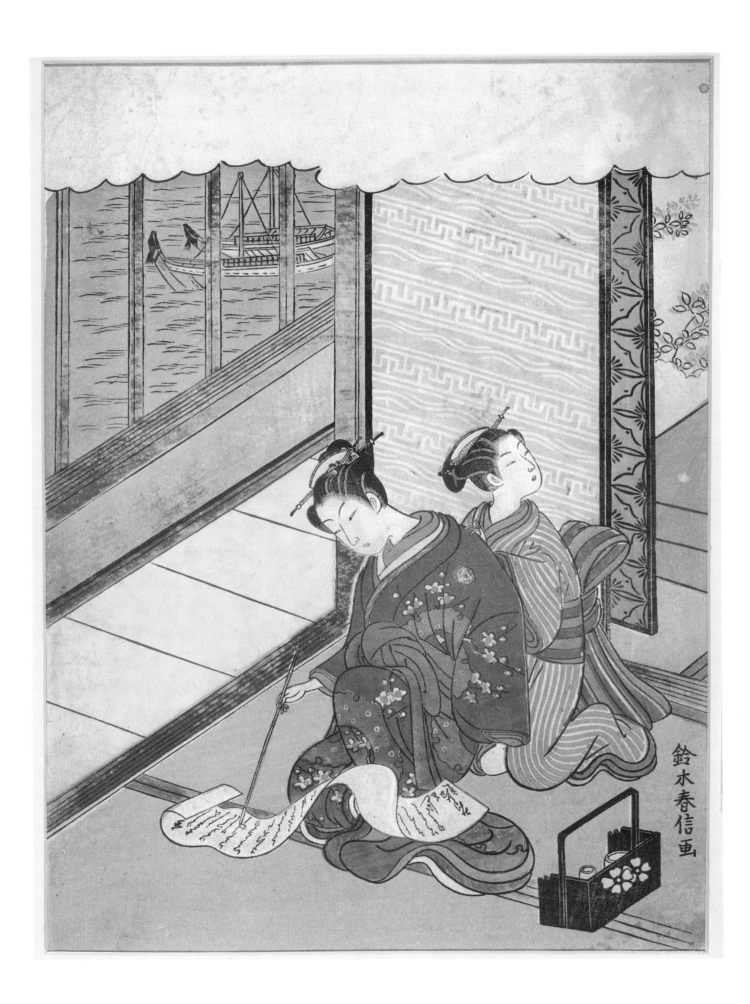

54

Suzuki Harunobu, 1725–1770
LADY ON THE VERANDAH AFTER A BATH
Chūban, nishiki-e, gaufrage, 10⅞″ × 7¾″
Signed: *Suzuki Harunobu Ga*
Miss Edith Ehrman, New York, N.Y.

THERE IS AN ETHEREAL QUALITY about the prints of Harunobu, and his skill at capturing atmospheric effects never ceases to enthrall the viewer. An extremely lovely subject is this one showing a woman cooling off on her verandah after a bath. Even though the depiction of the woman with bare shoulders and breasts slightly exposed would have been considered semi-taboo in polite society, one could not take offense for the treatment is natural, the composition beautiful, and the color breathtaking.

The girl wears a gray striped bathrobe over her underslip of bright red. To capture our attention, Harunobu also made one of the two combs in her hair red. Her face and body are a pearly white; and the entire drawing of her features, drapery folds, and setting is done with great delicacy. Once again right angles are employed in the pale blue verandah, pinkish pillar, and yellow split-bamboo blind. From the eave of the house a wind chime hangs to which a blank poem slip is attached. It moves gently in the soft summer breeze which is scented with the fragrance of the iris growing in a pond and the potted pinks. The ripples of the water are embossed, as is the design on the flower pot, adding a three-dimensional quality to the print. How could one but be at ease in this lovely setting!

The print has Harunobu's name in the far left corner, and is considered to have been from a 1766 series titled *Shimpan Shiki no Hana* (A New Printing, Flowers of the Four Seasons). The publisher is believed to be Sanuki-ya Tōbei; the engraver Endō Matsugorō; and the printer Ogawa Hachigorō.

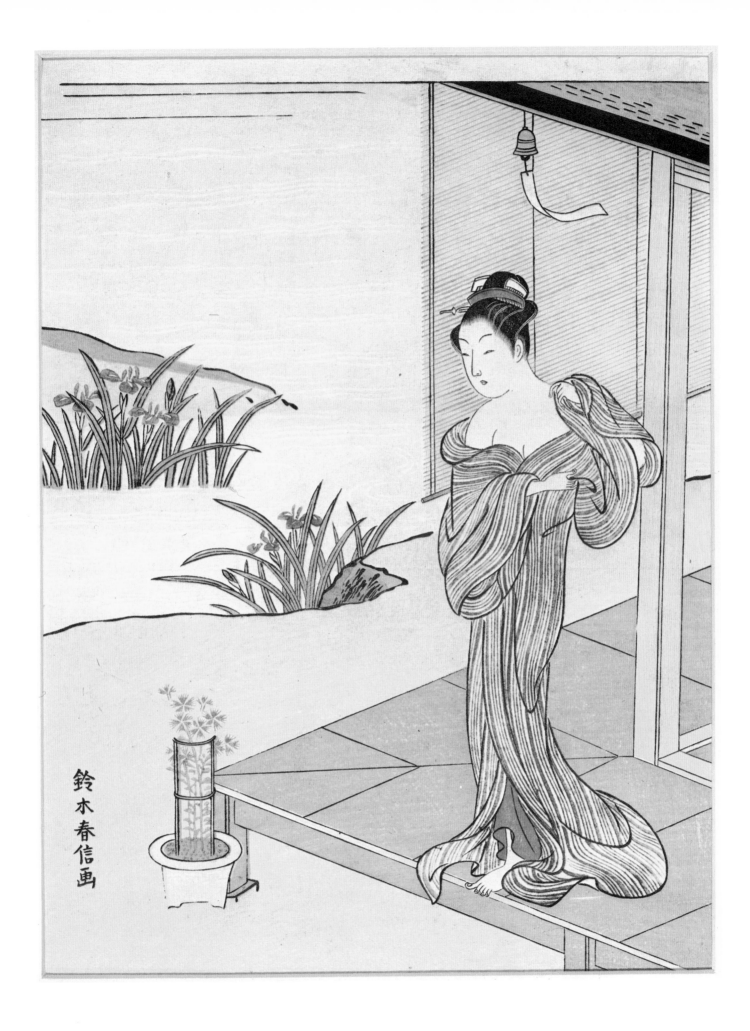

55

Suzuki Harunobu, 1725–1770

TWO GIRLS FISHING IN SHALLOW WATER: NETTING MEDAKA

Chūban, nishiki-e, 11″×8″

Unsigned

Miss Edith Ehrman, New York, N.Y.

RIVERS AND STREAMS have played an important role in the poetry and art of Japan. Among the most often portrayed is the Tama River, which originates in Yamanashi prefecture (formerly Kai province) and empties into Tokyo Bay in the vicinity of the International Airport at Haneda. This print, formerly in the Yoshikawa collection, is believed to depict that river. It would be impossible, however, to prove this unless one were to locate a copy inscribed with a Tama River title.

Harunobu in this print once again displays his love for the idyllic peaceful life. The scene, though one of action, is quiet and the movement graceful. Two girls have waded out to fish. The one on the right bends over as she dips her net into the water to catch a school of *medaka* (killifish), which appear to swim happily toward the trap. She wears a red and white striped obi to bind her red kimono patterned with

water plants and covered with a brown gauze outer robe. Wherever the two robes touch the red color realistically shows through. Experimentation of this nature indicates that Harunobu had become fascinated with the search for realism as expounded by the *Rangakusha* (The Scholars of Dutch Thought). The second girl stands and raises her robes with her right hand and in her other holds a small glass bowl in which three fish resembling goldfish swim. She wears a light red robe with an overall brown lattice design called *komochikōshi* and a green and purple obi. Behind them two clumps of iris and water lilies bloom, an additional reminder that the season is summer.

Although the print is unsigned, the relationship of the figures, the atmospheric effects, attempted realism, delicacy and harmonious color, all indicate it to be a work by Harunobu.

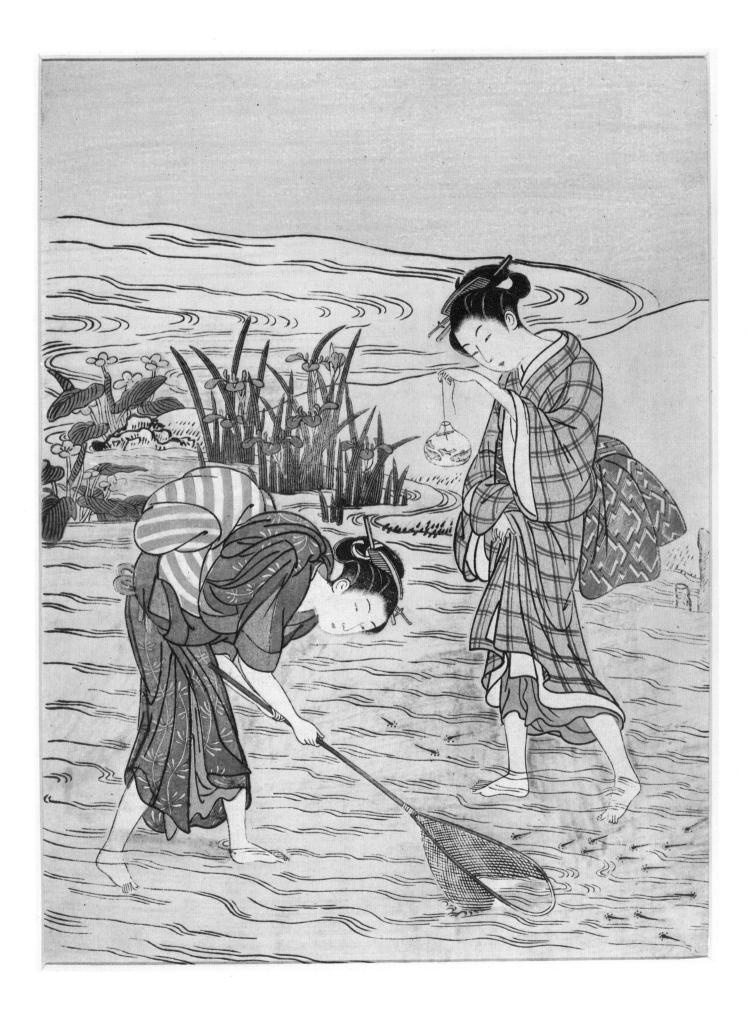

56

Suzuki Harunobu, 1725–1770

A YOUTH DISGUISED AS A KOMUSŌ

Hashira-e, nishiki-e, gaufrage, 28⅛″ × 5″

Signed: *Suzuki Harunobu Ga*

Metropolitan Museum of Art, Rogers Fund, 1936 (Mansfield Collection)

57

Suzuki Harunobu, 1725–1770

A YOUNG GIRL DISGUISED AS A KOMUSŌ

Hashira-e, nishiki-e, gaufrage, 27½″ × 5″

Signed: *Harunobu Ga*

Metropolitan Museum of Art, Rogers Fund, 1936 (Mansfield Collection)

IT HAS BEEN THE PRACTICE in the past for some collectors to couple these two prints as a diptych representing Shirai Gompachi and Komurasaki, the principals of a late seventeenth-century romance.

The tale relates how Gompachi, a swordsmith from Inaba, after killing a follower fled to Edo. While en route he met a beautiful enslaved girl, Komurasaki, with whom he fell hopelessly in love. He rescued her and returned her to her parents' home. Once again Gompachi set forth for Edo only to be attacked by robbers, and it was only through the assistance of a chivalrous man, Banzuiin Chōbei, that his life was spared. In Edo the swordsmith learned that his beloved Komurasaki had sold herself as a prostitute in order to remove her parents from debt. Gompachi vowed to buy her freedom and embarked on a criminal career in order to rapidly obtain the money he needed. After many escapades Gompachi was captured and executed. Komurasaki, overcome with grief, was unable to bear her sorrow and committed suicide at his grave.

Although the tragic romance was used at times as an art theme, one cannot say with certainty that these two prints depict the lovers. In No. 56 Harunobu has drawn a youth carrying a *shakuhachi* (a flageolet-type instrument) and a *tengai* (a basket-shaped rush hat). The youth is disguised as a *komusō*, who were originally priests of the Fuke sect of Zen Buddhism. They traveled about the countryside with their faces concealed under the unusual hats and played the *shakuhachi*

to solicit funds. Later samurai and *rōnin* (masterless samurai) joined the Fuke sect, and spies as well as those atoning for criminal and evil deeds adopted the costume. The youth wears a simple robe of embossed white crepe which covers black and faded purple underrobes. The bottommost layer is patterned with short phrases referring to the youth's eternal love, which is perhaps the reason for the figure being identified as Gompachi. He wears a black *kesa* (priest's surplice) and from his sash hangs an *inrō* (small tiered medicine case) and a brocaded bag for his musical instrument.

The girl is garbed in much the same manner with similar colors employed. Other than for hair the two differ only in sleeve length, underrobe patterns, and *geta*. The girl also carries a *shakuhachi* but hers is enclosed in its brocaded bag. The two prints are complementary for if hung together face each other.

After careful examination, the author would question the Gompachi and Komurasaki attribution as well as the theory that they were designed as a diptych. The female figure is quite a bit larger than the male. It is unlikely that Harunobu, who was a perfectionist, would have intentionally altered the scale. The printing of the background also varies, for that of the female has a pearl-gray color added to the paper surface, whereas that for the male is untouched. Thus, though these two elegant pillar prints may depict tragic lovers, their identity is unknown and the designs clearly were not intended to be a pair.

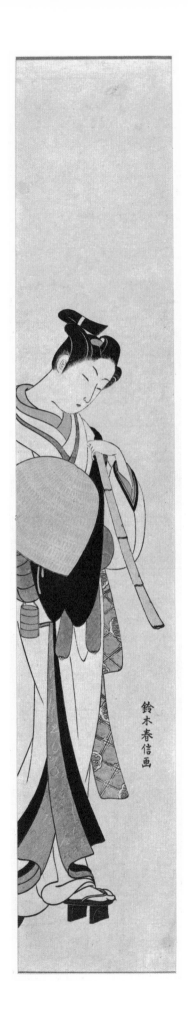

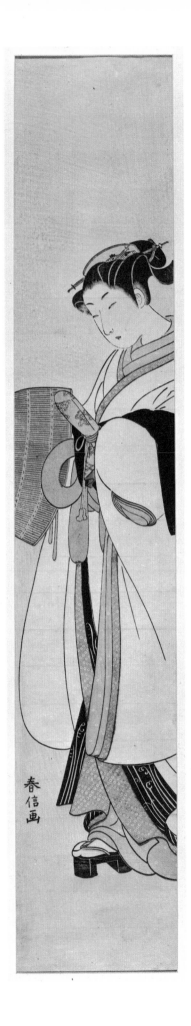

58

Suzuki Harunobu, 1725–1770

GIRL VIEWING PLUM BLOSSOMS AT NIGHT

Chūban, nishiki-e, gaufrage, 12¾″ × 8¼″

Unsigned

Metropolitan Museum of Art, Fletcher Fund, 1929

WE HAVE ALREADY SEEN Harunobu's fascination in depicting night in prints Nos. 49 and 52. In none, however, does he treat it as successfully and decoratively as in this one. A girl stands on a verandah and raises a lantern to view the blossom-laden branches of a gnarled old plum tree. The reasons for Harunobu's appeal to most every great collector and scholar become evident once we study prints such as this. It is not merely the many colors that captivate us but the freshness and beauty of the composition. The artist was inventive and through his beautiful people in their graceful settings brings about a sense of tranquility.

The sky is jet black, and the white plum blossoms with their yellow centers, and the girl clad in a red striped kimono with dark grayish purple crane roundels scattered over it, stand out in sharp contrast to the velvet night. Her green and red obi of a chrysanthemum-patterned brocade adds to the elegance of the figure as do her red and white underrobes. Gaufrage was used in indicating the lines of this virginal garment as well as for her white *tabi* (bifurcated socks). Another integral part of the design is the slanted red rail of the verandah. The girl is neither haughty nor aloof, but is jewel-like cloaked with the mantle of night.

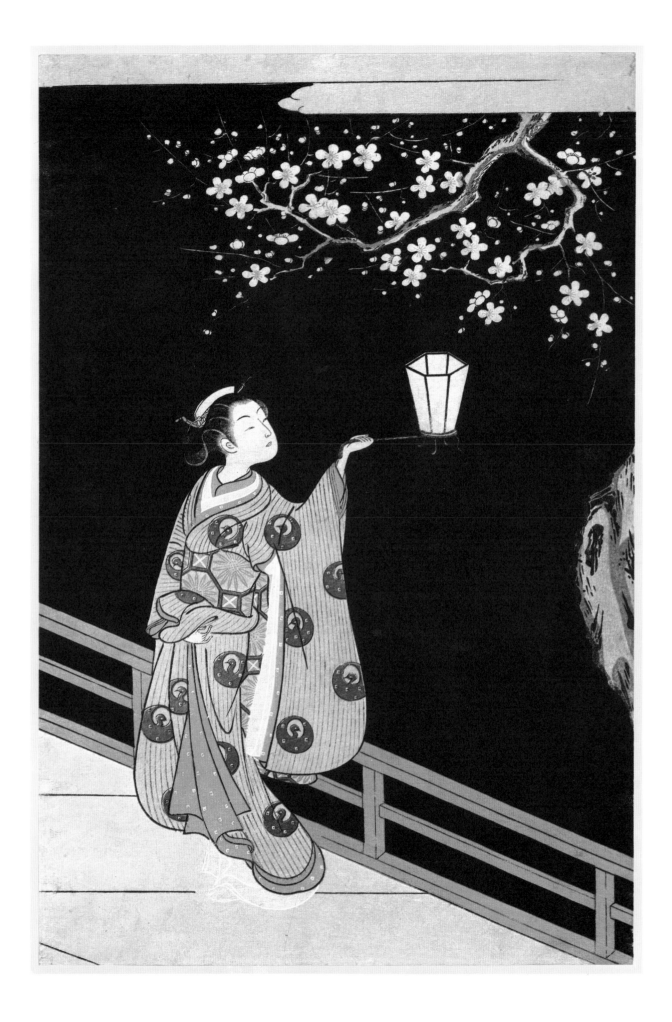

59

Suzuki Harunobu, 1725–1770

Series: FŪZOKU SHIKI KASEN (Popular Poets of the Four Seasons)

UZUKI: THE FOURTH MONTH

Chūban, nishiki-e, gaufrage, 11⅛″ × 8¼″

Signed: *Suzuki Harunobu Ga*

Museum of Fine Arts, Boston, Nellie P. Carter Collection

ABOUT THE YEAR 1768 Harunobu produced what we believe were originally twelve prints for a series titled *Popular Poets of the Four Seasons*. The poems were placed in cloud bands similar to those we have observed in Nos. 49, 50, and 53. The authors of the poems are unknown and the compositions do not always relate to them.

This print represents the fourth month of that series. On it Harunobu has depicted a young man who is disguised as a *komusō* and carries a *shakuhachi* and rush hat. He stands before the window of a house beside which a stream winds, and turns his head to watch a cuckoo in flight, shown in the upper right corner. This young man resembles the youth of the pillar print No. 56. Although carrying the accouterments of a *komusō*, his robes are too elegant and thus it is but a disguise. He wears a white crepe outer robe executed in gaufrage with a black *kesa* over it. The *shakuhachi* bag is of rich brocade with a phoenix-and-paulownia pattern, and the youth's underrobes are of

different colors. His presence has caused a stir of excitement within the house for two young girls peek out of the window at him. In front of the house there is a bamboo fence which protects the flowering deutzia plants. Upon examining the composition, one can note how successful Harunobu was in contrasting the soft and rounded forms of the figures, the rush hat, and stream with the right angles of the architectural elements. He was truly a master of design.

The poem may be read and translated as follows:

Hito no toe saku ya
Uzuki no hana sakari
Kochō ni nitaru yado no kakine o

Come and see the deutzia
 flowers blooming along the fence
 like butterflies

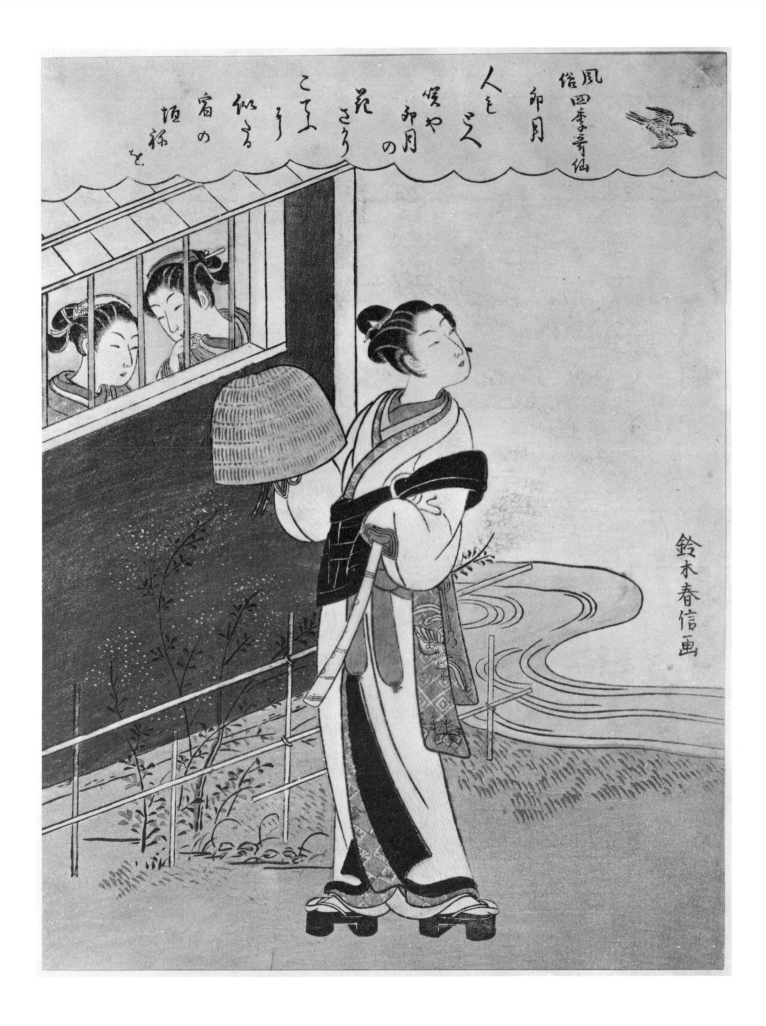

60

Suzuki Harunobu, 1725–1770

Series: SUZUMEGAI; MOTHER NURSING CHILD UNDER A
MOSQUITO NET

Chūban, nishiki-e, gaufrage, 10¾" × 8⅛"

Signed: *Harunobu Ga*

Museum of Fine Arts, Boston, Asiatic Curator's Fund in memory of Marjorie K. Hussey

FAMILY LIFE APPEALED GREATLY to Harunobu and thus he often used it as a theme in his prints. A young mother is shown nursing an infant and at the same time converses with a man (presumably the father) who holds a mirror and has been tweezing his beard. She lies on the floor with a portable mosquito net covering part of her body and the child cradled in her arms. Harunobu very ingeniously has portrayed the green net as it rests on bamboo hoops. It is a charming and peaceful summer scene. Both figures wear cotton *yukata* (thin robes worn in summer or for the bath), and through the open door one can see the verandah where a towel dries on a stand. A rush fence and bamboo are also visible outdoors. In the interior a *samisen*, box, and stack of books rest on a ledge. Music and chanting were undoubtedly important to this happy household. The woman's hand reaches out from under the net and the man has placed his tweezers on the floor before him as he pauses to chat. It is a very natural, homey scene.

The print is believed to be one of a series devoted to various shells. This sheet is titled *Suzumegai* (a small variety of univalve) and the shells are depicted together with a poem in the cloud area at the top of the print. It was written by a great priest poet, Saigyō Hōshi (1118–1190), and is included in his work titled *Sanka Waka Shū* (An Anthology of Poems from a Mountain Hut). The poem is erotic and it reads and may be translated as follows:

Nami yosuru
Take no tomari no
Suzumegai no
Ureshiki yo ni mo
Ai ni keru ka na

The waves approach and the
* suzumegai comes to rest upon a*
* bamboo perch.*
Thus are the two joined in happiness

[134]

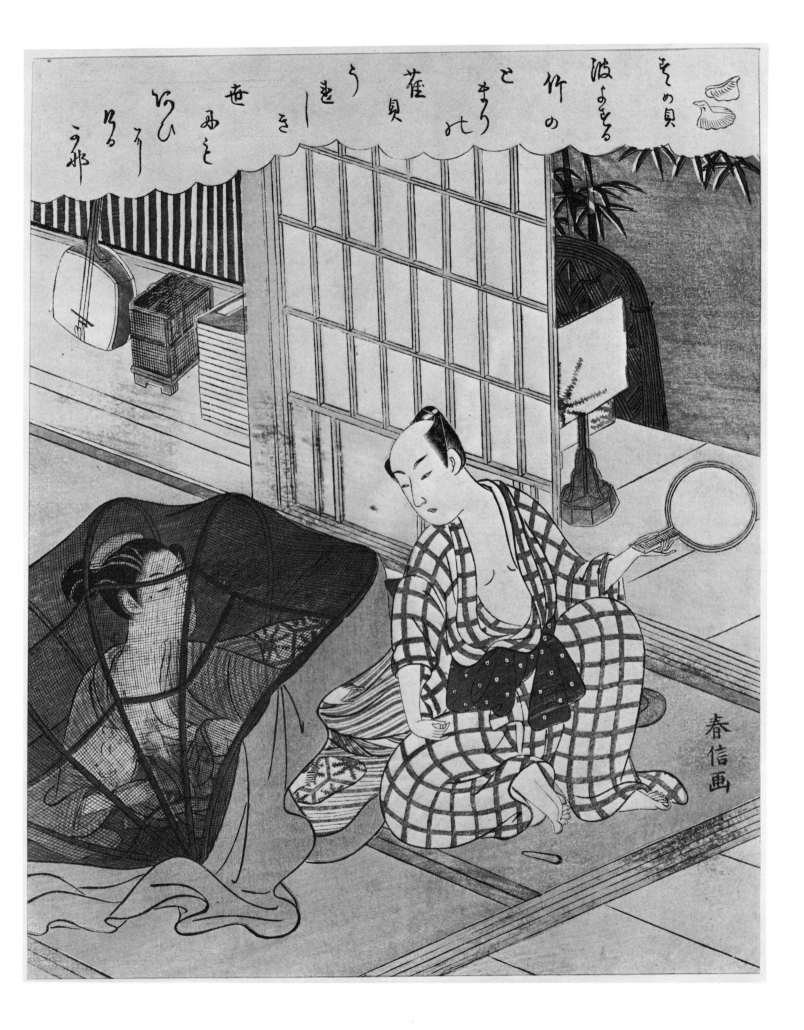

61

Suzuki Harunobu, 1725–1770

AN EVENING VISIT

Chūban, nishiki-e, gaufrage, 10⅞″ × 8⅜″

Signed: *Harunobu Ga*

Philadelphia Museum of Art, Given by Mr. and Mrs. Lessing J. Rosenwald

A YOUNG MAN PAYING AN EVENING visit to a young girl is the subject of this handsome print by Harunobu. The girl stands within the doorway of her house and raises her hand. The lower portion of her kimono is decorated with flowers of a gourd-bearing vine. The youth wears a striped robe and solid-colored *haori* with a butterfly-shaped crest. A black cowl covers his head and shoulders, and one hand rests lightly on the handle of his sword. His face is plumper than that of most Harunobu figures and there is a sense of uncertainty. Is the girl welcoming him or is she asking him to wait on the verandah?

The wall of the interior of the house is decorated with a paulownia pattern and the artist has once again made use of gaufrage techniques to make some patterns stand out.

Harunobu's weakness for right angles as part of a design is very evident here in the windows, door, and flooring. Only the figures, cherry tree blossoming outside, and lantern are soft and flexible. The blossoms indicate that it is early spring and the lantern rim is petal shaped. The print is not static and the artist has made us party once again to an intimate scene.

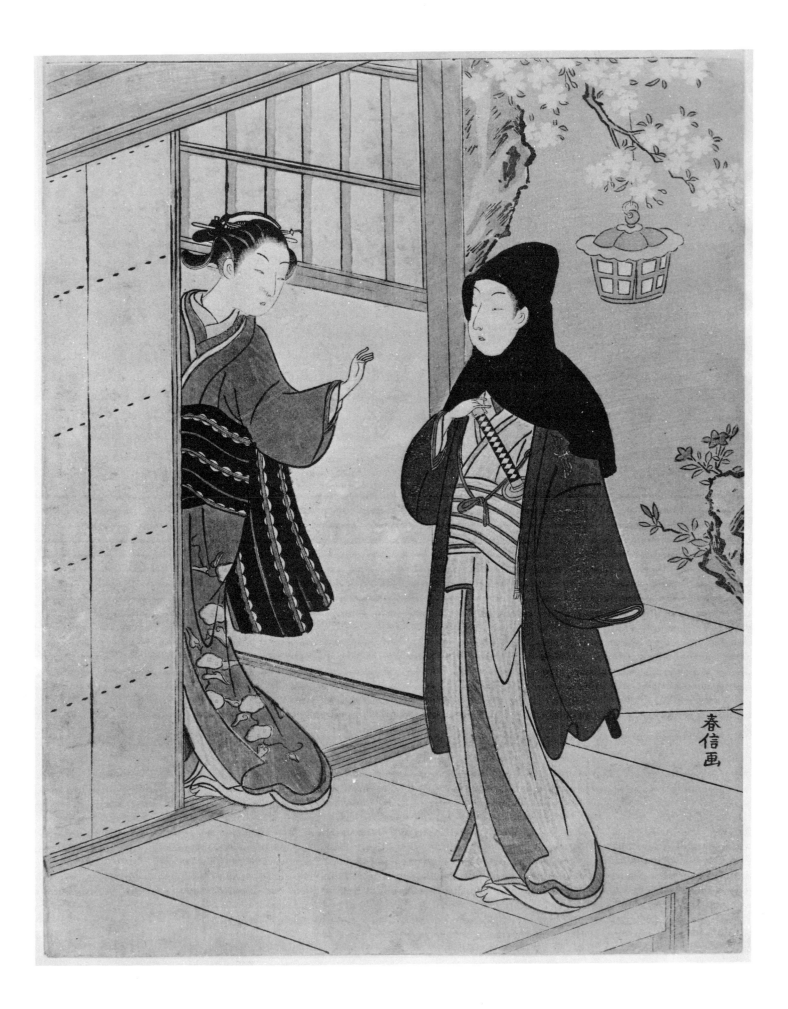

62

Ippitsusai Bunchō, act. 1765–1780, d. 1792
THE ACTOR ICHIMURA UZAEMON XI AS YOSHIIE
Hoso-e, nishiki-e, 12⅛″ × 6″
Signed: *Ippitsusai Bunchō Ga*
Seal: *Mori Uji*
Museum of Fine Arts, Boston, Nellie P. Carter Collection

A CONTEMPORARY OF HARUNOBU who was much influenced by him was Ippitsusai Bunchō. We do not know the date of his birth; however, some scholars have speculated on 1792 as being the date of his death. Although prolific, his work does not help us a great deal in piecing together other than the barest facts about his life. It is reported that he was the pupil of an obscure artist, Ishikawa Kōgen, who in all likelihood was trained in the Kanō school. Bunchō used a seal reading *Mori Uji* on many of his prints, and thus we feel he was of the Mori family. Through his dated illustrated books we are able to conclude that he was active during the two decades 1760 to 1780.

A comparison of the prints of Harunobu and Bunchō is quite interesting. We have already seen the lyrical and joyous nature of Harunobu's work, for other than in his earliest period he avoided theater and Yoshiwara themes. Bunchō relied heavily on him and borrowed Harunobu's color as well as the basic structure of his figures. He at the same time exerted his independence in elongating them and making them individuals, who on occasion are fiery in character. His prints should vaguely remind us of those produced by Torii artists, such as Kiyomitsu I and Kiyohiro. Bunchō, however, delves deeper into the character of those he portrayed and his people are not as stereotyped. Because of this individualization scholars have associated his work with that of Katsukawa Shunshō. A direct influence cannot be established and in all likelihood both artists were merely registering a general trend in print development. Concrete evidence exists showing that Bunchō collaborated with Shunshō as well as Koryūsai in producing prints, book illustrations, and paintings. There was undoubtedly an exchange of ideas, but we know too little to establish clear lines of influence or precedence.

The subject of this print is the actor Ichimura Uzaemon IX performing a lion dance and appearing in the role of Minamoto Yoshiie from the play titled *Otokoyama Yunzei Kurabe* (Otokoyama Compared to the Power of a Bow and Arrow). The family diety of the Minamotos was Hachiman, and their shrine to him was located at Iwashimizu on Otokoyama south of Kyoto. Thus Otokoyama equates with Yoshiie, who was a truly great warrior and lived from 1041 to 1108. He had undergone the *gembuku* ceremony and was considered to be of age at seven, whereupon he received the name Hachiman Tarō. In No. 43 we can see Torii Yoshimitsu's treatment of the same character, though portrayed by a different actor. Bunchō's figure is much more alive. He is clad in the traditional butterfly-patterned *haori* of the lion dancer with his role crest reading *Yoshi* on his right sleeve and the Ichimura family actor's crest on his left. Under this garment he wears a white kimono decorated with peonies growing behind a fence. He holds a branch of white peonies in one hand and pink in the other. Attached to the back of his head are two fans and long red hair. This costume at once should call to mind the figure of Nakamura Tomijūrō portraying Musume Yokobue, No. 42, by Kiyohiro. Of the two, Tomijūrō displays greater activity, whereas Uzaemon is a more personal depiction. In the background of the Bunchō print there is a stationary floor screen on which a humorous though fierce lion has been painted. The subtle and rather delicate use of color, now partially oxidized, is typical of this artist's hand.

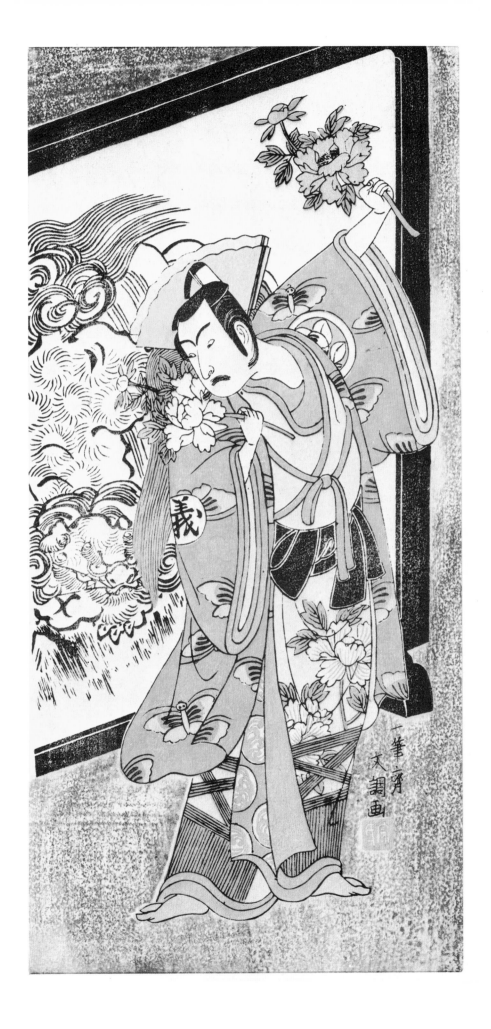

63

Ippitsusai Bunchō, act. 1765–1780, d. 1792
TAKAMURA OF KOMATSUYA
Hoso-e, nishiki-e, 11½″ × 5½″
Signed: *Ippitsusai Bunchō Ga*
Artist's Seal: *Mori Uji*
Publisher's Seal: *Nishimura*
Museum of Fine Arts, Boston, Special Funds

A GIRL STANDING BEFORE A FENCE at the entrance of a house is the subject of this print by Bunchō. She is identified in the cartouche shaped like a folded letter as being the courtesan Takamura of the house called Komatsu-ya. The entire presentation differs noticeably from the earlier artists'. The girl is incredibly thin. Not only are her wrists and ankles fragile but her entire body. Certainly she has no weight problem and one almost has the feeling that were she not wearing heavy *geta* she would float away. Her vertically striped kimono adds to the sense of weightlessness and attenuation. Bunchō elected to make his figures tall, perhaps feeling that this made them graceful. Takamura's obi is tied far above her waist. This also tends to accent the elongation of her figure as does the fan she holds upside down in her right hand. Its ribs are tightly spaced, and because of its comparative width the fan helps to stabilize the figure. Otherwise, she might have folded in two like a blade of bent grass.

The compositions of Bunchō are often very complex

and busy. He seems to have delighted in using props. Takamura is shown standing before a wooden railing. Behind it are two large hand lanterns, one with the *tachibana* crest used by the Ichimurat Theater and actors and the other with a paulownia crest not sufficiently visible to identify. In fact, both lanterns may have no theatrical connection and instead refer to two houses in the Yoshiwara, the Tachibana-ya and the Kiri-ya. At the entrance of the house hangs a curtain decorated with hawk feathers and an inscription hidden behind the cartouche. A lantern hangs in the doorway inscribed *gosairei* (festival) and at the entrance of the visible room hang two framed signs; the upper one reads *tsūshin* (prosperity) and the lower one Osaka. When all of this is combined with the interior pattern of the room, doorstep, lantern ribs, obi, underrobes, signatures, seals, and trademarks, one knows that Bunchō could not have suffered from claustrophobia. He skillfully utilized all of these patterns to create a well-designed and tastefully colored print.

64

Ippitsusai Bunchō, act. 1765–1780, d. 1792
THE ACTOR ONOE KIKUGORŌ I
Hoso-e, nishiki-e, gaufrage, 11¾″ × 5¾″
Signed: *Ippitsusai Bunchō Ga*
Artist's Seal: *Mori Uji*
Metropolitan Museum of Art, Rogers Fund, 1936 (Mansfield Collection)

THE ACTOR ONOE KIKUGORŌ I in a female role is the subject of this print by Bunchō. We have already seen other portrayals of this actor cast as a male in prints No. 37 and 45. Kikugorō had great appeal on the stage. He is believed here to represent a woman called Tonase who was married to Kakogawa Honzō, a loyal retainer of the Wakasa family, in a scene from a play having the *Chūshingura* (Tale of the Forty-seven *Rōnin*) as its basic theme. It was performed at the Ichimura Theater in the ninth month of 1773 to mark the actor's farewell appearance before he traveled to Osaka. Kikugorō was versatile and in this play took three roles: first that of the *rōnin's* leader, Yuranosuke; second, a *rōnin*, Kampei; and third, Tonase.

On the actor's robe is the fan-and-oak-leaf crest of Kikugorō set against an overall pattern of *kiku* (chrysanthemum) blossoms. In typical Bunchō fashion the actor looks back over his shoulder and his body is bowed and elongated. He wears a plum-blossom patterned obi and carries two swords which counterbalance the taut curve of his body and lessen

its attenuation. Bunchō once again demonstrates a concern for setting and fully occupies the space. The actor stands in the snow before a fence constructed of wood, bamboo, and reeds, behind which grow tall clumps of bamboo. There is no doubt about the season for even the actor's hands are withdrawn into his kimono sleeves to ward off the chill.

Color has been modestly used, making the cold appear even more bitter. Bunchō utilized gaufrage to accent certain textile patterns, especially the embossed haiku to the left of the bamboo. The poem is a tribute to Kikugorō for although he was physically departing from Edo his presence would continue to be felt. It reads and may be freely translated as follows:

> *Yuki sora ni*
> *Kiku no nagori ya*
> *Kaeribana*

> *In the snow-filled sky*
> *The chrysanthemum bids farewell.*
> *The blossom will return*

65

Isoda Koryūsai, act. 1766–1788

COURTESAN AND HER ATTENDANT

Pillar print, nishiki-e, 26″ × 4¾″

Signed: *Koryūsai Ga*

Seal: *Masakatsu*

Miss Edith Ehrman, New York, N. Y.

PERHAPS THE GREATEST MASTER of the pillar print was Isoda Koryūsai, and sadly our biographical knowledge of him is scant. Neither his birth nor death date is known, although from his illustrated books and stylistic evidence we are able to ascertain that he was active at approximately the same time as Bunchō, with emphasis on the latter half of the 1760s on through to the 1780s.

The biographers most always mention that Koryū-sai had once been a samurai in the service of the Lord of Tsuchiya; however, later he became a *rōnin*. In addition to the Isoda name he at times used Fujiwara, Shōbei, and Masakatsu. He also used the name Haru-hiro on his earliest prints while strongly under the influence of Harunobu. In the past scholars have related him to Nishimura Shigenaga; however, this is merely speculative and based solely on stylistic rather than documentary evidence. Koryūsai appears to have gained recognition, for sometime in the late 1780s he was given the title *Hōkyō*. This had original-ly been awarded only to priests of distinction but was later extended to include noted craftsmen. We thus know that Koryūsai had achieved official acclaim. As far as can be determined, his later years were devoted primarily to painting.

A very stylish courtesan and her *kamuro* are the subject of this beautifully preserved pillar print. The color is fresh and totally unfaded. The two figures barely fit the composition. They walk to the left and their bodies follow the tradition and bow forward. It was a device used by the *ukiyo-e* artists to impart movement as well as take advantage of the graceful-ness inherent in a curve. The girls are relatively tall and slender, resembling those by Bunchō; however, they are less personal. The courtesan wears three robes with the outer one of red having a tie-dyed wave pattern. Over this she wears an off-shoulder *uchikake*, an outer robe not tied by the obi and worn over the other garments. This is of rich blue fabric and patterned with cherry blossoms and fine irregular parallel lines. The *kamuro's* outer kimono is of two colors. The upper portion is a brilliant red decorated with two chrysanthemums, and the lower area is green and has a grapevine motif. The colors are so fresh that on first viewing they startle one.

In the upper portion of the print appears a haiku which reads and may be translated as follows:

> *Murasaki mo*
> *Ubau iro nashi*
> *Wakamidori*

> *Even purple*
> *Is captivated by colorless*
> *Fresh green*

Purple is a rich color loved by the Japanese yet it fades in beauty before the green of young foliage. The poem, needless to say, is open to interpretation. A second reading would be to consider Murasaki and Wakamidori names of courtesans. Thus, the haiku would point to rivalry between the two with Waka-midori the champion.

66

Isoda Koryūsai, act. 1766–1788

AN UMBRELLA JUMP

Hashira-e, nishiki-e, 27½″ × 3⅞″

Signed: *Koryūsai Ga*

Metropolitan Museum of Art, Samuel Isham Gift, 1914

A PRINT OF GREAT BEAUTY and charm as well as full of movement and humor is Koryūsai's depiction of a young girl performing what we may truthfully call an umbrella jump. The pillar-type format greatly enhances the subject, for its narrowness increases the space through which the girl plummets. It is a daring theme and though it was also used by Kiyotsune, the Koryūsai is much more impressive.

An unconfirmed and fanciful story is told that young girls who were uncertain of the prospective husbands selected for them would plunge off the balcony of the Kiyomizu Temple, using an umbrella as a parachute. If they were unharmed in the fall they considered it a sign that all would go well and that the future groom would bring them joy. Though the story is entertaining, the theme is more likely an illustration of a well-known proverb, *Kiyomizu no butai kara ushiro tobi* (To leap backwards from the platform of Kiyomizu). When interpreted the proverb

is said to symbolize a once-in-a-lifetime decision. Certainly one would be unlikely to repeat a leap from Kiyomizu's viewing platform.

At the top of the print the edge of the famous platform is shown. It overlooks a valley filled with cherry trees and from it one can view much of Kyoto. It is a scenic and beautiful spot. The girl has just jumped from this and she holds a paper umbrella above her head as she falls toward the cherry blossoms which peer through a bank of clouds at the bottom of the print. Her arms are pulled back by the force of the draft and she looks downward to her beautiful though frightening flowery cushion. Koryūsai has handsomely captured the moment. Her foot is raised and the drapery of her robes is agitated by her movement. They are of a delicate pinkish hue and patterned with dragonflies, whereas her obi has a decorative motif including birds in flight. How sad that they fly and she cannot!

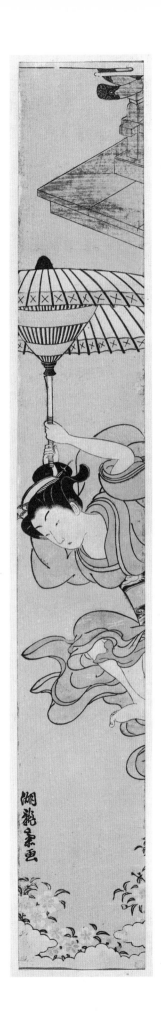

67

Isoda Koryūsai, act. 1766–1788

Series: HINAGATA WAKANA NO HATSU MOYŌ (The First Designs of Model Young Leaves)

NANAKOSHI OF THE ŌGIYA

Ōban, nishiki-e, 15¼″ × 10½″

Signed: *Koryūsai Ga*

Publisher's Seal: *Eijūdō*

Metropolitan Museum of Art, Bequest of Henry L. Phillips, 1940

KORYŪSAI WAS NOTED for his use of *tan* and black, harking back to the color scheme used by the early eighteenth-century masters of the Torii school. There is an air of elegance about these antique hues, as well as the figures of beautiful women who make up the series of prints titled in the cartouche *Hinagata Wakana no Hatsu Moyō* (The First Designs of Model Young Leaves). The series consists of many prints, and Kiyonaga also designed some for a set having the same title. All of these sheets serve as fashion plates, for they show the most noted and glamorous courtesans of the day modeling robes of beautiful design and groomed in the height of fashion.

Nanakoshi of the house called Ōgiya and her two *kamuro* are the figures in this print. The courtesan and one *kamuro* are shown seated on the floor, while the third girl stands. Nanakoshi wears the elaborate hair style which came into vogue in the late '70s and involved the use of many combs and pins, with the sidelocks billowing out. In general appearance, the hair took on the shape of a folding fan. She is adjusting one of the pins in her coiffure. Her outer kimono is of a red latticework pattern and is tied with an obi of gold fabric, decorated with chrysanthemums, upon which is superimposed red floral roundels. She also wears a black *uchikake* having a New Year motif of battledores and shuttlecocks. Koryūsai has cleverly indicated that it is made of a fabric having a thick nap. It is a striking contrast to the kimono. Her two attendants wear outer robes of the same pattern as Nanakoshi's *uchikake*. Though originally blue, they have now faded and appear grayish. Their underrobes are of red, pink, and wisteria tones, and the kimonos are tied by long obis decorated with a floral motif. The seated *kamuro* points to an open book and looks at the courtesan who glances back at her.

Behind Nanakoshi is a clock typical of the period and obviously showing the influence of props derived from the Western world. Though clocks had long been common to the Far East, this particular variety called a *yagura tokei* (tower clock) was borrowed from a European lantern clock prototype. The oxidized orange color adds a note of warmth to this already fashionable print.

68

Isoda Koryūsai, act. 1766–1788 (attributed)

HAWK PERCHED ON A SNOW-COVERED PLUM BRANCH

Large panel, ishizuri-e (rubbing), hand-colored, 29^{15}/$_{16}$″ × 10¼″

Unsigned

Metropolitan Museum of Art, Rogers Fund, 1923

ALTHOUGH UNSIGNED, it has been the custom to attribute a number of large panel prints of birds to Koryūsai. They are very beautiful designs and all are bold. This one is especially striking. On it a hawk is shown perched on a limb of an aged red plum tree. It is a winter scene, for the tree is covered with snow and the flowering vertical branches which frame the left edge of the print stand out against the rich azure night sky in which the new moon in its first quarter shines, bathing the scene. The blue decreases in intensity the farther one gets from the source of illumination. Thus, the sky below the branch is paler. This may have been unintentional on the part of the printer; however, it is very effective.

In truth, these panels are not what we would normally consider wood-block prints. They are executed on very thin paper in a technique called *ishizuri* (stone printing). In production they closely resemble the method of producing stone rubbings.

The design would be cut away into the wood-block and then dampened paper pressed carefully into the incisions. Once this was accomplished color was applied directly to the projecting parts of the paper. Thus, the colored areas would be in relief, while the deeply incised portions remained uncolored. The paper would then be backed onto a heavier sheet and evidence exists to prove that at times only portions of a print were treated in this manner, whereas the rest was handled in a traditional way. It is a process that is the reverse of what we normally associate with a wood-block, for the outline is without color.

It is quite difficult to explain why these *ishizuri-e* have been attributed to Koryūsai. It has become traditional to consider them his work partially because of the existence of a few signed examples and his fondness for birds and flower themes. They also reflect a love of nature and natural effects which is inherent in both the prints and paintings of Koryūsai.

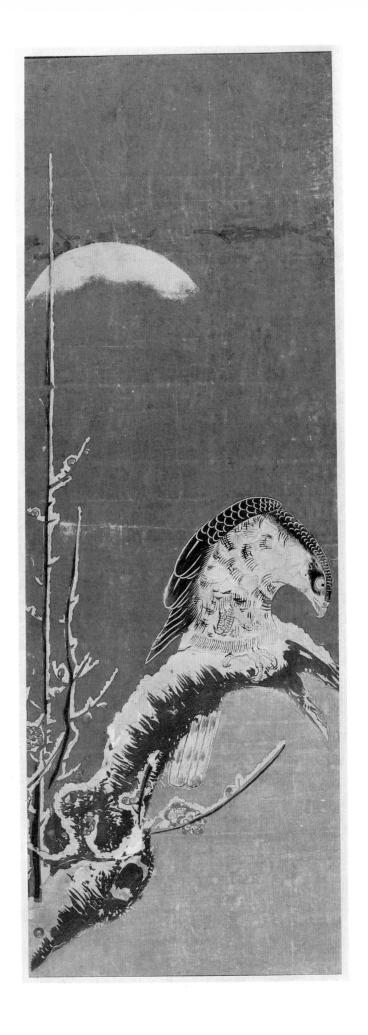

69

Katsukawa Shunshō, 1726–1792

TWO WRESTLERS OF THE EASTERN GROUP: NIJI-GA-TAKE
SOMAEMON (right); FUDE-NO-UMI KINEMON (left)

Ōban, nishiki-e, 15″ × 10″

Signed: *Shunshō Ga*

Publisher's Seal: *Matsu*

The Art Institute of Chicago

AS WE HAVE ALREADY SEEN, the world of *ukiyo-e* prints was periodically enriched by artists who not only were prolific and great in their own right, but were also talented teachers and went on to influence the future development of *ukiyo-e* through their pupils. Shunshō was such an artist. He was born in Edo in 1726 and appears to have at one time been a pupil of Shunsui, from whom his name is partially derived. In fact, he also used the Miyagawa and Katsumiyagawa names of this same master. The slight influence of Hanabusa Itchō can also be seen in his work and this is believed to have come through association with the painter Kō Sūkoku. Shunshō made use of many names during his lifetime, though most of these relate to paintings and literary work rather than prints. Among those employed were Yūsuke, Chihiro, Kyokurōsei, Yūji, Ririn, Rokuro-kuan, and the well-known name Katsukawa, henceforth used by him and his followers. Shunshō had a great opportunity to observe the fashionable illustrated literature of the period, for from approximately 1751 to 1771 he resided with Hayashiya Shichiemon, a popular book dealer. It was probably during this time that he became more and more interested in the portrayal of actors. He did not limit his depictions to their appearance on stage, but included views of their private life. It was at this same time that he commenced using a jar-shaped seal in which the character read *Hayashi* was placed. Though speculation, this probably was meant as a tribute to the bookseller who had befriended him. Shunshō brought to the wood-block print an added freshness. His actors carry the individualization noted in Bunchō a step forward, and serve as a link to the great

caricature prints of Sharaku, Nos. 122–127. Shunshō was a superb colorist and his appeal was great. About him gathered many pupils yet to be observed, such as Shunei, Shunkō, Shunchō, and Hokusai. After a relatively long and very productive life, he died in 1792, assured that these followers would perpetuate his name and the Katsukawa style.

Two *sumō* wrestlers representing the Eastern side are the subject of this print. The competitors at *sumō* matches are divided into Eastern and Western sides, with the former being the champions of the previous tournament. Thus we are viewing Shunshō's portrayal of the victors. These tall athletes are enormous creatures, often weighing over two hundred and fifty pounds, and the artist has cleverly trapped them within the confines of this sheet of paper. They are not idealized and stoop over to fit the space. Niji-ga-take Somaemon, one of the three first-ranking wrestlers classed as *Sekiwake*, is shown on the right. He is hunched over and certain muscles bulge, whereas his stomach that gives him his weight advantage protrudes and sags over his apron of rank. His ear is cauliflowered, his nose flattened, and his expression, with pinched eyes and sagging jowls, indicates the concentrated energy requisite to compete in such a contest. Next to him stands what appears to be a younger wrestler, called Fude-no-umi Kine-mon, who also belonged to the first-rank group but of a lesser *Maegashira* category. His ear has also been distorted, though he has obviously not weathered as many storms as his partner. On both Shunshō has pointed to their extra virility and coarseness by indicating their beards. They are truly individuals and immovable.

70

Katsukawa Shunshō, 1726–1792
ICHIKAWA DANJŪRŌ V IN HIS DRESSING ROOM WITH THE
PROGRAM ANNOUNCER
Ōban, nishiki-e, 15⅛″ × 10⅛″
Unsigned
The Art Institute of Chicago

SHUNSHŌ MUST HAVE FREQUENTED the Kabuki theater backstage as well as sitting in the audience. He produced a number of prints which strongly suggest that they were developed from live sketches. In this example he takes the viewer into the dressing room to see the great matinee idol, Ichikawa Danjūrō V, wearing makeup for a *Shibaraku* (Wait a Moment) performance. He is seated on the floor and smokes a pipe as he relaxes and chats with the program announcer prior to donning his heavy robes. Danjūrō V assumed that exalted name in 1770, and although he did not die until 1806, the title passed along to his son in 1790. Through his grotesque makeup he ap-

pears to be a mild man with a large hooked nose and rather sad eyes. On his head he wears the standard samurai hat, called an *eboshi*, and pleated sheets of paper said to symbolize bat wings and indicate strength extend from each side of his wig. The announcer who listens intently to his words holds the program in one hand and wooden clappers, *hyōshigi*, in the other. Against the wall is placed a dressing table and mirror stand, a wig stand, a box labeled "wig case," and a large wardrobe trunk. Ichikawa Danjūrō's name is written on paper and affixed to a pillar in the room. We are privileged to have this candid view of the great actor.

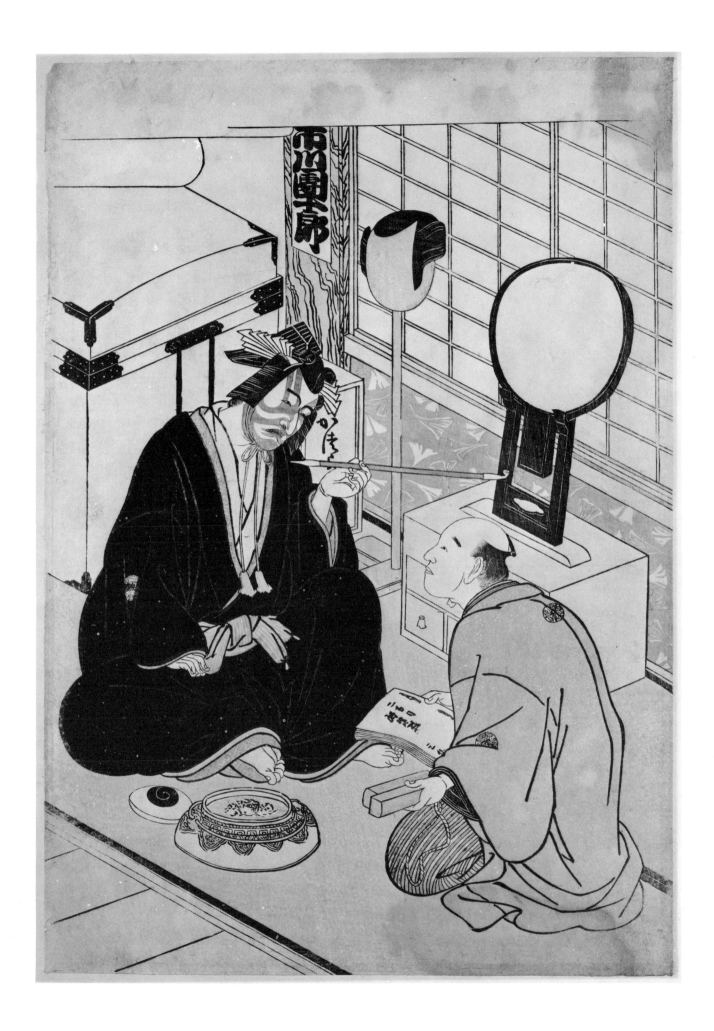

71

Katsukawa Shunshō, 1726–1792

ŌTANI HIROJI III IN HIS DRESSING ROOM

Ōban, nishiki-e, 15⅜″ × 10⅛″
Signed: *Shunshō Ga*
The Art Institute of Chicago

ANOTHER INTIMATE VIEW OF LIFE backstage at the Kabuki is provided for us in this print showing Ōtani Hiroji III making up in his dressing room. He wears a wisteria-patterned robe and is seated cross-legged before his mirror as he applies eye makeup for a role in a play, possibly having a Soga theme. This was one of the vehicles in which he excelled. His name is affixed, on paper, to the wall. A towel rests on the small chest which contains his brushes and cosmetics, and a tub of water is placed before him. Kneeling at his side is a smiling figure which at times has been identified as being Ōtani Tokuji, a pupil of Hiroji. It is also possible that this figure may be but an attendant who is in the service of Hiroji and thus wears his house crest. He is quite obviously a younger man with firmer features than the others. Standing on the left is an elder actor identified by the Art Institute of Chicago as being Yamashita Mangiku, who is dressed for the role of an older woman. A small

silk cloth covers his forehead and his hair is swept up and twisted into a knot. His coat hangs loosely over his shoulders and its sag is repeated in the droop of the actor's wrinkled face. His nose is huge, his mouth downturned, and his eyes but narrow slits. At his foot is a box labeled "wig case" and behind the actors is a large wardrobe chest upon which rests smaller cases containing costumes. One is tied with rope and marked with Ōtani Hiroji's house name, Maru-ya. Resting against the large chest is a cloth-covered case which probably holds the large sword this actor used when portraying the role of Asahina.

The composition is excellent and Shunshō has subtly and beautifully colored the print which has since faded and oxidized. He maintains the viewer's interest in his relationship of the three figures which are symbolic of three ages: youth, prime, and maturity. Shunshō quite often sought to vary and juxtapose the people captured on these precious sheets of paper.

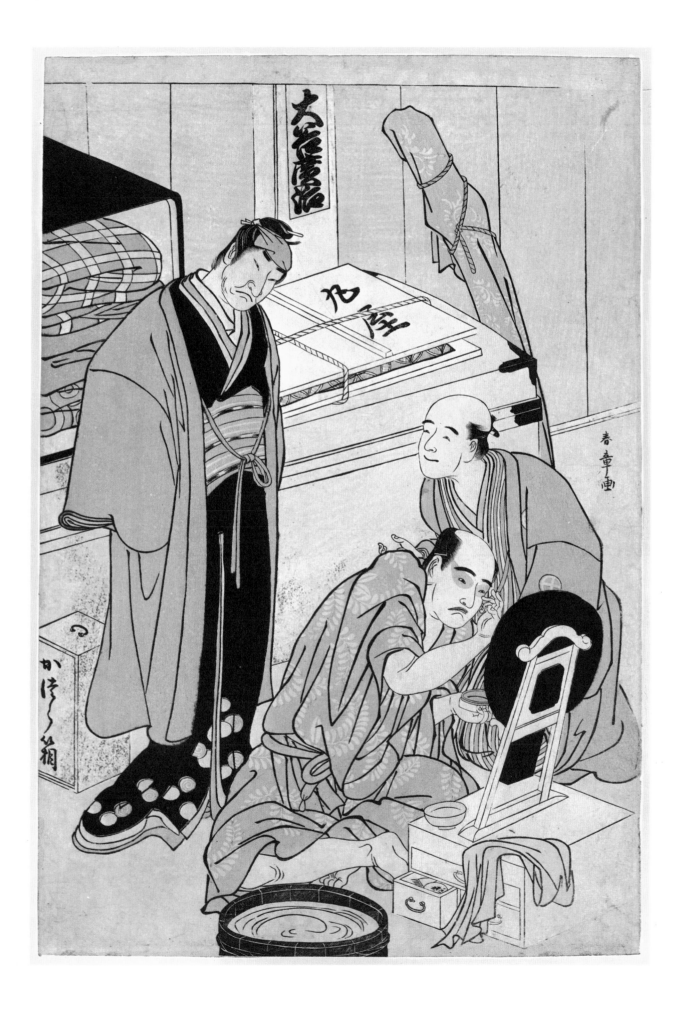

72

Katsukawa Shunshō, 1726–1792

FŪRYŪ NANA KOMACHI (Seven Graceful Representations of Komachi)

Ōban, nishiki-e, 16½″ × 10¾″

Signed: *Shunshō Ga*

Nelson-Atkins Gallery, Kansas City, Missouri (Nelson Fund)

AN UNUSUAL PRINT THAT DOES NOT ENTIRELY succeed as a great design, yet is very rare and beautifully executed, is Shunshō's single sheet showing seven representations of the noted ninth-century poetess Ono no Komachi. One is troubled when first viewing it, for the figures appear crowded and though they apparently look at one another, they actually do not relate to each other. The print is of larger scale than other known prints by Shunshō, making it stand out in his work. In addition to that, it is beautifully colored. The textiles worn by the seven Komachi are intricate and the precision of the cutting of the block establishes the print as a tour de force of the engraver's art.

The theme originates from a series of plays written by the fourteenth-century Nō playwright Kanami and his son Zeami, dealing with the *Nana Komachi* (Seven Komachi). *Jōruri* plays about Komachi by other authors had been performed in the Kyoto-Osaka region in the 1720s and in Edo in the 1760s, and thus there is little likelihood that Shunshō was unfamiliar with the subject matter. Ono no Komachi was considered to be a very beautiful and talented poetess. She easily captured the hearts of many men, yet was always distant and appears never to have fully returned their love. A note of sadness always prevails when one speaks of her, for her career ran the gamut from a court lady of refinement to a disheveled and unkempt beggar. Her fame as a poetess always comes first to mind, for she was the only woman included in the *Rokkasen* (Six Master Poets) of ninth-century Japan.

Shunshō found Komachi an excellent foil through which he could display his skill at depicting different classes of society and age, somewhat resembling No. 71. Clockwise from bottom left to right and ending with the central figure holding a lantern, they are as follows:

1. *Sōshi Arai Komachi* (The Book-washing Komachi). This refers to the incident when the poetess was accused by Ōtomo no Kuronushi of having committed plagiarism. She washed fresh ink from a manuscript and revealed her poem.

2. *Kiyomizu Komachi.* The poetess often visited the Kiyomizu Temple. (Shunshō represents her in the costume favored by the leading courtesans and holding a fan in her hand.)

3. *Ōmu Komachi* (Parrot Komachi). She is shown standing with brush in hand altering a poem by the Emperor Yōzei, which was brought to her by his courtier Yukiie. Her eyebrows are shaved and she again appears to be a lady of status.

4. *Sotoba Komachi* (Grave-post Komachi). She is shown as an older woman with a band about her head and holds a fan as she dances.

5. *Sekidera Komachi.* She is shown as an elderly beggar at the Sekidera Temple in Ōmi province. Komachi is now aged, her beauty has faded, and she carries a staff to support her pain-racked body.

6. *Amagoi Komachi* (Komachi Praying for Rain). She is depicted as a young girl holding in her hand a poem slip which she wrote on Imperial command to help bring an end to drought.

7. The central figure—*Kayoi Komachi* (The Often-visited Komachi). She is shown as a lady of distinction holding a lantern and waiting to receive her lover, whom she challenged to show his fidelity through frequent visits.

All seven Komachi are elegantly garbed and, though Shunshō took great liberty in the depictions, the print is a veritable guide to popular textile patterns of the period. The variety of design and color converts the print into a fascinating tapestry. For readers wishing to follow the Komachi theme further, David B. Waterhouse's *Harunobu and His Age*, The British Museum, London, 1964, pp. 297–302, is recommended.

This print was formerly in the collection of Baron Fujita.

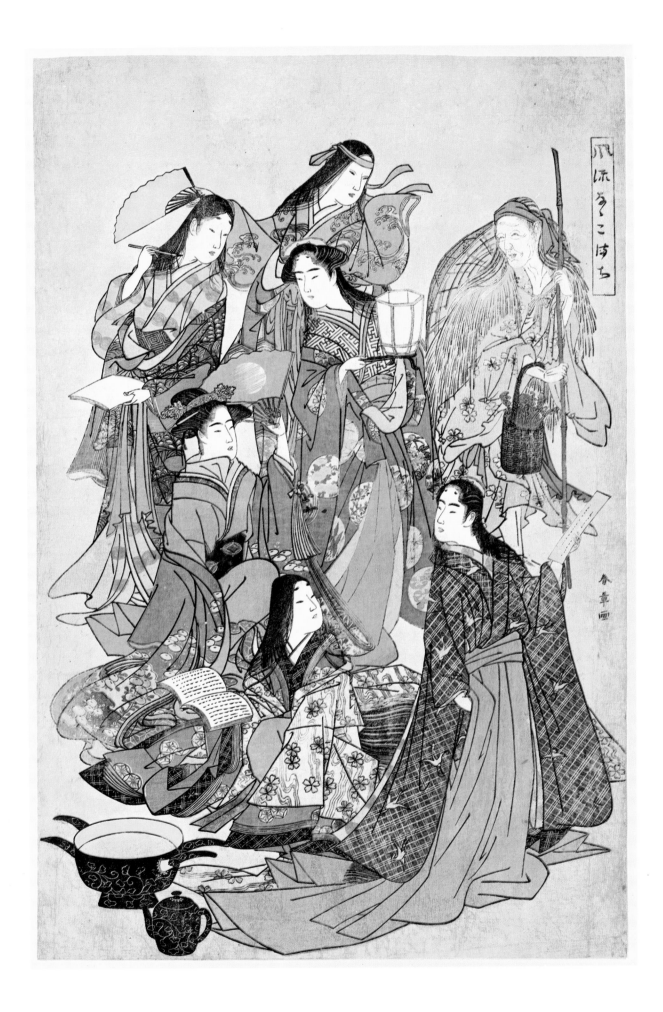

73 74 75 76 77

Katsukawa Shunshō, 1726–1792

FIVE ACTORS IN ROLES FROM THE PLAY
KARIGANE GONIN OTOKO (Karigane, Five Men)

Hoso-e, nishiki-e, Signed: *Shunshō Ga*

Nelson-Atkins Gallery, Kansas City, Missouri (Nelson Fund)

73: Ichikawa Danjūrō V as Gokuin Senuemon, 12⅛″ × 5¹³/₁₆″

74: Sakata Hangorō II as Hotei Ichiuemon, 12¼″ × 5⅝″

75: Bandō Mitsugorō I as Yasuno Heigoemon, 12″ × 5⅝″

76: Nakamura Sukegorō II as Kaminari Shōkurō, 11¹⁵/₁₆″ × 5¾″

77: Ichikawa Monnosuke II as Karigane Bunshichi, 12″ × 5½″

SHUNSHŌ'S SKILLED AND DISTINCTIVE MANNER in depicting actors is magnificently displayed in these five related prints. They show five great actors in a scene from a play listed in the *Kabuki Nendai Ki* (Chronological Record of the Kabuki) as *Karigane Gonin Otoko* (The Five Karigane Men). It was performed in the Nakamura Theater in Edo in the second month of 1780. These five young men from Osaka were led by Karigane Bunshichi in the Genroku period and banded together as rogues.

It would be difficult to determine the true sequence of these prints, for they fit equally well in several arrangements. That reproduced, however, appears to be the most acceptable. A thin figure is placed in the center, flanked by stouter actors, with another thin actor at each end enclosing the composition. The conception is fascinating and stimulates the viewer's interest. In addition the setting and color are bold and each print is strong enough to stand on its own merit.

The overall background is a long barred window with the woodwork executed in light orange and brick tones. Against this the actors stand on a yellow street and all wear the same patterned black and white striped outer robe and red obi. Their underrobes of red, yellow, and gray-green bear their actors' crests, whereas the striped robes carry the crest of the role they play. They all have swords and *shakuhachi*, although the latter is hidden from view in the fourth figure.

The actors may be identified from left to right as follows:

73. Ichikawa Danjūrō V as Gokuin Senuemon. The actor's crest of stacked boxes appears on his underrobe; however, even without it his profile is identifiable.

74. Sakata Hangorō II as Hotei Ichiuemon. On the underrobe is the spindle crest he wore as an actor and the striped kimono bears the role crest consisting of Hotei's pack and fan.

75. Bandō Mitsugorō as Yasuno Heigoemon. The actor's crest consists of three repeats of the character read *dai* (great) in a roundel, whereas his role crest consists of the character read *an* (peace).

76. Nakamura Sukegorō as Kaminari Shōkurō. The character read *sen* (hermit) on his underrobe is his actor's crest and the drum and sticks of the thunder god on his outer robe identify his role.

77. Ichikawa Monnosuke as Karigane Bunshichi. The stacked boxes of the Ichikawa actor with the character read *mon* (gate) form this actor's crest, whereas a wild-goose *(karigane)* crest is placed on his striped robe to identify his role.

There is no monotony in Shunshō's representation of these five actors. Each is an individual and varies not only in makeup but in expression, physical type, and emotion. The designs are uncluttered and like abstract patterns. They are not static, and one longs to see the actors' gestures and hear their words.

78

Katsukawa Shunshō, 1726–1792

THE ACTOR ICHIKAWA DANJŪRŌ V IN A SHIBARAKU ROLE

Hosoban, nishiki-e, 12⅛″ × 5¹⁵/₁₆″

Signed: *Shunshō Ga*

Grunwald Graphic Arts Foundation, University of California, Los Angeles

ICHIKAWA DANJŪRŌ V was the popular favorite of the stage, and therefore the demand for prints representing him must have been great. Many artists depicted him; however, those done by Shunshō may be the most dramatic. Danjūrō V portrayed many roles; his most successful was that in *Shibaraku* performances. For this he applied grotesque red and white decoration to his face, placed pleated paper in his hair, and wore an *eboshi*, as in No. 70. After applying his makeup, he would put on a voluminous outer garment and long trailing trousers colored a bright brick or persimmon-like color decorated with large Ichikawa crests. To finish off his costume he carried extraordinarily long swords. The costume and makeup were purposely designed to startle the audience as the actor postured on the stage.

Shunshō could not help being fascinated by the forms created by the robes. In this print Danjūrō V appears in a role that may be Miura Danmyō in the play *Godai Genji no Furisode* (The Fifth Generation, Genji's Long Sleeves) which was performed at the Nakamura Theater during the eleventh month of 1782. Most often the actor is shown facing forward; however, in this example he faces the right edge of the print. His profile is unmistakable, showing Shunshō's keen observation of his features. He is hunched over and the costume envelops him so that he appears shaped like an irregular ball. The large square crests on the outer garment and the underrobe busily decorated with cranes placed in lozenges provide a sharp contrast to the overall ball shape, as do the swords and drapery folds. Behind the figure hangs what was once a blue curtain containing the octagonal crest of the Nakamura Theater. It but adds to the forms that occupy the viewer's interest. This portrait of Danjūrō V by Shunshō resembles a tightly wound spring. We know that at any moment it will uncoil and the actor will leap into action.

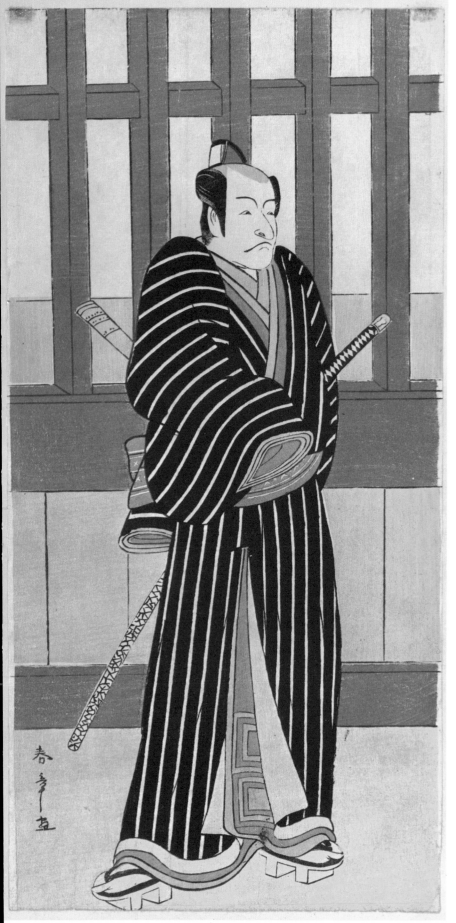
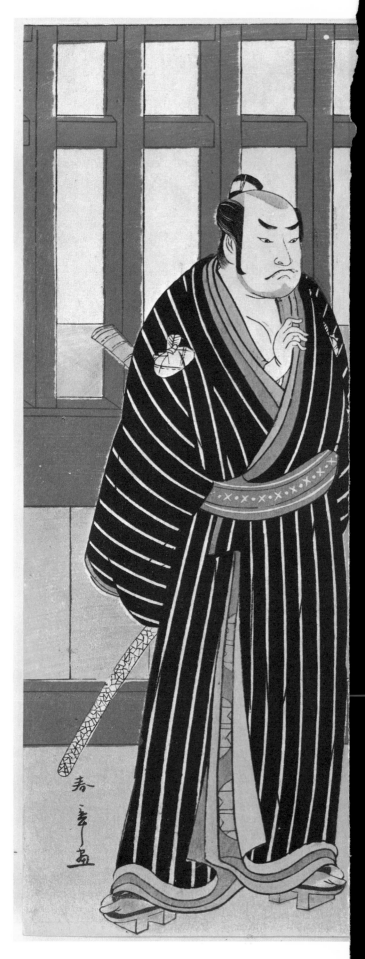

73

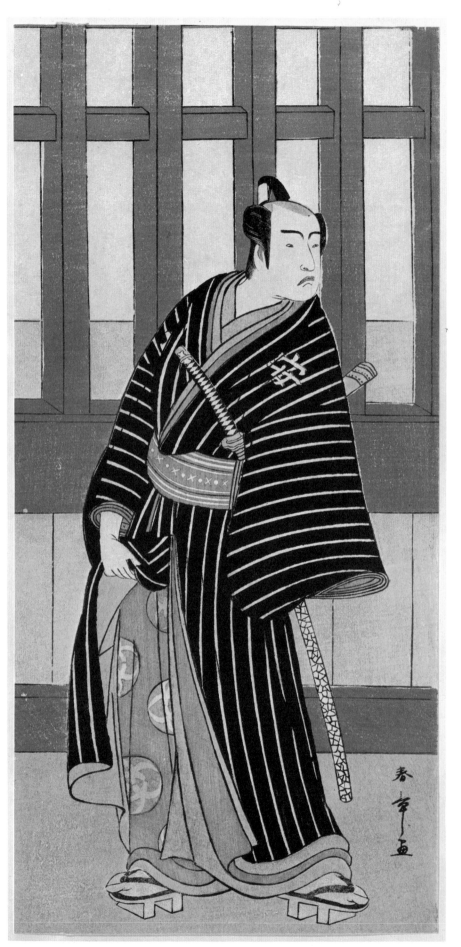

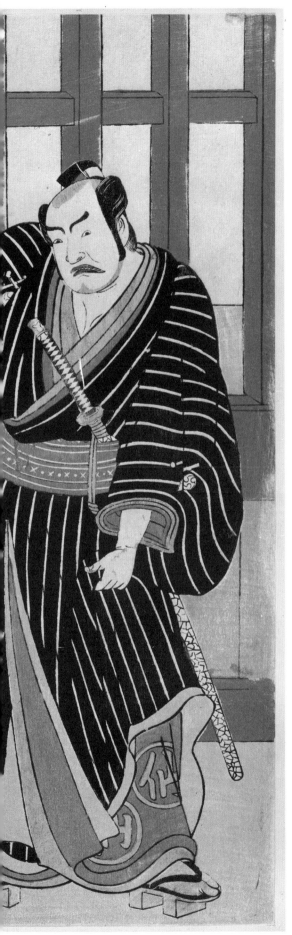

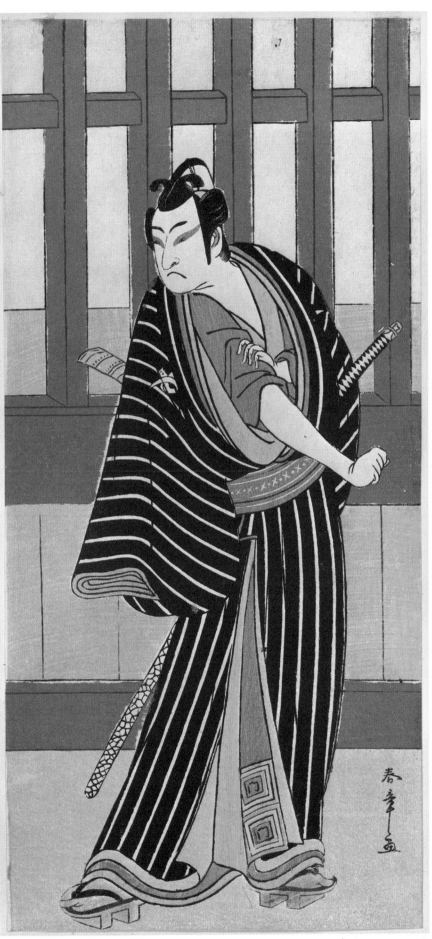

76

77

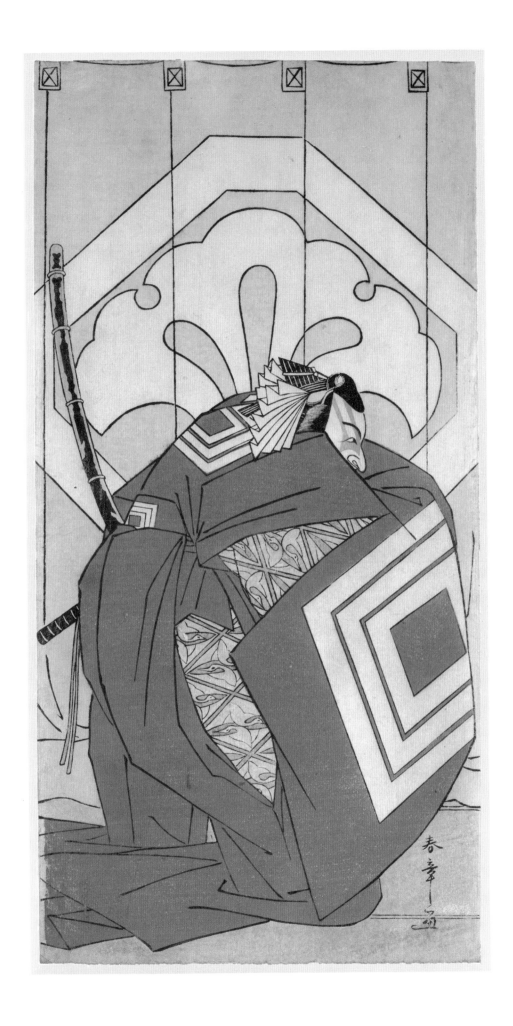

79

Katsukawa Shunkō, Act. 1772–1788

WOMAN WITH UMBRELLA WALKING ALONG THE SHORE

Hashira-e, nishiki-e, 26¾" × 4⅝"

Signed: *Shunkō Ga*

Museum of Fine Arts, Boston, Special Funds

AMONG THE PUPILS OF SHUNSHŌ there were a number of very talented men about whom we unfortunately know next to nothing. A number of these men elected to use as their name characters reading Shunkō. Two artists from this group are of special interest to us. The name of one means "Spring Fondness" and his work will be considered later, Nos. 137 and 138. The name of the other artist, who produced the fine pillar print shown here, means "Spring Radiance." He is reputed to have been a pupil of Shunshō, and to have been active between the years 1772 and 1788, producing mainly prints of beautiful women and children.

A courtesan promenading by the seashore holding an open umbrella is the subject matter. She is not too tall a girl and one can tell that the season is summer for she wears a gauze outer robe. It comes into contact with the underrobe and in those places the lines thicken and color is intensified. A pattern of folded paper origami cranes decorates the underrobe, which also has a butterfly crest. The courtesan's bare ankle and foot placed midway between the print's width centers the composition and keeps it in balance. This is also aided by the placement of the umbrella slightly off center to match the bulk of the figure. The girl is graceful and additional delicacy is implied in that she has wrapped part of the umbrella handle in cloth. Her hair style, with increased use of combs and pins, is typical of the 1780s.

Behind the figure, Shunkō has attempted to indicate distance. There appears to be a bay with fishermen out in their boats, and the curved horizon, made up of mountains and the sails of boats, is at the upper edge of the composition. Very few prints by this Shunkō are known to exist. His skill, however, is thoroughly attested to by this one.

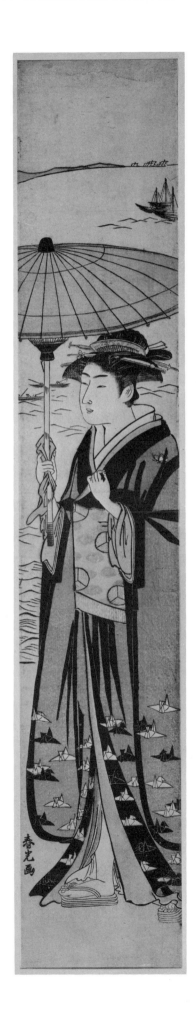

80

Katsukawa Shunei, 1762–1819 and Katsukawa Shunchō, act. 1780–1795
AN ACTOR AND TWO WOMEN WALKING
Ōban, nishiki-e, 12⅝″ × 9″
Signed: *Shunchō Ga* (left), *Shunei Ga* (right)
Nelson-Atkins Gallery, Kansas City, Missouri (Nelson Fund)

IN DISCUSSING PRINT No. 47, mention was made that it was not uncommon for *ukiyo-e* artists to join together to produce a work. Such is the case here, representing the collaborative effort of two of Shunshō's finest pupils, Shunchō and Shunei.

Both of these artists were very talented and I personally regret being able to include but a single example in which Shunchō's hand is involved. He was active in the 1780s and 1790s and is reported as having been deeply influenced by artists other than his teacher. Thus, in studying his work one is aware of a greater delicacy and refinement than found in Shunshō. He also turned early in his career from the portrayal of actors and instead followed the print trend being developed by Kiyonaga, Nos. 88–96, and Shunman, Nos. 98–102. In fact, biographers often mention that at one point in his career he switched allegiance from Shunshō to Shunman, even changing the *Shun* character in his name to that used by his newly found idol. He made use of a number of names during his career, including Shien, Tōshien, Kissadō, Yūshidō, and Kichizaemon. His prints most often depict rather lithe and happy men and women placed in graceful and beautifully executed settings. Not only did he produce single sheets, but also sets, diptychs, and triptychs. The color he used was often pastel-like which aided in making his figures look fragile.

The two girls on the left are by Shunchō. They appear to be a courtesan and a maid. The former carries a fan and wears a light pink striped kimono tied with an arabesque-and-coin-patterned red obi. The latter, her maid, has her hair piled up on her head in a knot almost as though she had just come from a bath. She holds her hand to her chin and wears a pink checked robe tied with a *sayagata*-patterned black and white obi. Also about her waist is an apron with a red band, but of green fabric decorated with white cherry blossoms. Both of these girls faintly resemble those of Kiyonaga.

The courtesan talks to what appears to be an actor, although he may be a *wakashū*. His hair is upswept and twisted on his head much like that of the maid. A traditional cloth covers the shaved portion, and its light brown color is the same as that of his *haori* on which is placed a fan-shaped crest. Under this robe he wears a summery black gauze *kasuri*-patterned robe tied with a red and yellow obi. He also holds a fan and rests his right hand à la Napoleon inside his robe. Being male, his features are stronger and his eyes wider open. The actor is the work of Shunei.

As a prominent pupil of Shunshō, Shunei rapidly rose in the ranks of the Katsukawa school. He was born in Edo in 1768 and was originally of the Isoda family and called Kyujirō; however, he also used the pseudonym Kyutokusai. Shunei followed the style of his teacher much more closely than did Shunchō for he primarily produced actor prints. His figures have a great deal of personality, though at the same time they are calmer than those of his teacher. Included in his work are bust-length portraits, and his style is felt by some to have influenced that mysterious figure Sharaku, Nos. 122–127, as well as Toyokuni, Nos. 146–148. His biographers report him as a man who loved to paint, recite, and play the *samisen*. He died in 1819 and was buried in Edo. Both artists joined efforts in this print to produce a handsome and effective design.

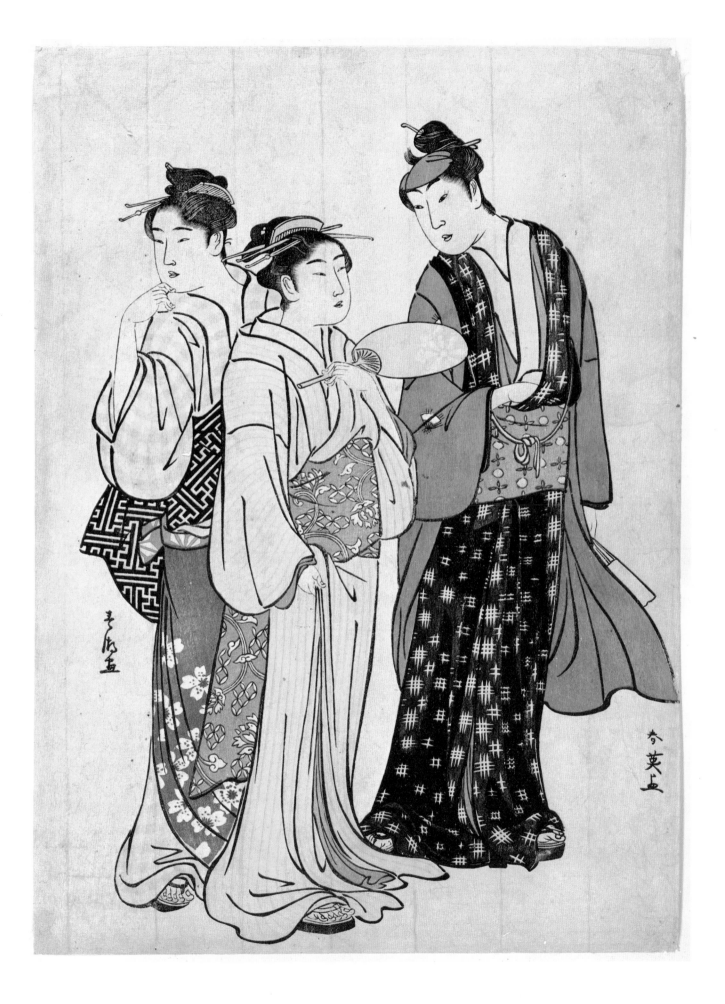

81

Katsukawa Shunei, 1762–1819
THE ACTOR NAKAMURA NOSHIO II(?)
Aiban, nishiki-e, 12⅞″ × 8⅞″
Signed: *Shunei Ga*
Publisher: *Yamashiroya*
Mr. and Mrs. Richard P. Gale, Mound, Minnesota

SHUNEI PRODUCED A NUMBER of bust-length portraits, and one of the simplest, freshest, and most beautiful is this print. While in the Ledoux collection the subject was identified as being the actor Nakamura Noshio II. In truth there is no way of identifying the figure, and scholars today tend to believe it is Iwai Hanshirō. In the compendium of prints titled *Ukiyo-e Taisei* (The Complete Ukiyo-e), Vol. VIII, plate 229, a similar figure wearing the same robe appears and is listed as Hanshirō. The reason for this is not given and one must be cautioned that errors are not uncommon.

The actor leans in at waist level from the right corner of the sheet with his head placed at the center. There is much blank space surrounding him, and to contrast with the natural white color of the paper used for the face, head cloth, collar, and snow, Shunei had a soft tone printed for the background. The effect is subtle and beautiful and the actor appears noble. He is obviously performing a female role and wears in his hair a yellow comb and pins. The forehead is covered with a white *tsunokakushi* (horn concealer) cloth lined with red, which was part of traditional wedding attire meant to hide the "horns of jealousy." The outer robe is of a rich green hue, and against this ground is a pattern of snow-laden willow branches. The only other colors are a touch of red of an underrobe at the left shoulder and the simple yellow obi. The design is uncluttered and one feels the presence of a fresh breeze. The beautiful color and sympathetic cutting of the block once again point to the close alliance that had to exist between the artist, publisher, engraver, and printer. It is a masterpiece of design.

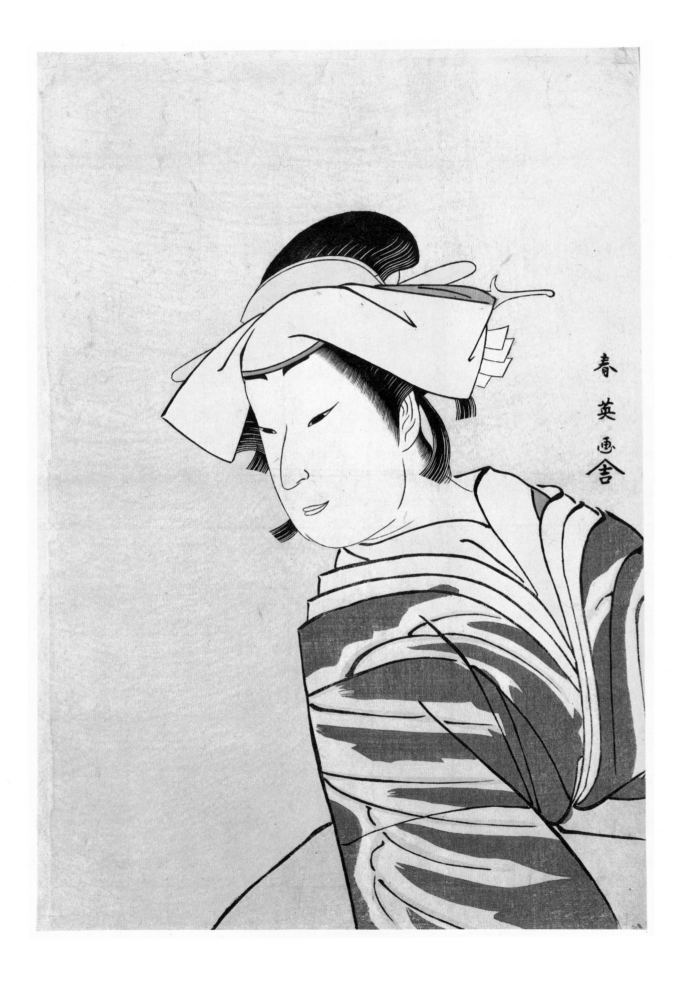

82

Katsukawa Shunei, 1768–1819

THE ACTOR ICHIKAWA MONNOSUKE II AS A CHIVALROUS COMMONER

Hoso-e, nishiki-e, 12¾″ × 5¾″

Signed: *Shunei Ga*

Censor's Seal, Publisher's Seal: *Tsutaya Jūsaburō*

Metropolitan Museum of Art, Rogers Fund, 1936 (Mansfield Collection)

A DEVICE OFTEN USED BY SHUNEI in his *hoso-e* was to have the branches of trees dip into the print from above. In this instance it is autumn and the leaves are red as Shunei depicted the actor Ichikawa Monnosuke II standing beside a bench placed at the side of a stream. The ground and bench are yellow and the stream blue. Once again the artist tinted the background sky so that it contrasts with the natural paper tone used for the face.

Ichikawa Monnosuke is believed to have been born in 1743, and he died in 1789. He started his career in Osaka; however, later moved to Edo, where he became a student of Ichikawa Danjūrō IV and called himself Ichikawa Benzō. He also was adopted by Ichikawa Monnosuke I and later acceded to his title. Monnosuke II appears with the same long and slight-ly hooked nose common to all the Ichikawa group. He is shown costumed as an *otokodate* (a chivalrous commoner), a rather Robin Hood-like character. He holds a pipe in one hand and attached to his waist is a sword. His robe is of brilliant red and white decorated with cherry blossoms and is tied in front with a green arabesque-patterned sash. Draped over one shoulder is his black *haori* patterned with yellow snow flakes and red plum blossoms. Long strands of hair hang down behind his ears and a ribbon is tied around his topknot. He seems to be a rather dour person with small eyes and downturned mouth. The glumness of his expression evaporates, however, before the brilliant color and wonderfully decorative pattern created by the print.

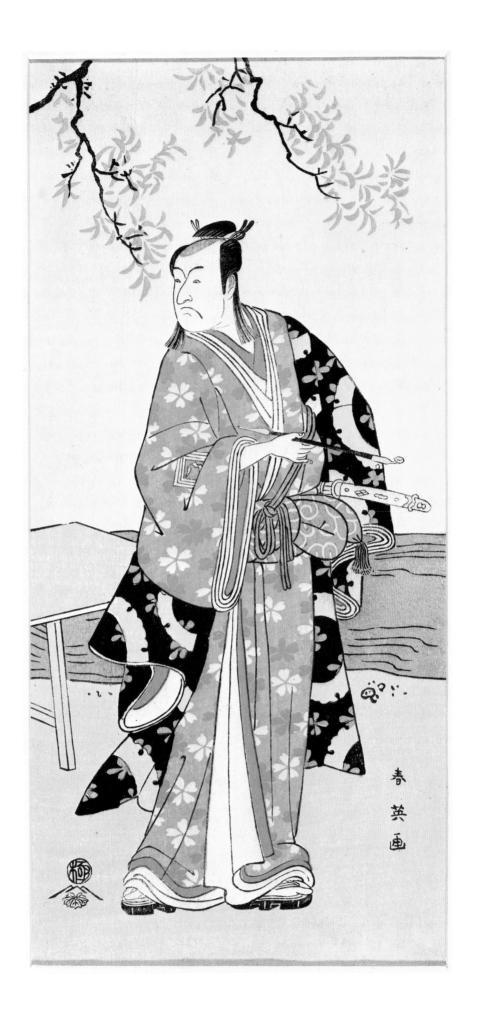

83

Katsukawa Shunei, 1768–1819

NAKAMURA KUMETARŌ II RECEIVING APPLAUSE BEFORE
GOING TO OSAKA

Hoso-e, nishiki-e, 11⅝″ × 5¼″

Signed: *Shunei Ga*

Collector's Seal: *Hayashi Tada[masa]*

The Art Institute of Chicago

A VERY UNUSUAL DESIGN CREATED by Katsukawa Shunei is this print showing the actor Nakamura Kumetarō II, who was raised to that title in 1784, bowing on the stage of the Nakamura Theater as he receives applause. It is a rare theme, and from the arrangement of the figures one is almost led to believe that it may have been but one sheet of a larger composition. The actor is seated on the stage and leans forward as he bows. He is shown as a young man who had been trained to perform female roles. His feminine underrobe has long flowing sleeves bearing his paulownia crest and is flower patterned. Over this he wears the traditional *kamishimo* garment worn by samurai and performers. It consists of pleated ankle-length trousers called a *hakama* and an upper loose jacket with stiff broad shoulders that project out from the side of the body. He clasps the top of a folded fan in one hand and wears a sword. On his head is a cloth used to conceal the shaved portion and in his hair is a comb and pin. Though but few lines were used in delineating his features, the actor appears moved by his warm reception. He responds in both gratitude and respect for his audience. The backdrop hanging behind him is the familiar curtain of the Nakamura Theater.

Shunei has cleverly linked the actor to his applauding claque. Only their shoulders and heads are shown as their hands move through the air. Kumetarō's sleeve curves over the edge of the stage and downward to them. They all wear on their heads scarves decorated with his crest. One is thus not certain as to whether they are employees, paid demonstrators, or a fan club. Only two of the figures have their hands raised; whereas the third and central one is shown in profile and appears to be scanning the audience. Kumetarō appeared in the eleventh month of 1790 in a *kaomise* (face-showing) role used to welcome the introduction of the theatrical season. It is this play that is believed shown. It was called *Sayo-no Naka-yama Hiiki no Tsurugane.*

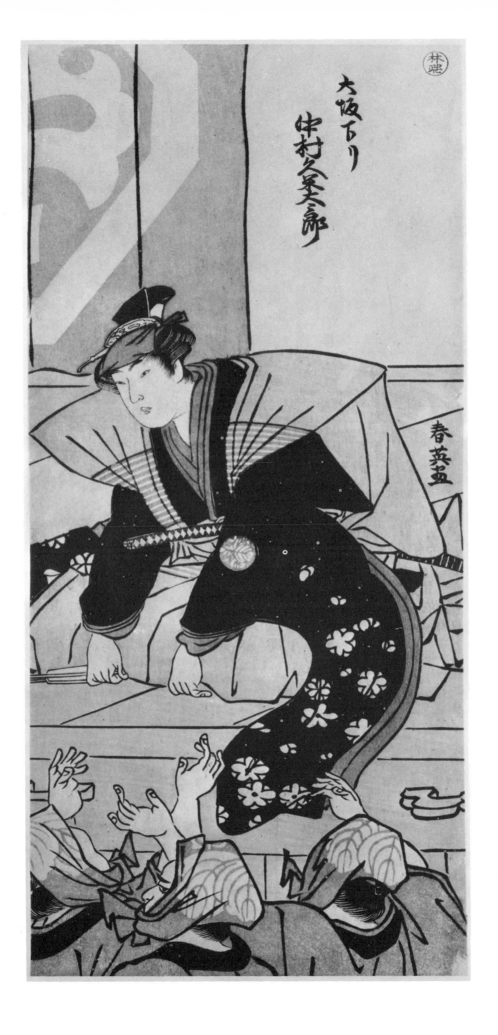

84

Katsukawa Shunei, 1762–1819

AN ACTOR AS SADAKURŌ

Ōban, nishiki-e, 14⅜″ × 9⅝″

Signed: *Shunei Ga*

Publisher's Seal: *Iwatoya Kisaburō*

Collector's Seal: Carlotta Maybury

Achenbach Foundation for Graphic Arts,

California Palace of the Legion of Honor, San Francisco

(Deposit of the M. H. de Young Memorial Museum)

SHUNEI PRODUCED A NUMBER of designs which, though never catalogued as a series, all have a common theme and in truth belong together. These are the *ōban* prints of single actor figures, all representing characters from the *Chūshingura* (Tale of the Forty-seven *Rōnin*). They are shown without any setting and Shunei once again had the area surrounding the figure colored to contrast with the natural paper color used for the actor's face. Each of these designs is very strong and it is very difficult to identify without question not only the performers but also the roles they portray. The play for this print appears to be that titled *Kana Tehon Chūshingura* (The Japanese Syllabary Example of the Chūshingura). It was a very popular vehicle and was revived a number of times. Louis V. Ledoux, in his *Japanese Prints of the Ledoux Collection, Sharaku to Toyokuni*, No. 35, reports that a performance of the play was given at the Morita-za in the third month of 1788; and Richard Lane, in his notes on prints Nos. 139 and 140, published in James A. Michener's *Japanese Prints from the Early Masters to the Moderns*, mentioned another performance in the fifth month of 1795 at the Kawarazaki-za.

The actor is shown wearing an undergarment resembling winter underwear tied at the wrists and ankles. Over this he wears a shin-length robe which appears to be lined, telling us that the season is winter. It is decorated with a pattern consisting of alternating groups of two and three triangles set in a row. His obi is tied in the back and his hands are crossed before him and placed in his sleeves. His neck is bent at a most awkward angle as he looks downward to the left. The actor's forehead is unshaven and his hair is rather unruly. It is the style normally associated with a figure on the Kabuki stage who has been ill and unable to shave his head or has become a *rōnin*. The actor's features are distinctive, for his nose is large and curved, resembling that of the Danjūrōs' but not quite as long and hooked. His eyes are wide open and his mouth is downturned in a morose expression. Its angle is almost the reverse of his left eyebrow and the two act as a frame for his eyes and nose.

The actor has been identified in the past as being Morita Kanya in the role of Okaru. No crest is placed on the robes to aid us in identifying the figure, but obviously something is wrong; it certainly is not that role. Okaru was a female figure in the *Chūshingura* who, though the wife of Hayano Kampei, served as the mistress of Ōishi Kuranosuke, chief of the *rōnin*. Few things could be further from a feminine portrayal. In all likelihood the print actually represents the role of Sadakurō portrayed respectively by Nakazō at the Miyako-za in the fourth month of 1795, Danjūrō at the Kiri-za in the same month and year, and by Torazō at the Kawarazaki-za in the fifth month of 1795. A positive identification remains open.

[174]

85

Kitao Masanobu, 1761–1816

THE ACTOR MATSUMOTO KŌSHIRŌ IV

Hosoban, nishiki-e, 12½″ × 5¼″

Signed: *Kitao Masanobu Ga*

Publisher: *Okumura*

Philadelphia Museum of Art, Given by Mrs. Anne Archbold

A VERY VERSATILE AND GIFTED MAN, Kitao Masanobu was the creator of this print. In Japanese history he is most noted as a popular novelist and composer of *kyōka* (comic odes) who signed his work Santō Kyōden. He had great literary talent and evidently found it both a more enjoyable and lucrative profession than that of illustrator. One, however, must not feel great concern over his financial status, for K. Masanobu, as he is commonly called to distinguish him from the earlier artist of the same name, also ran a profitable shop that sold tobacco pouches and pipes. He was born in 1761 into the Iwase family and lived in Kyōbashi, Ginza, Itchome. With Masayoshi and Shunman, Nos. 98–102, he was one of the ablest pupils of Kitao Shigemasa. He started producing book illustrations in 1778 when only seventeen years old, and most of his creative work in the print endeavor ended in the early 1790s, for from that time on he devoted most of his effort to writing. His literary name, Kyōden, is a composite of the area of his residence, Kyōbashi; his shop name, Kyōya; and another name, Denzō. K. Masanobu early in his career appears to have struck up a close acquaintance with the great publisher Tsutaya Jūzaburō. Although

we cannot discuss the artist's literary achievement here, his endeavor in prints was crowned by an album produced in 1784 titled *Yoshiwara Keisei Shin Bijin Awase Jihitsu Kagami* (A New Selection of Beautiful Yoshiwara Courtesans and Mirror of Their Writing). No examples from this album are shown for it is a quasi-literary work and in original state appeared in book form.

The print shown here is a single sheet on which K. Masanobu has portrayed the actor Matsumoto Kōshirō IV. He wears a scarf tied about his head and raises his outer robe with one hand as he rests his other on the handle of his sword. The outer robe is white with a pattern of gingko leaves and flowers. His underrobes are blue with white stripes and red. Kōshirō IV appears about to go into action for he has removed his sword arm from the encumberment of the white robe. Masanobu placed the figure in the center of the sheet and made use of a setting. Behind Kōshirō IV are three bunches of tied rice stalks, and to the left is the trunk of an old tree and branches. He stands before a rice field and the harvest has already been reaped. The color is fresh and serves as a unifying force to this strong composition.

86

Utagawa Toyoharu, 1735–1814

USHIWAKAMARU SERENADING JŌRURI-HIME

Ōban, yoko-e, nishiki-e, 10¼″ × 15⅛″

Signed: *Eshi Utagawa Toyoharu*

Publisher: *Matsumura Yahei*

Philadelphia Museum of Art, Given by Mrs. John D. Rockefeller

AN ARTIST CALLED TOYOHARU WAS BORN in 1735 who was destined to become the founder of the Utagawa school, producing such able masters as Toyohiro, as well as Toyokuni, Nos. 146–148, and his pupil Kuniyoshi, Nos. 160–163. A great deal of confusion exists as to the birthplace of Toyoharu; Toyooka and Usuki as well as Edo are all listed. His early life remains a mystery; however, some scholars feel that he studied the Kanō style of painting with a rather obscure artist, Tsuruzawa Tangei. Wherever he spent his youth, he was active in Edo in the 1760s. There appears to have been a link with the artist Toriyama Sekien (1712–1788), and both produced votive panels. He also is mentioned as having been influenced by Toyonobu, Nos. 35–40, as well as Shigenaga, No. 34. We cannot, however, establish a clear relationship with any of them. Toyoharu produced many prints and book illustrations and, in addition to these, was noted for his painting and sense of color. He was thus asked to help in the redecoration of the Tōshōgu shrine at Nikkō in 1796 by the Shogun. This was a task usually assigned only to the academic artists of the Kanō school. Toward the end of his life Toyoharu took the tonsure, and after a successful career died in 1814.

Among the most notable achievements of Toyoharu was the *uki-e*, which he brought closer to perfection following the early attempts of Kiyoharu, No. 33, and Masanobu, Nos. 29–30. This print is an example. In the upper right it is titled *Uki-e Jūnidan Kangen no Zu* (A Perspective Print, No. 12, a Picture of an Orchestra). It shows Ushiwakamaru, the name given to Minamoto Yoshitsune when he was a youth, serenading Jōruri-Hime. The story is related in the *Jōruri-Hime Monogatari* (Tale of Princess Jōruri). Yoshitsune and his brother, Minamoto no Yoritomo,

spent their lives in attempting to revenge the death of their father, Yoshitomo, at the hands of the Taira clan. The scene illustrated in this print, however, is one of romance. Ushiwakamaru was captivated by the beauty of Princess Jōruri; thus, he traveled to Ōshū and appeared one evening at her gate accompanied by a servant who squats beside a lantern. It was evening, and as he played a tune on his flute Jōruri-Hime heard the sound. She was seated inside her handsome villa playing the *koto* along with seven other female musicians using many of the instruments familiar to the *Gagaku* (court ceremonial music). Jōruri-Hime could resist his serenade no longer and dispatched her maid to find out who was playing. As a result he spent the night and she fell desperately in love with him. Ushiwakamaru then journeyed to Fukiage no Hama where he became ill, and upon hearing this Princess Jōruri rushed to his aid and nursed him back to health. In the Art Institute of Chicago a print by Utagawa Toyonobu exists, No. 25.2870, in which a portion of the Toyoharu print is reproduced as a votive panel before a shrine.

The space is well treated. In the foreground is the outer gate and a fence with chrysanthemums in bloom, indicating that it is autumn. Stepping stones lead back to the verandah of the villa with its sliding doors pushed back to reveal the orchestra and interior. To the right there is a handsome garden and in the rear are the additional halls of the villa. The figures, foliage, and structures diminish as one's eye retreats into the picture. The setting is one of great beauty and charm, clearly illustrating Toyoharu's skill with color. Autumnal tones prevail with soft red, orange, yellow, and green dominating. The moon in its warm silvery sky bathes this idyllic scene.

浮繪十二段管絃の圖　繪師 歌川豐春　版元　松村弥兵衛

87

Utagawa Toyoharu, 1735–1814

FOXES' MARRIAGE PROCESSION

Ōban, yoko-e, nishiki-e, 9³/₁₆″ × 13¼″

Signed: *Utagawa Toyoharu Zu Nari*

Publisher: *Iwatoya Gempachi*

Nelson-Atkins Gallery, Kansas City, Missouri (Nelson Fund)

ANOTHER EXAMPLE OF UTAGAWA Toyoharu's skill at producing *uki-e* is this print showing a parody of a wedding procession with all the participants foxes. The theme is the same as that in the Harunobu wedding ceremony series, No. 49; the deep central perspective with the architectural elements leading us to the background should remind us also of the Masanobu, No. 29. The fox appears often in Japanese legend, and one story relates how a fox named Kuzu-no-ha fell in love with a warrior and spent many happy married years with him. Light seen in the marsh areas at night is called fox fire and is said to symbolize the torches lit for their wedding. The tales are of magic and so is the setting that Toyoharu used to illustrate one of them. The legend to the right of the print reads *Uki-e Kitsune no Yomeiri* (A Perspective Picture of the Foxes' Wedding Procession).

It is a night scene, and the striking deep black sky is filled with stars which twinkle and add to the excitement of the joyous occasion. The gates of a noble villa are open, and in the foreground the bride's palanquin and procession of attendants proceed up the walk to the home of the groom. His attendants and servants bow in welcome while the groom waits on his porch clad in formal robes to receive the bride. It is a festive scene and they all smile. Their lanterns are decorated with the gate symbolic of the *inari* (fox) shrines, and the male robes bear symbols of the fox fire (a flaming jewel like that used in Buddhist iconography); whereas the female robes are entertainingly decorated with autumn grass and fox traps. In the rear portion of the villa seen in the distance, shadow figures are reflected on the *shoji* as they prepare to make the bride welcome.

The print is a complex one and a great design. The sky contrasts with Toyoharu's usual muted red, yellow, orange, and brown hues. It appeals with charm and humor as well as beauty. It is a continuation of the Japanese love of nature and animals as seen in the Fujiwara and Kamakura period handscrolls of the twelfth and thirteenth centuries. Surely this print has brought joy to many of all ages and lands.

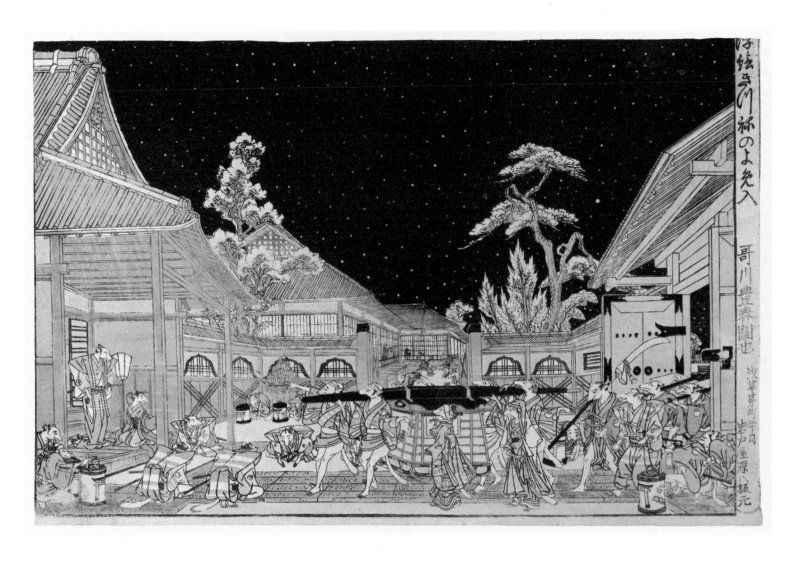

88.

Torii Kiyonaga, 1752–1815
Series: JIJO HŌKUN ONNA IMAGAWA
 (Onna Imagawa: Precious Precepts for Girls)
A PRODIGAL SON
Chūban, nishiki-e, 9¾″ × 7½″
Signed: *Kiyonaga Ga*
Publisher: *Ise-ji*
Nelson-Atkins Gallery, Kansas City, Missouri (Nelson Fund)

THE WORK OF FEW ARTISTS OF THE UKIYO-E school has been as carefully documented as that of Torii Kiyonaga. All scholars in this field of study owe a great debt of gratitude to Miss Chie Hirano who, with great patience and accuracy, catalogued over a thousand designs by this great master. How wonderful it would be if all of our print artists could be treated in the same manner. Alas, too little is known about most of them and not enough of their work survives to make this possible. We all dream of the day when new discoveries and insights will light the many dark corridors we pass through, permitting us to terminate much speculation and correct or verify past research.

Torii Kiyonaga was born in 1752 and died in 1815. His real name was Sekiguchi Ichibei and he was the son of a bookshop keeper called Shirakoya Ichibei. Kiyonaga dwelt at Moto Zaimoku-chō, though he later moved to Honjo Bamba-chō. He was a pupil of Kiyomitsu and went on to be elevated and adopted by the Torii family as their fourth-generation representative. His production of actor prints commenced in the early 1770s and flowered in the 1780s. The work of Kiyonaga is rather distinctive. Design and grace were key elements and he imparted a feeling of calm and ease to most of his prints. They are beautifully decorative, the result of the artist's composition, draftsmanship, and fine sense of color. As a result, figures rarely seem excited or deeply emotional. There is a general similarity of types rather than individuality. An examination of his work points to the strong influence of Harunobu, Koryūsai, and Shigemasa. We can also see in it parallels to the work of Shunchō. Kiyonaga's figures were somewhat taller than those of the earlier masters, and were dressed in the height of fashion and wore the coiffure in vogue during the late eighteenth century.

A series by Kiyonaga that appears originally to have been designed to contain twenty-five prints is that titled *Jijo Hōku Onna Imagawa* (Onna Imagawa: Precious Precepts for Girls). These were didactic of

nature and meant to serve as an illustrated guide to morals and etiquette. Thirteen of the designs seem to have survived and all of these are concerned with types of behavior to be avoided. The theme ultimately is derived from a fourteenth-century work by Imagawa Ryōshun composed for young men. The *Onna Imagawa* by Sawada Kichi appeared in 1700 as the feminine version of the earlier work. The sixth precept, commonly titled "The Prodigal Son," depicts a man seated beside a bed. His light blue robe with paulownia crests is patterned with white polka dots. He holds a packet of tooth powder in one hand as he brushes his teeth with the other. His hair is not carefully groomed, indicating that he has just risen. Seated before him is a young *kamuro* whose robe is patterned with phoenix feathers. She rests one hand on his ankle, possibly in an attempt to delay his departure. A courtesan wearing a white night robe tied with a yellow obi and with a checked purplish *uchikake* stands beside him. In her hand she holds a packet of paper. Immediately to her left a second *kamuro*, bearing a bowl on a tray, is standing on the verandah about to enter the room. Her kimono is patterned with a *shippō* design. It is a gray morning and outside the slatted window rain can be seen falling. Although it is quite obviously a busy scene, the figures seem relaxed.

The title of the series is placed in the cartouche to the right. Beside it, in a cloud-like bank resembling the *chūban* prints of Harunobu, is the precept. One cannot improve on the reading and translation given by Miss Hirano in her book *Kiyonaga*, page 350:

> *Fubo no fukaki on o wasure kō no michi
> orosoka ni naru koto*

> *A woman who forgets how much affec-
> tion she owes to her parents does
> not pay it back with gratitude*

It is rather difficult to explain without question the relationship of the illustration to the precept.

89

Torii Kiyonaga, 1752–1815

TWO ACTORS CELEBRATING THE FESTIVAL OF THE SHRINE OF THE SOGA BROTHERS, May 1788

Ichikawa Monnosuke II (right), Segawa Kikunojō III (left), One of five prints

Hoso-e, nishiki-e, 12¼″ × 5½″

Signed: *Kiyonaga Ga*

Nelson-Atkins Gallery, Kansas City, Missouri (Nelson Fund)

FEW STORIES PROVIDED MORE THEMES for the theater than the tale of the revenge of the Soga brothers, Sukenari and Tokimune. They were the sons of Itō Sukeyasu, who had been killed by Kudō Suketsune, the displaced Lord of Izu Province, in 1177. Following Sukeyasu's death, his wife married Soga Sukenobu and he adopted her two sons. While still children they determined to destroy their father's murderer. They gained protection from Hōjō Tokimasa, who had been appointed governor of Kyoto by Minamoto no Yoritomo, and continued to plot their revenge. One day in 1193 while Yoritomo was absent hunting they entered his camp, confronted Suketsune, and put him to death. As a result of this, they also forfeited their lives. The legend that grew from this historical event has been magnified and the brothers have become permanent heroes of loyalty, perseverance, and filial respect.

A gathering was held at the Kiri-za theater in May of 1788 to celebrate the festival of a shrine dedicated to the Soga brothers. To mark this event Torii Kiyonaga produced five prints containing thirteen figures. The five sheets, although an overall design, may also be viewed individually and each is good. The sheet shown here is the fifth when the set is viewed from the left. In it the actor Segawa Kikunojō III is shown seated on a bench, holding a pipe. As he portrays *onnagata* (female) roles, the shaved portion of his scalp is covered with a cloth. His nose is straight and

his small mouth is partly open. His outer robe is faded; however, originally it was blue with large white butterflies and plover in a reserve pattern. Under this he wears a white robe decorated in smaller scale with the same pattern in red. About his waist is a chrysanthemum-patterned obi. The standing figure at his side is Ichikawa Monnosuke (Nos. 77 and 82) who wears similar robes and holds a yellow-edged fan in his hand. His nose is long and curved, and in the Ichikawa tradition his mouth is downturned. Both actors wear their crests which are repeated on the two pink paper lanterns that hang above them. Also crossing above their heads are swags of white drapery on which are placed large crests of the Kudō family. They consist of a house-shaped elevation containing a decorative floral motif. Whenever this crest is seen, one is assured that the play is of the Soga revenge. The composition should remind us of the pyramid-and-needle arrangement seen in Nos. 13 and 18. Kiyonaga's sense of color was great and although faded the print remains one of great beauty.

The other sheets in the series, reading from the left, represent the following actors:

1. Arashi Ryūzō and Ichikawa Komazō
2. Ōtani Tokuji and Azuma Tōzō
3. Ichikawa Danjūrō V and Ichikawa Ebizō
4. Iwai Kumesaburō (later Hanshirō VI), Iwai Hanshirō V, and Yamashita Mangiku

90

Torii Kiyonaga, 1752–1815

THE JŌRURI PLAY OMINAESHI SUGATA NO HATSUAKI

Ōban, nishiki-e, 15⅜″ × 10⁵/₁₆″

Signed: *Kiyonaga Ga*

Publisher's Seal: *Nishimura*

Nelson-Atkins Gallery, Kansas City, Missouri (Nelson Fund)

A GREAT NUMBER OF THE THEATRICAL prints produced by Kiyonaga not only depict actors but also the supporting performers, such as the chanters and the musical accompanist. This is especially true of a group illustrating various *Jōruri* performances. The one shown here is that titled *Ominaeshi Sugata no Hatsuaki* (An Early Autumn Figure of a Prostitute Flower). The characters read *ominaeshi* refer to a plant called *Patrinia Scabiosaefolia*; however, they also may be read *jorō hana*, literally prostitute flower, and certainly it is this latter meaning which was intended in the title.

One of the most noted names taken by courtesans of fame was Takao, and it is the Takao reigning in 1788 who is represented standing here, played by the actor Sawamura Sojūrō III. He was born in 1753 as the son of Sojūrō II and became a pupil of Ichikawa Yaozō III. When his father died in 1770 he was cared for by Arashi Mitsugorō and the following year was acclaimed Sojūrō III; he died in 1801. Takao's symbol was the maple leaf, and the robe and obi worn by Sojūrō III are patterned with these. Takao raises her hand concealed inside her sleeve and looks at Ukita Sakingo, her lover, played by Matsumoto Kōshirō IV, No. 85. On the ground a love letter burns and the scene is said to show the appearance of Takao's ghost. Ukita Sakingo, who is seated on the ground with one knee raised and the other bent, unrolls a hanging scroll and shows it to the spirit. It contains a portrait of an earlier-day Takao as can be determined by the maple-leaf patterned robe and pre-1770s hair style. The painting is symbolic of Sakingo's devotion to his beloved even though she be dead. The Torii pyramid-and-needle composition is utilized again by Kiyonaga in presenting the two actors. Behind them is a bamboo fence and a mat-covered dais. Placed on it is a red carpet, and three additional figures important to the play are shown seated upon this. From left to right are the two chanters identified respectively by Miss Hirano as Tomimoto Itsuki-dayū and Tomimoto Awa-Tayū. Their robes appear to be white, and over this they wear green striped *hakama* and stiff black gauze *kataginu*, which are worn like jumpers and project from the shoulders. The *samisen* accompanist, who wears a white robe under a black *haori*, has been identified as Sasaki Ichishirō. Once again Kiyonaga's beautiful and passive treatment of an active scene is evident. It leaves the viewer with the feeling that the artist loved design more than action.

91

Torii Kiyonaga, 1752–1815

Series: CHAMISE JIKKEI (Ten Views of Teahouses)

RYŌGOKU

Chūban, nishiki-e, 10¼″ × 7½″

Signed: *Kiyonaga Ga*

Publisher's Seal: *Eijūdō*

Museum of Fine Arts, Boston, Francis Gardner Curtis Fund

KIYONAGA PRODUCED TEN PRINTS in 1789, each dedicated to a noted teahouse. These were Shitaya, Yushima, Kinryūzan, Tomigaoka, Shinmei, Nakasu, Takanawa, Gotenyama, Ryōgoku, and Yagenbori. It is the one located at Ryōgoku along the Sumida River that is shown. This was also the site of a famed bridge connecting the left and right banks of the Sumida.

The artist has actually depicted very little of the teahouse. One can only see bamboo fences and benches with a smoking set resting on one of them. All of this is raised above river level and protected by a stone wall. Rather than show the teahouse, Kiyonaga elected to depict two geisha about to embark in a small boat for a trip down the stream. One holds on to the prow of the boat as she stands on a stone, about to step aboard. The boat is roofed, with only an edge of this showing, and in its bottom rests a pair of *geta* probably belonging to the boatman. The second figure, holding a folded umbrella, waits her turn to enter as she daintily raises her robes to protect them from the water. It is summer and both of the girls wear gauze outer robes over their kimonos. Their sleeves sweep smoothly backward indicating a breeze and action. At the same time, the clean sweep is typical and symbolic of Kiyonaga's unruffled style. Nothing is hurried; the boat is not about to depart, and one moment or ten minutes will not matter. They are delicate figures though sturdier than those of Harunobu, whose influence, however, cannot be denied. Thus, in the work of Kiyonaga we return once again to a world of beauty and an ideal life.

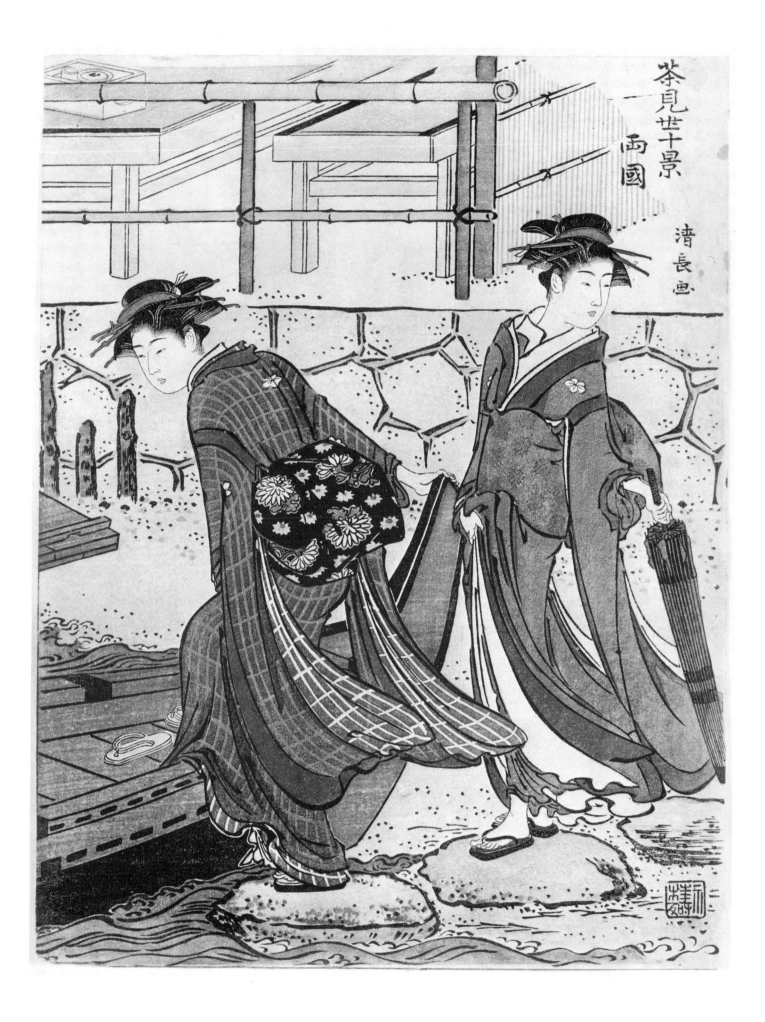

92 93 94

Torii Kiyonaga, 1752–1815
VISITORS TO ENOSHIMA
Triptych, ōban, nishiki-e
92: 13¾″ × 9½″, 93: 13⅞″ × 10¼″, 94: 13¾ × 10″
Signed: *Kiyonaga Ga* (each sheet)
Publisher: *Nishimura*
Collector's Seal: *Hayashi Tada[masa]*
Museum of Fine Arts, Boston, Nellie P. Carter Collection

ONE OF THE MANY BEAUTIFUL triptychs produced by Kiyonaga is that showing a group of visitors who have paused at a teahouse at Katase just opposite Enoshima. It is a very successful design and once again, although the sheets connect in terms of composition, each is meritorious enough to stand alone. The Japanese print artists were brilliant in achieving this goal and they brought harmony to the separate parts and unified them. The relative standardization of block sizes must have done much to encourage this, for the artist's maximum sizes were established, and though he would create an overall composition, he also kept in mind the fact that each part would be carved on a separate block.

Enoshima is a lovely rocky island, clad with pines, located in Sagami Bay. It is close to the town of Kamakura and because of its association with the deity Benten has always been popular. It is this goddess who is believed to have created the island from the sea bed. Visitors came to it not only because of its scenic beauty and proximity to Edo, but also to visit Benten's shrine. It is this verdant island that appears in the background of each print. The other popular landscape element which graces the triptych is Mount Fuji, which rises in snow-covered majesty on the far right sheet. Oddly enough, the season appears to be summer.

The three prints from left to right are as follows:

92. A woman wearing a black gauze robe with a white *kasuri* pattern and a large umbrella-shaped traveling hat has stopped beside a hillock. She braces her hat with her hand against the breeze, while another young lady, wearing a white *yukata* patterned with iris blossoms, stoops to tie her sandal. In the background two men have stopped on the beach to watch and chat with three figures bathing in the rough surf. Enoshima crops up in the middle of the bay and on the distant horizon the sails of five boats can be seen.

93. A simple palanquin with straw matting for a roof and a red carpet tied in place as a cushion and back support rests on the ground. Seated in it is a woman dressed in a light salmon-colored robe, who holds a pipe and converses with a squatting woman who wears a white robe and holds a tobacco pouch. The luggage for the journey is tied up in a *furoshiki* (a cloth wrapper) and rests on the roof of the vehicle. Behind the squatting woman is a fisherboy, who has a band tied about his head and wears a deep red *haori* and blue loin cloth. He is speaking to a young man dressed in a blue *yukata*, who has been bathing and is drying his ear with a towel. At the water's edge four other male figures converse and on the distant shore of Enoshima the houses of the village can be seen. Kiyonaga has miraculously placed approximately twenty Lilliputian inhabitants in the setting.

94. The composition is pyramidal and echoes the shape of Fuji in the background. One girl leans on the pole used to support the palanquin. Her purple-and-white striped robe is slipped off one shoulder, revealing a bright red underrobe. She also dries her face with a towel. The central woman wears a blue paulownia-patterned robe tied with an orange obi, decorated with yellow chrysanthemums or peonies. She fans herself and glances at the third woman who is seated on a bench at the beachside teahouse, busily adjusting her hat. Her *yukata* is white decorated with purple roundels and tied with a red tile-patterned obi. Beside her rests her walking staff.

The total effect of the print is one of great ease and happiness. It is not difficult to understand how the inner calm and beauty of Kiyonaga's work reached out not only to influence Japanese artists such as Utamaro, but later also Western artists such as Whistler.

95

Torii Kiyonaga, 1752–1815

MINAMOTO SHIGEYUKI EXECUTING CALLIGRAPHY

Ōban, nishiki-e, 14¾" × 9⅝"

Signed: *Kiyonaga Ga*

Publisher: *Nishimura*

Philadelphia Museum of Art, Given by Mrs. John D. Rockefeller

ALL FACETS OF LIFE MUST HAVE fascinated Kiyonaga and he expended effort to document his hometown, Edo. He almost appears to be reporting news, for he captured in prints some of the curiosities of his day and through them the viewer is privileged to learn much about life in late eighteenth-century Japan.

A theme that especially caught the artist's interest was the genius of children who, at a tender age, had mastered the difficult art of beautiful calligraphy. In a number of prints he separately depicted a young girl, Gyokkashi Eimo, age nine, and a boy, Minamoto Shigeyuki, age six, demonstrating their mastery of writing. It is the latter, the boy, who is shown in this handsomely preserved print. Kiyonaga shows us the interior of a shop which appears to be one that sold a panacea called Manō. A chest stands to the rear of the print and its open drawers bulge with envelopes filled with this medicine. Standing on top of the chest, in addition to the brushes placed in holders, is a small framed single-panel screen on which the name of a medicine is inscribed, Manō-maru, as well as the location of the main store, east of the castle in Kōfu. Hanging from the lintel above this is a signboard only partially visible, which Miss Hirano read as *Eijuken*, and she reported it as being the name of the shop.

Along the right edge of the print is a panel written by the precocious youngster, Shigeyuki. Next to it hang three large brushes and inscribed on the wall is a statement which reads *Demise Asakusa go monzeki mae nite urihirōme mōshi soro* (Branch store located before the gate of the Asakusa Higashi Honganji, where this item is sold). The six-year-old genius is seated on the floor with his writing implements before him. He leans forward as he writes the character *kotobuki* (also read *ju*), meaning felicitations and long life, as well as those read *yama chi*, a thousand mountains. A woman whose obi pattern matches that of the boy's short-sleeved coat is seated beside him and watches. As the patterns are the same, some scholars have interpreted her as being his mother. Standing behind them is a young man who wears a green-striped *hakama* and black kimono. He has just hung up two recently completed calligraphies to dry and his hand still rests on one which is filled with references of longevity, "A crane dances in a thousand-year-old tree." On his kimono he also has a crest read *kotobuki*, and thus he may well be the owner of the so-called *Eijuken* shop. Though this is likely, I would also suggest that it is subtle advertising for the miraculous medicine which since it cures all brings *kotobuki*, long life.

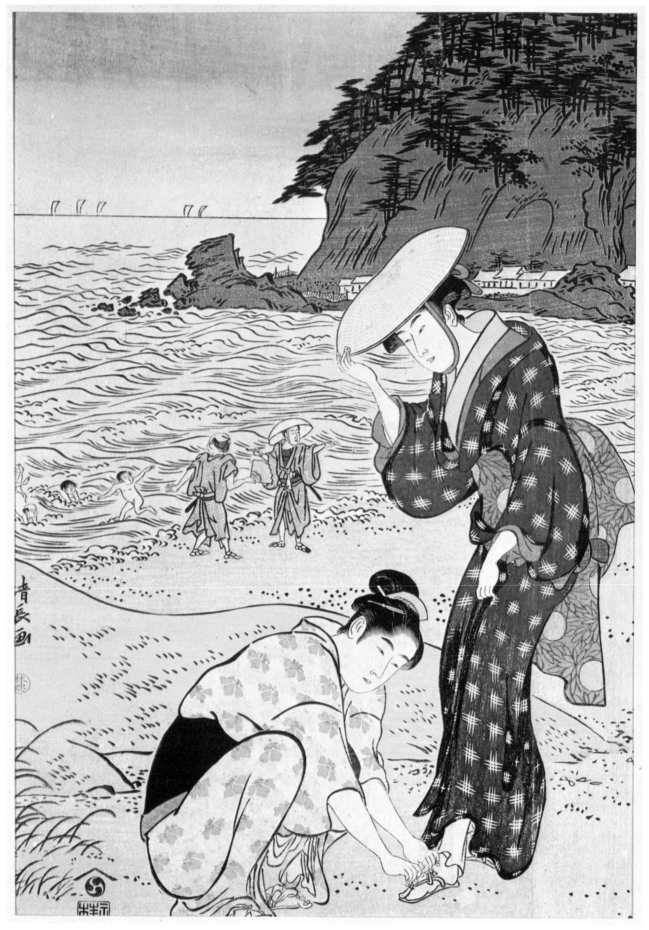

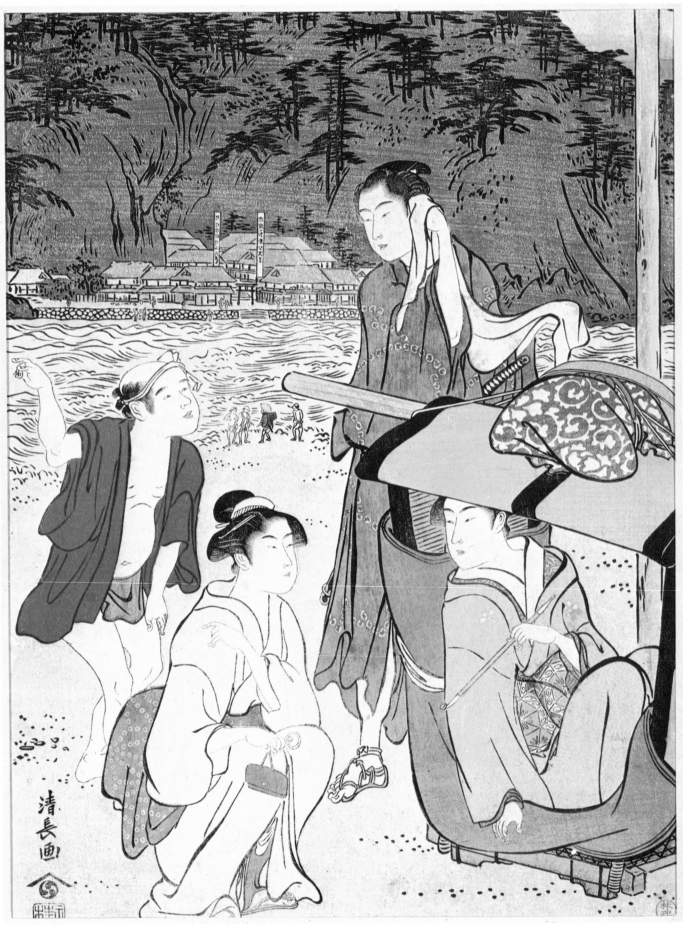

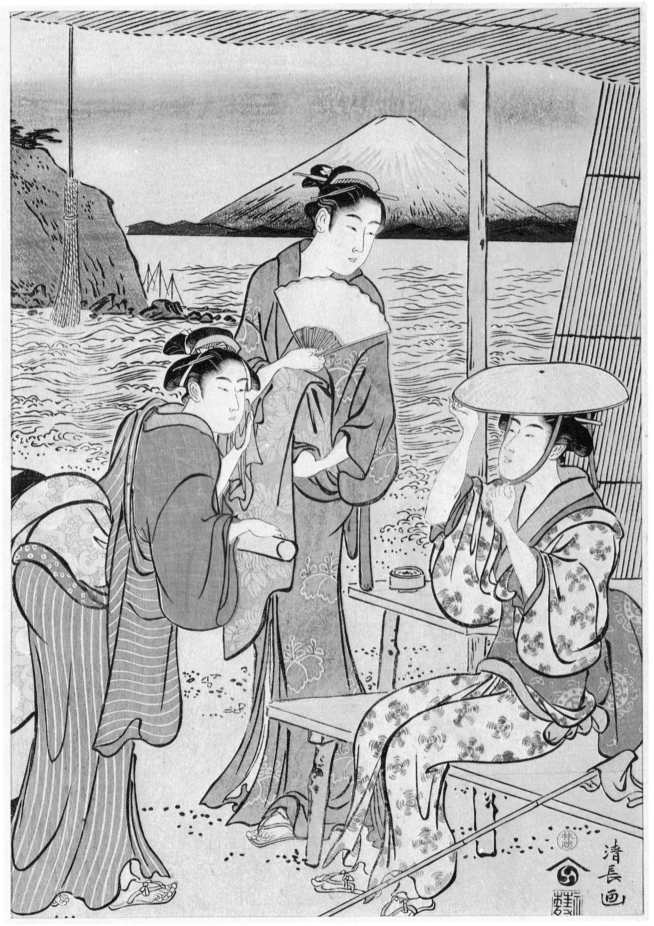

94

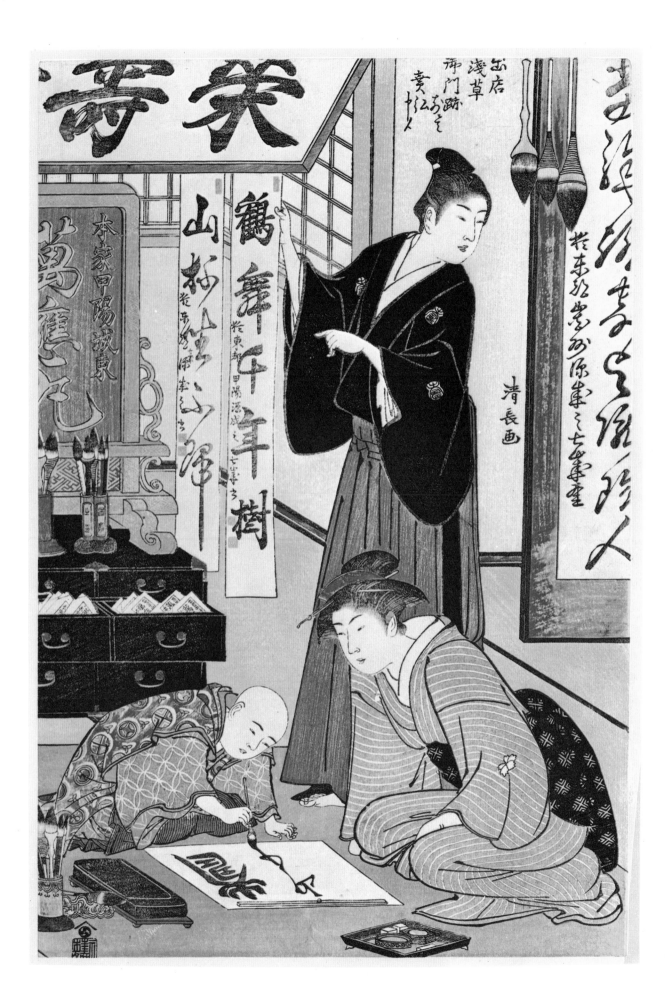

96

Torii Kiyonaga, 1752–1815

Series: TŌSEI YŪRI BIJIN AWASE (A Contest of Fashionable Beauties of the Licensed
 Quarters); NAKASU NO SUZUMI (Cooling off at Nakasu)

Ōban, nishiki-e, 14½″ × 9¹³/₁₆″

Signed: *Kiyonaga Ga*

Collector's Seal: *Hayashi Tada[masa]*

Achenbach Foundation for Graphic Arts

California Palace of the Legion of Honor, San Francisco

ARTISTS SUCH AS KIYONAGA FOUND that representations of the beauties of the Yoshiwara had great appeal and especially when gathered together into sets. The men who purchased prints tended to lionize these girls and the sheets of paper served as both a memento of what they had attained or what they dreamed of. This print is an example of such a series and shows the most fashionable beauties of the licensed quarters. According to Miss Hirano, it represents a group cooling off in a room at a restaurant in the Nakasu district. She felt that the lantern and calligraphic panel at the top of the print indicated this. Unfortunately, the conclusion would be difficult to defend, for not enough of either of these elements is visible on any of the impressions viewed to validate Miss Hirano's contention, and I leave it under this title only out of respect for her sholarship and a feeling that perhaps other information was available to her.

A rather tall courtesan is represented standing.

She holds a round fan in one hand and rests the small finger of the other on its edge. A poem which praises Hyakuen (Danjūrō V) in the role of Kagekiyo, in which he often appeared, is written on the fan. Her kimono is simple, with a modest pattern at its bottom, and is tied with a brocaded obi. It is summer and the lightweight quality of her kimono is indicated by the underrobe showing through. On her sleeves and shoulders her kimono carries her crest, consisting of a portion of three blossoms set in a roundel. Seated beside her is another girl who is tuning a *samisen*. She wears a floral-patterned robe tied with an obi containing phoenix-shaped roundels. Before her is a folded black *haori*, role of paper, and the instrument's plectrum. Slightly behind her sits a young man who wears a *kasuri*-patterned kimono. In his right hand he holds a pipe and in a rather lovestruck way looks at the girl beside him. Kiyonaga cleverly linked the three figures through their costumes and glances.

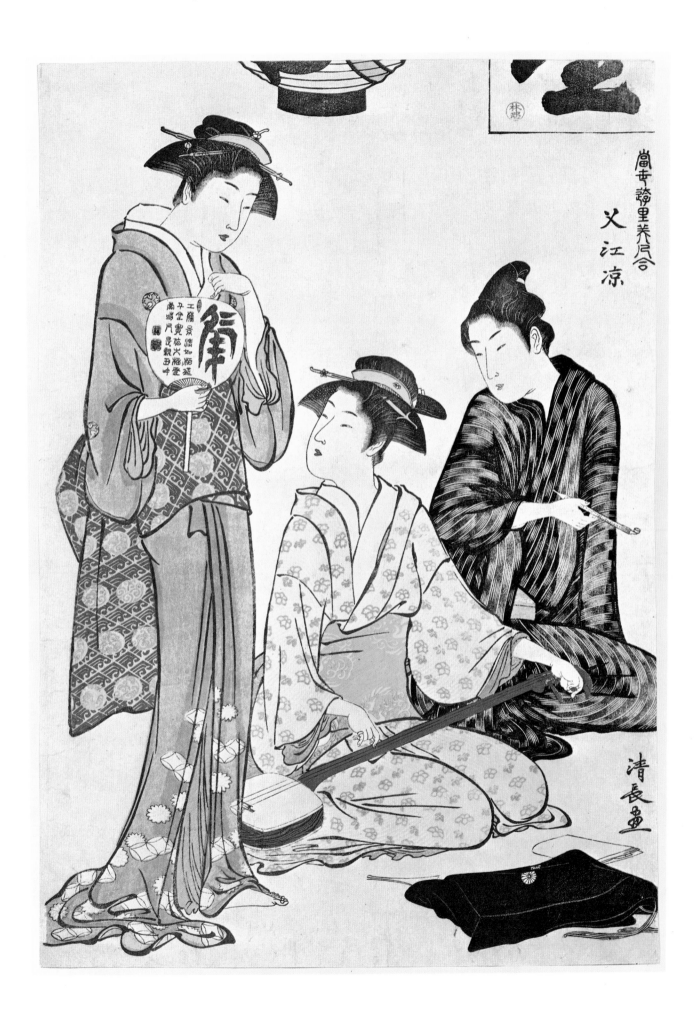

97

Enkyō (Kabukidō), 1749–1803

THE ACTOR NAKAMURA NAKAZŌ II AS MATSUŌMARU

Ōban, nishiki-e, 14³/₁₆″ × 10½″

Signed: *Kabukidō Ga*

Mr. and Mrs. Richard P. Gale, Mound, Minnesota

THERE ARE A GREAT NUMBER OF mysteries that confront the researcher studying *ukiyo-e* prints. Some of these deal with proper identification and iconography, whereas others concern artists of great skill who produced few prints and worked for a very limited time. One of these unusual masters was the man now called Enkyō, who is also known as Kabukidō. There are but seven prints that can be definitely assigned to his hand and these are all believed to have been executed in the span of but a year, 1794–95. It is because of the proximity in time and the caricature-like bust-length actor portraits he produced that Enkyō and Sharaku are sometimes considered to be one and the same. The only biographical data we have is based on an article by Ochiai Naonari, in the periodical *Ukiyo-e no Kenkyū*, No. 17, 1926. In this publication Ochiai claims that Enkyō was in truth the dramatist Nakamura Jūsuke, who was born in 1749 and died on the twentieth day of the ninth month of 1803. This dramatist is reported as having produced a lengthy essay on the theater titled *Shibai Noriai Banashi* (Theater Talks).

All of Enkyō's prints are striking. In this one he shows the actor Nakamura Nakazō II in the role of Matsuōmaru, probably from a performance of the play *Sugawara Denju Tenarai Kagami* (The Teaching of the Secrets of Sugawara's Calligraphy). Nakazō II's features very closely resemble those of the Ichikawa family actors. His nose is beak-like and his hair is peculiarly brushed out to the sides. As Matsuōmaru he wears a hat on his head, carries a covered lance, and is clothed in a checkered robe. His mouth is but a single slashed line and the pupils of his eyes seem to press against the bridge of his nose, making him very cross-eyed. The actor's crest on his right shoulder resembles the letter "h" repeated three times in a row. It actually is derived from the type of crest used to signify the chapters of the *Tale of Genji*. The entire treatment of the actor should remind us of Shunei's actor portraits, such as No. 81. Enkyō was more caustic than Shunei in treating his performers. They completely fill the space of the sheet and appear ready to burst from the paper confines.

It is amusing to note that this man whose crest resembles the initials of Mr. Hubert H. Humphrey now resides in a great Minnesota collection.

[196]

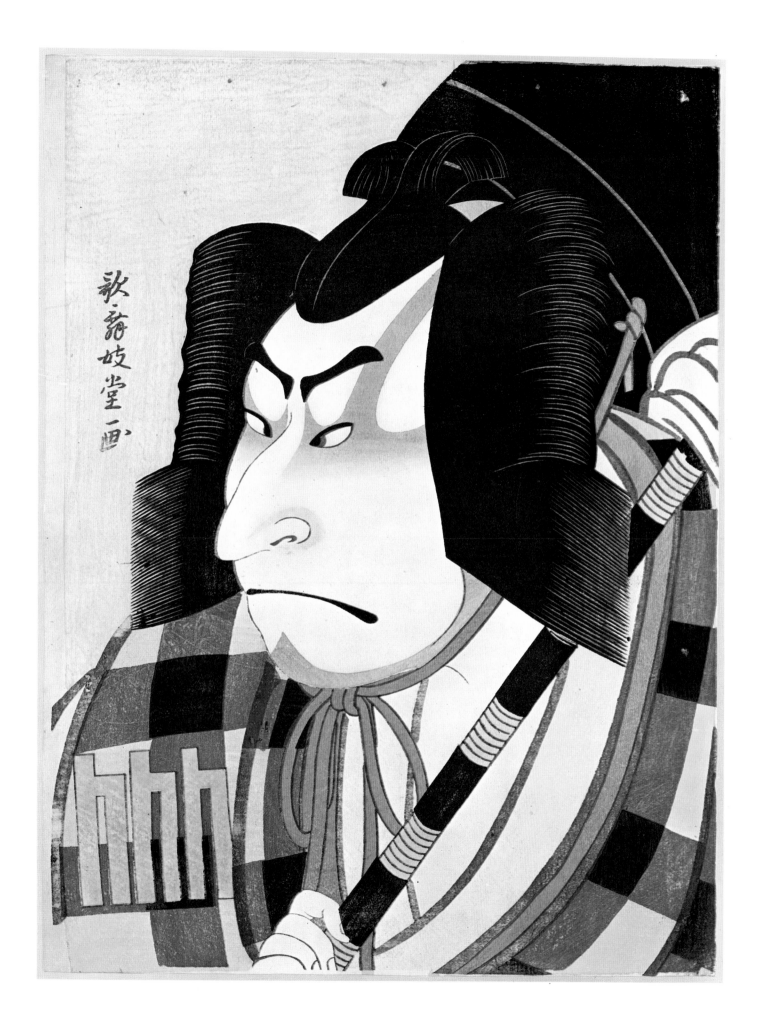

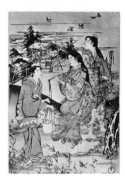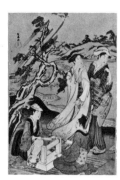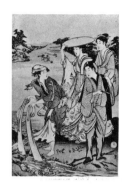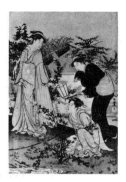

98 99 100 101 102

Kubo Shunman, 1757–1820

Series: THE SIX TAMA RIVERS (five of the set of six prints)

Ōban, nishiki-e

Signed: 98. *Kubo Shunman Ga*, 99–102. *Shunman Ga*

Artist's Seal: *Shunman* (each sheet)

Publisher's Seal: *Fushimiya Zenroku* (each sheet)

Nelson-Atkins Gallery, Kansas City, Missouri (Nelson Fund)

98: The Tama River of Kōya in Kii Province, 15⅛″ × 10⁵⁄₁₆″

99: The Tama River of Noda in Mutsu Province, 15⅛″ × 10⁵⁄₁₆″

100: The Tama River of Mishima in Settsu Province, 14⅞″ × 9⅝″

101: The Tama River of Tatsukuri (Chōfu) in Musashi Province, 14⅞″ × 9¾″

102: The Tama River of Noji in Ōmi Province, 14⅞″ × 10″

IT SHOULD BY NOW BE CLEARLY evident that it is rare to find print artists about whom more than the barest facts are known. Shunman is such a man, and although not an extremely prolific artist, his work is endowed with dignity and is more painterly than that of his contemporaries. His themes were often poetic of nature or based on literature, for he was closely associated with that pursuit as well as art.

Shunman was born into the Kubota family in 1757, although he later abbreviated that name to read Kubo. In his youth he was called Yasubei. His father died while Shunman was still a child. Although his early years are somewhat clouded, we know that he studied painting with the Nanga artist Katori Nahiko (1723–1782), who also was a qualified expert at haiku poetry. Nahiko undoubtedly greatly inspired the young man's interest in literature. It is also believed that he was responsible for giving Shunman his name. After a short while, however, Shunman changed the character he used for Shun, for he wanted to distinguish his work from that produced by the many pupils of Shunshō. Following his period of study with Nahiko, he turned to Kitao Shigemasa (1739–1820) as a source of inspiration. Some of the names he used were Nandakashiran, Kosandō for his *gidayū* (a form of ballad drama), and Hitofushi Chizue as a pen name for his *kyōka* (comic odes). In addition, all evidence points to the fact that he was left-handed and that is why he signed some of his work Shōsadō (in honor of the Left Chamber). Throughout his mature years Shunman maintained close ties with the family of Ishikawa Toyonobu. In fact, they prayed at the same temple. Toyonobu's son, Rokujuen Ishikawa Masamochi (Gabō), was his teacher of *kyōka*, and when Shunman died he was buried on the same site as Toyonobu's family.

One of Shunman's most ambitious, successful, and rare print sets was that titled the *Roku* (or *Mu*) *Tamagawa* (The Six Tama Rivers) first produced about 1787. Six rivers in Japan bear this name, for *tama* means jewel and the streams were all noted for their crystal purity. Other artists had treated this theme; for example, those by Harunobu, such as No. 55, are also of high caliber. Unfortunately, only

[198]

continued on page 306

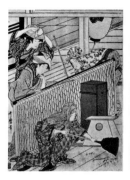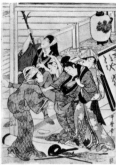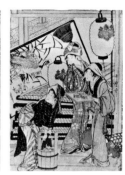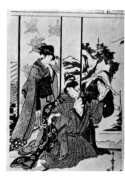

103 104 105 106 107

Kitagawa Utamaro, 1753–1806

HOUSE CLEANING (five prints)

Ōban, nishiki-e, 14³/₁₆″ × 10″ (each sheet)

Signed: *Utamaro Hitsu* (each sheet)

Publisher's Seal: *Yamada* (each sheet)

Nelson-Atkins Gallery, Kansas City, Missouri (Nelson Fund)

FEW JAPANESE ARTISTS HAVE RECEIVED as much acclaim, both at home and abroad, as Kitagawa Utamaro. His name has become synonymous with portrayals of beautiful women, most often of the Yoshiwara and lower classes. He must have loved them dearly, for he made them tower and imparted a sense of majesty to their rather precarious lives. At the same time he was capable of commenting, via scathing designs, on the most intimate, as well as sordid, aspects of their existence. Once again it seems strange that so little is known about an artist who was so skilled and prolific.

The facts about Utamaro's life, especially his early years, are rather hopelessly muddled. It is unlikely that they will ever be unraveled without a major miracle. Theories have him born in Kawagoe, Edo, Osaka, and Kyoto, which would be quite a feat. It is believed that he was called Ichitarō as a child, but he also made use of a multitude of other names, including Yūsuke, Yūki, Nobuyoshi, and Toyoaki. It is believed that it was not until approximately the year 1782 that he commenced using the name Utamaro. In addition to all of these, he also made use of a number of pen names for his poetry and literary productions. One story reports that he was befriended by a successful maker of cauldrons from Tochigi who sparked his career by introducing him to the leading artistic talent of the day. Utamaro met the artist

Toriyama Sekien (1712–1788), and entered his studio. Although Sekien was basically a Kanō school trained artist, he also produced *ukiyo-e* under the name of Toyofusa. Sekien became very fond of Utamaro and as the youth's career progressed, he encouraged him. In 1788 Utamaro produced a magnificent book titled *Ehon Mushi Erabi* (A Picture Book Selection of Insects). Sekien wrote the epilogue for this and in it lauds the young artist. As Utamaro became more intimately acquainted with the bustling city of Edo he turned especially to the Yoshiwara and Shinagawa districts. He left the household of Sekien and moved into a sphere dominated by the personality of the noted print publisher Tsutaya Jūsaburō (1750–1797). During this period his interest appears to have shifted almost exclusively to the Yoshiwara and girls of great charm and beauty, such as Hanaōgi and Wakaume. Utamaro, though fascinated by the licensed quarter, was married and had a family. He was a very prolific artist and the quality of his work was consistently high. Though the theme of beautiful women may eventually have become tiring, he never permitted it to lessen his ardor. His career probably would have continued to climb to new heights had he not run afoul of the government. In 1804 he published a triptych titled *Taikō Rakutō Go Sai Yukon* (The Taikō [Hideyoshi] and His Five Wives Picnicking at Rakutō). This was contrary to the censorship laws

continued on page 307

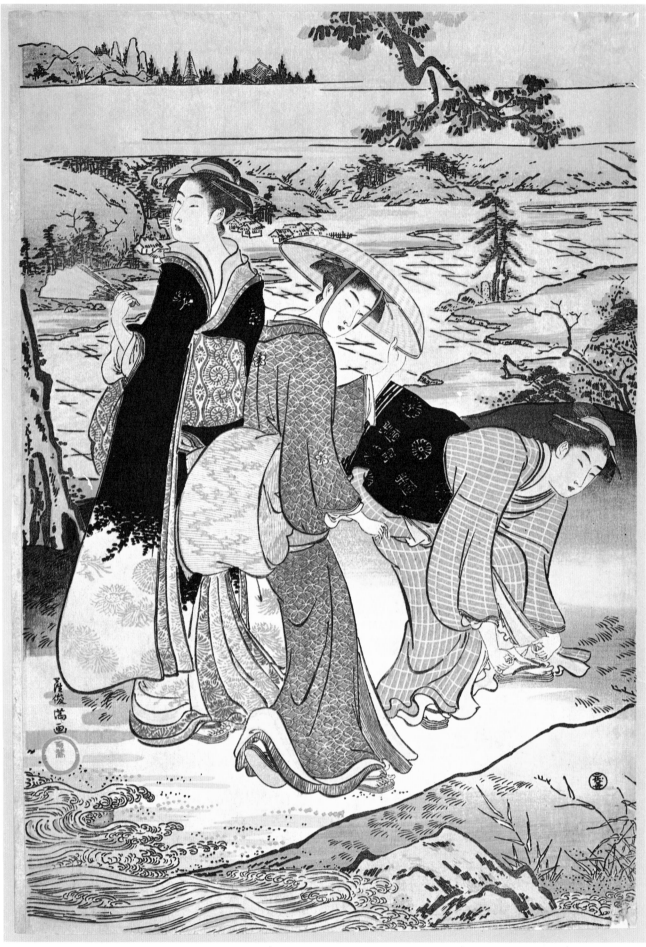

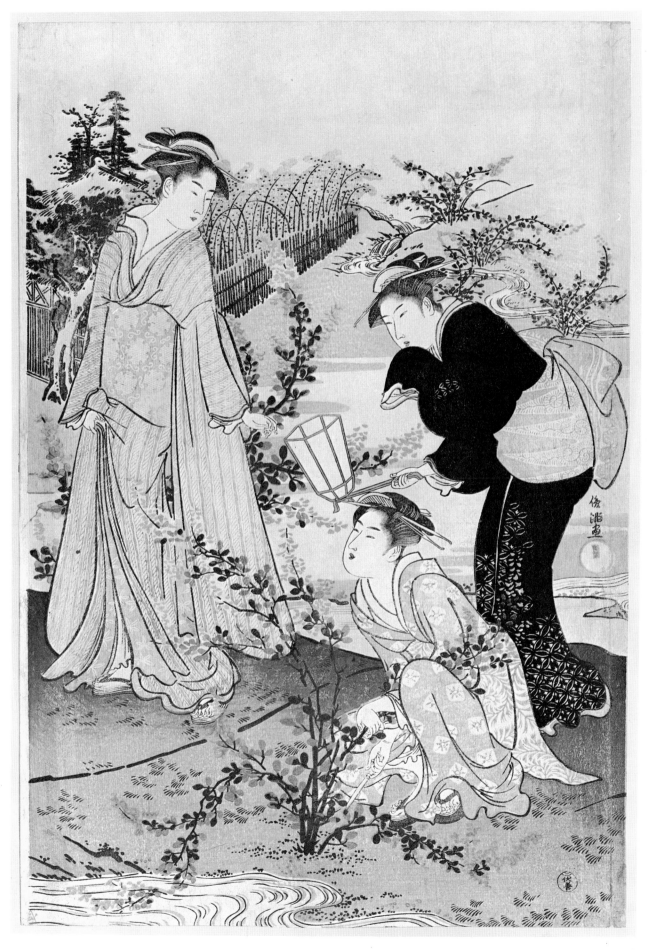

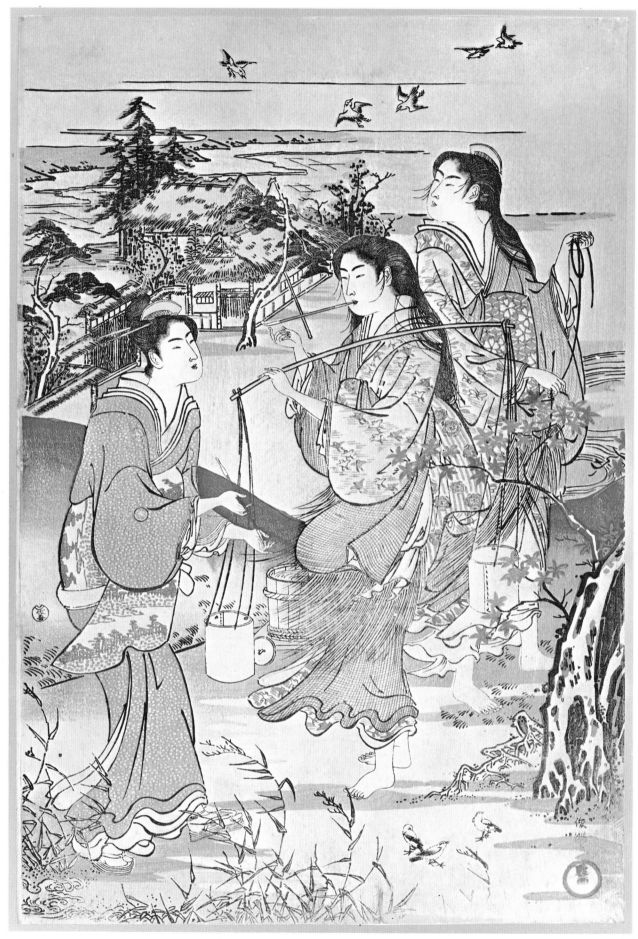

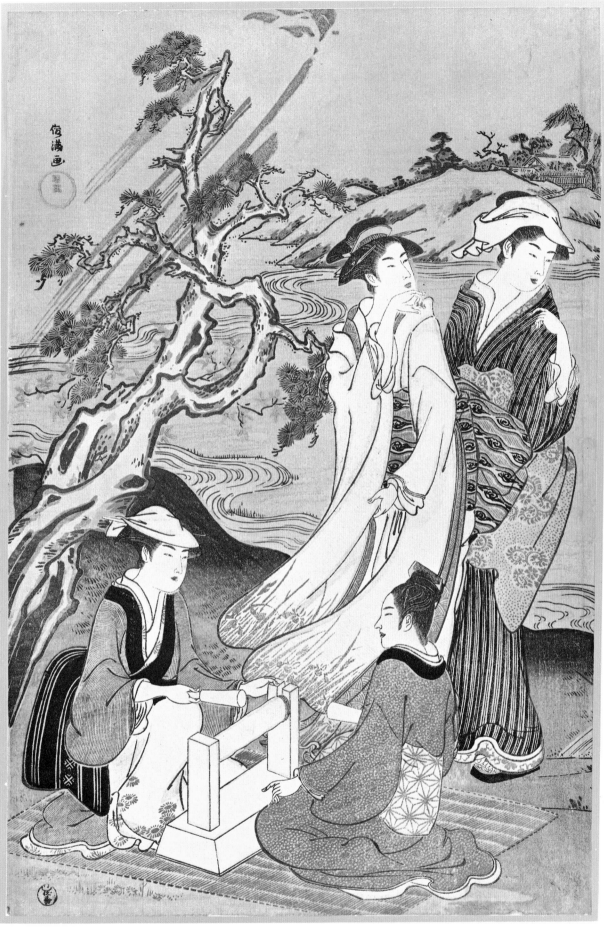

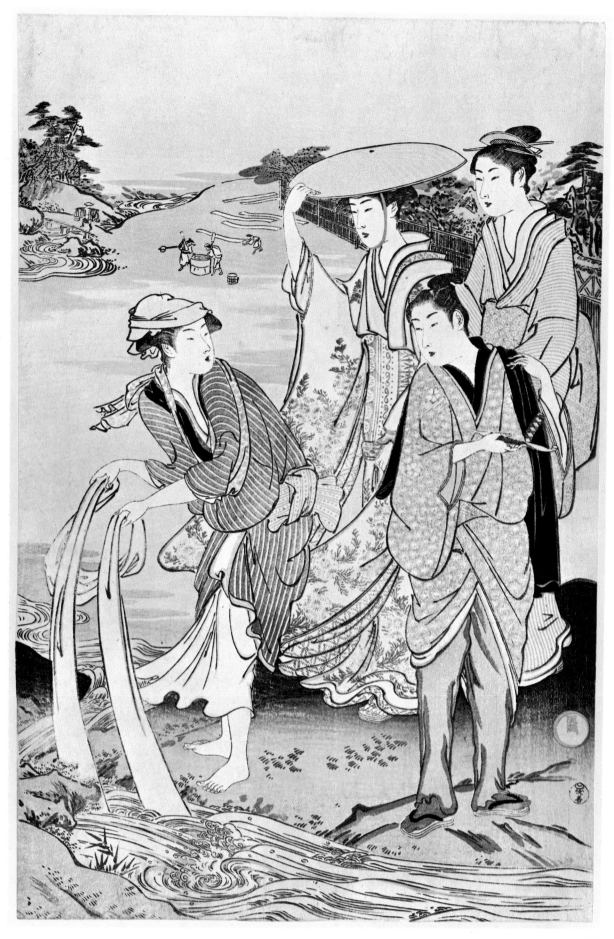

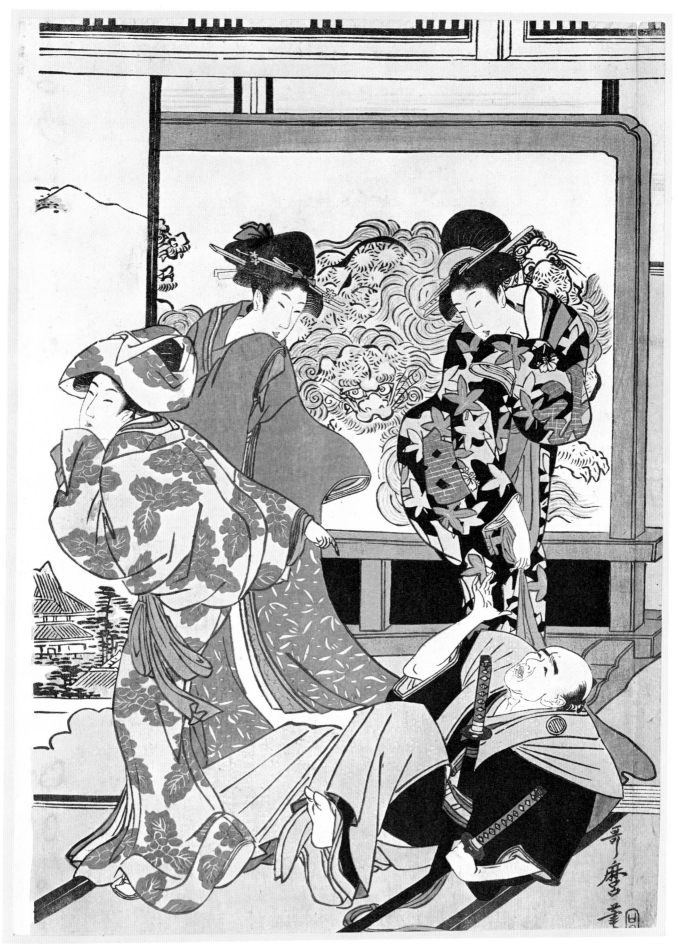

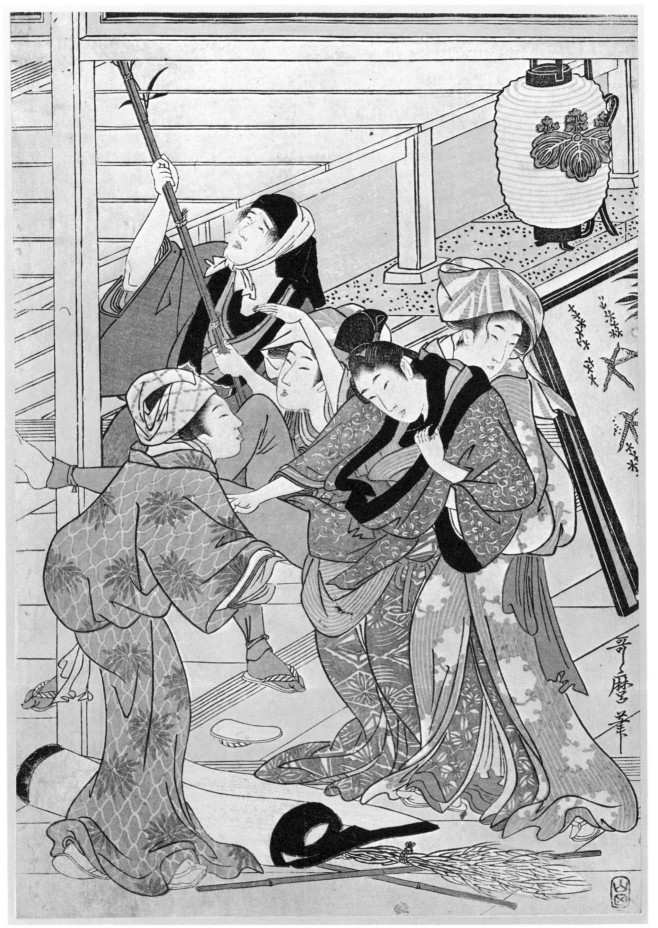

104

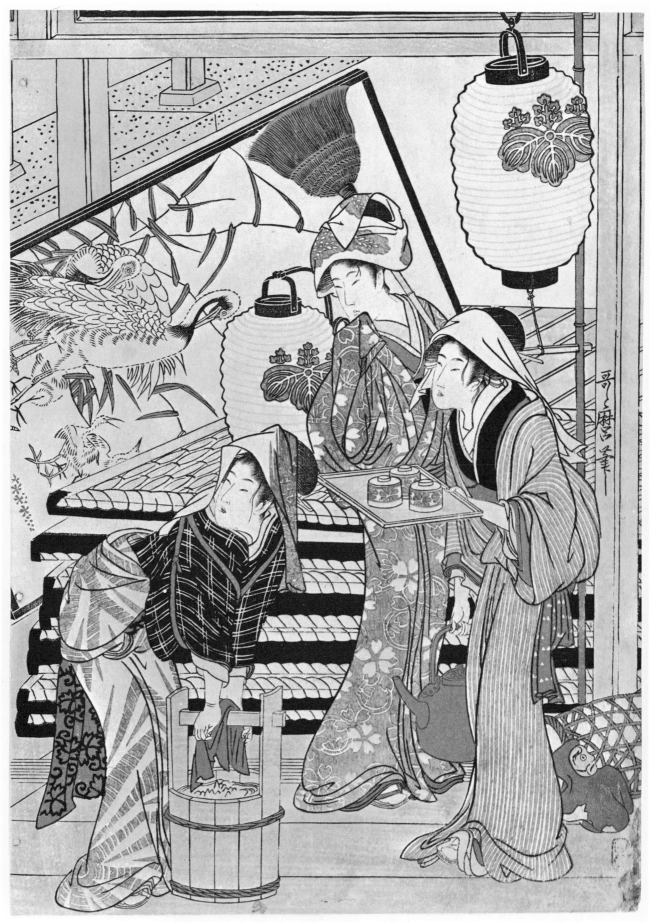

105

106

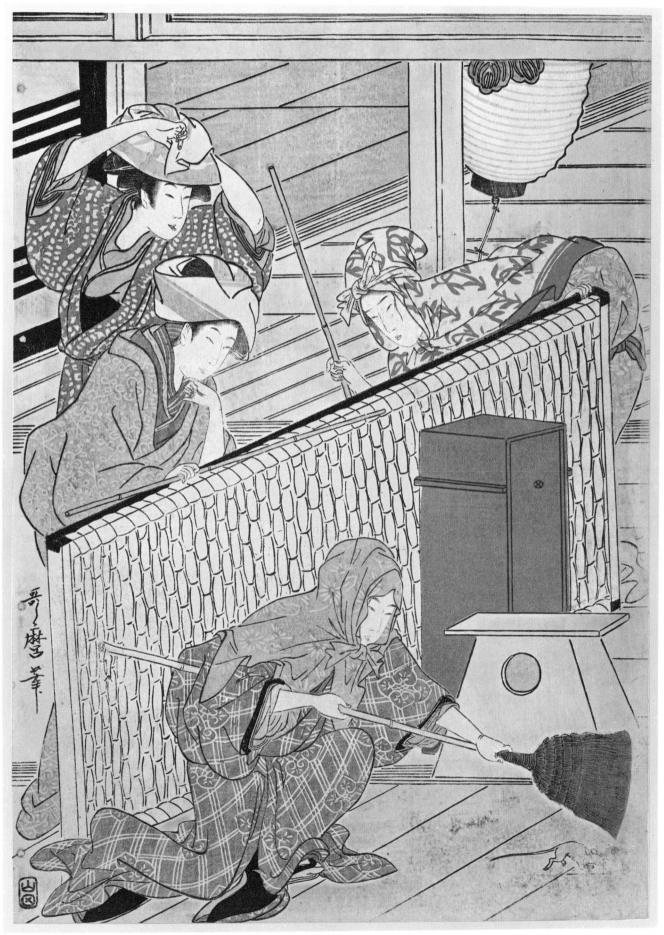

108

Kitagawa Utamaro, 1753–1806
TWO WOMEN
Ōban, nishiki-e, 15⅜″ × 10⅛″
Signed: *Utamaro Hitsu*
Metropolitan Museum of Art, Rogers Fund, 1936 (Mansfield Collection)

UTAMARO DISPLAYED GREAT inventiveness in arranging his figures within the confines of the sheets of paper they occupy. Some of his most successful prints were those that were not concerned with the entire figure, but were bust portraits or heads of the beautiful women he had grown to love and know so well. In this example two women are depicted with their eyes cast downward to the lower left corner of the print. The pearly whiteness of their complexions, their simple features, and black hair immediately capture our attention. They contrast with the slightly colored background. A simple comb and pins elaborate the coiffures, and the standing figure (for one appears to be seated) must have just arisen or come from the bath, for her hair is not elegantly styled. It is twisted into a knot on top of her head and a single pin holds it in place.

The robes of the two courtesans are elegant and beautifully colored. The brilliant orange and yellow obi of the standing figure is dazzling against her black-and-white *kasuri*-patterned robe. The collar of her inner robe is embossed and white and she holds a painted fan decorated with pinks. The seated girl has an unpatterned brown obi and her blue summer robe is of a water-and-reed design. She holds her pipe in one hand and a fan in the other.

This print is considered to be a proof rather than a final design, for about 1790 Utamaro produced a series titled *Bijin Ichidai Gojūsan Tsugi* (The Lives of Beautiful Women Compared with the Fifty-three Stations of the Tōkaidō). The Tōkaidō was the great road that led from Edo to Kyoto and along it were fifty-three post stations which became principal themes for the artists and poets of the age. The title, plus the fifth station name, Totsuka, is usually placed in the upper right corner of this print.

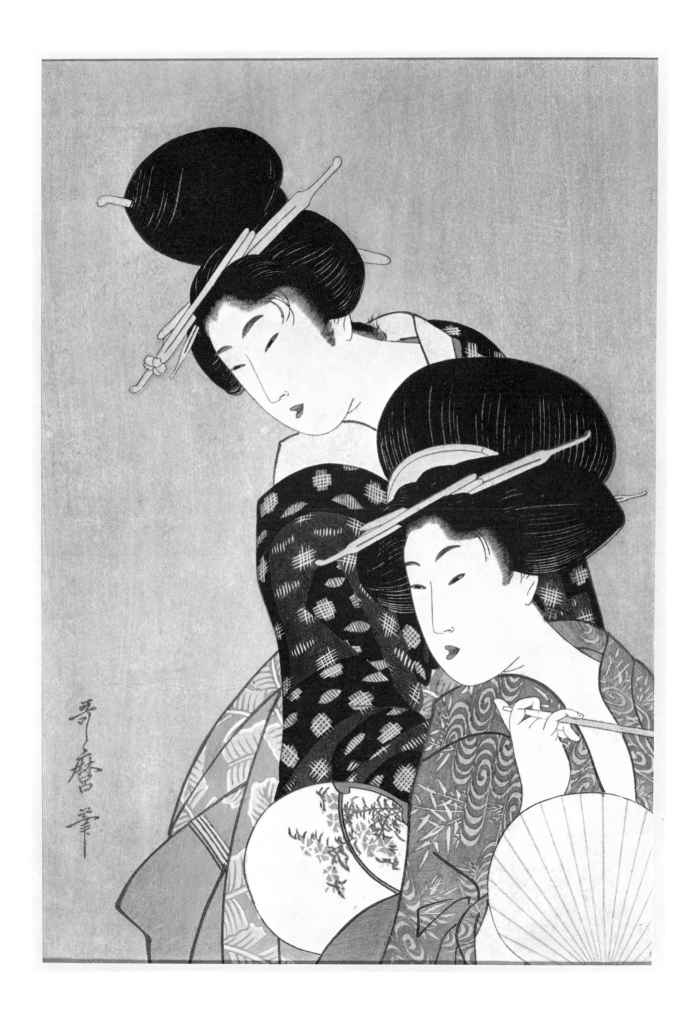

109

Kitagawa Utamaro, 1753–1806

Series: BIJIN HANA AWASE (Beauties Compared to Flowers) HYŌGOYA UCHI
HANATSUMA (Hanatsuma of the House Called Hyōgoya); SAKURA AND NIOI

Ōban, nishiki-e, mica ground, 15¼″ × 10¼″

Signed: *Shōmei Utamaro Hitsu*

Artist's Seal: *Motoie*

Publisher's Seal: *Ōmiya*

Metropolitan Museum of Art, Bequest of Henry L. Phillips, 1940

THE PRINT ARTISTS OF JAPAN started experimenting with the use of *kira* (mica), powdered and applied to paper, from about the mid-1760s. It was not until Utamaro and Sharaku, Nos. 122–127, however, that the technique was both skillfully and widely used. The mica gave the prints extra elegance and made their surfaces glisten as though sprinkled with crystal or silver. It is very likely that its employment was but another step on the path to give greater richness and stature to these inexpensive sheets of paper. Gold and silver foil were too expensive to employ and the government tightly regulated their usage. Gradually more and more people of status began to demand prints and the appearance of mica raised them above those that had gone before. The mica could be used untinted or mixed with red or *sumi* to create a delicate translucent film.

In this print Utamaro has placed the head of a girl

against a mica ground. She grasps a letter and raises it to her eyes to read and its proximity to her face indicates myopia, a common complaint in Japan. Her neck is elongated and its nape, which is considered an area of great beauty in Japan, is handsomely displayed. Her side locks are tied up and her hair is meticulously detailed with lines of the utmost fineness. It is truly a tour de force of the engraver's art.

Though the print represents Hanatsuma, of the Hyōgoya house, who was attended by the *kamuro* Sakura and Nioi from a series of beauties, Utamaro used exactly the same blocks without this cartouche for another set dating about 1789 titled *Gonin Bijin Aikyō Kurabe* (Five Beauteous Lovelies Compared). Utamaro quite often reused and reworked his designs. He was very popular and the demands on his time made this inevitable.

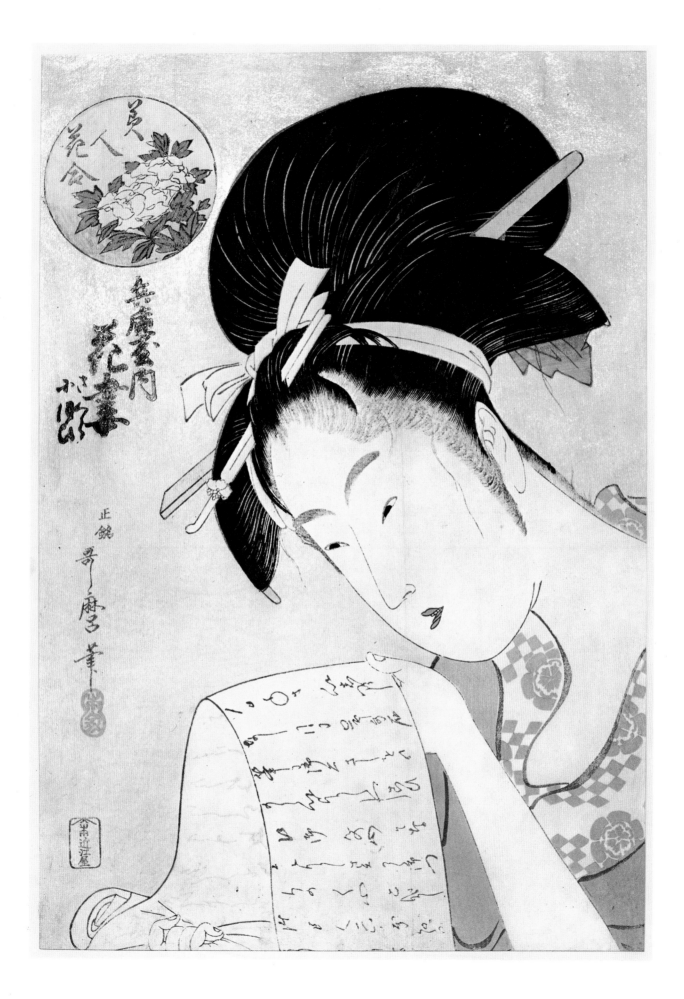

110 111 112

Kitagawa Utamaro, 1753–1806
COOLING OFF BY THE RIVERBANK
Triptych, ōban, nishiki-e
110: 14½″ × 9¾″, 111: 14½″ × 10″, 112: 14½″ × 9¾″
Signed: *Utamaro Hitsu*
Publisher's Seal: *Yamaguchiya Chūsuke*
Museum of Fine Arts, Boston, Nellie P. Carter Collection

THE SUMIDA RIVER WINDS THROUGH Edo and divides the two provinces of Musashi and Shimosa. A number of bridges linked these provinces together and the most noted was that called Ryōgoku (Two Provinces). The bridge was a wooden structure and always crowded with the many visitors that thronged to the city. It was a favorite area where people gathered on sultry summer evenings to take advantage of any cooling breeze that stirred over the water. Annually in the latter part of July, a fireworks display was held at this site. It was called *kawabiraki*, which originally was a term used to express the opening of a river for trout fishing. It was used as a device to entertain the populace and occupy their minds and relieve the humdrum daily routine. During such displays not only was the bridge crowded, but people massed along the banks of the Sumida and pleasure boats plied up and down it as the viewers oh'ed and ah'ed at the magic pyrotechnical display.

Utamaro depicted the fireworks at Ryōgoku bridge in this handsome triptych. It is interesting to note that in addition to the employment of three sheets, three figures (two adults and a child) appear on each.

Oddly enough, though the fireworks explode behind them, they seem totally uninterested and instead face forward and observe each other. It is a moment of great relaxation. In the print on the left a boy who holds a lantern looks backward at two tall and typical Utamaro women. Their bodies are long and their necks stretched as they support their elongated heads topped with heavy coiffures. In the center print a woman holds the hand of a very young boy who carries a cricket cage while a stately beauty holding a fan observes her. Behind them a man stands in the prow of a boat and releases the fireworks into the sky. How much this scene with bridge and fireworks recalls to mind James Whistler's treatment of such a display at Old Battersea Bridge in London! The entrances to the small cabins of the pleasure boats are ringed with lanterns, a form repeated in the coiffures and fans. In the third print one woman stands and holds a fan while another is seated on a bench and holds a pipe. A young girl leans forward and places both her hands on the bench as she also looks out upon the passing parade. Certainly this was a scene that Utamaro had observed.

113

Kitagawa Utamaro, 1753–1806

Series: JITSU KURABE IRO NO MINAKAMI

AZAMINO OF ONITSUTAYA TATTOOING GONTARŌ OF ISAMI-DŌRI

Ōban: nishiki-e, 15¼″ × 9⅞″

Signed: *Utamaro Hitsu*

Censor's Seal

Publisher: *Nishimura*

Museum of Fine Arts, Boston, Gift of Mr. and Mrs. Frederic Langenbach in Memory of

 Charles Hovey Pepper

THE PAIN THAT GONTARŌ OF ISAMI-DŌRI suffers as the courtesan Azamino of the house called Onitsutaya tattoos his arm is wonderfully captured in this Utamaro print. He grimaces as she jabs a needle into his flesh and writes her name. His features are distorted as he tightens his muscles to bear the onslaught. His mouth is but a strong single line with a hook at one end as he opens it slightly to draw in a breath. Its angle is repeated by the pipe in his clenched fist. Utamaro has adroitly contrasted the two sides of his face and the wrinkles of his neck as he turns his head away to avoid watching her progress. The representation of his axillary hair adds an earthy touch. The plump-faced Azamino seems to be enjoying her task. She grasps his arm at the elbow and has bound a cloth tightly about his arm as a tourniquet. Her hair is unkempt and rather carelessly piled. She wears unelegant robes patterned with leaves and origami birds. The heads of the two figures lean together, creating a strong pyramidal shape. The intense black of Gontarō's collar aids in making the tattoo the center of interest.

Utamaro used broad lines as well as those of the finest nature in designing this print. Its subject reveals his versatility in treating all aspects of life. The series is based on the love exchange found in well-known *Jōruri* and the title purports it to be a glimpse offering a true comparison of the erotic beauties of noted houses.

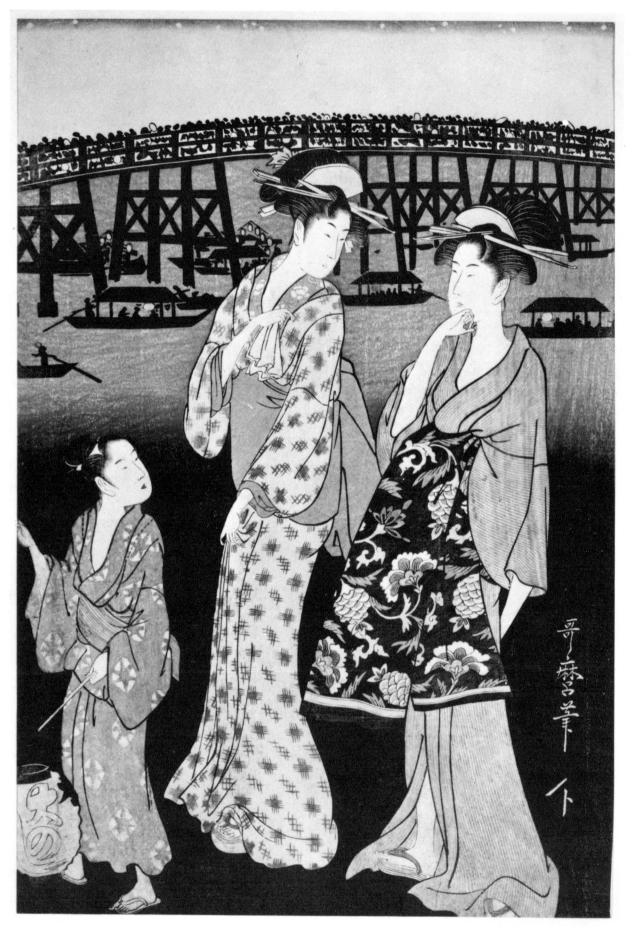

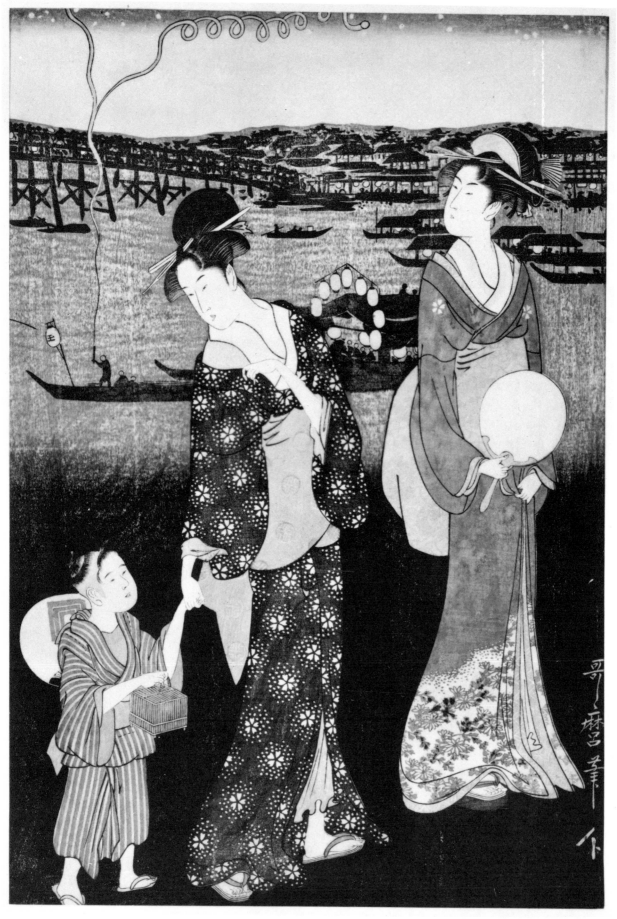

111

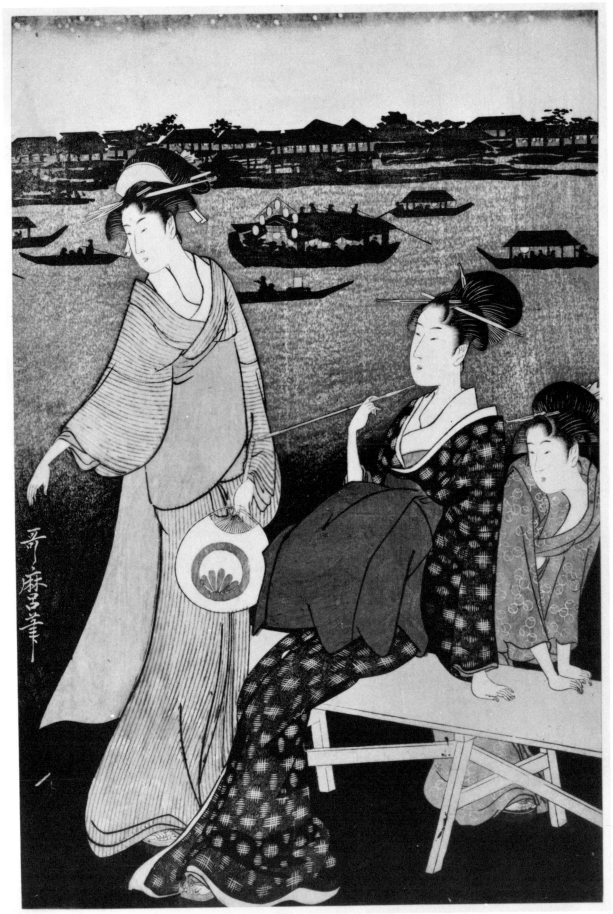

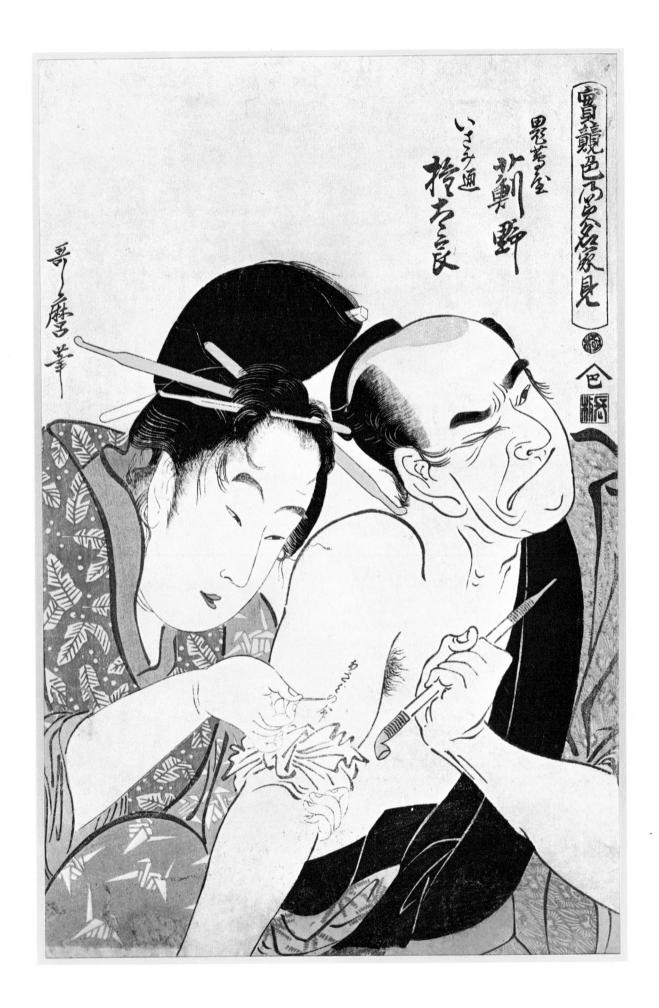

114

Kitagawa Utamaro, 1753–1806

A MOTHER BATHING HER SON

Ōban, nishiki-e, mica on the bottom, 14⅞″ × 10⅛″

Signed: *Utamaro, Hitsu*

Nelson-Atkins Gallery, Kansas City, Missouri (Nelson Fund)

NO ARTIST OF THE UKIYO-E SCHOOL handled scenes of child and parent relationships more poignantly than Utamaro. He frequently turned to the ordinary citizens of Edo and their home life as themes. In this exciting design he shows a youthful mother or maid bathing a young boy. She squats rather ungracefully, with legs widespread, by a large wooden tub in which the child sits. The tub extends beyond the confines of the sheet and the boy looks unhappy and resistingly grasps the hand which holds a cloth and washes his face. He also holds a miniature water bucket. It is a toy meant to amuse him as well as educate him in the rituals of bathing. The water is transparent and his body can be seen through it as he squirms about, complicating the woman's task. The woman wears a work robe of blue fabric with a well pattern decorating it. Her hair is bound to prevent the side locks from getting in her way, and the comb, which is normally firmly placed, has fallen precariously forward. A single plum blossom of gold lacquer appears to be painted on it. In the upper right corner the child's checked clothing hangs and the leaves of a plant appear at the sleeve. Perhaps the robe hangs from the bough of a tree, for the scene appears to be outdoors as the ground is represented by coarse black mica. It is a most touching and sympathetic study.

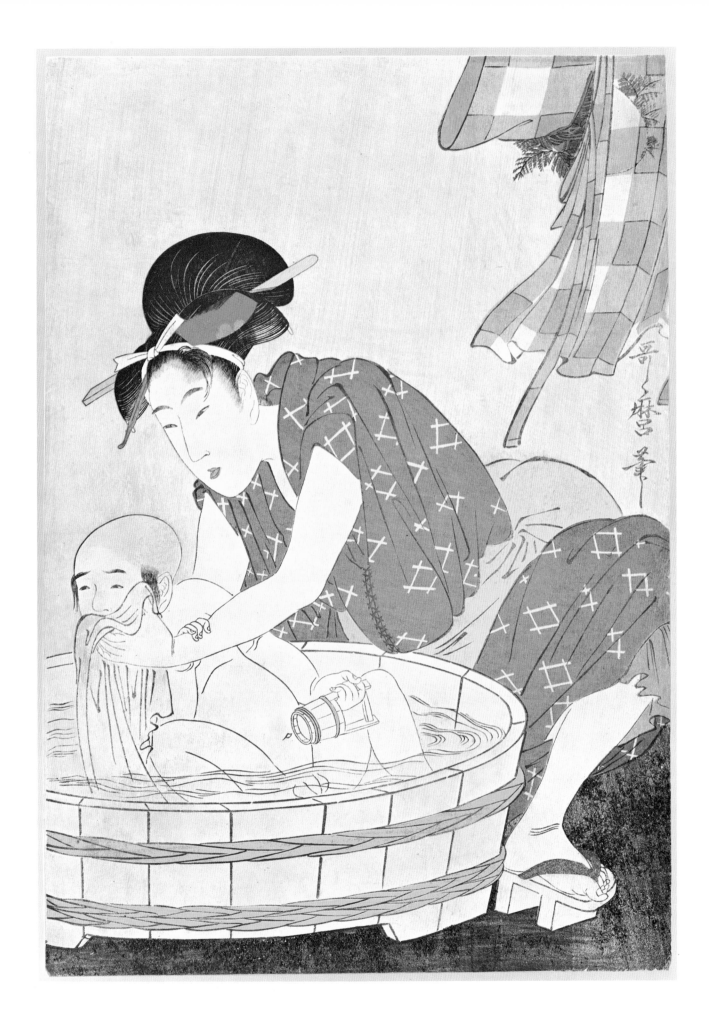

115

Kitagawa Utamaro, 1753–1806
Series: YAMAUBA AND KINTARŌ
YAMAUBA CLEANING KINTARŌ'S EAR
Ōban, nishiki-e, 14¾" × 9¾"
Signed: *Utamaro Hitsu*
Publisher's Seal: *Tsutaya Jūsaburō*
Philadelphia Museum of Art, Given by Mr. and Mrs. Lessing J. Rosenwald

A DEEP LOVE FOR CHILDREN must have played an important role in Utamaro's life. As already mentioned in No. 114, he used themes depicting them over and over again. In all of them there is a warmth and sense of trust that relates the mother and child. Utamaro produced over thirty prints dealing with Yamauba and her son Kintarō, who grew up to be a great legendary hero. When he attained manhood his strength was formidable. He was the father of Kimpira, whom we have already seen represented in print No. 26. Mother love is the theme of the Kintarō series. In this one Yamauba holds him firmly on her lap as she pushes his head forward and cleans his ear. The child, who is always depicted as having a ruddy complexion, rebels against her ministration. One eye is partially closed and his mouth is slightly twisted as he appears about ready to wiggle out of her grasp and move his head. His robe is decorated with a twisted-rope pattern and his hair is rather thick.

Utamaro soon developed a highly stylized method of representing Yamauba's head. Her face was very long and her eyes were always almond shaped. Her hair was always represented as being long and unruly. It cascades down her shoulders; the many strands provided a perfect foil on which the engraver could display his skill. Yamauba's eyebrows were always bushy and her teeth blackened. Though there be a grotesque element in the relationship of the long-faced mother and round-faced son, there is also great tenderness and devotion. The Yamauba-Kintarō theme must have been of special and as yet unrevealed significance to Utamaro.

116

Kitagawa Utamaro, 1753–1806
Series: SEIRŌ NANA KOMACHI (The Seven Komachi of Brothels.)
SHINOHARA OF THE TSURUYA
Ōban, nishiki-e, 14⅞″ × 9⅞″
Signed: *Shōmei Utamaro Hitsu*
Publisher's Seal: *Sensa*
Collector's Seal: J. S. Happer
Philadelphia Museum of Art, Given by Mrs. Emile Geyelin in Memory of Anne Hampton Barnes

THE NAME OF ONO NO KOMACHI, a noted poetess, was often invoked as the theme or title of a print series. Shunshō's interpretation can be studied in print No. 72. Utamaro also put the name to use. *Ukiyo-e* artists very often sought fanciful names to apply to the series of prints they created and anything that involved historical connotation and numerical limitations was embraced. Snob appeal certainly exerted its force and the artists naturally sought to use catch phrases and tricky titles. This one from a set of seven sheets represents the seven Komachi of the brothels. Its subject is the courtesan Shinohara of the house called Tsuruya, and the *kamuro* who attend her are listed as being Shinobu and Utano. Shinohara is majestic, and her head and shoulders fill the entire sheet. One hand reaches up to adjust one of the pins in her very elegant coiffure held in place by seven pins, single bar, and comb. The placement of the comb in her hair completes the arc created by

her sidelocks. Her coiffure is of the latest style, for it is knotted and shaped at the back of her head to resemble the outspread wings of a butterfly. One cannot help but recall the popular song "Poor Butterfly," for though beautiful and popular, one wonders whether she was ever truly loved. Shinohara's hands are elegant and the fingers curve gracefully. Her eyebrows are full but there is never a trace of an eyelash. Her nose is long and patrician, her mouth is tiny, and her lips resemble the petals of a chrysanthemum. Utamaro very painstakingly indicated every hair and the engraver once again displayed his virtuosity in keeping each strand separate.

Utamaro makes us concentrate on the faces of his grand beauties by making the heads and coiffures broader than the shoulders. Though this is anatomically incorrect, it somehow does not disturb the viewer.

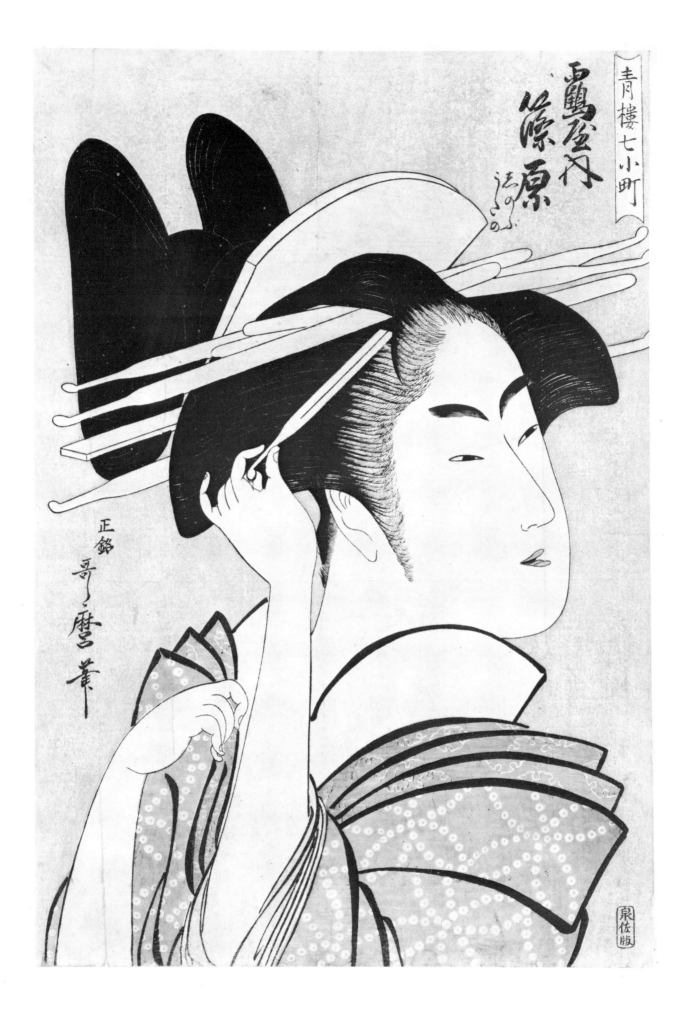

117

Kitagawa Utamaro. 1753–1806
Series: CHŪSHINGURA
SHICHI DAMME (The Seventh Act of the Play Chūshingura)
Ōban, nishiki-e, 15⅛″ × 10⅛″
Signed: *Utamaro Hitsu*
Publisher's Seal: *Nishimura*
Miss Edith Ehrman, New York, N. Y.

WE HAVE EARLIER SEEN THAT the *Chūshingura* often was employed as a source of inspiration by *ukiyo-e* artists. Utamaro also turned to this noble tale and did a number of illustrations of it. In this print he depicts an event that occurs in the seventh act. In the single sheet he treats the subject twice. The traditional mode is shown in the cartouche placed beside the title in the upper left corner. The hero of the story, Ōishi Kuranosuke, who in the play is called Ōboshi Yuranosuke, is shown standing on the verandah reading a letter from Lady Kaoyo, which describes in detail the status of his enemy. He unrolls the letter and his mistress, the noted Kyoto beauty called Okaru, tries to read it but the light is too dim, so she raises her mirror to reflect light upon it and ease her task. At the same time one of Yuranosuke's enemies, Kudayu, hides under the verandah and also tries to read the letter as it is unfolded and touches the ground. In the play he is later discovered and punished for his spying, as is Okaru for her indiscretion.

In the second version, which occupies the main portion of the print, Utamaro has treated the theme humorously. It is a hot summer day and a young man who has just come from the bath sits on a verandah with his robe thrown off his shoulders and draped over his waist. His torso and legs are bare. He is a parody of Yuranosuke as he intently studies a letter. His brow is furrowed as he concentrates on the content of the message trying to comprehend it. A cricket in a cage hangs just beside his head. Seated on what appears to be an upper verandah is a rather bored courtesan. She ignores the man reading, and leans against a post with a fan in her hand. Her robe is also pushed off her shoulders and her ample breasts are exposed. To complete the trio of figures Utamaro placed a wonderfully drawn dog under the verandah. He equates with the spy, Kudayu, and raises his snout as he glances at the letter which because of its length trails over the ledge.

The treatment of the *Chūshingura* theme in this manner is fresh and daring. It is quite obvious that Utamaro was taking a jab at conventional society in poking fun at the story. It also indicates his attitude toward spies and red tape, for they and it had the sensibility of dogs. He thus openly and in a humorous gesture of ridicule breaks with tradition.

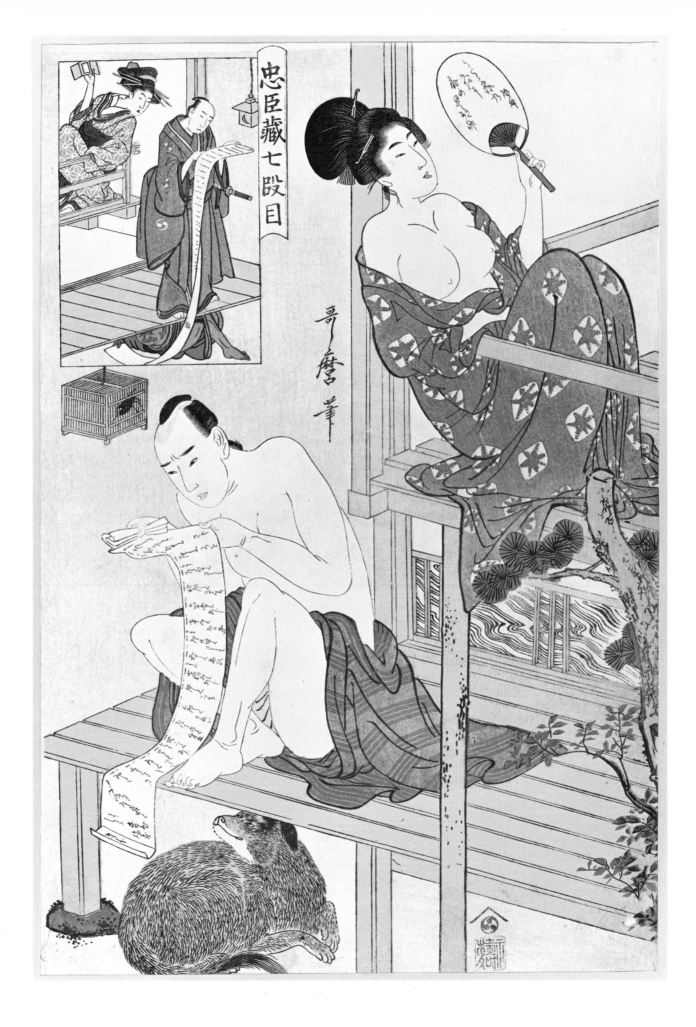

118

Kitagawa Utamaro, 1753–1806

Series: HOKKOKU GOSHOKU SUMI; GEIGI

Ōban, nishiki-e, 15⅛″ × 10⅛″

Signed: *Utamaro Hitsu*

Publisher's Seal: *Ise Mago*

Collector's Seal *Hayashi*: *Tada[masa]*

Mr. and Mrs. Edwin Grabhorn, San Francisco

ONE OF THE SERIES OF PRINTS (Nos. 118, 119, 120) produced about 1789 by Utamaro in which he most ably reveals his knowledge of the women of the licensed quarter is that literally titled *Hokkoku Goshoku Sumi* (Five Kinds of Ink from the North Country). It is a play on words, for although the characters composing the title are placed in cartouches resembling ink sticks, the word *sumi* is also the verb "to dwell" and the Yoshiwara was located in the northern *(Hoku)* part of Edo. Thus the title could be interpreted as reading Five Varieties of Residents of the Yoshiwara.

The series depicts five different types of women, and the most elegant and highest on the social scale is that titled *Geigi*, the geisha. She is a rather coquettish young lady who is beautifully groomed. Her hair is perfectly combed and brushed with not a strand out of place. The hairpins are decorated with an ivy *(tsuta)* leaf, which is also the crest worn by this geisha on her unpatterned tan gauze outer robe, indicating that she was probably employed by a house called Tsutaya. Beneath this she wears a salmon-and-white striped robe and her undergarment is of traditional tie-dyed red fabric. Utamaro has delicately handled the gauze outer robe to capture the natural effect of the pattern of the underrobe showing through wherever the two cloths touch. The obi is decorated with a simple leaf pattern placed on a mica ground.

The collars of the robes resting on the geisha's right shoulder are rather angular and contrast sharply with the soft curve as they fall over her left shoulder. This angularity leads one to concentrate on the truly gentle and sweet face of this charmer who could capture her man with ease. The back of her neck is clean and graceful, and her throat is slender and almost patrician. Her eyebrows are well brushed; her smiling mouth is just slightly open as the raises her left arm from the elbow and, with her palm turned slightly outward, moves her fingers with index finger extended as though about to point to herself and coyly say, "Me?" She is truly an accomplished beauty.

The background for this entire series is a rather rich yellow color, and the ink-stick cartouches in each print are of a different hue; that of the geisha is black. They all bear the seal of the publisher *Ise Mago* who was active in the Kansei period (1789–1800), and who also published Utamaro's series *Seiro Niwaka*, *Eri-ashi*, and *Mayu Niki*. The publisher's seal consists of the two characters *yama* (mountain) and *yoshi* (good), also read *beku*, rounded to form a device. This print also bears the seal of the Hayashi Tadamasa collection, and was acquired by the present owner, along with Nos. 119 and 120, from the Cartier sale in 1962.

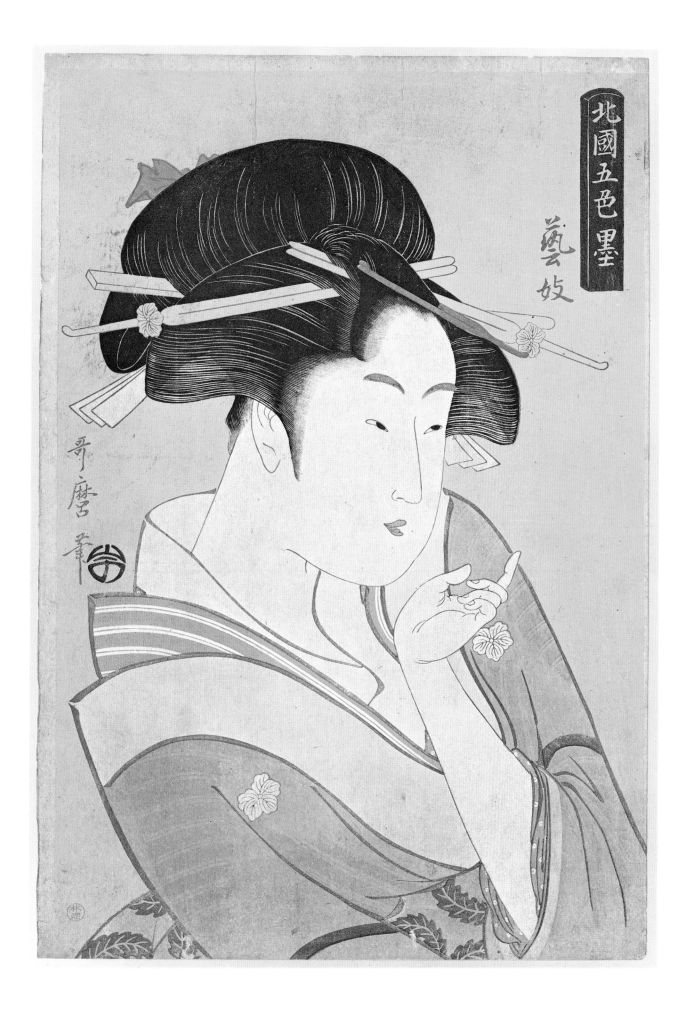

119

Kitagawa Utamaro, 1753–1806
Series: HOKKOKU GOSHOKU SUMI; KAWAGISHI (KASHI)
Ōban, nishiki-e, 14¾" × 10⅜"
Signed: *Utamaro Hitsu*
Publisher's Seal: *Ise Mago*
Collector's Seal: *Hayashi Tada[masa]*
Mr. and Mrs. Edwin Grabhorn, San Francisco

THE FOURTH PRINT OF THIS *Hokkoku Goshoku Sumi* series, if we follow the descending scale of social order, is that titled *Kawagishi*, which literally means "riverbank." Everything about the girl is softer, but in a harder way than the geisha (No. 118). She lacks dignity and in the social scale is ranked beneath the geisha, *kirimusume*, and *oiran*. This class of prostitute in all likelihood lived outside of the actual Yoshiwara and plied their trade along the canal. They were untrained and unskilled.

This girl is round-shouldered, and her black geometric *kasuri*-patterned robe edged with a tie-dyed collar is pushed back to reveal her right shoulder and breast. Draped around her neck on a cord is a small pouch containing scent used to perfume her body. This pouch is made of a red and green fabric with a delicate yellow-banded wisteria-colored tortoise-shell pattern. Her right hand at the bottom of the print clasps the edges of her robe together, and with her left hand she picks her teeth through pursed lips. Her mouth is turned down and shows no trace of sweetness, as she appears to be plotting her next conquest. Her hair is not fully set and is unruly. It is tied together with a band and loose strands hang over her brow and about her neck. This rather calculating girl has a full face and just the slightest indication of a double chin.

The cartouche announcing the series in this instance is green.

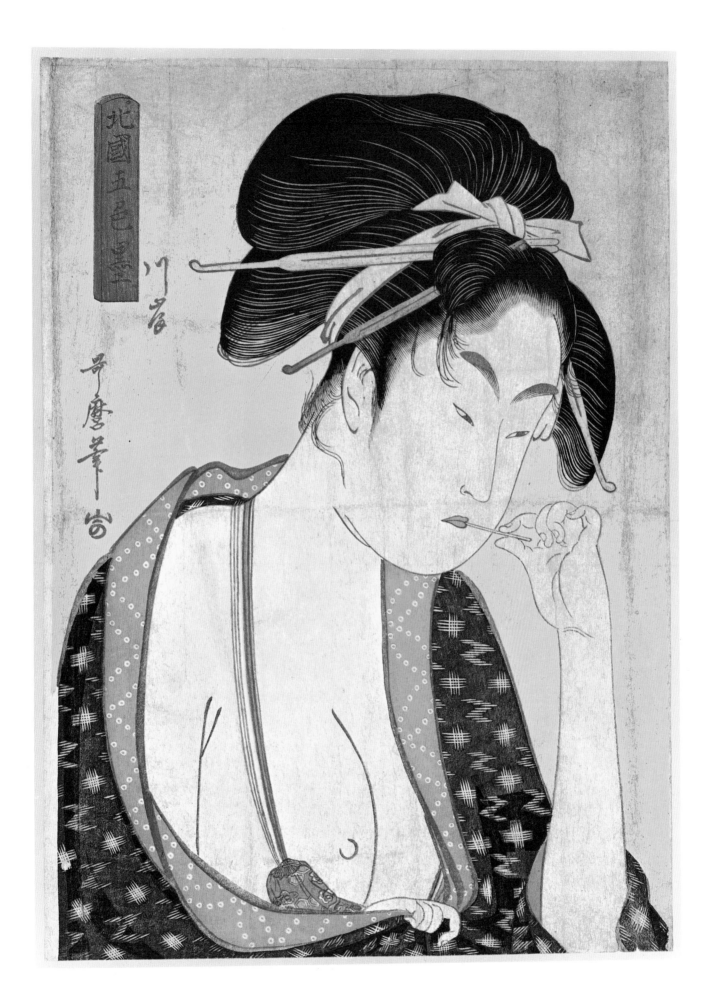

120

Kitagawa Utamaro, 1753–1806
Series: HOKKOKU GOSHOKU SUMI; TEPPŌ
Ōban, nishiki-e, 14¾″ × 9⅞″
Signed: *Utamaro Hitsu*
Publisher's Seal: *Ise Mago*
Collector's Seal: *Hayashi Tada[masa]*
Mr. and Mrs. Edwin Grabhorn, San Francisco

THE LOWEST GRADE GIRL OF THE SERIES is a prostitute called *Teppō*, which when translated means "rifle." They, like the *Kawagishi*, were found outside of the actual Yoshiwara and catered to those who could not afford the tariff inside the quarter. The *Teppō's* rates were so low that most anybody could afford her services. She was neither a very righteous nor upright lady, and Utamaro has captured her character. She slumps down and the line created by her right arm is rather like the slope of Mount Fuji. Her unpatterned red-lined light blue robe with a tie-dyed purple collar is open to her abdomen and her breasts are exposed. The robe has a round crest composed of small white chrysanthemums and the pattern on a bolder scale is repeated in her obi in a reddish brown on a bronze or tea-dust colored ground.

The *Teppō* holds clasped between her lips three sheets of paper in a gesture often seen in erotic Japanese prints and paintings. In this polite version of the theme, it is quite possible that the sexual act is underway.

Utamaro has balanced the darker color and weight of the obi with the black hair of the prostitute. There is no chic about her coiffure. The side locks are pulled back and rolled on top of her head. Only one hairpin is present and strands of her hair hang untidily over her forehead and on her neck. She is truly a fallen woman.

The same bronze or tea-dust color that appears on the obi is the color of the ink-stick cartouche. The print also carries the seal of the Hayashi Tadamasa collection.

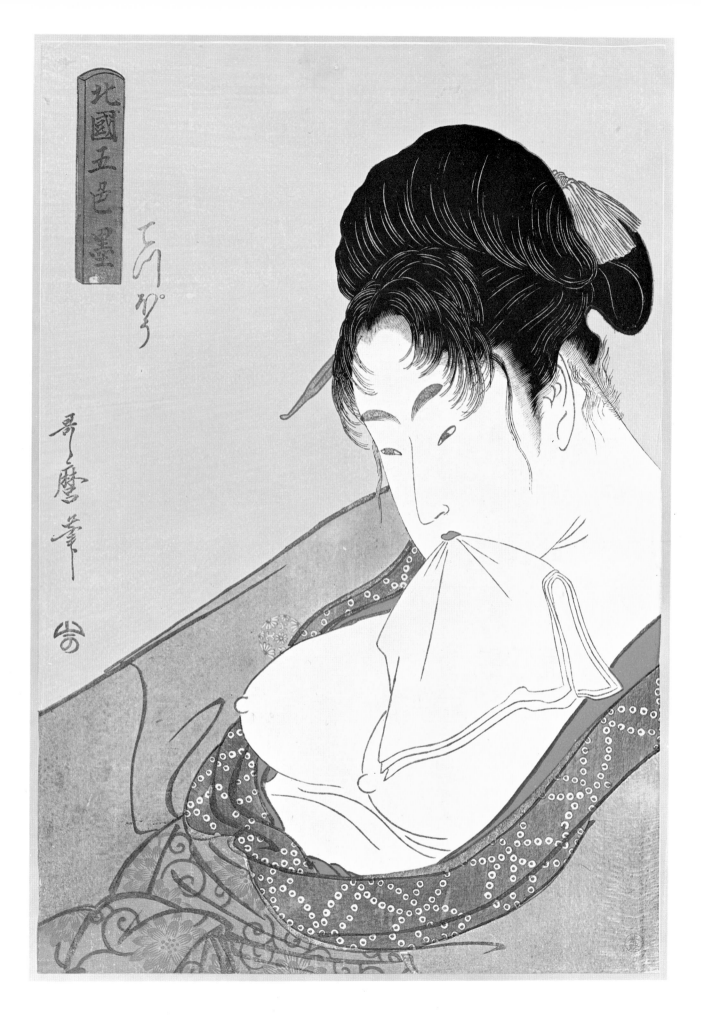

121

Taga Ryūkōsai, act. 1772–1816

THE ACTOR ASAO TAMEJŪRŌ HOLDING A PUPPET

Hoso-e, nishiki-e, 11½″ × 5½″

Signed: *Ryūkōsai*

Publisher: *Daisa[?]*

The Art Institute of Chicago

RYŪKŌSAI, WHO WAS ACTIVE DURING THE LAST quarter of the eighteenth and first quarter of the nineteenth centuries, is a rather rare artist. In contrast to most of the others whose prints we have examined, he worked outside of the mainstream and in the Osaka area where the *ukiyo-e* artists and prints were popularly known as *Kamigata-e*. Little biographical data is available on Ryūkōsai other than that he lived in Osaka and in all likelihood was the pupil of Kangetsu, a very slightly known artist. Single-sheet prints by Ryūkōsai are not often seen and one usually comes upon his work via book illustrations and paintings. During his career he made use of the names Jokei and Jihei, and his favorite theme was the portrayal of actors. In these representations the strong influence of Shunei (prints Nos. 80–84) and Shunkō (print No. 138) can be seen. Although the *ukiyo-e* movement appears to have originated in the Kansai (Kyoto-Osaka) area, Edo soon became the true center. It is thus interesting to see how rapidly Edo's influence spread out over the land and how truly common the prints and names of artists became.

A portrait of the actor Asao Tamejūrō holding a puppet garbed in the costume of a *sambasō* dancer is the subject of this print. There is a great deal of realism and character in the actor's face. His jowls are full and he appears to be stout and advanced in years. He certainly was not the type to play juvenile leads. Although the edges of his mouth are turned down, one can expect that he will burst forth in a grin at the next moment. He wears the traditional formal *kamishimo* costume and an *inrō* (medicine case) hangs from his sash. Osaka was and still is noted for its puppet theater, and thus it is perfectly natural to find Ryūkōsai using it as a prop. Normally the great puppets of the *Bunraku* theaters were not manipulated in this manner but from below. Asao Tamejūrō's puppet is suspended from a wooden paddle and the actor makes it perform by cleverly plucking and moving the strings. The frantic movement of the doll provides a clever contrast to the staid and almost immovable appearance of the actor, as he portrays a puppeteer.

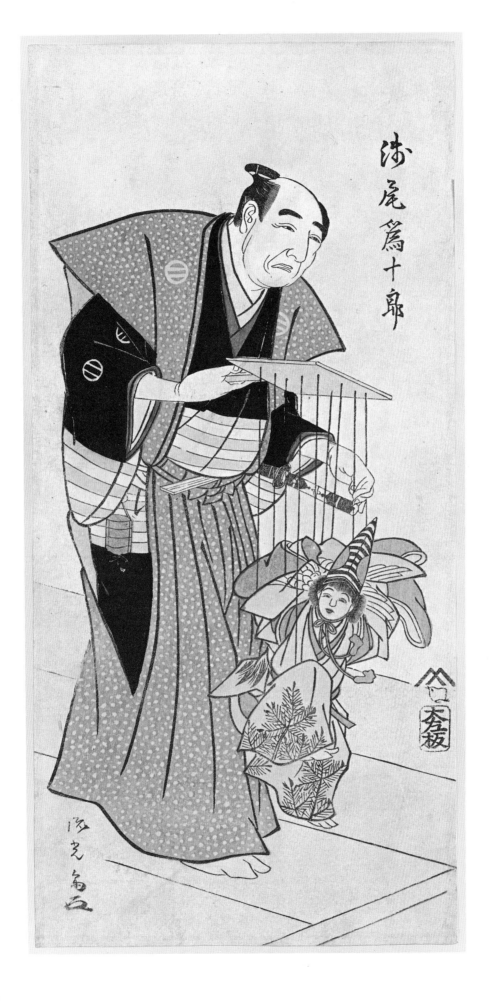

122

Tōshūsai Sharaku, act. 1794–95

THE PROGRAM ANNOUNCER SHINOZUKA URAEMON OF THE MIYAKO-ZA THEATER

Ōban, nishiki-e, mica ground, 14 3/8″ × 10″

Signed: *Tōshūsai Sharaku Ga*

Censor's Seal

Publisher: *Tsutaya Jūsaburō*

Metropolitan Museum of Art, Whittelsey Fund, 1949 (Ledoux Collection)

SHARAKU IS THE NAME OF AN ARTIST who, at the same time, was one of the most noted and least known of the entire school of *ukiyo-e* print masters. His prints evoke both excitement and controversy. During his lifetime his name was recorded in the earliest chronicle of artists of this school, titled *Ukiyo-e Ruikō*, which was compiled by Ōta Nampo, a noted author of comic odes, in the Kansei era (1789–1801). His inclusion in this work indicates that he had achieved some level of popularity, although Nampo cautions that Sharaku's realistic portrayals of actors were peculiar and that his fame was short lived. Authors of both the Eastern and Western world have decried his work and yet it is hypnotic. His name appears again and again in the literature, and in the present day his work is known throughout the world, for he is considered to rank among the top ten masters of the Japanese print.

Why, one might ask, should a man who is considered so noteworthy be virtually unknown? This is in part due to the terrible handicap one faces in unearthing biographical data, for no one sat with pen in hand to jot down the events that surrounded the lives of these artists. In the case of Sharaku the situation is most acute, for all that we have is a name, and, gratefully, some one hundred and fifty-nine prints produced roughly during a ten-month period in 1794–95. His biography is perplexing, for nothing is factual. In truth, we really do not know who Sharaku was or why he worked in the manner that he did. One of the most recent and able appraisals of the problems associated with him appears in a pamphlet by Suzuki Jūzō, titled *Masterworks of Ukiyo-e: Sharaku*, Tokyo, Kodansha International Limited, 1968. A review of this data and study of the artist's work reveal that he used the name Tōshūsai; according to the novelist, Shikitei Samba, in notes found in a manuscript edition of the *Ruikō* dated 1831, he dwelt in Hatchōbori in Edo. This statement is supported by a further commentary by Saitō Gesshin, who, in an edition of the *Zōho Ukiyo-e Ruikō* written in 1844, reported that his name was Saitō Jūrōbei and that he was a *No* actor in the Lord of Awa's troupe dwelling at Hatchōbori. Evidence confirms that such an actor existed and that he was employed by the Lord of Awa of the Hachi-suke family, whose residence coincidentally was in Hatchōbori. All attempts to prove that Sharaku and this actor were the same person have proved futile, as have the theories which identify him as being Ōkyo and Hokusai, to mention but two. The only concrete facts we have are the name Tōshūsai Sharaku and the prints.

One of this artist's most evocative masterpieces is a portrait of a stout elderly man seated on the floor, holding and reading a scroll. He occupies the entire space of the sheet and the design is very powerful. In the past the subject has been reported as Miyako Dennai III, the manager of the Miyako-za theater, announcing the program. Other identifications have also been put forth, but recently Mizoguchi Yasumaro, in an article titled: "Who is reading an announcement of the second series of actor's figures in Sharaku's works?" published in No. 17 of the journal *Ukiyo-e Geijutsu* (Ukiyo-e Art), Tokyo, 1968, pp. 25–28, convincingly establishes the figure as being Shinozuka Uraemon, of the Miyako-za theater. He has discovered Uraemon's name listed as announcer on a program of that theater executed by Torii Kiyonaga in November 1794. Mizoguchi also points out that it would be unlikely that the theater owner would personally appear in this capacity when somebody else was already employed to perform the task. The figure wears a red *kamishimo* patterned with the character *kotobuki* (felicitations) written in seal form and placed in diamonds. On the upper portion of his robe he wears the crossed fan and paulownia crest associated with the Miyako Theater. The hands of the announcer are massive, and though drawn of thin angular lines, they have the strength of resilient blocks of wood. His face is heavy with sagging jowls and cheeks. His brow is furrowed and wrinkles outline his eyes. The announcer's robes, engraved in broad strokes with soft folds, contrast with the strength of his personality. The background of powdered mica and color aids in creating the atmosphere that makes this print startling. A second impression of the print exists. Those portrayed by Sharaku must have grimaced when they saw themselves revealed in the brilliant harsh light of his mirror.

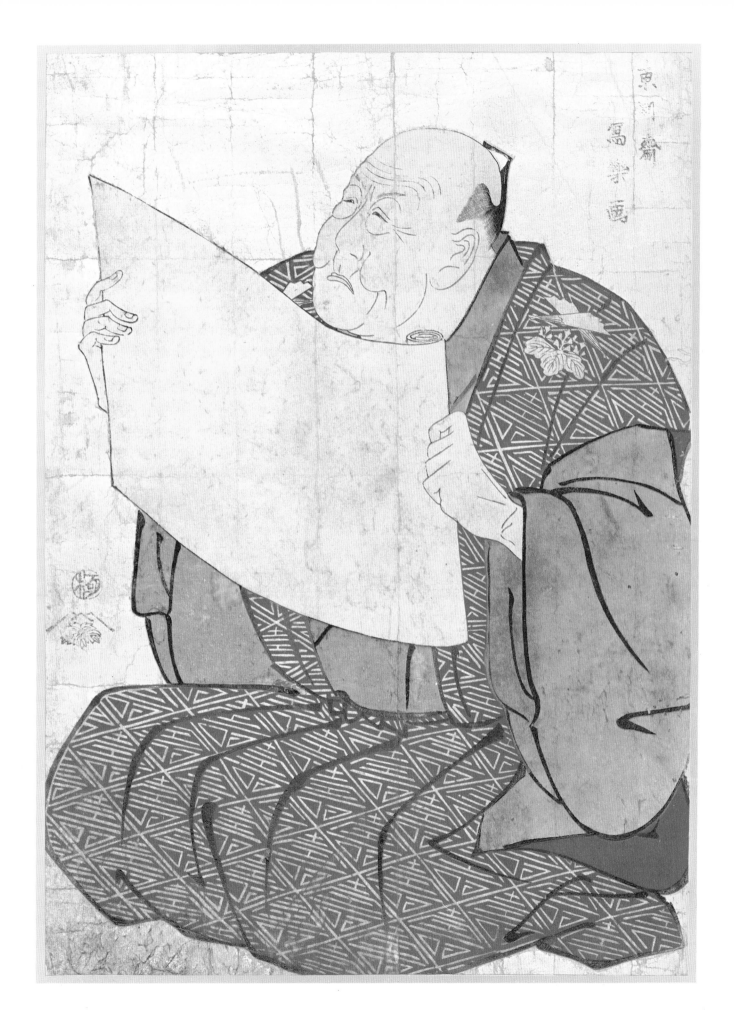

123

Tōshūsai Sharaku, act. 1794–95

THE ACTOR SEGAWA TOMISABURŌ II AS THE COURTESAN
TŌYAMA SHELTERING ICHIKAWA KURIZŌ AS HIGASHIYAMA
YOSHIWAKA-MARU

Hoso-e, nishiki-e, 13″ × 5 7/8″

Signed: *Tōshūsai Sharaku Ga*

Censor's Seal

Publisher's Seal: *Tsutaya Jūsaburō*

Metropolitan Museum of Art, Whittelsey Fund, 1949 (Ledoux Collection)

ALTHOUGH SOMEWHAT COMIC because of Sharaku's tendency to produce caricatures, his prints are also very expressive and emotional. They are meant to capture the characters and through them tell the stories of the plays they perform. Segawa Tomisaburō II was a very noted and skilled performer and Sharaku shows him here in a tender scene as a courtesan shielding a young boy. The actor's body twists as he pushes the child behind him and raises his left arm to ward off the foe. The turn of the actor's body is most inventive as it angles in from the right edge of the print. The neck and head serve as vertical elements which link the torso to the lower body. The figure almost resembles a branch bent for *ikebana* (flower arrangement). The robes are tastefully patterned and the black obi serves as a unifying and stabilizing force. Tomisaburō's face is typical of Sharaku. It is elongated and square jawed. The eyes resemble jet beads which look out for approaching trouble, and with the slightest variation in placement of the pupils Sharaku was able to vary the emotion. The lips are pursed tightly together in concern for the ward Tomisaburō protects. The artist has also made great use of the actor's crest, as well as the censor's and publisher's seals, to add interest to the print. The child does not appear to entirely accept the aid, for his body twists and one sleeve is raised as though he were in movement.

The play depicted appears to be that titled *Keisei Sambon Karakasa* (The Courtesan and the Three Umbrellas), which tells of the revenge of Nagoya Sanza in capturing and killing Fuwa no Banzaemon, his father's assassin. Tomisaburō played the role of Tōyama, a courtesan, in the play. Tōyama fled with the child, believed to be Ichikawa Kurizō in the role of Higashiyama Yoshiwaka-maru, after his father had been murdered by the play's villain, Fuwa. The print is often reported as but one of a related group telling this story. Unfortunately it is difficult to accept the theory of Suzuki Jūzō expressed in his *Masterworks of Ukiyo-e: Sharaku*, page 65, where he publishes four prints. It is difficult to believe that Sharaku would have ever designed four prints of such varying scale to go together. The identification of both play and role remains open to investigation.

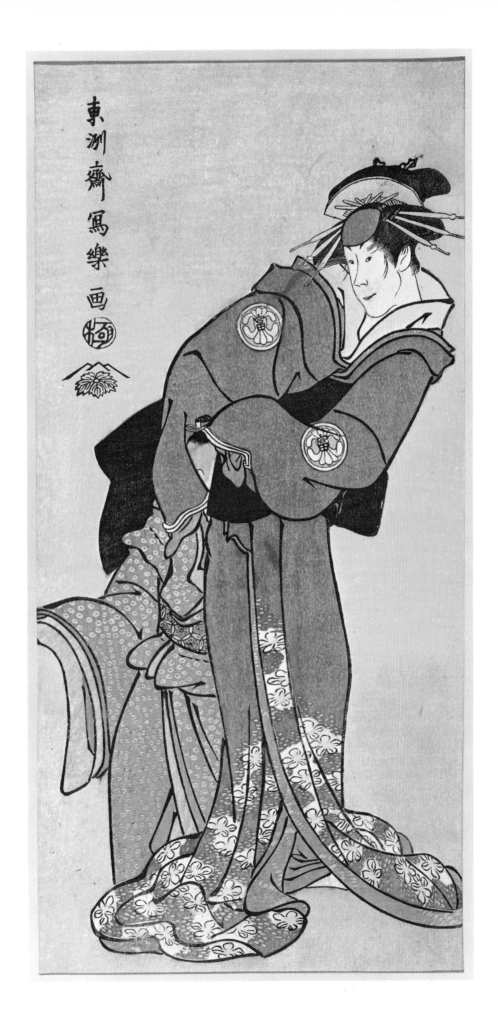

124

Tōshūsai Sharaku, act. 1794–95

SEGAWA KIKUNOJŌ III AS A COURTESAN
AND SAWAMURA SŌJŪRŌ III

Ōban, nishiki-e, mica ground, 14 3/4″ × 9 3/4″

Signed: *Tōshūsai Sharaku Ga*

Censor's Seal

Publisher: *Tsutaya Jūsaburō*

Metropolitan Museum of Art, Whittelsey Fund, 1949 (Ledoux Collection)

THIS PRINT BY SHARAKU is believed by Louis Ledoux and Harold Henderson, as well as Suzuki Jūzō, to represent the most heroic characters from the *Keisei Sambon Karakasa* play slready mentioned in print No. 123. The composition is slightly similar to the "needle and pyramid" arrangement seen in No. 13; however, at the same time it is fresh. It is much more angular, in part because the figures form a diagonal that roughly divides the print from left to right. The figures are said to be Segawa Kikunojō III as the courtesan Katsuragi, and Sawamura Sōjūrō III as the hero Nagoya Sanza. Once again Sharaku's representation of the actors is biting, though I would hesitate to use the term caustic. Sanza appears to be a simple, almost cross-eyed man. His robe is richly colored and handsomely patterned with, among other things, the "Eight Treasures." The seated Katsuragi clasps her hands over a pipe and looks out at the viewer. Her black outer robe and head serve as focal points for the center of the print. Again Sharaku's typical face with lips tightly pressed together can be seen, and one senses a strong element of truth. Katsuragi is not a pretty girl, so it is likely that Kikunojō III had the earthy quality seen in this portrayal.

Sharaku used a great deal of artistic license in creating this print, for if the courtesan were to stand she would tower above the hero. The device of her hands clasped over the mouth of a pipe aids in softening the transition from the straight torso to the curve of her knee and flowing drapery. The viewer could easily interpret it as indicating Sōjūrō's annoyance at being so portrayed. The mica ground adds greatly to the beauty of the print.

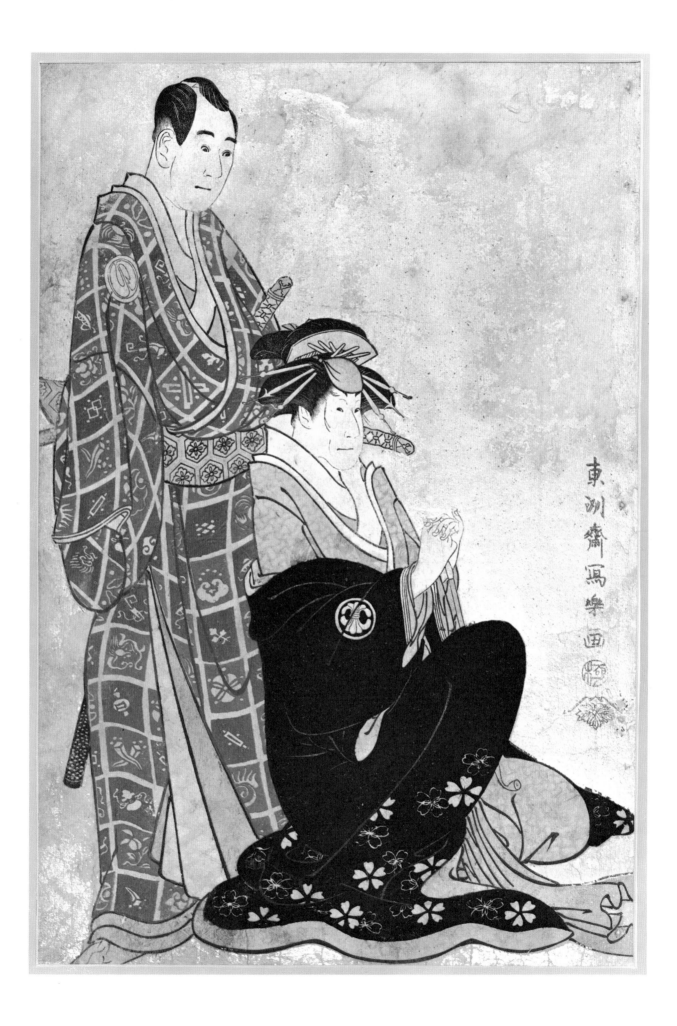

125

Tōshūsai Sharaku, act. 1794–95

THE ACTOR ICHIKAWA EBIZŌ IV AS WASHIZUKA KANDAYŪ

Ōban, nishiki-e, mica ground, 14 1/2″ × 9 5/8″

Signed: *Tōshūsai Sharaku Ga*

Censor's Seal

Publisher's Seal: *Tsutaya Jūsaburō*

Metropolitan Museum of Art, Whittelsey Fund, 1949 (Ledoux Collection)

IT HAS BEEN POINTED OUT a number of times that a great deal of confusion exists as to the positive identifications of the actors and the roles that they play in the *ukiyo-e* prints. Sharaku's best portraits of actors are clearly a case in point. So often we are really in the dark and, though it is practice to accept one theory or another, the truth is that no one really knows. It is convenient, however, to have a label or tag and thus I shall succumb and follow suit, though I feel that many such interpretations will change in the light of future research. There appears to be little doubt that the actor represented in this print is Ichikawa Ebizō IV. The crest and features are typical of portrayals by other artists on which his name is inscribed.

Although we feel relatively certain of the actor's identity, great disagreement exists over the role he plays. The author has put his faith in the least popular identification and until scholarly evidence refutes the theory I accept the Ledoux and Henderson belief that the figure represents Washizuka Kandayū. Most authorities agree that the play is that titled *Koinyōbō Somewake Tazuna* (The Beloved Wife's Parti-colored Reins). The story tells of the great loyalty of a subject to his feudal lord. Date no Yosaku and his wife, Shigenoi, were devoted to each other, and to symbolize the intertwining of their lives, led his horse with parti-colored reins. Just as Yosaku was loyal to his lord, Shigenoi was devoted to both her family and the daughter of her lord prior to her marriage, for she had served as the girl's wetnurse. Two major villains appear in the play, the Washizuka brothers, Kandayū and Yaheiji. Kandayū cleverly robs the faithful husband, Yosaku, of money entrusted to him in his capacity as chief retainer to his feudal lord. This places him in great disgrace and as part of the complex plot Kandayū also causes the death of Takemura Sadanoshin, Yosaku's father-in-law. Yosaku's half-brother rushes to his aid and tries to assist him in replacing the stolen money; however, he is thwarted and murdered by the second villain Yaheiji.

To illustrate the problems one faces in cataloguing such a print, let us examine the four major theories. The print was originally felt to represent Kono Moronao, whose rejection at love by Kaoyo led him to plot against her husband Enya Hangan Takasada, leading to Enya's banishment and revolt against the Shogun. The story is woven into the famed *Chūshin-gura* play. After careful examination it has been determined that the costume of the actor in the Sharaku print is not proper for the Moronao role. The second theory reports the actor to be Kudō Suke-tsune, the villain who caused the Soga revenge. A search of Kabuki records, however, reveals that Ebizō did not appear in this role during the year 1794, when it is believed the print was done; and thus this theory cannot be supported. The third interpretation claims that the actor is Shigenoi's father, Sadanoshin, and most Japanese scholars have accepted this as the correct representation. Several peculiarities, however, aroused the suspicion of Ledoux and Henderson. In the first place it is doubtful that Sadanoshin would have worn his hair in this manner. Ebizō's hair copies that normally worn by villains of rather low social rank. Ledoux and Henderson state that the figure is Kandayū—theory number four. They found prints in the Museum of Fine Arts, Boston, of other productions which depicted Sadanoshin. In all of these the hair style is different from this print and he is shown as a relatively young man. These portrayals are contrary to the Ebizō portrait and it is unlikely that Sharaku would have strayed so far from the standard interpretation. We also know that Sadanoshin dies early in the story, and it is thus improbable that the artist would have devoted a print to this rather minor role. Unfortunately, we are still in doubt, for the *Kabuki Nendai Ki* (Chronological Record of the Kabuki) lists Ebizō as Sadanoshin and Oniji as Kandayū. We do know, however, that actors often substituted and changed roles and that Ebizō at times took many parts in a single play; thus it is likely that the Ledoux and Henderson theory is correct. It certainly is the most logical theory in terms of available evidence.

The portrait is one of Sharaku's most noted. The figure is set against a dark mica ground. It must be remembered that the government forbade the use of mica on prints in 1794. Sharaku's continuous flaunting of the law in the use of it may well account for his sudden disappearance. Ebizō's face is most expressive. His lips are pressed tightly together, except in one corner, revealing his tongue and teeth.

continued on page 308

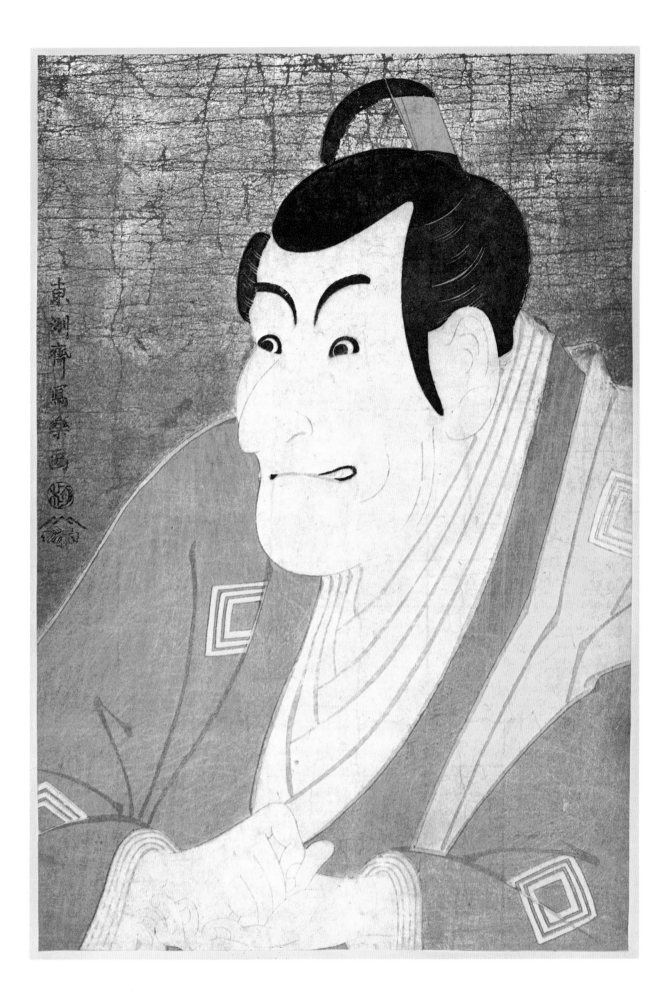

126

Tōshūsai Sharaku, act. 1794–95

THE ACTOR OSAGAWA TSUNEO II

Ōban, nishiki-e, mica ground, 14 3/8″ × 9 3/4″

Signed: *Tōshūsai Sharaku Ga*

Censor's Seal

Publisher's Seal: *Tsutaya Jūsaburō*

Miss Edith Ehrman, New York, N.Y.

ANOTHER PRINT BELIEVED to represent a role from the same play as No. 125, *Koinyōbō Somewake Tazuna*, is Sharaku's portrayal of the actor Osagawa Tsuneo II. The performer can be identified by the crest; however, the role and play remain uncertain. Ledoux and Henderson believed that Tsuneo was appearing in the role of Ayame, the wife of Sadano-shin and mother of Shigenoi. Suzuki Jūzō mentions that the actor has at times been identified as either Osan in the aforementioned play or as Shizuka Gozen in *Yoshitsune Sembon-zakura* (Yoshitsune, a Thousand Cherry Trees). He reports, however, that the costume fits neither of these roles and thus we can only speculate without the slightest certainty of being correct.

In a print of this quality all else is secondary to aesthetics. There is a great sensitivity in Sharaku's portrait of Tsuneo II. The face is elongated and the lines are fine and unwavering. The same type of drawing and cutting was used for the hand, which is bent downward at the wrist, the fingers curled back. The delicacy of these elements is in sharp contrast to the broad strokes representing the robes, which swell and are often hooked, and the hair mass, thick eyebrows, and sad eyes. The woman appears to be fragile and almost about to weep. The hand, though large, impresses one as being incapable of anything other than the most delicate gestures. This impression of the print is trimmed less than most of the published impressions; and to the author's knowledge, this print, although faded, has rarely been exhibited.

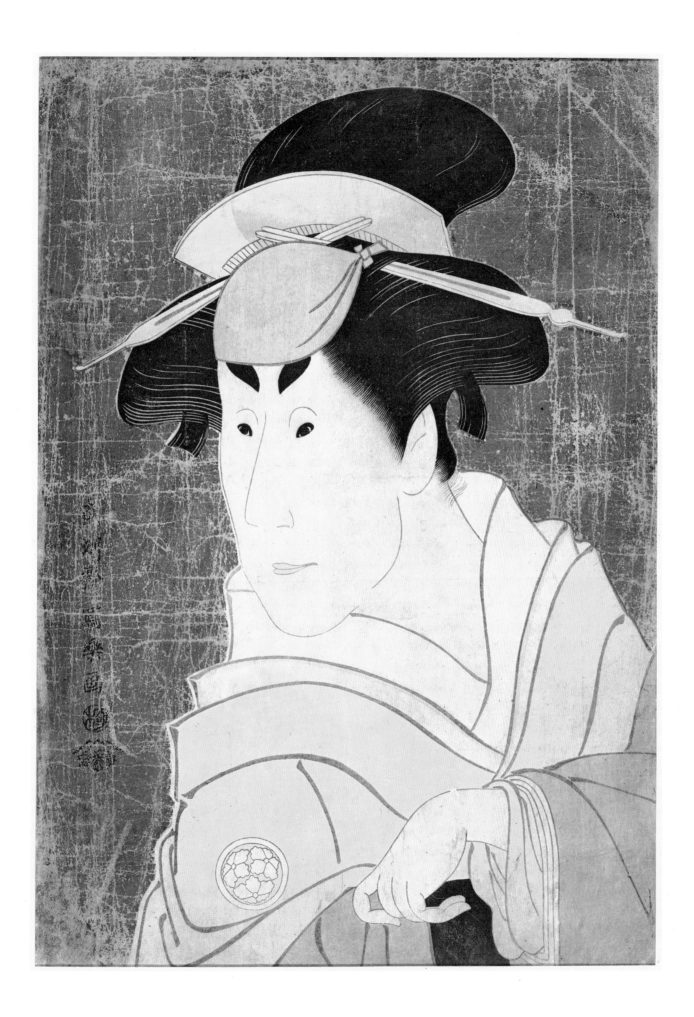

127

Tōshūsai Sharaku, act. 1794–95

NAKAMURA KONOZŌ THE HOMELESS BOATMAN AND
NAKAJIMA WADAEMON

Ōban, nishiki-e, mica ground, 15 1/8″ × 10″

Signed: *Tōshūsai Sharaku Ga*

Censor's Seal

Publisher: *Tsutaya Jūsaburō*

Metropolitan Museum of Art, Whittelsey Fund, 1949 (Ledoux Collection)

ONE OF THE BEST OF SHARAKU'S half-length portraits is that which represents the slender actor Nakajima Wadaemon as Bodara Chōzaemon, and the shorter and stouter Nakamura Konozō as Kanagawaya no Gon, a homeless boatman. The two could almost serve as caricatures of today's popular comedians Danny Kaye and Jonathan Winters, were they to appear in Japanese costume. The play is believed to be *Katakiuchi Noriai-Banashi* (A Medley of Tales of Revenge). No text has survived, although Ledoux and Henderson reported that the playbill tells of the revenge of the two courtesans Miyagino and Shinobu on Shiga Daishichi for having killed their father, Matsushita Mikinojo. Both Kanagawaya no Gon and Bodara Chōzaemon were at the house that employed the two girls when Daishichi and his friend, Sasaki Genryū, visited. The print, whether intentionally or not, is entertaining, and the two characters are wonderful opposites. Wadaemon's face is thin, his jowls sunken. His nose is very prominent and beak-like. His mouth is broad, though thin-lipped, and it is outlined in black and open at one end as though he were ranting away at his partner. Thin lines form lunettes above his piercing eyes, adding to his gaunt scarecrow-like appearance. His hand is in movement as he gesticulates to the solid Konozō.

Sharaku made great use of the character read *ichi* (one) in signifying the eyebrows of the pair. Those of Wadaemon slant downward away from the nose, whereas those of Konozō slant in the opposite direction. Konozō is a very rotund being. His face is full and stuffed. His nose is small, the tip upturned. His eyes are narrow, as though he were squinting and seething over Wadaemon's complaint. There is a great sense of stubbornness expressed in his face. His lips are pursed and the edges are turned down and accented by heavier lines. They somewhat resemble a stylized mountain in form, which equates with the actor's shape and immovability. His plumpness is further heightened by the circular lines used to indicate his chest and diaphragm. The hands, checked robe, and box he carries also add to the weightiness of the figure. If either of these actors were vain, he certainly would have withered under the shock of Sharaku's print.

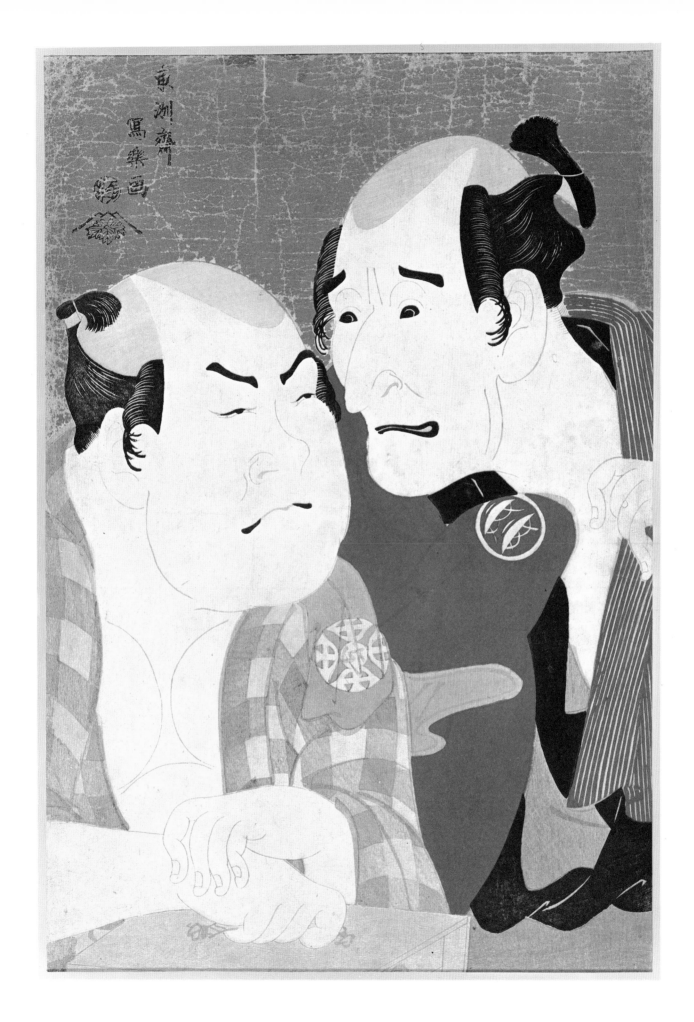

128

Chōbunsai Eishi, 1756–1829
Series: SEIRŌ BISEN AWASE (A Comparison of Selected Brothel Beauties)
 Three in the set
SHŌBAI ZASHIKI NO ZU (A Picture of the First Purchase in the Parlor)
TAKIGAWA OF THE HOUSE CALLED ŌGIYA
Ōban, nishiki-e, mica ground, 14 5/8″ × 10″
Signed: *Eishi Giga*
Publisher's Seal: *Iwatoya*
Metropolitan Museum of Art, Fletcher Fund, 1929

AS WE HAVE SEEN, the unsolved problems relating to *ukiyo-e* prints are many. One of the great mysteries is the rather arbitrary or dogmatic method by which scholars have designated certain prints as being first, second, third, or fourth state. This specimen by Eishi is a perfect example of the almost total lack of factual evidence which leads to a watering down of all attempts at scholarly research.

Hosoda Eishi was an unusual man, for in contrast to most of his fellow artists he was descended from the gentry. He was born in 1756, the eldest son of Hosoda Tokiyuki, a government police inspector. Eishi's great-grandfather was Lord of Tamba Province and also served in official capacity as Minister of Finance. As a youth his interest in art was encouraged and he was permitted to study with the academic Kanō school painter Eisen-in Norinobu. The tenth Shogun, Tokugawa Ieharu (1737–1786), took a liking to him and appointed him to his service, and later raised him to a rank comparable to Official Artist in Attendance. It is conjectured that Eishi was rather bored with the lack of artistic freedom allowed by the academic schools of painting, and being a young man was fascinated by the great growth and social upheaval taking place in Edo; thus, he turned his talents in the direction of *ukiyo-e*. He found the work of the Torii masters appealing, especially that of Kiyonaga. Eishi's fame was quite firmly established, for he was commissioned by the Imperial Priest of the Myōhōin in Kyoto to do a landscape of the Sumida River; this was presented to the retired Emperor Go Sakuramachi who is said to have praised the work. Eishi was so flattered that on some of his paintings he placed a seal read *Tenran* (Seen by the Emperor). He made great use of one of his pseudonyms, Chōbunsai, and remained an active, prolific artist of both paintings and prints until his death during the seventh month of 1829.

Almost all of the work of Eishi is imbued with elegance and refinement; there is a lack of vulgarity. His use of very thin lines and rich textile patterns, as well as his elongation of the human form, make his figures delicate and almost fragile. There is great beauty in his handling of color, and a sense of serenity in his work, for he generally avoided displaying action other than in his erotica and a few exterior scenes. His courtesans and girls move with regal stateliness.

A print from one of his most beautiful series is that reproduced here. To date only three designs bearing this overall title have been found. This one depicts the beautiful courtesan Takigawa of the house called Ōgiya. She holds the collar of her *uchikake* with one hand as she rearranges a hairpin with the other. The robes are of beautiful design. They are obviously costly, for the expense of weaving and dyeing fabrics such as these was never cheap. Flowers, phoenixes, polka dots, nets, maple leaves, and other plant life are carefully worked to capture our interest. In the printing certain colors subtly bleed out and vanish, displaying the printer's mastery of his craft. An optical illusory effect is also created by the large obi which is tied and billows out before the girl. It is almost like a watered-silk effect or an imitation of a slatted bamboo blind with foliage in movement behind it. To add to the richness of the print, the entire background was once covered with light mica.

It is this use of mica that has been employed by scholars in attempting to designate the four variations (or states, according to some scholars) of the print. These variations arranged in the generally accepted state order are as follows:

1. There is a floor line on the lower portion of the print. The area above this is dark colored, and mica has been placed over it.
2. A dividing floor line is present and mica covers the light surface above that.
3. There is no floor line and the entire surface is light and covered with mica.
4. The artist's signature and the publisher's mark are absent and at times the mica was omitted.

As can be seen, this example would be catalogued by most scholars as the third state. I shall take a rather unfashionable viewpoint and question the logic behind this conclusion. In the first place, there is no true evidence to tell us which is which; and in the second place, and this I admit may be a matter of

[238]

continued on page 308

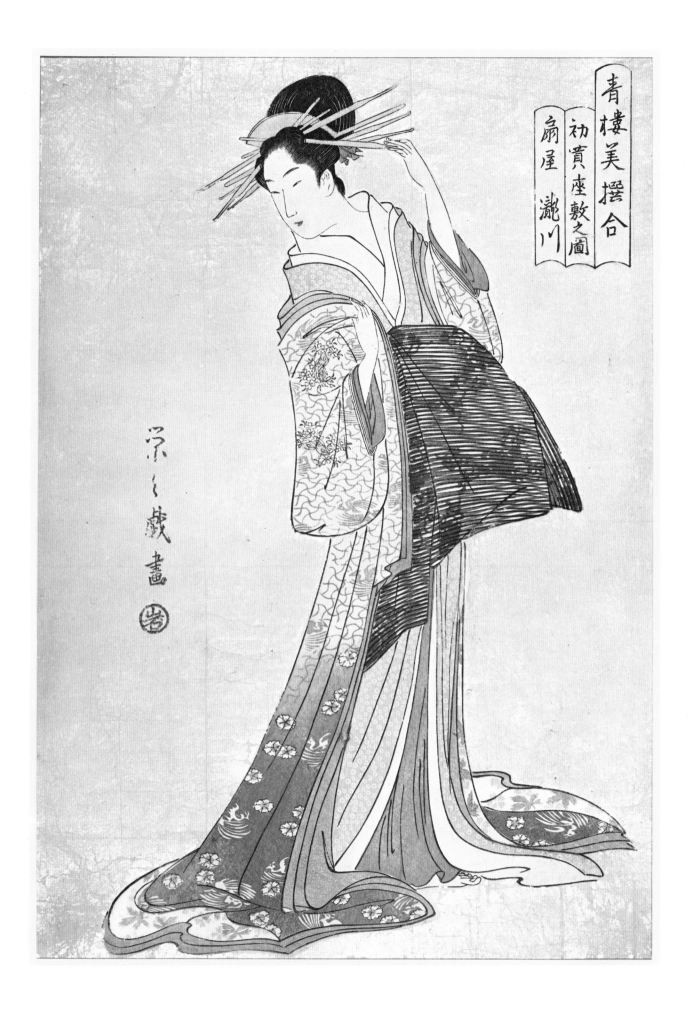

129

Chōbunsai Eishi
Series: FŪRYŪ ROKKASEN (A Popular Abridgment of the Six Master Poets)
No. 2 ONO NO KOMACHI
Ōban, nishiki-e, mica ground, 14 5/8″ × 9 5/8″
Signed: *Eishi Zu*
Censor's Seal
Publisher: *Nishimura*
Metropolitan Museum of Art, Bequest of Henry L. Phillips, 1940

ONE OF THE MOST BEAUTIFUL and intricate prints I have ever seen is this impression of Eishi's Ono no Komachi (see Nos. 72 and 116) from his series of the Six Master Poets. Komachi's elegance and grandeur is almost unparalleled. The print is rich not only in composition but also in color and material. It is truly a harmonious blending of all the ingredients and skills necessary to produce a great work of art.

Eishi represented Komachi as a very tall and stately woman, seated gracefully on the floor. She is distinguished by her beauty and has very delicate features. Her underrobe is of a common tie-dyed pattern called *asanoha kanoko* (speckled hemp leaf). Over this she wears an exquisite jewel-like robe decorated with cherry blossoms. Though it is an overall pattern one tends to view each blossom separately as it floats against a crystalline mica ground. Both of Komachi's hands repeat the same curve and with utmost ease bend downward. One holds a fan, whereas the other is hidden inside her sleeve. The drapery of her sleeves and skirt gently undulates, controlled by the movement of her hands and body. Before Komachi a branch of cherry blossoms rests on a sheet of paper and its bend echoes that of her knees and thighs. Her hair is beautifully

groomed with but a single comb and a minimum of pins. Decorative strips of paper and sprigs of blossoms add to the grandeur of the coiffure. To Komachi's side is a floor curtain which is patterned with symbols of joy and longevity. Its cloth subtly changes from a purple to a warm white.

In the cartouche to the left of that enclosing the title is a poem by Komachi. As is often the case, its subject is the sadness of love and fickleness of man, for love, unlike the flower, fades without outward signs or warning. It has been published by Asatarō Miyamori in *Masterpieces of Japanese Poetry Ancient and Modern* as follows:

Iro miede
Utsurō mono wa
Yo no naka no
Hito no kokoro no
Hana ni zo ari keru

Alas! it is the flower
Within a man's heart
Which fades without signs of a fading color

Though man's ardor may diminish and Komachi may have won and spurned many a lover, her beauty as captured by Eishi will never vanish.

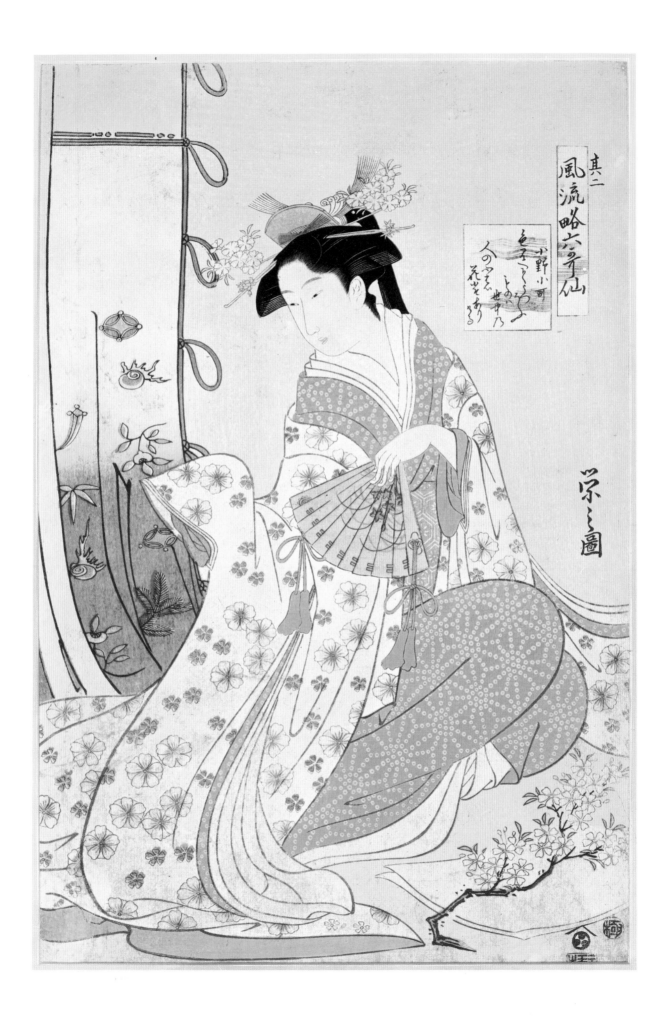

130

Chōbunsai Eishi, 1756–1829

Series: FUKUJIN TAKARA AWASE (A Comparison with the
 Treasured Gods of Good Fortune)

BENTEN

Ōban, nishiki-e, 14 3/4" × 9 7/8"

Signed: *Eishi Zu*

Censor's Seal

Publisher's Seal: *Nishimura*

Philadelphia Museum of Art, Given by Mr. and Mrs. Lessing J. Rosenwald

ANOTHER TRADITIONAL THEME that served as a subject for Eishi was the *Shichi Fukujin* (The Seven Gods of Good Fortune). Benten, the only female deity of the group, who is the patron of art, literature, music, and eloquence, is shown as an exquisite courtesan. Women, and in particular the geisha and lower strata of the Yoshiwara, worshiped Benten because she was considered capable of endowing them with great feminine beauty and charm. Behind her is her *biwa* (a four-stringed lute) and a plectrum. This and a sea serpent are symbols usually associated with her appearance.

The courtesan wears a simple robe sparsely patterned with some of the "Eight Treasures." Her placement in the center of the print, the curve of her knees, and position of her hands are similar to that already seen in print No. 129. She is also a very majestic woman of straight posture and is impeccably groomed. Her hair falls neatly over her shoulder and down her back. It is dark and lustrous and contrasts with her delicate handsome features. Her coiffure is enriched with ornaments—the edges of the pins and bar terminate with finials which repeat the textile patterns, and their projecting ends almost act as a halo or crown to announce her deity.

The title of the series is written on the partially unrolled frontispiece of a handscroll. This sophisticated deity translated into the costume of the Edo period must have been very popular, for in her many women found themselves mirrored.

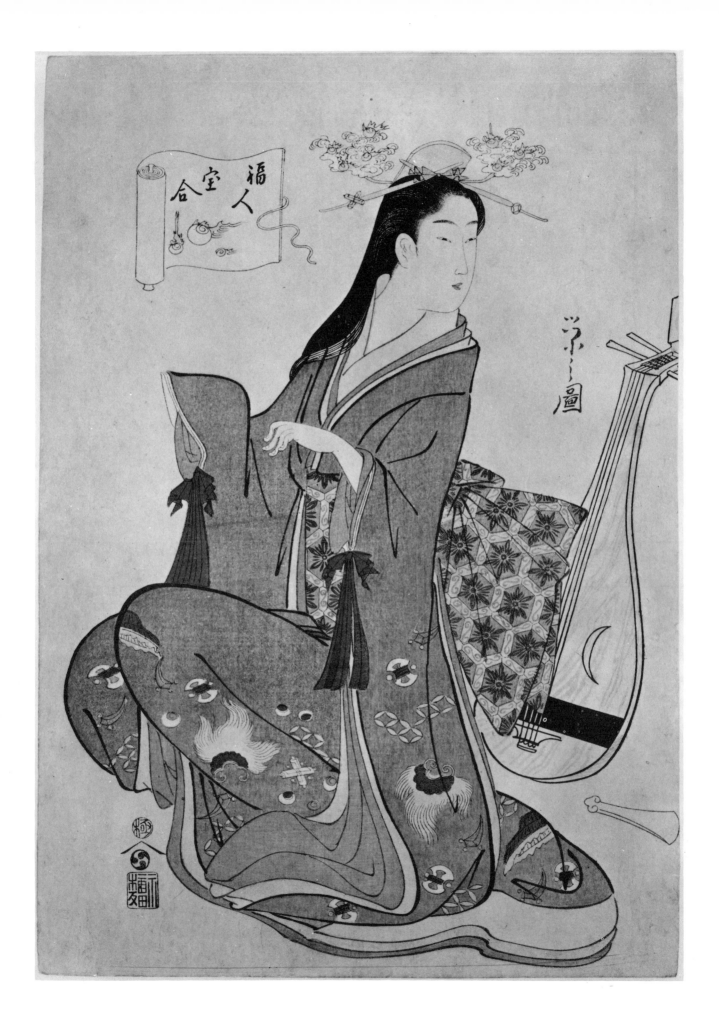

131

Chōbunsai Eishi, 1756–1829

Series: FŪRYŪ NANA KOMACHI: (The Seven Genteel Komachi)

ŌMU (The Parrot)

Ōban, 14 5/8″ × 9 7/8″

Signed: *Eishi Ga*

Publisher's Seal: *Senichi*

Metropolitan Museum of Art, Bequest of Henry L. Phillips, 1940

THE KOMACHI THEME was repeatedly used by artists. We have already seen its employment by Shunshō, No. 72, and Utamaro, No. 116, as well as by Eishi, No. 129. The variation reproduced here is paradoxical for, although a color print, there is very little color. It is basically grisaille in nature, and one primarily senses the presence of variations of intensity and value. There is a fine harmony and clarity brought about by this absence of brilliant color. All is calm and peaceful, and in mood and atmosphere the print should remind us of the similar effect achieved by Shunman in his Six Tama Rivers (Nos. 98–102). The Eishi print, however, is even more peaceful, one might say almost static, for the girls pause and pose. His strong reliance on Kiyonaga can be seen here; but the women are shorter than Eishi's usual canon of proportions and their features are somewhat less elegant.

The subject of the print is the *Ōmu* (Parrot) Ko-

machi. The three figures wear intricately patterned robes of great beauty. The girl on the right holds a love poem undoubtedly indicative of the poet's many affairs. Although it has not been properly read, the poem is in all likelihood a creation of Komachi. The block cutting of the pattern of her robe is incredibly complex and skilled. The second figure holds a folded fan; her obi, like that of the previous figure, leads us to the young girl who carries a closed umbrella and wears a chrysanthemum-patterned black kimono and obi decorated with plover in flight. It is interesting that Eishi cleverly made the plover fly in the same direction that the child glances. The landscape has a high horizon line. On the left, the print is framed by a twisting tree that reaches in and out of the composition. A small cluster of farm huts, a winding stream, rice fields, and distant hills occupy the landscape. A sad figure of an elderly woman leaning on a staff is also symbolic of the aged Komachi.

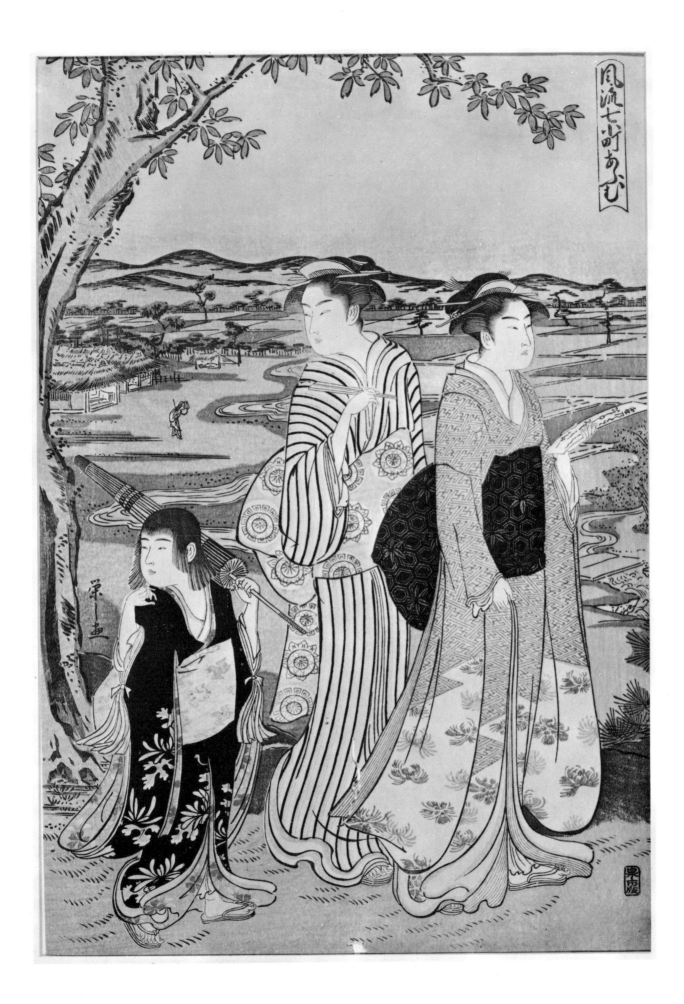

132

Hosoda Eisui, act. 1790–1800

Series: BIJIN GO SEKKU (Beauties of the Five Annual Festivals)
SOMENOSUKE OF THE MATSUBAYA

Ōban, nishiki-e, 14 7/8″ × 9 7/8″

Signed: *Ichirakutei Eisui Ga*

Censor's Seal

Publisher: *Maruya Bunemon*

Nelson-Atkins Gallery, Kansas City, Missouri (Nelson Fund)

ONCE AGAIN WE COME TO an artist about whom we know very little. Eisui was his name and, from stylistic evidence as well as the name, we can conclude that he was a pupil of Eishi. He appears to have been active about the start of the nineteenth century, for there exist dated illustrated books signed by him. His birth and death dates, however, are unknown, as are the facts about his origin or training. Some scholars have ranked him with Eiri as having been one of the best of Eishi's pupils. Such comparison, however, is really of little importance and is most often based on but a superficial evaluation of the artist's work. The tendency on the part of art historians to pit artists against each other is reprehensible. Points of comparative reference are important and relative quality is of interest, but aesthetics and beauty should not be sacrificed solely for the purpose of creating a ladder of success.

Eisui's women have the same elongated faces, drawn with great delicacy, as those used by his teacher. In contrast to Eishi's, his women are a little less noble. They are earthier, and in their eyes one can detect a twinkle and the slightest trace of mischievous-ness. Such is true of this print by his hand in which he has portrayed the courtesan Somenosuke of the house called Matsubaya, as part of a series depicting beauties of the five festivals. In all likelihood, being an early summer scene, with the fan and iris in the cartouche, this is *Tango*, or the fifth day of the fifth month, the Boys' Festival. The girl's coiffure is beautifully depicted. The side locks are tied up with a band, adding to the elongation of her face. Her pins are simple and tastefully decorated with plaques on which appear three *wakaba* (young leaves). In her hair is a twist of cloth that adds interest and depth to the slick raven hair. Somenosuke may well have just stepped from the bath for she wears a *yukata* with a hemp-leaf pattern. The leaves are not stiff and formal but curve, adding softness to the robe and comple-menting the loveliness of her bare shoulder, which can be seen suggestively through the green gauze fan she holds. There is no harshness present in the print. Everything is soft and sweet, though not saccharine. Somenosuke, attended by her two *kamuro*, Wakaki and Wakaba, must have been a beauty of great charm.

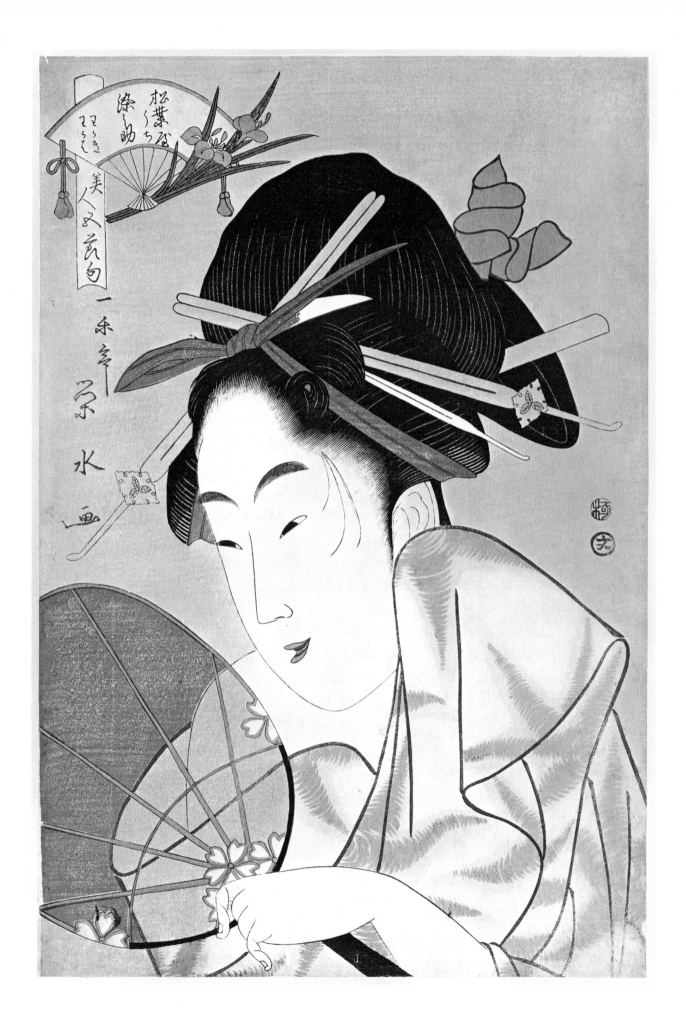

133

Eishōsai Chōki, act. 1785–1805

CATCHING FIREFLIES

Ōban, nishiki-e, mica ground, 14 7/8″ × 9 5/8″

Signed: *Chōki Ga*

Publisher: *Tsutaya Jūsaburō*

Mr. and Mrs. Edwin Grabhorn, San Francisco, California

EVERY ONCE IN A WHILE one comes upon an artist who produced a good number of prints but is noted only for a small group carefully selected from his total production. Eishōsai Chōki is such a man. He was active during the closing years of the eighteenth century and the opening of the new era. As competition was keen his work was often overshadowed by his colleagues, such as Kiyonaga, Shunshō, Utamaro, and Eishi. We are somewhat in the dark as to his biography. It is believed that he was a pupil of Toriyama Sekien, who, as we have already seen, had befriended Utamaro. A good deal of confusion exists over the names that he is said to have used. One theory contends that he called himself Hyakusen Shikō; but sometime between 1781 and 1788 he changed it to Chōki, only to revert to Shikō about 1796; he further complicated matters by returning to the use of Chōki about 1801. As usual, all this is theoretical, without factual backing. He appears to have been well acquainted with the same publisher, Tsutaya Jūsaburō, who had so greatly inspired Utamaro. Many illustrated books carry the Shikō name; however, we really do not know whether or not the two were the same man.

Whoever Chōki was, his ability as a creative artist was great. One of his finest designs is this print depicting a boy trying to catch fireflies, while a girl, holding a fan and cage, looks on. The background is of dark mica and the insects light up and glow in the deep night. Fancifully their light reveals the hunters as they walk along the edge of an iris-banked pond. Chōki's use of color is very striking and rich. He combined it with subtle effects such as the white *yukata* worn by the girl which is patterned with a most delicate blue tie-dyed hemp-leaf design. The boy races with his hands raised as he tries to capture the evasive flashes of light. In comparison with the figures of his contemporaries, Chōki's girls are even slenderer—graceful and beautiful flowers. They do not bend as do those of Eishi or Utamaro, but are stiff-backed and formal, much as the iris spikes which occupy the background. Several impressions of this noble print exist, and all of them are breathtaking. This is among the finest. How peaceful the summer evening must have been when fireflies danced and lit the sky, and we were privileged to walk in the presence of beauty, disturbed only by the sound of fans moving the summer air.

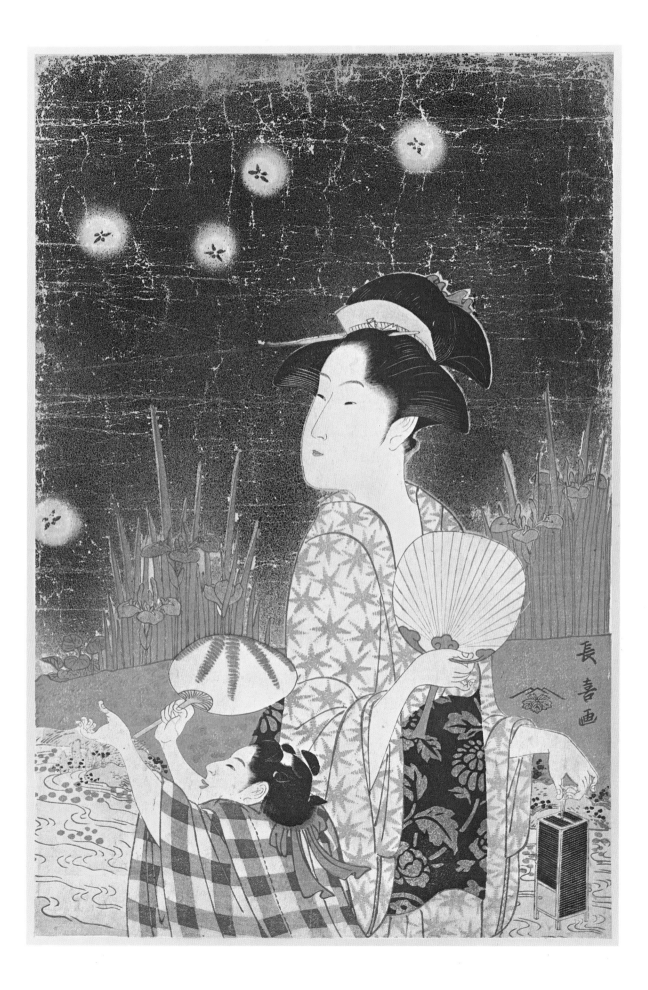

134

Eishōsai Chōki, act. 1785–1805

SUNRISE ON NEW YEAR'S DAY

Ōban, nishiki-e, mica ground, 15″ × 9 7/8″

Signed: *Chōki Ga*

Censor's Seal

Publisher's Seal: *Tsutaya Jūsaburō*

Mr. and Mrs. Edwin Grabhorn, San Francisco, California

A SECOND VERY STRIKING PRINT executed by Chōki that is considered, with Nos. 133 and 135, to be among his masterpieces is this refreshing depiction of a girl who has stepped forth into the cold morn of New Year's Day to watch the sunrise. There is an ethereal beauty about the print. The sun glows with rich intensity as it penetrates the darkness of the night and drives it away. Its curvature is repeated in the coiffure of the woman, who wears a coat and clasps her robes close to her body to protect herself from the chill. Her garments are sophisticatedly patterned, the designs subdued. Her face is refined; one almost feels that her eyes are still laden with sleep, for they are not fully open. She stands before a rush fence and a stone wall on which rest a dipper and a potted *Fukujusō (Adonis sibirica)* plant, symbolic of New Year's Day. The straightness of the girl's posture adds to the effect of the crisp winter day.

Once again much discussion and confusion exists regarding different so-called "states" of the print. Generally, this impression follows those mentioned by Ledoux and usually referred to as French, for the publisher's mark is placed over the waves. The moon has undoubtedly not totally vanished; with the rising sun it illuminates the blue and silvery water. A band interpreted as being either a cloud or sand bar bisects the water. Its edges are not outlined and this, according to some scholars, marks the print as being a rare, early impression. It is a unique specimen of loveliness.

In the catalogue titled *Japanese Prints of the Ledoux Collection, Sharaku to Toyokuni,* the other known impressions are listed and the related problems are briefly discussed.

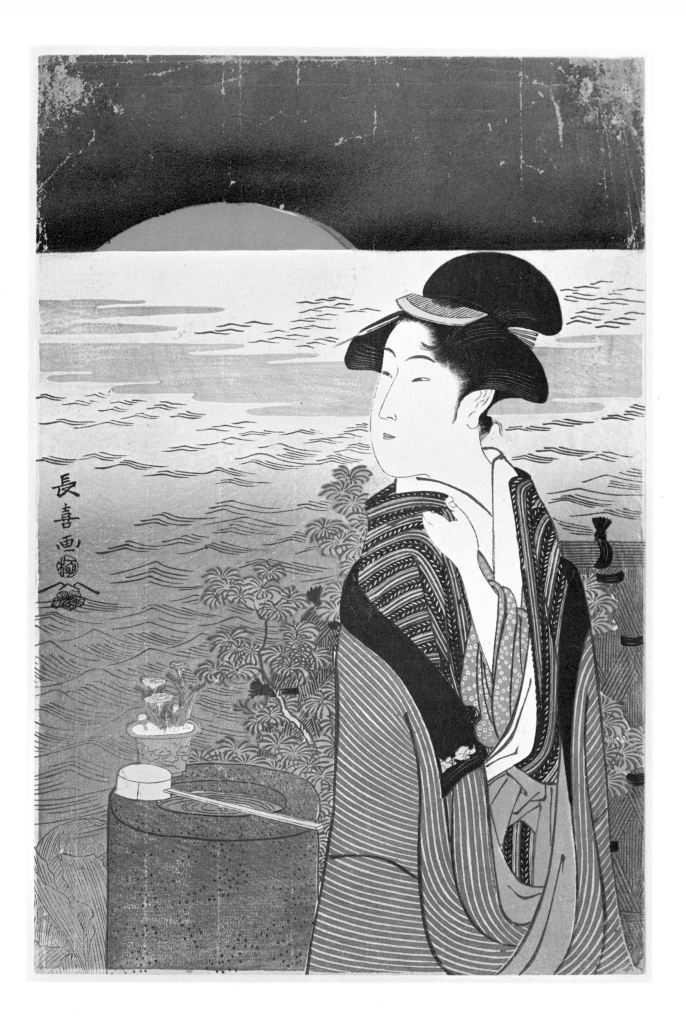

135

Eishōsai Chōki, act. 1785–1805
GIRL IN THE SNOW
Ōban, nishiki-e, mica ground, 15″ × 10″
Unsigned
Mr. and Mrs. Edwin Grabhorn, San Francisco, California

THIS IS THE LAST of the three prints (with Nos. 133 and 134) by Chōki considered to be his masterpieces. They are all seasonal and it would have been tempting to refer to them as a set of beauties of the seasons. Such is not the case, however, for winter appears twice. A fourth print depicting an autumn moon scene also exists, but due to the lack of documentation it would be wisest for the present to consider it unrelated.

Chōki's approach to the subject is fresh and beautiful. The woman holds an open umbrella and leans on the shoulder of her porter as he stoops, probably to remove the freshly fallen snow which has gathered in her clogs. There is a general lack of angularity in the print save for the "Y" formed by her robes as they are folded across her bodice. Her parasol is snow-covered and its form is somewhat echoed by the porter's hat and the girl's hair. Chōki cleverly contrasts the two types. The male's face is plump and his beard is bristly. He is a simple, rather coarse man serving his mistress. The girl is tall and elegant, her face thin and elongated. Her robes, partially hidden by her black coat, are colorful and richly patterned. Her hair is impeccably arranged. The comb and bar are carefully placed, and even the paper ornaments curve in to avoid the semblance of angularity, thus adding to the towering effect of the coiffure. The colorful rings of the umbrella are balanced by the single color of the stooped form of the man. Though this impression has faded a good deal, it retains the beauty of the original design.

It is believed that the print originally had a light mica ground and that white snowflakes were floated against this. Evidence of their presence can still be seen in this specimen. Once again there is confusion, for in some impressions of the print the artist's signature, censor's seal, and publisher's mark appear. Such is the case of the Matsukata print and former Straus-Negbaur impression now in the Honolulu Academy of Arts. As can be noted, the signature and seals are missing in the impression published here as well as on that formerly in the Ledoux collection. It is difficult to conclude which was the first state; however, most scholars would tend to favor that with the signature. Oddly enough, the signature appears unnecessary and clumsy, and the author, on aesthetic grounds, would favor the impression on which it has been omitted.

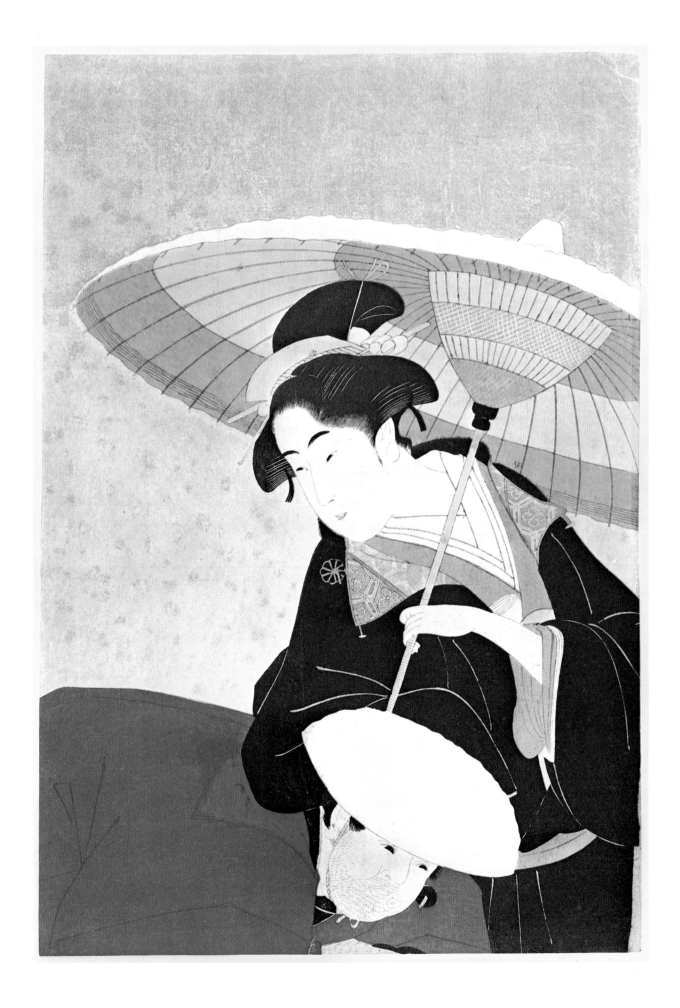

136

Eishōsai Chōki, act. 1785–1805

Series: SEIRŌ NIWAKA ZENSEI ASOBI (Burlesques Performed by Residents of the Brothels)

...JU MIYAKO NO NISHIKI, KAKKO-URI TETSU, AND HŌROKU-URI SANOSUKE

Ōban, nishiki-e, 14 5/8" × 9 3/4"

Signed: *Chōki Ga*

Publisher's Seal: *Tsuruya Kiemon*

Collector's Seal: *Wakai Oyaji (Wakai Kanesaburō)*

Metropolitan Museum of Art, Rogers Fund, 1936 (Mansfield Collection)

AN EXAMPLE OF CHŌKI'S WORK showing strong reliance on a design often favored by Utamaro is this print, in which three bust portraits of figures are arranged in a pyramidal composition. The fascinating feature of this print is the amazing degree of realism the artist has imparted to the portrait of the older gentleman on the right. He is not simply an idealized type but is quite obviously a person known to the artist. He appears to be consulting a play libretto, and this print may be a portrait of the author of the play. His face is very long and his nose is not one of the stereotyped forms used by Japanese artists; it is large and curved, imparting character to the face, as do the large sad eyes, wrinkles, and open mouth. He appears oblivious to the action going on about him. The two other figures posture in their roles. The foreground figure appears to be called Sanosuke and is a peddler of earthenware pots. He is an actor made up with hair brushed forward creating two puffs at each side of his head projecting from beneath a floppy green hat. This figure has one hand curved and raised in his sleeve, whereas the other holds a gong which will be struck to summon clients. The central figure appears to be called Tetsu and is a seller of drums. One of these is tied to a branch of maple held behind his head. The actor's other hand, like that of Sanosuke, is raised and hidden within his sleeve. From the cloth tied over the forehead, the figure is clearly identifiable as an actor in female disguise. The robes of both actors are beautifully patterned with designs of cherry blossoms. Their richness and color give the print a festive air.

Chōki enhanced the realism of the gentleman on the right by adding flesh color to what normally was left white; thus, in contrast to the actors, he does not wear theatrical make-up. The print is a most effective design, but unfortunately has been trimmed at the top. The author knows of no other impression and it is possible that part of the title on the upper right is missing. One can speculate that the portrait was meant as an honor to one of Chōki's friends or may even be a self-portrait.

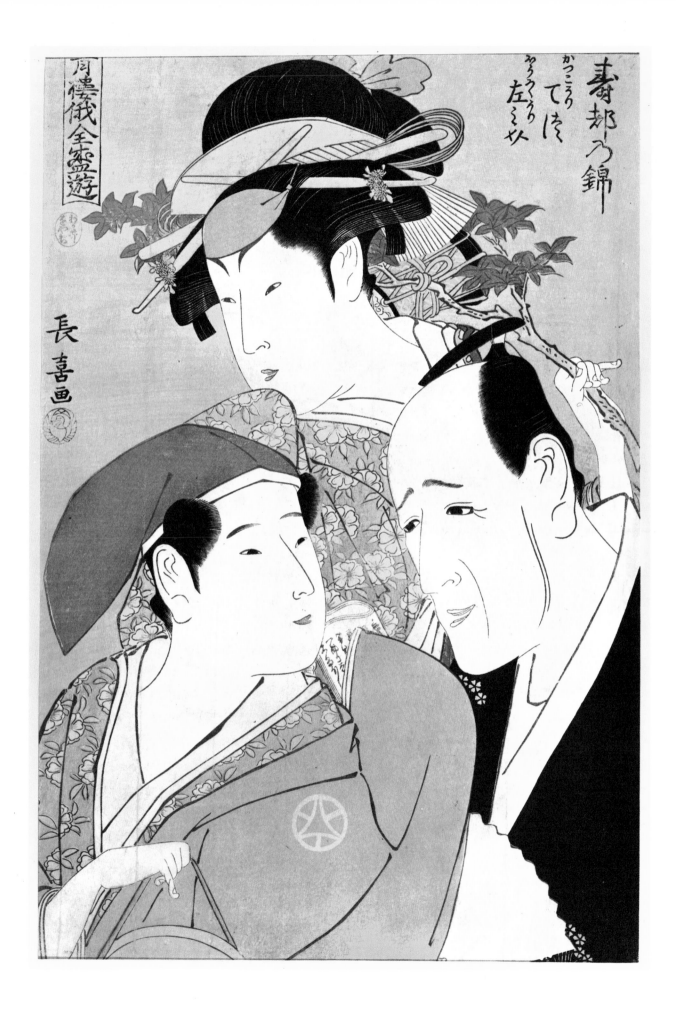

137

Katsukawa Shunkō, 1743–1812
THE ACTOR ICHIKAWA MASUGORŌ II PERFORMING
THE LION DANCE
Hoso-e, nishiki-e, 12 5/8″ × 5 3/4″
Signed: *Shunkō Ga*
Grunwald Graphic Arts Foundation, University of California, Los Angeles

AN ARTIST WHO WAS A PUPIL of Shunshō and continued the Katsukawa tradition that he had founded was Katsukawa Shunkō. He was born in 1743 as a member of the Kiyokawa family and was noted as a master of theatrical portraits. In fact, he excelled at this so well that he was scheduled to succeed to his master's mantle upon his demise as leader of the school. Unfortunately he was stricken with paralysis in 1787 or 1788 and his right hand became useless. He bravely did not give up painting, but was forced to use his left hand and signed his work, accordingly, Sahitsusai (The Studio of the Left Brush). As an artist he also made use of the name Denjirō, and dwelt for at least part of his life in Edo at Hasegawa-chō. He is reported to have feuded with Hokusai, then known as Shunrō, and appears to have been one of the reasons that Hokusai parted with Shunshō. As a result of Shunkō's paralysis, Shunshō's studio did not fall to him and instead Shunei, Nos. 80–84, succeeded as chief of the Katsukawa school. Not much later in

his life Shunkō entered the priesthood and died during the sixth month of 1812.

In this print he has depicted the actor Ichikawa Masugorō II performing the well-known lion dance, which we have already seen in prints Nos. 42 and 62. The same basic costume elements appear, with the actor wearing long red hair and having as a hat two fans topped by a huge peony blossom. It is a very energetic portrayal—he dances away as he waves peony branches in his hands. About his head flit butterflies, attracted by the beautiful fragrant blossoms. One of Masugorō's robes repeats the theme and is butterfly patterned. Shunkō carefully related the actor to the space, for not only are the floor lines indicated but also the ceiling paneling. The contrast between the angularity of the architectural elements and curvilinear figure in motion is very effective. The robes are all disarranged and the drapery twists madly about following the pattern of the dance in this lively portrayal.

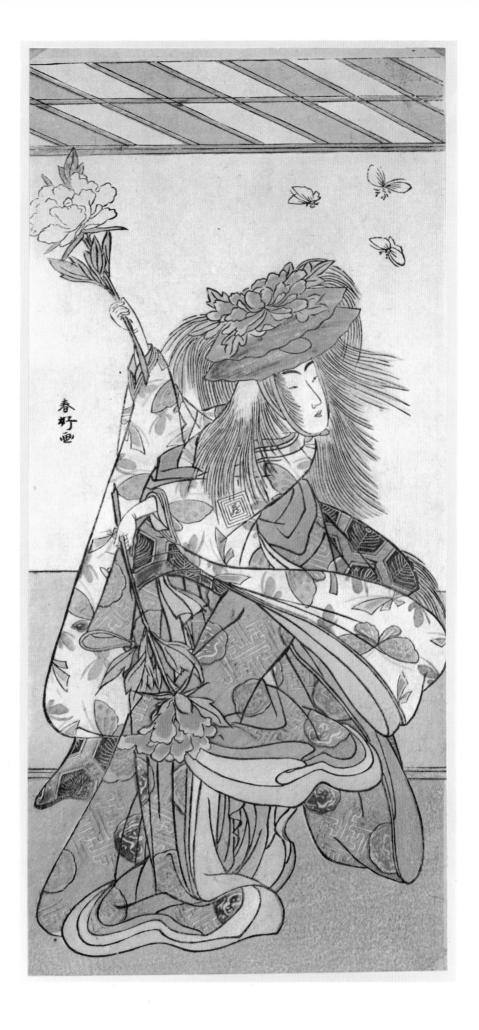

138

Katsukawa Shunkō, 1743–1812

THE ACTOR ICHIKAWA KOMAZŌ II

Ōban, nishiki-e, 14″ × 9 1/2″

Signed: *Shunkō Ga*

Nelson-Atkins Gallery, Kansas City, Missouri (Nelson Fund)

SHUNKŌ'S SKILL at large bust portraits of actors was great. He approached the subject with a biting commentary similar to that of Enkyō, Shunei, and Sharaku. In some ways his actors appear to posture more noticeably, for they jut their chins forward as though seeking to bask a moment in the limelight that meant their livelihood. In contrast to the other mentioned artists Shunkō's hand was somewhat heavier, the drawing bolder. Thus, the lines are broader, and the engraver was able to make wide grooves in his block as he chiseled out the print.

In this portrait Shunkō depicted the notable actor Ichikawa Komazō II. Much like the Danjūrōs, Komazō strutted across the stage and had rather markedly grotesque features. His nose was large, with a decided curve. In addition to this his nostrils flared and his mouth was but a single downturned slash. There is little doubt about his being cross-eyed, for his pupils focus on the bridge of his nose. His unshaven head indicates that he may be portraying the role of a villain. His sideburns billow out and frame his face, making his features even more noticeable, while his make-up indicates a slight trace of a beard. Komazō's crest is placed on the robe which, being richly colored and patterned, also leads the viewer to concentrate on the stark face. The ends of the actor's bushy eyebrows are composed of but a single line pointing downward and accenting his eyes. It is truly a bold representation of Komazō II (who in later life took the name of Matsumoto Kōshirō V). One might speculate on what would have happened to *ukiyo-e* history and especially to our next artist, Hokusai, had Shunkō not suffered paralysis.

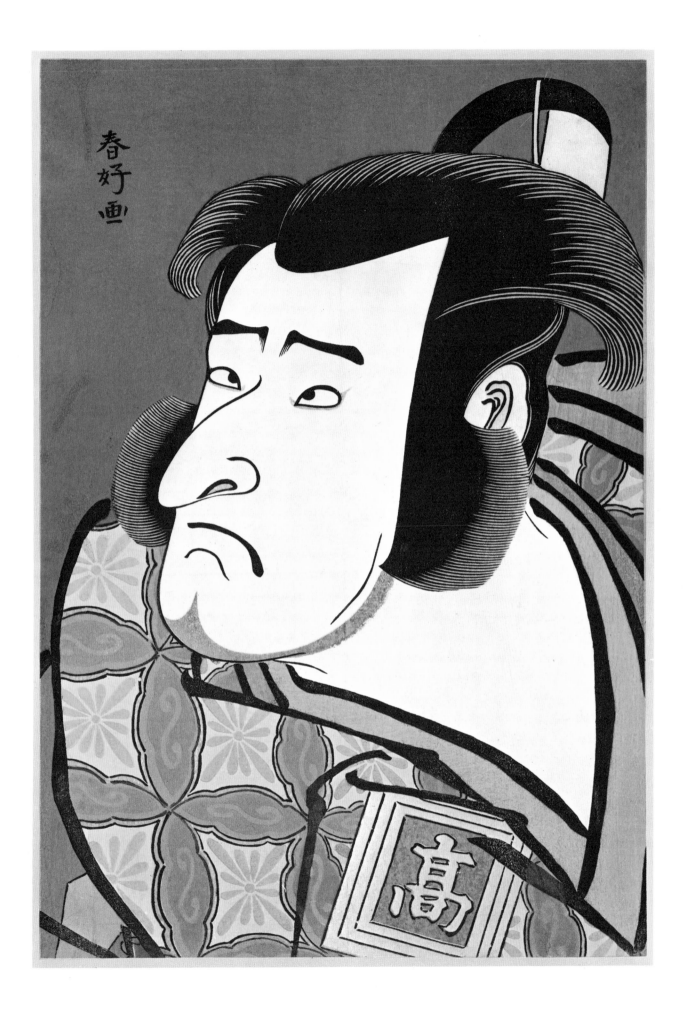

139

Katsushika Hokusai, 1760–1849

PEONIES AND CANARY

Chūban, nishiki-e, 10″ × 7 7/16″

Signed: *Zen Hokusai Iitsu Hitsu*

Censor's Seal

Publisher's Seal: *Eijudō*

Mr. and Mrs. Richard P. Gale, Mound, Minnesota

FEW ARTISTS LEFT as great an imprint on a school of art as did Katsushika Hokusai on the realm of *ukiyo-e*. His influence extended far beyond Japan and there are few areas of the world where in cultured circles his name is not known. It is rather strange that this basically modest man who was devoted to naught but his art should have achieved such fame. In the Western world he came to light partially through a fortunate set of circumstances, for legend reports that pages of his illustrated books were used as wrapping paper and packing around crockery shipped to France. Paris, the center of the Western art movement, was in the throes of great artistic change and Hokusai's handsome and deft designs were snatched upon by the renegade artists because of their curiosity and aesthetic appeal. This was, however, almost fifty years after his death. Yet there never seems to have been any lack of demand in Japan for his work during his lifetime. He was not a man of means, but a man married to his art. Thus, his use of the signature Gakyō Rōjin (The Old Man Mad about Painting) is truly applicable. Hokusai did quantities of book illustrations, prints, sketches, and paintings. His brush was filled with life and his work remains as alive today as when it was first created. It has survived the test of time.

As has so often been the case, insufficient biographical data exists about Hokusai, though scholars such as Professor Muneshige Narazaki, Jack Hillier, and others have tried to untangle the twisted skein that holds the thread of his life. Confusion even exists at the present moment as to his parentage. Hayashi Yoshikazu in an article titled "Hokusai no chichi wa Nakajima Ise" (Hokusai's father was Nakajima Ise), published in *Ukiyo-e Geijutsu* (Ukiyo-e Art), No. 17, Tokyo, 1968, pp. 14–22, dismisses the story that he was born of the Kawamura family and adopted into that of the mirror maker Nakajima Ise. The facts are not yet thoroughly substantiated; however, we do know that Hokusai was born during the ninth month of 1760, supposedly in Honjo, Warigesui, which formerly was a part of Shimosa Province, Katsushika Gun (County). It is from this last name that Hokusai borrowed his studio name. As a child he was called Tokitarō and later Tetsuzō and as son or adopted son dwelt in the household of the mirror maker Nakajima Ise. While in this household Hokusai was quite obviously exposed to craftsmanship and this prepared him for his career, for at fourteen he was apprenticed to an engraver of wood blocks. At approximately eighteen, in 1778, Hokusai entered the studio of Shunshō and was given the name Katsukawa Shunrō. This fact raises one of the frustrating problems in studying Hokusai, for he constantly changed his name as well as his residence. Estimates include fifty names or combinations and ninety residences. After a few years in Shunshō's studio, Hokusai moved on to study the techniques of the Kanō and other schools. This occurred about 1785; some scholars feel it was the result of a conflict with Shunkō (Nos. 137 and 138). He later used the name Sōri and even investigated the artistic style of the Rimpa school of painting. It actually was not until 1799 that he seems to have adopted the Hokusai name alone, and it appears first in a book titled *Azuma Asobi* (On the Town). In 1804 and 1817 he executed colossal paintings of Daruma in Edo and Nagoya. He even entered a painting competition with the popular artist Tani Bunchō (1764–1840) and is said to have startled the viewers by creating a composition of red hen tracks on a broad blue line and titling it *Maple Leaves Floating on the Tatsuta River*. Hokusai's creative ability and originality were great.

In 1811, at the age of fifty, he commenced using another of his favorite names, Taito. During this same period he quarreled with Kyokutei Bakin (1767–1848) whose books he had often illustrated, and a few years later in 1818 he traveled to Osaka and Kyoto; through the aid of Bunchō he survived what commenced as a disastrous trip. When sixty-nine years old Hokusai became chronically ill with palsy; however, following Chinese medical advice he cured himself. It was shortly after this period that he was severely plagued with a cause of great sorrow, his grandson. The young man was constantly in debt and Hokusai repeatedly bailed him out. The stories of Hokusai's life are too many to include here. He brought freshness to the wood-block print in the form of landscape and humor through his *Manga* (Cartoons).

We know Hokusai principally through the prints executed later in his life when he used the Gakyō

continued on page 308

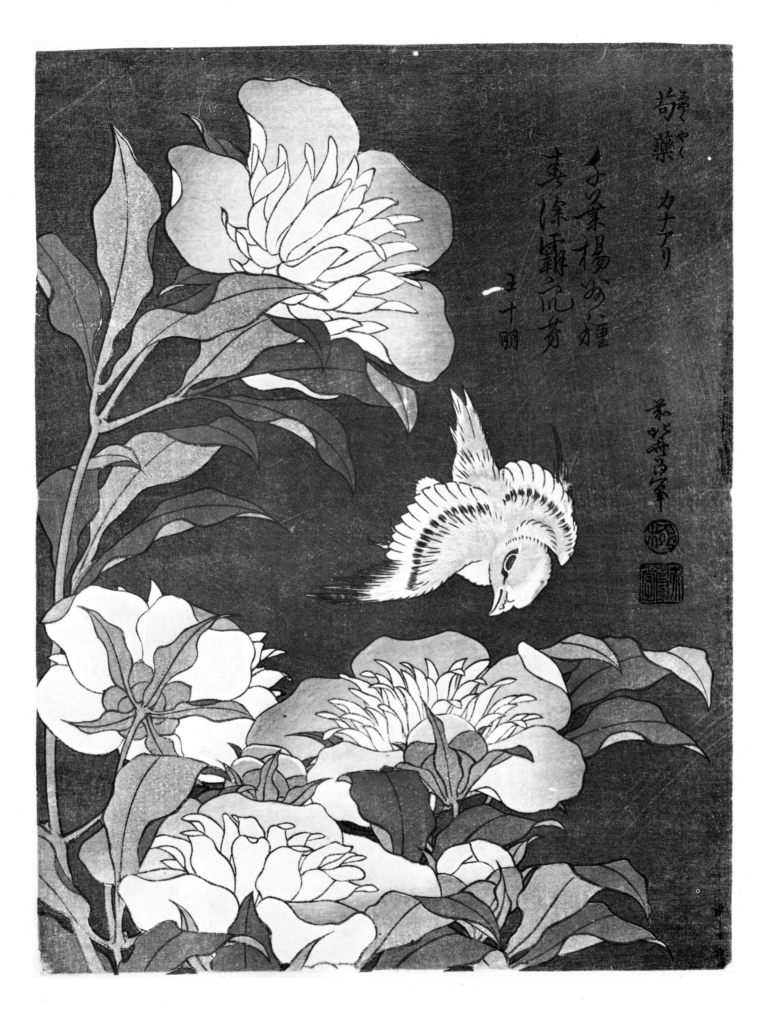

140

Katsushika Hokusai, 1760–1849

Series: SHOKOKU TAKI MEGURI (Travels to the Waterfalls
 of the Various Provinces)

THE KIRIFURI WATERFALL

Ōban, tate-e, nishiki-e, 14 1/5″ × 9 5/8″

Signed: *Zen Hokusai Iitsu Hitsu*

Censor's Seal

Publisher: *Eijudō*

Nelson-Atkins Gallery, Kansas City, Missouri (Nelson Fund)

THE SUDDEN APPEARANCE and flourishing of landscapes in the second quarter of the nineteenth century almost makes one think that the local authorities had inaugurated a campaign dedicated to "See Japan First." Such was not the case, for Japan was still closed to the Western world and travel abroad was carefully controlled and prohibited save under certain set conditions. In the past the artists of Japan rarely portrayed the landscape of their homeland. There naturally were exceptions, such as the screens depicting scenes in and about Kyoto as well as paintings of Mount Fuji, Lake Biwa, Amanohashidate, and temple or shrine environs; however, these were not the standard fare and the academic schools of art generally avoided the local scene. In the second decade of the nineteenth century travel flourished and the Japanese appear to have rushed about on pilgrimages to see the scenic wonders of their beautiful land. It is such a scene that Hokusai captured in his print series *Shokoku Taki Meguri* (Travels to the Waterfalls of the Various Provinces).

There were eight prints in the waterfall series, and it appears likely that Hokusai had actually visited the sites. In Shimozuke Province at Mount Kurokami there was a handsome fall called Kirifuri (Falling Mist). It is truly a magnificent fall—the water cascades down a cliffside and breaks over rock outcroppings to divide into many fast-moving rivulets that foam and plunge earthward. The many streams of water almost resemble the root structure of a tropical banyan tree. Once the water reaches the mainstream, it bubbles and sends up a veil of mist. Hokusai has placed small figures in the landscape gathered in awe to view this marvel of nature. These simple pilgrims are placed at the bottom of the print. Their heads are raised in wonder at the sight and also in concern for the two other men who cling precariously to the cliffside and a tree branch. Hokusai cleverly worked into the design a reminder that Eijudō was the publisher of this series and, in fact, this may also indicate that he had sponsored the waterfall excursion. The center figure at the bottom has the trademark of Eijudō stamped on his back pack, and the man clasping the tree above has the character read *Ei* inscribed on his hat. It is summer and the trees are in full foliage. Hokusai's color is rich and appealing, and he keeps the viewer's eye in movement. Nature is bountiful and wonderful, and Hokusai loved it and shared it with his fellow man, reminding him either of a visit he had made or one he someday hoped to take. Somehow, through this series of prints, Hokusai harnessed the falls.

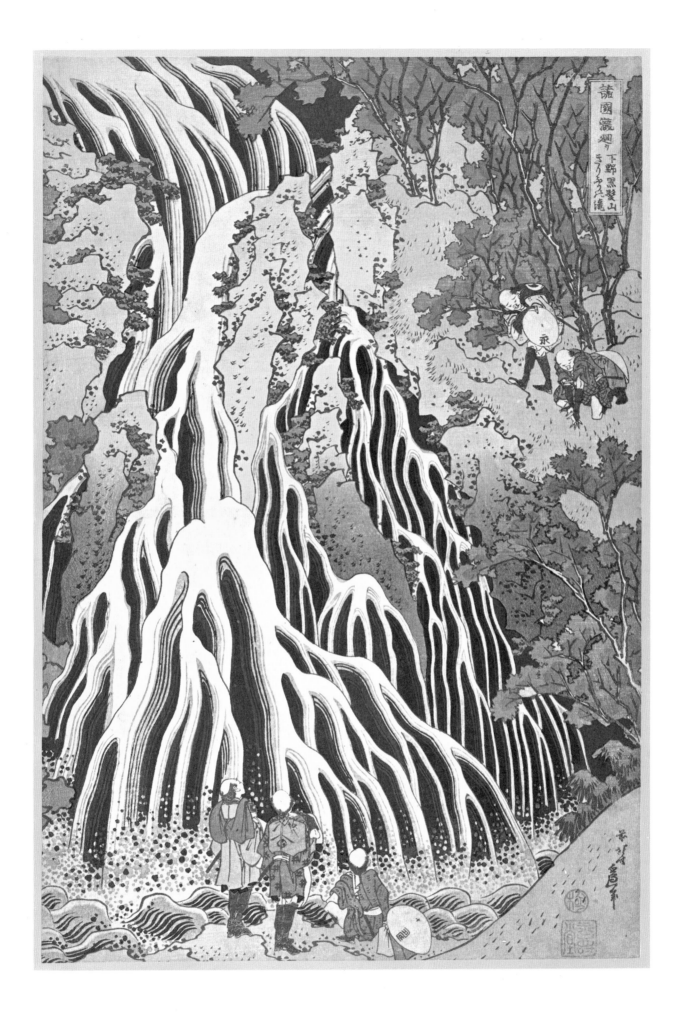

141

Katsushika Hokusai, 1760–1849

Series: FUGAKU SANJŪROKKEI (Thirty-six Views of Fuji)

GAIFŪ KAISEI (South Wind and Clearing Weather)

Ōban, nishiki-e, 10″ × 15″

Signed: *Hokusai Aratame Iitsu Hitsu*

Metropolitan Museum of Art, Rogers Fund, 1936 (Mansfield Collection)

THE JAPANESE HAVE always had a love of beautiful shapes and forms, and what could be simpler and lovelier than the optically inverted fan-shaped symmetry of Mount Fuji! Hokusai's keen eye recognized the incredible beauty of this sacred mountain that has stood ageless before the myriad inhabitants of Japan. The mountain had been favored in literature and occasionally in painting; however, Hokusai took a different approach. He fell in love with it and examined it from every angle and clime. He revealed it in the harshest of light; at other times he hid it in dense mist that gently cushioned it against the sky and masked the flaws marking its rugged volcanic existence. Fuji quite clearly symbolized Japan to him, and its strength was probably equated as symbolic of his own life and the monument he wished to leave behind when summoned from this earth. He used the subject more than once, for in 1834 and 1835 he issued a series of illustrations titled *A Hundred Views of Fuji*. Sometime in the late 1820s he produced his most noted and beautiful series of prints titled *Fugaku Sanjūrokkei* (Thirty-six Views of Fuji). Although the entire series is notable, one of the most striking prints is that which is often called the *Red Fuji*, but is actually titled *South Wind and Clearing Weather*.

In this print Mount Fuji rises majestically against a sky of fleecy clouds. The snow has almost entirely melted and summer has brought greenery to its lower reaches, away from the reddish volcanic cone. It is pure landscape; man does not intrude upon the scene. Fuji is placed asymmetrically on the sheet to counter its own symmetry. One can only marvel at Hokusai's creative ability in so capturing the purity and solitary sanctity of this mountain. It is almost as though we have been invited to pause in silence and join Hokusai in meditation before it.

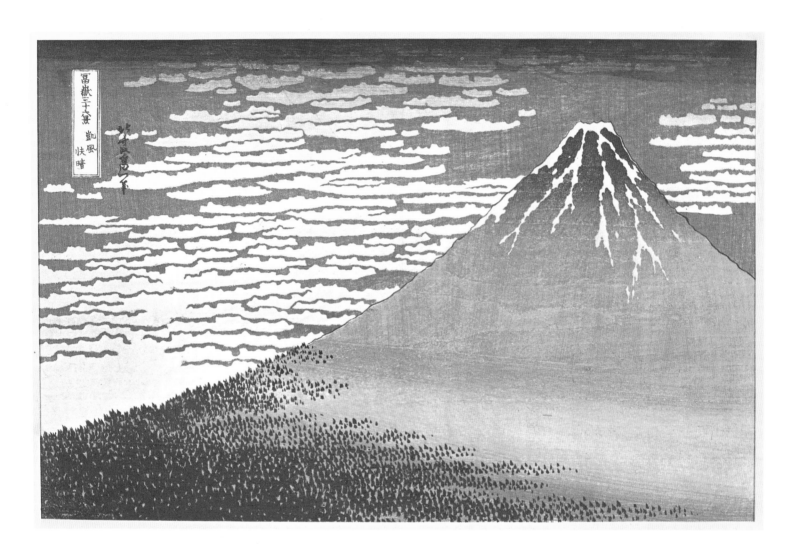

142

Katsushika Hokusai, 1760–1849

Series: FUGAKU SANJŪROKKEI (Thirty-six Views of Fuji)

KAZUSA NO KAIRO (The Sea Off Kazusa)

Ōban, nishiki-e, 10 1/8″ × 15 3/16″

Signed: *Zen Hokusai Iitsu Hitsu*

Grunwald Graphic Arts Foundation, University of California, Los Angeles

MOUNT FUJI WAS BEAUTIFUL when seen close up, and Hokusai also makes us aware that from wherever it be viewed its loveliness does not diminish, even though it be but a speck on the horizon. Fuji is visible over much of the land and dominates the landscape.

The *Fugaku Sanjūrokkei* series (Nos. 141–143), although translatable as *Thirty-six Views*, actually consists of forty-six sheets. Hokusai's love of the mountain was so great that he lost count; also, the print had great popularity and the public and publisher demanded more. On this sheet Hokusai has represented Mount Fuji as seen from the sea off Kazusa, looking across what would today be the mouth of Tokyo Bay. Two large boats appear in the foreground. The wind tugs at their sails and directs our eye back to the snow-covered Fuji on the distant horizon. The boats are sturdy wooden crafts that ride in the water. Through an open panel in the foremost boat four men can be seen; three peer out while the fourth man's back is turned. In a fashion more typical of Hokusai than print No. 141, the human element and action are present. The bay curves gently and in the distance the sails of a second group of boats can be seen as well as the shoreline. The palette is that so often employed by Hokusai, composed of blue, green, yellow, and brown. The dark horizon line and upper edge of the print draw us miles into Japan.

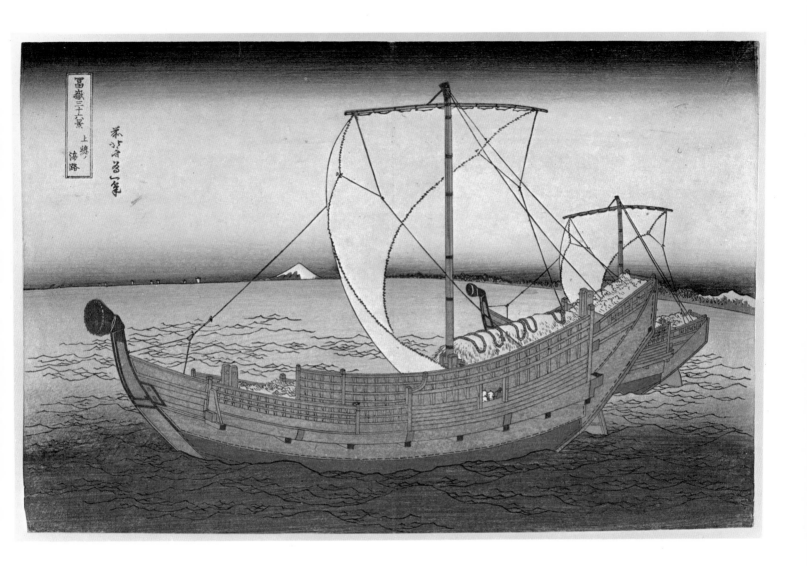

143

Katsushika Hokusai, 1760–1849
Series: FUGAKU SANJŪROKKEI (Thirty-six Views of Fuji)
JŪ SENJU KAGAI CHŌBŌ NO FUJI (Fuji as Seen from the Licensed
 Quarter of Senju)
Ōban, nishiki-e, 10″ × 14 3/4″
Signed: *Zen Hokusai Iitsu Hitsu*
Collector's Seal: *Hayashi Tada[masa]*
Grunwald Graphic Arts Foundation, University of California, Los Angeles

A DAIMYO'S PROCESSION moving along a roadway is the subject of this third print from the *Thirty-six Views of Fuji* series by Hokusai. The location is Senju, a suburb of Edo, where one of the licensed quarters was located. The retainers and samurai of a feudal lord proceed to a small wayside rest stand set on the edge of a field. They wear the same robes and all carry on their shoulders what probably are matchlocks. At the far left, the standards of the procession project over the roof of a farmhouse and continue the line of its pitched thatched roof. Rice sheaves are tied about the trunks of the trees and, when combined with the warm outer robes worn by the men, signify that it is cold and probably early autumn. The faces of the figures are composed of but a few lines, yet the drawing is so skilled that they express a multitude of emotions. This, as well as the stylized anatomy, is characteristic of Hokusai. Through his genius he was able to relate figures and make them all appear active.

Hokusai truly understood human nature for the warriors are being lured by two farm maids who sit on a raised path and teasingly dangle their feet as they watch the troops move by. The line of march is somewhat broken, for some of the men have turned to gape at the girls. Hokusai placed a walled village in the background. Many white-walled storehouses appear, indicating that it is a relatively prosperous area. Blue clouds move in and out like fingers over the landscape, and on the far horizon Mount Fuji, wearing a mantle of snow, rises above the trees, which have yet to lose their leaves. Fuji reigns in majesty regardless of locale.

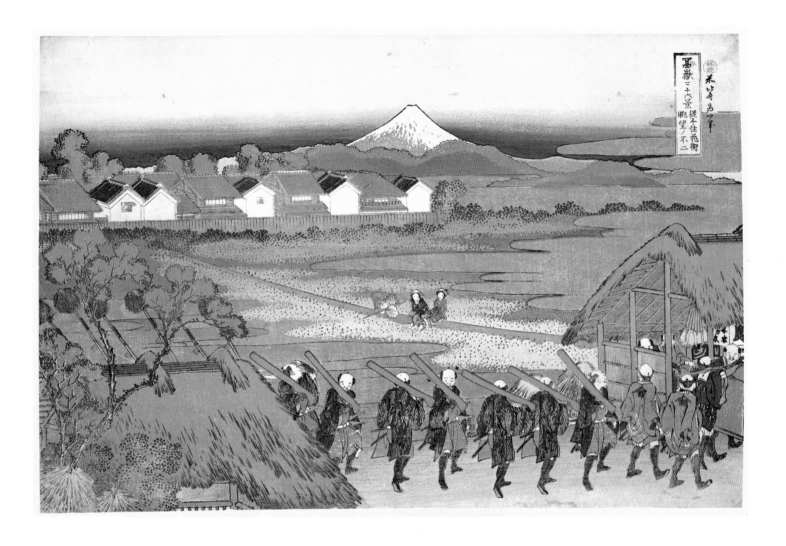

144

Katsushika Hokusai, 1760–1849

Series: HYAKUNIN ISSHŪ UBA GA ETOKI

(One Hundred Poems by Master Poets as Explained by a Wet Nurse)

KAKINOMOTO NO HITOMARO, NO. 3

Ōban, nishiki-e, 9 7/8″ × 14 5/8″

Signed: *Zen Hokusai Manji*

Censor's Seal

Publisher's Seal: *Eijudō*

Grunwald Graphic Arts Foundation, University of California, Los Angeles

LATE IN HIS LIFE, during his eighties, Hokusai commenced a series of prints curiously titled *One Hundred Poems by Master Poets as Explained by a Wet Nurse*. Each print was to be devoted to one of the master poets of the *Hyakunin Isshū* anthology, which had been assembled in 1235. The classical themes were reinterpreted by Hokusai into everyday, themes, and at times it is difficult to find a relationship between the poem and the illustration. One of the most noted poets to appear in this anthology was Kakinomoto no Hitomaro, an eighth-century master who is honored as the god of poetry in Japan.

It appears that but twenty-seven of Hokusai's designs for this series were made into prints by the publisher, although in 1921 five designs were carved into prints by Satō Shōtarō. In total, some eighty-nine designs are now known; most of these exist in the form of final sketches or zinc plates of reduced scale, evidently made by the noted French engraver Gillot in Paris prior to the disappearance of certain sketches. Over forty of these final sketches are in the collection of the Freer Gallery of Art, Washington, D.C.

In this print Hokusai portrayed men drawing in a net. They may have been fishing or gathering seaweed from the water. How hard they work as they energetically pull away, trying to ascend the hilly landscape. A fire burns on the beach and its smoke curls up into the distance. A small thatched farm hut and single figure seated within it are set deep in the richly colored landscape.

The poem by Hitomaro may be freely read and translated as follows:

Ashibiki no
Yamadori no o no
Shidari o no
Naganagashi yo o
Hitori ka mo nemu

Listless as the long and drooping tail of a
 copper pheasant,
I am alone through the long and
 lonesome night

The solitary figure seated in the hut was probably meant to signify the lonesomeness of man.

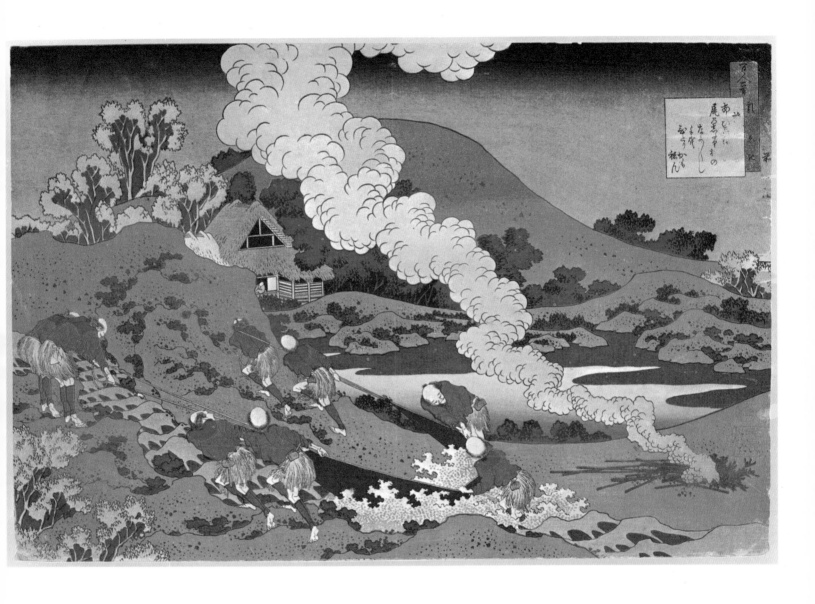

145

Katsushika Hokusai, 1760–1849
Series: SHIKA SHASHIN KYŌ (The Imagery of the Poets)
THE POET ARIWARA NO NARIHIRA
Large panel, nishiki-e, 18 1/2″ × 8 3/4″
Signed: *Zen Hokusai Iitsu Hitsu*
Publisher: *Moriya Jihei*
Museum of Fine Arts, Boston, Nellie P. Carter Collection

ONE OF HOKUSAI'S RAREST sets of prints is the series commonly called *The Imagery of the Poets*. It consists of some ten large vertical sheets which were issued about 1830 and are incredibly handsome designs. The example shown here is dedicated to the great ninth-century poet Ariwara no Narihira, whose adventures and romantic rendezvous and intrigues provided the theme for the early tenth-century classical literary work, the *Ise Monogatari* (Tales of Ise). Narihira was a heroic character, and painters of the academic Tosa school, as well as Rimpa artists, often turned to his exploits for subject matter. Hokusai's awareness of the literature of ages past is evident in prints of this nature, though in using it he cast the subject matter into a modern vein.

The setting is autumn and Hokusai leads us out of the city and into the countryside. A simple farmer has laid down his hoe and towel upon the ground and strains to move baskets filled with reddish produce. Before him a young boy and woman have spread a mat on the ground and have placed undyed silk over a roller. They then proceed to beat it with wood clubs to soften and shape it before making it into robes. This is a typical country pastime. The top of a tree and a thatched roof serve as the foreground. To aid in setting the season Hokusai cleverly placed maple leaves along the edges of the bamboo poles which hold the thatch of the roof in place. How natural it would be for them to accumulate there. As one recedes into space, a tree around whose trunk rice straw is stacked cuts diagonally through the print to the top. Beside it is a small shrine, and geese waddle across the now barren fields. In the sky the harvest moon shines and more geese are shown in flight before it. In fact, the patch of blue which embraces the moon is even roughly shaped like a goose in flight. I feel that Hokusai was certainly conscious of this when he created his design. The compound of a distant temple and thicket peek through the clouds in the distance. It is a lovely, peaceful scene in which lyricism and mood rise to the forefront. Even today in the countryside of Japan we may escape, to become part of the same setting. In autumn one can hear the call of the wild goose and feel the cool air brush summer aside. How sad it is that Hokusai did not live to fulfill his desire of one hundred and ten years of life.

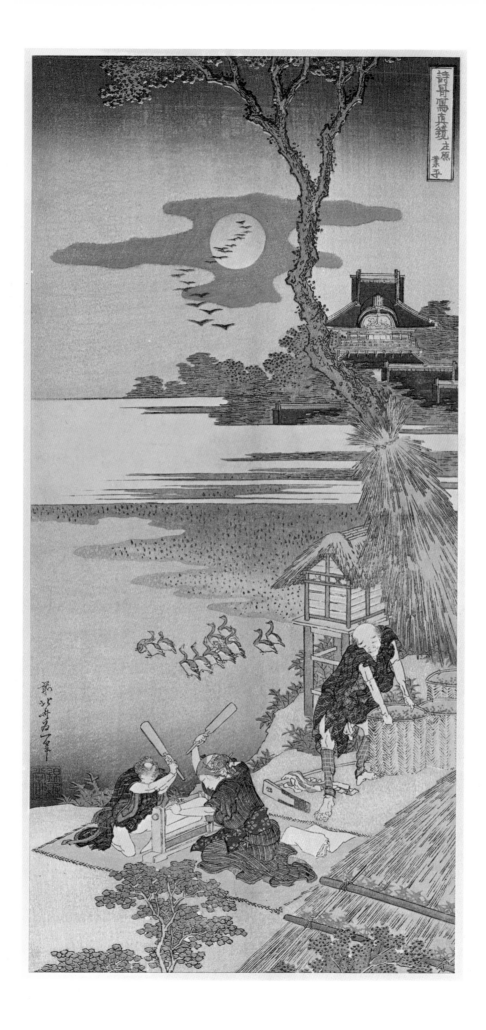

146

Utagawa Toyokuni I, 1769–1825

THE ACTOR SAWAMURA SŌJŪRŌ III AS ŌBOSHI YURANOSUKE

Ōban, nishiki-e, 15″ × 10″

Signed: *Utagawa Toyokuni Ga*

Censor's Seal

Publisher's Seal: *Uemura*

Art Institute of Chicago

TWILIGHT HAD COMMENCED to descend upon the realm of the *ukiyo-e* print with the opening of the nineteenth century. There were still great masters to be heard from, but the commercialization of the print had brought a corresponding decline in standards. An artist who was witness to *ukiyo-e's* final great years was Utagawa Toyokuni. He was born in 1769 as the son of an artisan engaged in the carving of wooden figures. As a child he was surrounded by and became familiar with the nature of wood-carving tools, and it is more than likely that his fascination with them led him to designing prints. Toyokuni's family name was Kurahashi and as an artist he primarily used the pseudonym Ichiyōsai. While still a youth he became a pupil of the founder of the Utagawa school, Toyoharu (prints Nos. 86 and 87). Toyoharu trained him; however, Toyokuni never seemed to develop the creative spark that had inspired the other masters we have seen. He appears to have been uncertain of himself and in a dilettantish manner borrowed from others. His style is clearly recognizable, and yet one usually has the feeling when studying his prints that someone else had done better ones. Though this generally was the case, he at times did rise to heights and produce distinctive and exciting designs. I often feel that part of our criticism of Toyokuni is due to the fact that scholars studying prints have become jaded by the time they reach him. Regardless of that, we do know that Toyokuni's style

is eclectic and was influenced by the work of Kiyonaga, Shunman, Eishi, Chōki, Shunshō, Shunei, Sharaku, Shunkō, and Utamaro. His first prints appear to date from some book illustrations done in 1786. His work can roughly be divided into two periods: until about 1794 he produced designs in which beautiful women dominate the scene, and from 1795 on devoted his attention to portraits of actors. The latter are some of his most successful designs. Toyokuni left his mark not only in his personal work but also in that of his students, who were numerous and, save for Hokusai and Hiroshige, dominated the *ukiyo-e* scene well past the mid-nineteenth century.

A bust portrait by Toyokuni that is most effective is this one depicting Sawamura Sōjūrō III in the role of Ōboshi Yuranosuke, the leader of the forty-seven *rōnin* in the *Chūshingura*. The large head of the actor resembles an egg, topped by a slight fringe of hair, with features added. Sōjūrō's nose is prominent, similar to a hawk's beak. His eyes are almost hypnotic as they stare upward to the right, and are heavily elaborated with theatrical make-up. There is less originality and comment to be found in this work when it is compared to the portraits of Sharaku, Shunei, or Shunkō. It is, however, a good design. The tilt of the actor's head and contrast of its simplicity with the busy-patterned robe are admirable. The fact remains, however, that Toyokuni's Sōjūrō is more actor than caricature.

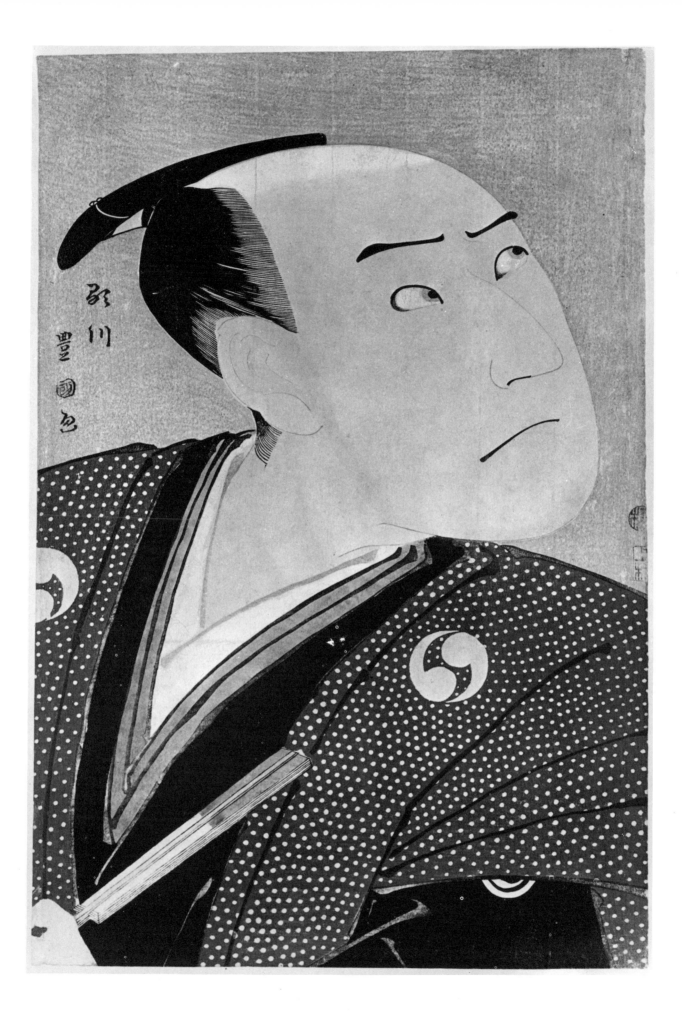

147

Utagawa Toyokuni I, 1769–1825

Series: YAKUSHA BUTAI NO SUGATA-E (Pictures of Actors on the Stage)
ONOE MATSUSUKE I
Ōban, nishiki-e, 15 7/8″ × 10 1/2″
Signed: *Toyokuni Ga*
Censor's Seal
Publisher: *Izumiya Ichibei*
Mr. and Mrs. Richard P. Gale, Mound, Minnesota

TOYOKUNI'S MOST SUCCESSFUL series of prints is that titled *Pictures of Actors on the Stage*. His portrait of the actor Onoe Matsusuke I in the same role of Ōboshi Yuranosuke as that of print No. 146 is most effective. It appears that Matsusuke I performed this role in a *Chūshingura* drama at the Kawarazaki Theater during the fifth month of 1794.

The actor is represented by Toyokuni as being a very tall man with large hands and feet, and a rather small head placed on a fragile neck. His head, composed of delicate though homely features, juts forth to the left, helping to balance his swords, which project to the right. The fan he holds acts as a stabilizer. Toyokuni made use of very fine lines in drawing this figure; they tend to add nobility to the heroic role being portrayed. The actor has been removed from any setting, because for the artist his personality was important, not the play. One can well imagine seeing such a man upon the stage. In this print Toyokuni has reduced his drawing to a minimum of lines, and it is so much more effective than his fussier work.

This impression of the print is notable; the freshness of its color reveals that Toyokuni could also excel at this. Although the actor's name does not appear on the print, his house name, Otowa-ya, is inscribed on the cartouche.

148

Utagawa Toyokuni I, 1769–1825

THE ACTOR SAWAMURA SŌJŪRŌ III AS UMA NO SAMURAI

Ōban, nishiki-e, 15″ × 10 3/8″

Signed: *Toyokuni Ga*

Publisher's Seal: *Yamaguchiya Chūsuke*

Mr. and Mrs. Richard P. Gale, Mound, Minnesota

ANOTHER PRINT OF EXCELLENT quality by the hand of Toyokuni is this example in which he has depicted an actor who stands with feet firmly placed and holds an *ema* (votive painting of a horse on wood) in one hand and tucks his other into the sleeve of his robe. He seems rather nervous, as if on the lookout, for his eyes are averted. Perhaps he has just stolen the *ema*.

There appears to be some question as to who is actually represented in the print. The Art Institute of Chicago has, through comparative means, identified the actor as being the same Sawamura Sōjūrō III already seen in print No. 146. They incorrectly mention the role as that of Umakata Muchizō from the play *Yuki Onna Keizu no Hachi no Ki* (The Snow Woman's Chronicle of the Potted Trees). This play is listed as having been performed at the Kiri-za theater during the ninth month of 1797. A check of the *Kabuki Nempyō* for that date, however, mentions that the role Sōjūrō III performed was that of

Uma no Samurai Muchizō and that the play was *Miyamairi Musubi no Kamigaki* (A Visit to a Shrine: the Knotted Fence). The role and play, however, are a matter of little importance; the composition is what counts. Once again, as in most of Toyokuni's prints, the features are indicated with thin lines. The rest of the design is bold. The robe is made of a simple, broad, diagonally striped fabric. It is like looking at a barber's post, and it immediately captures one's attention. The actor wears a towel knotted about his neck. Hanging from his waist is a tobacco-and-pipe pouch. Toyokuni's skill in depicting the highly stylized horse suggests that he may even have painted some of these professionally at one time. His ability is also apparent in his separation of the figure from any background. It is not lost in the void and without competition is even more striking. How wonderful it would be if all Toyokuni's prints were of this caliber.

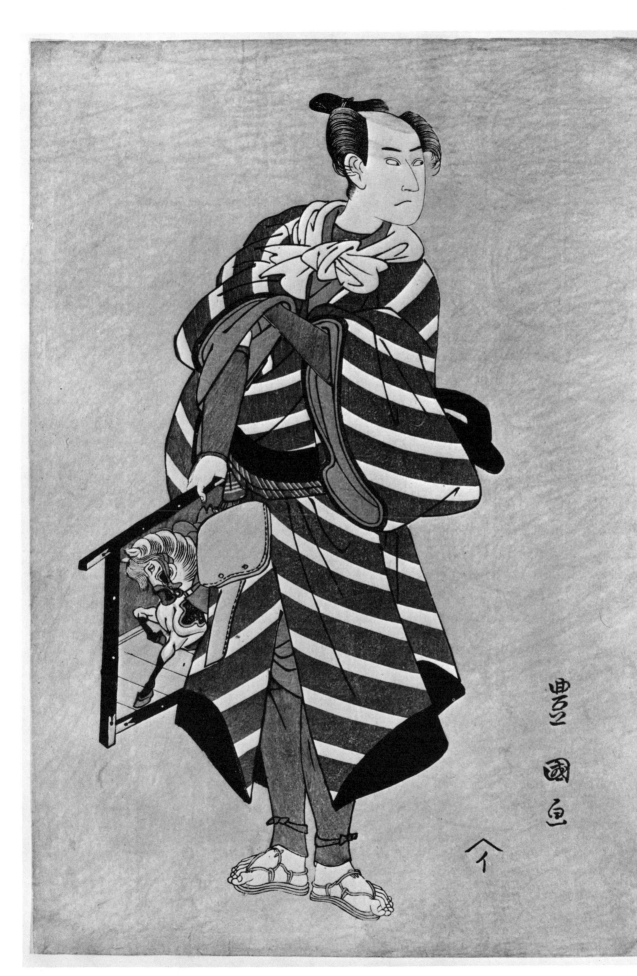

149

Andō Hiroshige, 1797–1858

Series: ŌMI HAKKEI NO UCHI (Eight Views of Lake Biwa)
NIGHT RAIN AT KARASAKI

Ōban, nishiki-e, 8 7/8″ × 13 3/4″

Signed: *Hiroshige Ga*

Publisher: *Eikyūdō*

Grunwald Graphic Arts Foundation, University of California, Los Angeles

THE SECOND AND FINAL great landscape artist produced by the *ukiyo-e* school of printmakers was Andō Hiroshige. It seems odd that of all the masters who designed prints only two excelled in landscape, and they both occur late in the development of this school. Hiroshige's landscapes are poetic and the mood is almost always one of peace or quiet; this is true even when sudden showers are depicted. Nobody ever seems hurried in his work. An ever-present inner calm distinguishes his work from that of Hokusai, which is explosive, packed with energy.

Hiroshige was born in 1797, the son of Andō Geneimon, an Edo fire warden. The great Hiroshige scholar, Uchida Minoru, suggests that Hiroshige's father was actually of the Tanaka family and that he had been adopted by the Andō family and entered into their family registry. Hiroshige fell heir to the hereditary fire warden's position when tragically in 1809 both his father and mother died. He was then only twelve years old. His inheritance gave him a certain amount of freedom; however, at the same time he was quite shaken by the double tragedy. Hiroshige appears to have sought to become a pupil of Toyokuni, perhaps hoping through creative means to dispel his grief. Toyokuni, for an unknown and often guessed at reason, refused to accept him into his studio, and thus he turned to Utagawa Toyohiro for art instruction. He was very precocious, for at the age of fifteen he was sufficiently accepted in art circles to be given the name Utagawa Hiroshige. One year later he adopted an additional name, Ichiyūsai.

Hiroshige was not content with only the *ukiyo-e* style for he had already delved into Kanō painting methods with Okajima Rinsai, and when eighteen went on to study with Ōoka Umpō the Nanga (Southern) style of painting. Much in the same manner as Hokusai, he was curious about painting techniques of the Western world and the style of art produced by members of the Shijō academy. Hiroshige in his earliest work tended to portray the traditional beautiful women of Japan. In about 1827, however, he began to concentrate almost solely on landscapes. He changed the characters used for his pseudonym, Ichiyūsai, adopted a new one, Yūsai, and proceeded to abandon both of these for that of Ichiryūsai in 1832. He had already commenced pro-

ducing the many series of landscape prints that were to lead him to fame, as well as bird and flower studies. In the latter works, much as was the case with Hokusai, poetry was employed as part of the design. His most famous series was the *Tōkaidō Gojūsantsugi no Uchi* (Fifty-three Stations on the Tōkaidō [the eastern highway that linked Edo and Kyoto]). Fifty-five sheets actually compose this incredibly handsome series, published by Hōeidō. As they have been reproduced very often, I have purposely excluded them from this book. The set was in all likelihood the outgrowth of a trip Hiroshige made in 1832 with an official mission that left Edo on orders from the *Bakufu*, to lead horses to Kyoto to participate in the annual *Komabiki* ceremony at the Imperial Palace. During the journey the artist kept busy at his sketchbooks and filled them with drawings that were later to provide the basis of many of his great prints. Once unleashed, a torrent of designs poured forth and one notable series after another left his publishers' shops. When but forty-two tragedy once again struck Hiroshige, for his wife died, and six years later his son also perished. In 1847 Hiroshige took a second wife, who was but a young girl, the daughter of a farmer. Throughout his life he remained active, never ceasing his favorite pursuit. During 1858 when he was only sixty-one years old, he perished, victim of a cholera epidemic which had swept Edo, the city he so loved.

One of Hiroshige's most poetic and lovely prints is this one, in which he depicted the *Night Rain at Karasaki*. It is part of his *Eight Views of Lake Biwa* series which was published by Eikyūdō in 1830. Most often the publisher's name is incorrectly given as Eisendō. The second character in the seal clearly reads *kyū* and not *sen*. Both of these publishers were employed by Hiroshige. The famous old pine tree spreads out and completely fills the space. The sky has opened up and a heavy soaking rain envelops the scene. It falls straight down from a dark cloud. The rain is so intense that most of the tree is ghostly and only the outline can be seen. Hiroshige limited his colors to gray, blue, and black, adding to the somberness of the scene. There is no way of escaping the rain—it falls everywhere. We can compare this print with No. 24 by Torii Kiyomasu. The Hiroshige is

continued on page 308

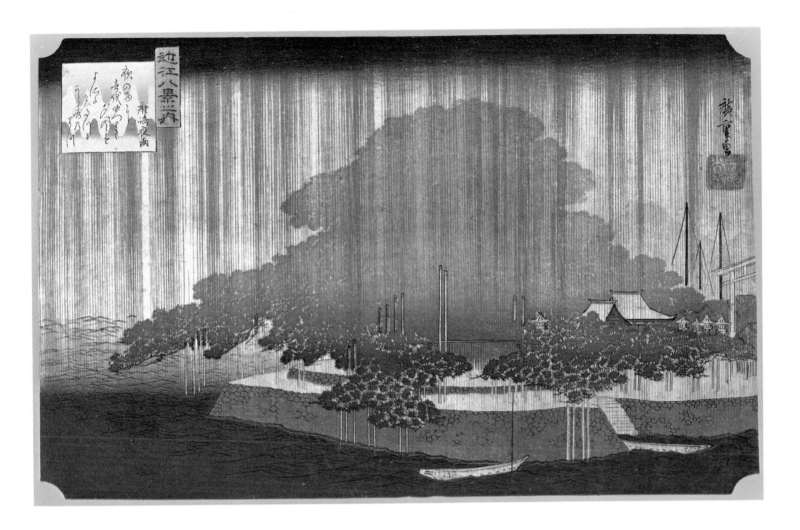

150

Andō Hiroshige, 1797–1858

Series: KISOKAIDŌ ROKUJŪKU TSUGI NO UCHI
(The Sixty-nine Stations on the Kisokaidō)
SEBA NO. 32

Ōban, nishiki-e, 9 7/8″ × 14 5/8″

Signed: *Hiroshige Ga*

Seal: *Ichiryūsai*

Publisher: *Kinjudō*

Grunwald Graphic Arts Foundation, University of California, Los Angeles

THE KISOKAIDŌ, also called Nakasendō, was a second road that eventually linked Kyoto and Edo. It was originally established in 702 and its route, rather than following the Tōkaidō, traversed the mountains; because it followed the Kiso River for many miles it took its name.

Once the publishers awoke to the salability of landscapes they drove their artists in attempts to capitalize on it. Thus Hōeidō first approached Keisai Eisen (1790–1848) to create designs for a Kisokaidō series. He evidently faltered at the job or his designs were not popular, for in 1837 Hiroshige commenced work on the set for a different publisher, Kinjudō, which continued over the next six years. In total there were seventy prints, twenty-four by Eisen and forty-six by Hiroshige.

Seba, the thirty-second station along this road, is the subject of this print. Two boatmen pole their way along the river. One carries a load of wood, whereas the other guides his raft of bamboo to market. It is one of Hiroshige's great lyrical subjects. A full moon bathes the landscape. It hangs in the sky as pinkish-tinted clouds move across it. The willow trees are in bud and their silhouettes reach lonesomely, almost like pleading hands, into the sky. The river bank is flat and on the horizon the simple huts of sleeping farmers can be seen. All is still, the reeds and branches are motionless, and mist has been banished. Only the sound of the poles entering the water, the current gently slipping past the boats, and perhaps the soft plaintive songs of the boatmen awaken the night washed with silvery moonlight.

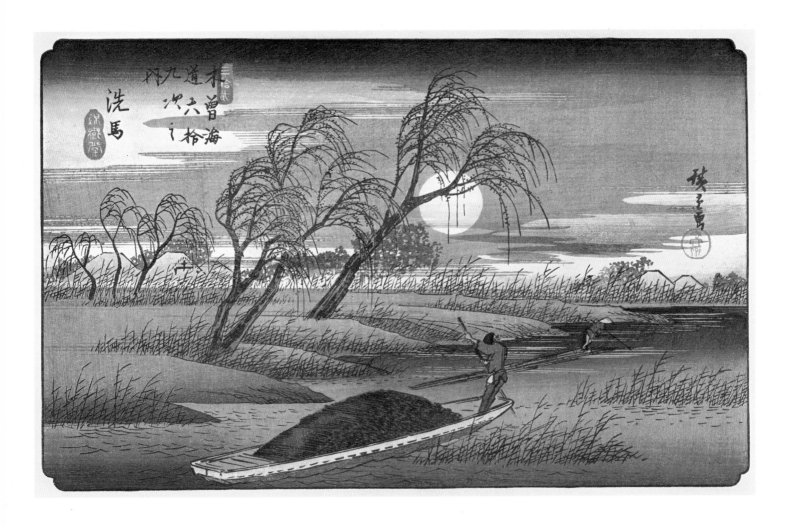

151

Andō Hiroshige, 1797–1858
Series: KISOKAIDŌ ROKUJŪKU TSUGI NO UCHI
(The Sixty-nine Stations on the Kisokaidō)
SUWARA NO. 40
Ōban, nishiki-e, 9 3/4″ × 14 5/8″
Signed: *Hiroshige Ga*
Artist's Seal: *Ichiryūsai*
Publisher's Seal: *Kinjudō*
Grunwald Graphic Arts Foundation, University of California, Los Angeles

A SECOND PRINT from the very handsome Kisokaidō series is that which represents the fortieth station, Suwara. Once again Hiroshige turned to the atmospheric effect of rain. Suwara is located in the mountains along the Kiso River. The day is truly dismal, and two men rush to the shelter of a small wayside temple. As it is wet and chilly in the mountain air, they have gathered together anything convenient to protect themselves from the rain. The small temple they hasten to is already crowded and all they can hope for is a place in which to huddle under the eaves. All of the figures within its relative shelter wear hats. Two wear rush basket-like hats worn by *komusō*-type pilgrims. One holds a mallet—he has struck the gong hanging before the lattice behind which the votive image is placed. A second figure appears to be seated on a small bench, grasping one of his rain-soaked straw slippers to squeeze the water from it. Another pilgrim holds his pen box in one hand and writes an inscription on the temple post, while the fourth man rests squatting on the ground. He has no place to go, at least until the rain has ended.

The right side of the print is framed by a sturdy cryptomeria tree. In the background is the silhouette of a man riding a horse followed by another man on foot. Both men seek to lessen their misery by shielding themselves with straw matting. Fog-shrouded trees fill the distance. The rain, falling in diagonal streaks, effectively soaks all it touches. Sadness and melancholy prevail over the entire landscape.

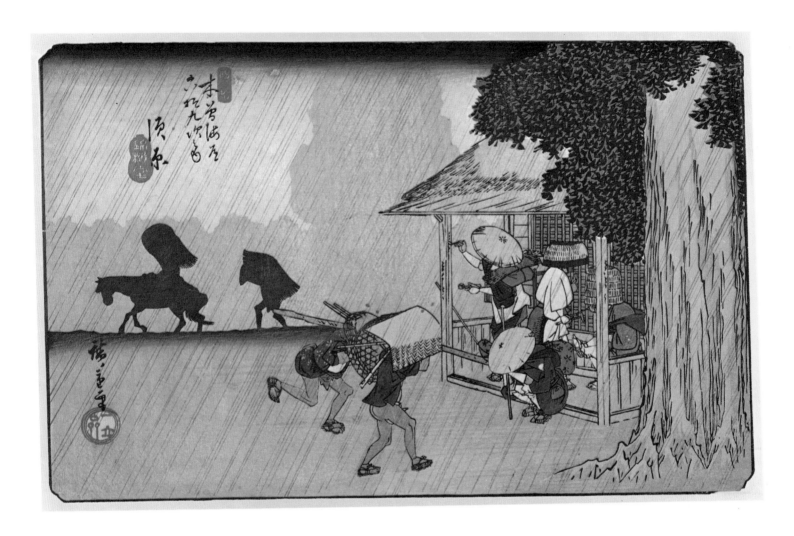

152

Andō Hiroshige, 1797–1858

Series: TŌKAIDŌ GOJŪSAN TSUGI (Fifty-three Stages of the Tōkaidō)

HAMAMATSU NO. 30

Ōban, nishiki-e, 9 7/8″ × 14 1/4″

Signed: *Hiroshige Ga*

Artist's Seal

Censor's Seals

Publisher's Seal: *Marusei*

Grunwald Graphic Arts Foundation, University of California, Los Angeles

THE TŌKAIDŌ figured often in Hiroshige's work. In fact, Uchida Minoru lists some twenty series based on this theme in which the artist was involved. I have already referred to the extremely popular and famous Hōeidō series, which is excluded from this volume. The artist's second most popular Tōkaidō set was that produced for the publisher Marusei during the Kaei era (1845–1853). Once again there are fifty-five prints rather than fifty-three as listed in the subtitle.

One of the handsomest sheets in the Marusei series is that representing the beach at Hamamatsu, the thirtieth stage, along the road. It is a simple and beautiful design. A sandy beach occupies the foreground and two wonderful gnarled pine trees rise from it, their intertwined branches towering into the sky beyond the confines of the print; they have been twisted by the winds that sweep across the water. A rather dour priest holding a staff pauses on the beach, and the edge of his robe is caught by a gust of wind. Walking in the opposite direction is a couple who have been gathering kelp. The woman carries a rake on her shoulder, whereas the man drags his through the sand as he carries the heavy basket of kelp on his back. The sea is heavy and the waves foam as they break along the beach. The water is not placid, and each crest leads the viewer further out to sea, where one can see three boats tossing about. At the edge of the horizon line on the right another stand of the famous pine trees is visible. The color values of the print are cool and refreshing. Anyone with love for the sea will hear its sound and feel the breeze.

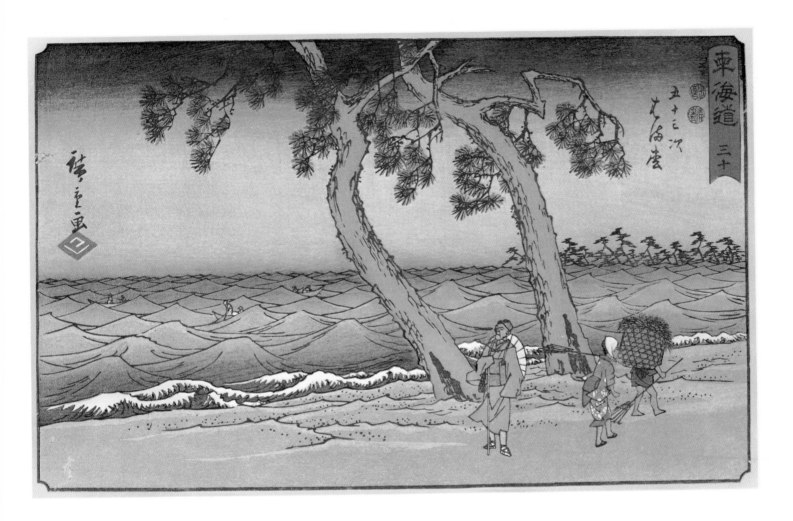

153

Andō Hiroshige, 1797--1858

HAWK IN A PINE TREE

Large panel, nishiki-e, 30″ × 10 1/2″

Signed: *Hiroshige Hitsu*

Publisher's Seal: *Sanoki*

Censor's Seals

Grunwald Graphic Arts Foundation, University of California, Los Angeles

THIS HAWK PERCHED on a branch of a pine tree is one of Hiroshige's most successful and handsome bird compositions. From the censor's seals in the lower right-hand corner it can be determined that it was executed roughly about the middle of the nineteenth century. The print is of very large format and the composition is impressive.

Hiroshige placed the hawk in the center of the print. One foot grasps the tree branch, the other is raised. Its plumage is carefully indicated. Its back, head, and tail feathers are grayish blue and black, and provide a cloak for the soft downy feathers of its throat and breast. Though it is highly stylized, Hiroshige has captured the true essence of this sharp-eyed, bold, swift bird. Its head is turned as it looks backward, framed against a dulled reddish sun. The hawk is nobly portrayed and, though at rest, one senses that it might fly off again at any moment. Hiroshige achieved this effect by placing it on a branch that zigzags in and out of the confines of the sheet. The pine needles are swordlike and sharp; they cluster here and there along the branch and aid in making the hawk even more formidable. Its speed and endurance are laudable.

In viewing this print one is reminded that Hiroshige also studied the painting styles of the more academic schools of Japanese art. In the mid-seventeenth century the Soga artists, such as Chokuan and Nichokuan, excelled in the portrayal of hawks. This print clearly indicates that Hiroshige was familiar with their work.

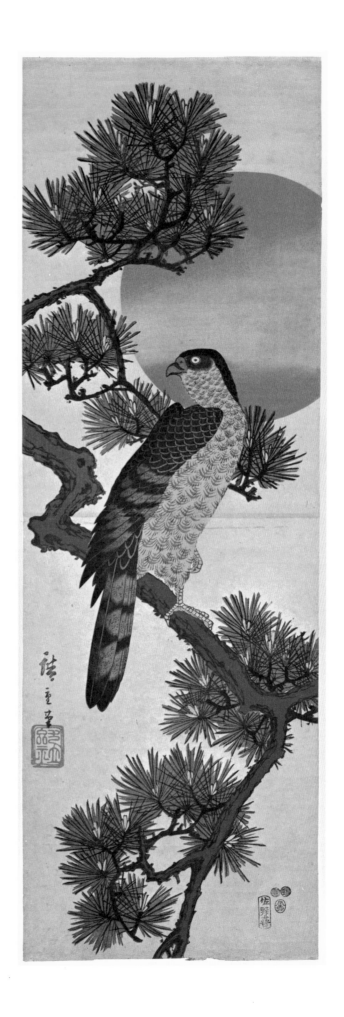

154 155 156

Andō Hiroshige, 1797–1858

KISOJI NO SANSEN (Mountain and Kiso River along the Kisokaidō) Triptych

Ōban, nishiki-e, 154: 14 3/4″ × 10 1/8″;

155: 14 7/8″ × 10″; 156: 14 7/8″ × 10 1/8″

Signed: *Hiroshige Hitsu* (right sheet)

Artist's Seal: *Bokurin Shōkō*

Censor's Seals: each sheet

Publisher's Seals: *Tsuta*

Grunwald Graphic Arts Foundation, University of California, Los Angeles

IT WAS IN THE WINTER OF HIS LIFE, his last year, 1858, that Hiroshige created three of his most romantic and poetic designs. All are triptychs, and each rivals the other for beauty and originality. They are *Mountain and Kiso River along the Kisokaidō, Moonlight at Kanazawa*, and *Whirlpools at Naruto*. It is the first that is shown here.

The composition is exciting and new. Hiroshige has represented the mountain landscape covered with snow, once again displaying his love for atmospheric effects. The sky is dark and snow continues to fall, piling up to great depths and obliterating the harsh forms of the rocks. The mass of white spreads over the three sheets, almost smothering the patch of sky and the winding river. All is pure and still, with only four figures depicted in the right sheet wending their way along the mountain path. Nature is majestic,

winter rules, and man is but its pawn. The skill with which Hiroshige was able to reserve areas of untinted paper for the snow is breathtaking. The overall treatment should recall to our mind that the artist had studied the academic styles of painting, and especially that of the Nanga school. One almost feels the presence of a sober, literati-school painter. My mind at once turns to the winter-landscape screens by Sesson (1504–1589) in the Freer Gallery of Art, Washington, D.C., or the snowy landscape painted by Uragami Gyokudō (1745–1821) in the collection of Japan's great Nobel prize winner for literature, Kawabata Yasunari. Hiroshige's work is quieter and yet is endowed like the others with the same grandeur that only nature can evoke. The snow falls so heavily that Hiroshige vanishes, covered by its blanket.

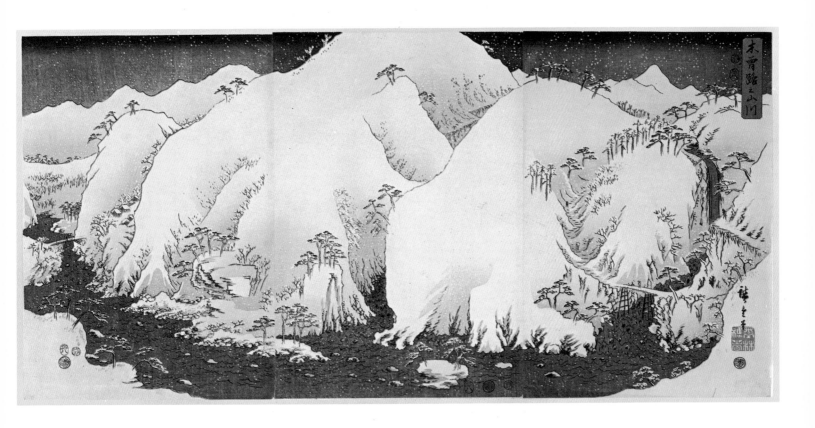

157

Andō Hiroshige, 1797–1858
Series: MEISHO EDO HYAKKEI (One Hundred Famous Views of Edo)
KOMAGATADŌ AZUMA BASHI (Azuma Bridge at Komagatadō)
Ōban, nishiki-e, 13 3/4″ × 8 7/8″
Signed: *Hiroshige Ga*
Censor's Seals
Publisher's Seal
Grunwald Graphic Arts Foundation, University of California, Los Angeles

BETWEEN THE YEARS 1856 and 1858, Hiroshige executed some one hundred and eighteen print designs for a publisher named Uoei. They are among his best vertical landscape designs and are a tribute to his beloved city, Edo. They are actually divided on a seasonal basis with forty prints representing spring; thirty, summer; twenty-six, autumn; and twenty, winter. Hiroshige was familiar with every aspect of the city, and he transferred to these sheets of paper the poetic beauty that had so impressed him.

The Azuma bridge at Komagatadō was a very busy spot. It spanned the Sumida River and linked the Asakusa and Honjo districts. On the Asakusa side was located a great temple, and Hiroshige has represented its roof in the left corner of the print. He gives us an aerial view of the summer setting. We look down upon the river from a high point, perhaps from a fire tower familiar to Hiroshige in his profession. The bridge is reduced to but a small diagonal, as the artist's approach to this landscape was on a grand scale rather than specific. On the river, boatmen pole along moving their cargoes to market. Most of the vessels are engaged in trade; however, one or two appear to be excursion boats. On the Asakusa bank a red banner flies from a mast and timber is seen stacked vertically along the riverbank. The houses and shops of the Honjo district are visible on the far bank, surrounded by a forest of trees. It is a cloudy day and here and there a few drops of rain fall. The color of the sky is carefully graded to achieve the miraculous atmospheric effect. Oblivious to it all, a cuckoo sports in the sky. Its beak is open; its call is traditionally associated in Japan with loneliness and sadness. Hiroshige must often have envied this bird and its power to soar and view mankind.

158

Andō Hiroshige, 1797–1858

Series: MEISHO EDO HYAKKEI (One Hundred Famous Views of Edo)

KAMATA NO BAIEN (The Plum Garden at Kamata)

Ōban, nishiki-e, 14″ × 9 1/2″

Signed: *Hiroshige Ga*

Censor's Seals

Publisher's Seal

Grunwald Graphic Arts Foundation, University of California, Los Angeles

SPRING IS THE SEASON for viewing the famous plum gardens located at Kamata, and Hiroshige has captured the beautiful grove in this second print from the *One Hundred Famous Views of Edo* series.

It is a rather magical day. The hour must be late afternoon for Hiroshige has made the sky red with the sunset's glow. The color makes the delicate white plum blossoms stand out; the branches and buds create lacelike patterns against the sky, and the light casts their shadows upon the ground. Happy the visitors must be now that the harshness of winter is gone. The new grass is intense green. Resting on it, along the right edge of the composition, is a simple palanquin which has brought a lover of nature to Kamata.

The print is rich in colors, which contrast sharply with each other. Vincent van Gogh was fascinated by Hiroshige's representations of plum and cherry groves and made copies of these designs. One can well understand the reason for this, for Hiroshige reduced the setting to only that which is necessary. His impression of nature is true and emotional, not bland or viewed only to be forgotten. It impresses the mind and its memory lingers on, just as the picnicker at this heavenly spot would be tempted to remain.

159

Andō Hiroshige, 1797–1858

AWABI, SNIPE-FISH, AND PEACH BLOSSOMS

Ōban, nishiki-e, 10 1/4″ × 14 7/8″

Signed: *Ichiryūsai Hiroshige Ga*

Censor's Seal

Publisher's Seal: *Eijudō*

Grunwald Graphic Arts Foundation, University of California, Los Angeles

BOTH HIROSHIGE AND HOKUSAI periodically produced still lifes. In addition to indicating their intense love of nature studies, prints such as these tell us that their training in the art tradition of schools other than *ukiyo-e* was great. In this print Hiroshige has portrayed two awabi, a snipe-fish, and a single branch of peach blossoms. They are symbolic of March and the Doll Festival. The four elements are carefully arranged, linked one with the other, and accompanied by poems. The awabi are encrusted with growths from the sea, which no longer protects and supports them. The peach blossoms have also been torn from their life source and, indicative of the struggle, a few petals have fallen away. In a like manner the snipe-fish is dead, for air instead of life-giving water surrounds it. Life is short and fickle, and fate had often dealt sadly with Hiroshige. Although the elements of the still life he depicted were capable of producing joy for man, one cannot escape feeling that the artist was also commenting on the tragedies of existence.

The series that this print comes from consists of ten sheets once arranged in book form. They were published by Eijudō about 1832, and on each sheet the sea life is related to vegetables, seasonings, flowers, or seasonal plants, linking them to the time they are most often found or used in the Japanese household.

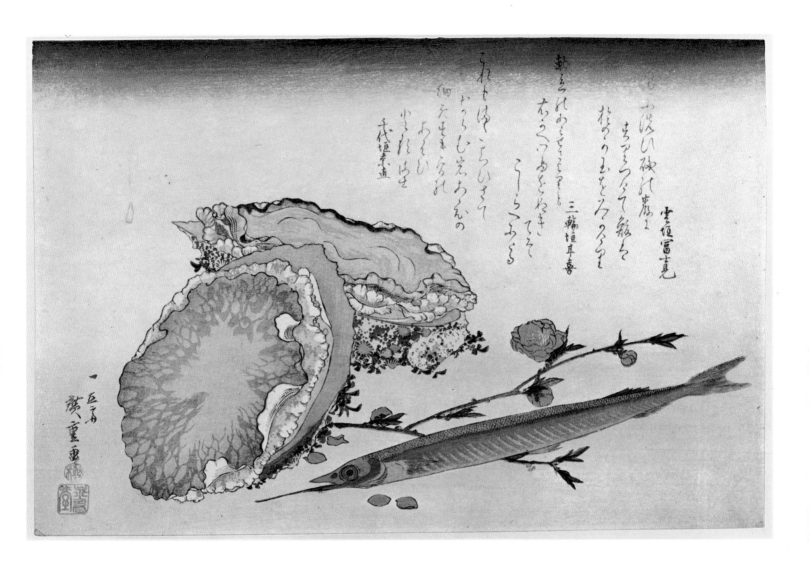

160

Utagawa Kuniyoshi, 1797–1861

SPARROWS IMITATING HUMANS IN THE YOSHIWARA

Fan-shaped, nishiki-e, 7 3/4″ × 9 1/2″

Signed: *Ichiyūsai Kuniyoshi Giga*

Censor's Seal

Publisher: *Ibaya Kyubei*

Philadelphia Museum of Art, Given by Mrs. John D. Rockefeller

MANY SCHOLARS TERMINATE their study of *ukiyo-e* prints with Hiroshige and ignore the pupils and followers of Toyokuni. In the past these followers have been treated as being very decadent and important only as symbols that mark the road to the decline and death of prints. Such was not the case, for the popularity of prints continued and, though many of the artists were not great masters capable of producing designs of beauty, every once in a while there was an exception which should not go unheralded. Both Kunisada and Kuniyoshi fall within that category.

Kuniyoshi was born during January, 1798, into the family of a dyer of silk, named Yanagiya Kichiemon. He evidently learned a sense of color and design from his father, though he never seems to have employed it in the same profession. Instead Kuniyoshi, who as a youth was called Yoshizō and Yoshisaburō, and later Ikusa Magosaburō, went to live with the artist Kuninao, a Toyokuni pupil. He was only a child at the time, but evidently already felt the urge to paint and produced a drawing of the demon-queller, which Toyokuni praised. Kuniyoshi's first true artistic training appears to have been with Katsukawa Shunei, although later he also studied the styles of Kitao Shigemasa and others. When but thirteen he was accepted as a pupil of Toyokuni, and three years later received the name by which we know him.

The early years spent by Kuniyoshi as an artist were evidently very trying. He was extremely poor and is even mentioned as having been reduced to selling secondhand *tatami*. His struggle to exist was difficult, and a popular story is told of his taking offense at his elder colleague Kunisada's display of affluence. The true story is not known; however, the confrontation did seem to spur Kuniyoshi on to higher levels. He went on to produce very complex designs. Actors, landscapes, courtesans, warriors, and animals abound in his prints. The *Suikoden* (One Hundred and Eight Chinese Heroes) figure strongly in his work. There is an overall busyness, or what some might term fussiness, in many of his prints.

From about 1830 on, Kuniyoshi's work begins to crystallize. He appears to have become more certain of himself, and commenced producing many series of works. He also experimented; in a good number

of his prints the influence of Western art themes can be seen. In one set illustrating the *Twenty-four Paragons of Filial Piety* he even included an illustration from *Robinson Crusoe*. He also often depicted in his prints his fondness for cats, and they sometimes take over the subject matter.

Like other artists, Kuniyoshi was undoubtedly hampered by the censorship restrictions of Tempō 13 (1842), which forbade the sale of prints depicting actors or courtesans, triptychs or above that number, and prints which employed the use of more than seven blocks. The censorship regulations were fortunately not too tightly enforced; however, Kuniyoshi did run into trouble with the authorities and one triptych of Raikō and the Earth-Spider was ordered destroyed. He found during the forties that the *Tale of Genji* provided a good theme. Censorship was somewhat relaxed early in 1847 and Kuniyoshi's work flourished. For a short while he associated with the great lacquer artist and painter Shibata Zeshin (1807–1891) and continued to produce prints in his later life, although as he suffered from poor health his production was less. In 1861, on the fifth day of the third month of the first year of Bunkyū, he died.

Kuniyoshi's love of animals is clearly seen in this charming fan-shaped print of sparrows disporting as humans in the Yoshiwara. The print should remind us of Toyoharu's foxes, No. 87. The print is not one of Kuniyoshi's best designs; but its freshness makes its inclusion important. It is in the tradition of the late eleventh- and early twelfth-century priest painter of *Yamato-e* animal caricatures, Toba Sōjō. A full moon lights the street as the night sparrows (instead of owls, unfortunately) assemble. A group of four playbirds stands on the right before a barred enclosure wherein rest four ladies of the night. On the left a gentleman and his date step forth into the street. The thoroughfare is busy. Two females attended by a *kamuro* chat with a male and exchange glances with a bird of a different-colored robe who is attempting to lead them on. In the rear a servant strolls along balancing a tray of food on his head, including a platter of fish. Somebody has obviously arranged for an order from the take-out and home-delivery shop.

Kuniyoshi charmingly had the humor to equate these humble birds with the foibles of his fellow man.

161

Utagawa Kuniyoshi, 1797–1861

A DRUNKEN STREET SCENE IN THE YOSHIWARA

Fan-shaped, nishiki-e, 9 1/4″ × 11 5/8″

Signed: *Ichiyūsai Kuniyoshi Ga*

Artist's Seal: *Paulownia Crest*

Publisher's Seal: *Iseya Sōemon of Horie-chō*

Grunwald Graphic Arts Foundation, University of California, Los Angeles

A SECOND fan-shaped print that uses the Yoshiwara as a theme is this one which shows a group of revelers cavorting on the street. Once again it is a night scene, and in the upper left corner shadowy figures in silhouette move along before the houses.

Kuniyoshi must have been very familiar with the Yoshiwara and observed the effects of sake. His figures dance, sing, and clown along the way. One man who is terribly drunk dances away wildly in abandon. The man to his left grabs hold of the dancer's obi and tobacco pouch as he awkwardly stoops to pick up a red pouch he has dropped. Two other men appear to be more sober and one attempts to steady the dancer. A girl, obviously employed by the Tsutaya house, carries a lantern and leads the way. Another lantern lights the street, and a vendor, balancing a huge tray of food on his head, walks beside it. His fists are clenched and he appears to be somewhat apprehensive about crossing the path of the carousing group. Beside him, facing in the opposite direction, stands a man who holds a large lantern and calls forth into the night. A cloth covers his hair and it almost appears as though the tray of the vendor also rests on his head. Perhaps he is advertising the menu.

The presence of the paulownia seal indicates that this print dates from after 1844, when Kuniyoshi first made use of this seal.

[300]

162

Utagawa Kuniyoshi, 1797–1861

SASHŪ TSUKAWARA SETCHŪ (Nichiren in the Snow)

Ōban, nishiki-e, 8 3/4″ × 13 1/2″

Signed: *Ichiyūsai Kuniyoshi Hitsu*

Artist's Seal

Censor's Seal

Publisher: *Iseya Rihei*

Philadelphia Museum of Art, Given by Mrs. John D. Rockefeller

KUNIYOSHI'S PRAISE as an artist could rest on but this single design. It is from the series of ten prints published between 1835 and 1836 titled *Kōsō Go-Ichidai Ryaku Zu,* which is an abridged biography of the life of the great priest Nichiren (1222–1282).

This holy man, though trained in the Shingon sect, abandoned it and founded the Hokke sect of Buddhism based on the worship of the Lotus Sutra. He was an activist of that day and was twice exiled, once to Itō and later to Sado Island in 1271. At Minobu he built the Kuon-ji Temple, which is the seat of his sect.

Nichiren's exile to Sado and wandering through the mountains of Tsukawara are represented in this print. It is a bleak and lonesome scene. Nichiren has just left a small village that clings to the foot of a mountain beside the sea. Winter reigns supreme and all is covered with snow. The weather at Sado is bitter in winter and Kuniyoshi has captured it well. Not a bush or blade of grass is visible on the mountain; there is only one tree, its wintry skeletal form shrouded in white bends as it is blown by the wind. Nichiren walks beside it; his form is bent, too, by the storm. His tattered robes whip about his body as he grasps his snow-covered hat to hold it in place and shields his face from the wintry blast. His thin bonelike legs are whiter than the snow as he wanders amidst the bitter elements in sadness, longing to return to the land he loved.

Even the houses in the village seem burdened with his sorrow. They are about to topple under the weight of the snow, which has magically transformed their roofs into mountain peaks. Only Nichiren walks, his body and spirit bowed but unbroken.

163

Utagawa Kuniyoshi, 1797–1861

Series: TŌTO MEISHO (Famous Views of the Eastern Capital)

SHIN YOSHIWARA (The New Yoshiwara)

Ōban, nishiki-e, 9 15/16″ × 14″

Signed: *Ichiyūsai Kuniyoshi Ga*

Censor's Seal

Publisher's Seal: *Kagaya, Kichibei*

Nelson-Atkins Gallery, Kansas City, Missouri (Nelson Fund)

THE WESTERN ART THAT KUNIYOSHI had seen and is reported to have collected left its imprint on his work. Though a relatively uneducated man, he had an inquiring mind and was not content to simply repeat the stereotyped formulas employed by other artists. His role is important, for it acts as a link to the modern period.

It is almost prophetic that night plays such an important role in the previous group of prints, Nos. 160 and 161. Dusk had descended on *ukiyo-e*, night was to fall, but periodically the moon was full, and its bright light revealed occasional scenes of beauty and greatness. In about 1834 Kuniyoshi produced ten prints for a *Tōto Meisho* (Famous Views of the Eastern Capital) series. The *Shin Yoshiwara* (New Yoshiwara) is the locale of this print. It is startling at first, because an imitation frame encloses it and the full moon in the sky is surrounded by an eerie corona of luminescence. It lights the figures as they walk along a path and projects their shadows onto the ground. The horizon is very low and rice paddies and the New Yoshiwara spread out in the distance. The entire feeling is that of a Dutch landscape, save for the presence of the figures celebrating their night out on the town. The trees are partially cloaked by shadow as the moonlight bathes them. They are thin and would offer little shade. The area appears to slumber save for the late visitors. Two dogs have unobtrusively curled up beside a street lantern, and point once again to Kuniyoshi's love of animals.

On the path two men pause to look at an approaching figure. Their hair is covered with cloths and one pulls the edge of his up to further shield his face. Perhaps he does not wish to be recognized by the man in the loosely tied striped robe, whose sleeves hang limp. He appears to be joyous as he sings away in an inebriated state. Is it a bawdy song or one of sorrow? Whatever its nature, he is beyond the state of caring. Next to him, two porters hold staves and rush along carrying a closed palanquin. What difference does it make who is in it or where it goes, for our vocalist is happy and continues to sing? The full moon has cast its spell. Some scholars have speculated that this man may be a self-portrait of Kuniyoshi, who has relaxed and unburdened his heart. It would be impossible to substantiate this. I personally feel it might equate with the author of a book who has just completed a manuscript. Night has come, it is romantic and lovely, and just as it has appeared, so will day with its bright light, revealing how much we all have yet to learn about the world of *ukiyo-e*.

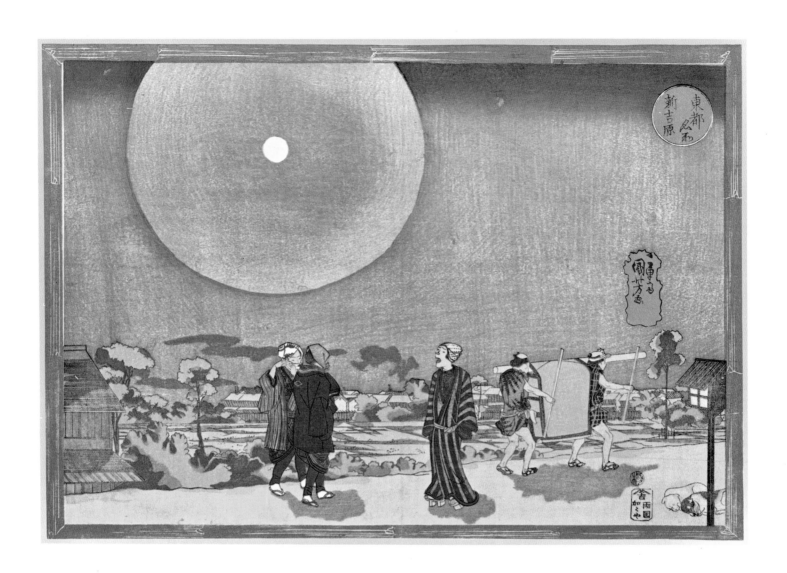

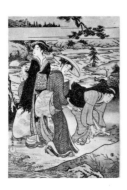 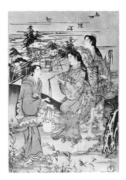 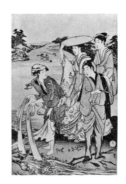 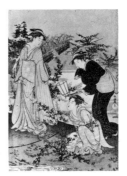

continued from page 198

five of the six sheets dedicated by Shunman to this subject are shown here. These were formerly in the collection of Baron Fujita. The handsome and complete set previously in the Ledoux collection is now the property of Mr. and Mrs. Richard F. Gale.

The prints all have poetical associations and from left to right they are as follows:

98. The Tama River of Kōya in Kii Province. Three women walk along the edge of a stream. One stoops to tie her sandal. There is a slight breeze and the middle figure holds her hat, while the third one holds a fan and looks back across the stream. In the background are rice fields and a distant landscape with the temple and pagoda of Mount Kōya. The beauty of this river caused Kabō Daishi (774–834), the founder of the Shingon Buddhist complex on Mount Kōya, to compose the poem that inspired this sheet.

99. The Tama River of Noda in Mutsu Province. A woman holding a pipe chats with two barefoot girls wearing kimonos decorated with plover and butterflies. The center figure carries two buckets on a pole over her shoulder, whereas the other one pulls a wagon. They have been engaged in taking salt water from the Bay of Shiōgama, and undoubtedly are a parody of the famous brine maidens, Matsukaze and Murasame. In the background a country compound is shown, and plover hop along the ground and dart above the heads of the girls. The maples are bright red and autumn has come. The associated poem appears to be one composed by Nōin Hōshi, a tenth-century monk.

100. The Tama River of Mishima in Settsu Province. Two girls are seated on a woven mat beside gnarled pine and maple trees, and are engaged in beating cloth with wooden mallets to full it. Behind them stand two other young girls. The river winds through the setting and in the background is a distant farm house. The sky is streaked, for a small shower has burst upon the bucolic scene. Shunman's design seems to have been inspired by a poem of the twelfth-century poet Toshiyori.

101. The Tama River of Tatsukuri (Chōfu) in Musashi Province. A visiting trio, consisting of an elegantly garbed young lady who holds onto the brim of her straw traveling hat, her maid, and a man, have stopped to watch a barefoot country girl wash a length of cloth in the swiftly moving stream. She turns politely to answer their questions, yet does not cease carrying out her task. In the rear is a farmyard fence and on the riverbank cloth is stretched out to bleach and dry, while two figures pound fabric in a large wooden tub, and a man carrying buckets on a pole crosses a bridge. The inspiration for this print seems to derive from a poem by the late twelfth- and early thirteenth-century poet Fujiwara no Sadaie, already portrayed in No. 14 by Kiyomasu I.

102. The Tama River of Noji in Ōmi Province. The setting is apparently night and one woman holds a lantern while a maid stoops to the ground and holds a branch of a *hagi* (lespedeza) bush which she is about to cut with a knife. An elegantly robed young lady looks on as though passing approval on the selection. A farm house can be seen in the rear behind a fence. Once again the poet Toshiyori, as in No. 100, seems responsible for the inspiration.

The sixth print, not shown here, depicts a young lady being assisted in wading across a river and is titled The Tama River of Ide in Yamashiro Province. Shunman's skill at composing this series is breathtaking. In a manner characteristic of him, color was sparingly used, with black and gray predominating. Only the plants, grass, and flowers are toned; thus, the entire atmosphere is one of dignified restraint and elegance. There is also a great freshness and novelty, for he has led us out of the theater, Yoshiwara, and the bustling city into the peaceful autumnal countryside. His six Tama Rivers become one as they flow gracefully from sheet to sheet.

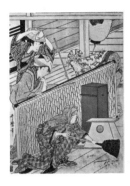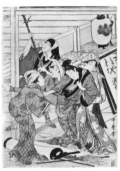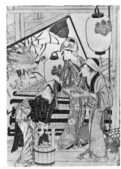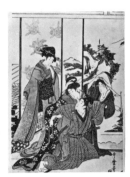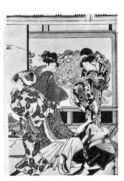

continued from page 200

which forbade the portrayal of military heroes in prints and popular works. He was sentenced to serve three days in prison and fifty days in handcuffs. It appears that the shame of this broke his spirit, for Utamaro's health soon declined and he died in 1806.

Utamaro, in this set of five sheets, has depicted a very humorous house-cleaning scene. The interior of a very large establishment bustling with activity is shown. Once again, although each print can stand alone, they also relate and can be joined together to make an exciting design. The manner in which the five prints are treated is also interesting, for it is a close-up of the *uki-e* (perspective picture). At times the five sheets have been considered to be a parody on the story of the *Chūshingura*. The scenes depicted and stories related from right to left are as follows:

107. A gentleman wearing formal costume and bearing two swords has fallen to the floor, perhaps dropped by the three girls, who appear to be taunting him. The girl on the right wears a maple-patterned robe much like that worn by Takao. On it is a tie-dyed inscription which has not been interpreted. A paulownia crest is placed on her sleeve and it is interesting to note that in each print the same crest is worked somehow or other into the composition. The second girl wears a simple purple kimono, with reserved chrysanthemum-petal decoration, and the third wears a leaf-and-flower patterned white robe and has a cloth tied about her hair to protect it from the dust. Behind the figures is a single fixed-panel floor screen with two very animated lions painted upon it. Perhaps the fallen gentleman symbolizes the attack made on the Lord of Kozuke in the *Chūshingura*.

106. Two girls are shown trying to assist a young gentleman from the floor while a third girl looks on. They grasp his arms to support him, for he has evidently become too tipsy to stand. The lone standing figure is a courtesan and she appears to be laughing at the struggle. The house is in all likelihood one of the establishments patronized by Utamaro. The suggested *Chūshingura* parallel is

that of the noble Asano Takumi being restrained by bystanders.

105. Three girls engaged in the cleaning project stand beside a pile of *tatami* (straw mats) and a handsome two-fold screen depicting cranes which has been carelessly bent in the wrong direction and rests against a pillar. They all have protected their hair with dust cloths. The girl on the right carries a large water pot in one hand and holds a tray with three turned-over tea cups in the other. Behind her is a roly-poly Daruma doll which is erotically symbolic of the girls of the Yoshiwara. The center girl holds a broom over one shoulder and the girl on the left stoops to lift a bucket of water from the floor. They are all busily engaged in watching the next scene. The *Chūshingura* parallel has been said to be the scattering of the retainers of Lord Asano. I, however, find the relationship difficult to establish.

104. A young man has been raised from the floor by three cleaning girls. He slumps forward as though slightly inebriated and they gently cradle his body as they remove him from the path of their labor. Behind them a servant holding a broom dusts the ceiling. Rolled matting and brooms are visible on the floor, as well as the edge of the screen seen in the third sheet. Once again it is difficult to accept the suggested *Chūshingura* reference of the loyal retainers, Ōishi and Otaka Genzo, deceiving their enemy.

103. Two girls have been beating a mat and another girl stands behind them and adjusts her hair cloth. In the foreground a girl with a cloth draped around her head brandishes a broom and tries to frighten off a mouse. This fifth sheet is believed to equate with the final attack on Kira's villa from the *Chūshingura*.

The overall design of these five sheets is one of great skill. They reveal Utamaro's keen observation of the Yoshiwara and his sympathy for the girls. The portrayals of the noble gentlemen may also be an early indication of the trouble that would later interrupt the artist's career.

continued from page 232

His nose is beak-like and his eyebrows, though groomed, are thick. Ebizō's eyes are haunting, for in addition to the large pupil, Sharaku outlined them with a heavy black crescent. His head has not been shaven and his topknot is sickle-shaped. The print must have been very popular, for more than a single edition exists. In the state that is generally accepted as being the earliest, the robe is a reddish orange, and the *kami*, now faded to yellow, was once a light blue. In the early edition teeth are also visible in Ebizō's mouth. The actor, with his heavy hands resting one upon the other, his twisted mouth and piercing eyes, appears to be conniving. It is truly a monumental print.

continued from page 238

personal taste, number three is the most aesthetically pleasing. Eishi sought delicacy and I believe that to mask it with a dark, rather muddy background was contrary to his nature. At the same time, I question why any artist would title a series only to then seek to obliterate the cartouche under a film of color and mica. I tend to believe that the floor line was a later addition. If future research proves the darkgrounded specimens to be the first state, I can only conclude that Eishi and his publisher soon recognized their error and sought to remedy it.

continued from page 260

Rōjin, Zen Hokusai, Iitsu, and Manji signatures. He loved Mount Fuji and it stars in his great masterpiece *Fugaku Hyakkei* (One Hundred Views of Fuji). For that matter, Hokusai loved all life—every blade of grass or change of atmosphere, mood, or expression was dear to him. He died on the eighteenth day of the fourth month of 1849. It is fancifully reported that shortly before his death he composed a letter. His character is reflected in it for it is said to have read:

"King Emma [Yama, who is the Buddhist ruler of Hell] being very old is retiring from business, and he has built a fine country home and has asked me to go and paint a *kakemono* for him. I am obliged to leave and, when I go, I shall carry my drawings with me. I am going to take a room at a corner of Hell Street and shall be happy to see you whenever you pass that way."

In this handsome print from one of his bird-and-flower series, Hokusai has depicted peonies and a canary in flight. The design is florid and the color rich with the bird and flowers against an intense blue sky. It is a very decorative but at the same time instructive print, for in it Hokusai has meticulously indicated and catalogued the bird and flowers. The blossoms twist and turn and we are shown various stages of the plant from bud to full bloom. In a similar manner the bird's wings are spread, revealing their feathery construction. The canary twists rather awkwardly as it plummets towards the blossoms. In the upper right next to the identifications Hokusai placed a rather complex poem supposedly by a Chinese named Wang Shih-ming. How welcome is this gentle bird which for a brief moment brushes aside all thought of the theater and Yoshiwara.

continued from page 280

much truer to nature and more poetic. Both prints are inscribed with the same poem.

The study of Hiroshige's prints always raises many problems, as so often the colors vary in different printings. To date nobody has established an irrefutable standard for determining which prints are first editions. The great old pine of Karasaki perished some years ago and is now replaced by a new tree. We are fortunate that Hiroshige so ably captured its beauty as it was nourished by a shower in the twilight of its life.

GLOSSARY

Asanoha kanoko: A textile pattern resembling a speckled hemp leaf.

Baren: A circular rubbing pad of coiled bamboo cord covered with white bamboo leaf; used in transferring the block impression onto the print paper.

Beni: A red pigment extracted from the *benibana* (*Carthamus tinctorius*)—safflower plant.

Beni-e: Prints on which the principal hand coloring was executed with *beni*. At times other pigments were used with it.

Benizuri-e: Prints on which *beni*, green, and other colors were actually printed. They are thus the first true color prints.

Bishamon-ten (Sanskrit: *Vaiśravana*): One of the twelve Heavenly Kings and Guardian of the North in the Buddhist pantheon.

Biwa: A four-stringed Japanese lute of Chinese derivation.

Chidori: The plover.

Daruma (Sanskrit: *Dharma*): A follower of Shaka, the patron saint of Zen Buddhism, who brought it to China, from where it later reached Japan.

Dōbori: The engravers who were entrusted with carving out what were considered the less delicate areas of the wood block.

Dosa: A solution of alum and glue used in sizing print paper.

Eboshi: A type of lacquered-paper hat worn by noblemen, samurai, or court officials.

E-goyomi: Pictorial calendar prints. The date symbols are worked into the design.

Ema: A picture of a horse; especially those votive pictures painted on wood and hung in places of Shinto worship.

Fukujusō: Adonis sibirica or *Adonis amurensis*.

Furoshiki: A cloth used for wrapping objects.

Fusuma: Sliding interior doors.

Futon: Quilts used as bedding.

Gagaku: The ceremonial music of the Imperial Court.

Geigi: An abbreviated term used to refer to the geisha of the Yoshiwara.

Gembuku: The coming-of-age ceremony which for the male formerly consisted in shaving off the forelock and changing the name.

Geta: Wooden clogs.

Gidayū: A form of musical ballad drama.

Hagi: The lespedeza plant, a symbol of autumn.

Hakama: Pleated ankle-length trousers.

Hanshita-e: The line drawing or final sketch on a tissue-like paper which is pasted on the block and serves as the engraver's pattern.

Haori: A short outer coat that was fastened in front with ties.

Happi: A short jacket or coat.

Heiji: A bottle- or pitcher-shaped vessel.

Hikitsuke: One of the two marks of the *kentō* register system. A short, straight guideline left in reserve along one edge of the block. Also called the draw stop.

Hyōshigi: Wooden clappers.

Ikebana: Flower arranging.

Inari: The deity of harvests, who employs the fox as his servant.

Inrō: A small tiered medicine case to which a toggle was attached so that it could be drawn through one's sash and the case carried on one's person.

Ishizuri-e (stone printing): A technique resembling that used for stone rubbings. The outline areas are without color.

Jōruri: A form of ballad drama accompanied by music.

Kagi: One of the two marks of the *kentō* register system. A right-angle guide mark left in reserve along the bottom right edge of the block.

Kakemono: A hanging picture.

Kamigata-e: Prints made in the Osaka-Kyoto area of Japan.

Kamishimo: A samurai or formal costume composed of ankle-length trousers (*hakama*) and loose upper jacket (*kataginu*) with projecting shoulders.

Kammuri: A hat worn by nobles and court officials.

Kamuro: A young girl attendant to a courtesan.

Kana: The characters of the Japanese syllabary.

Kaomise: A face-showing role used to introduce the theatrical season.

Kashirabori: The chief engravers employed to execute the face and other areas of a print considered the most important.

Kasumi: Mist or haze.

Kasuri: Splash-patterned fabric.

Kataginu: A loose jacket or jumper that projected winglike at the shoulders; worn with the *hakama* by the samurai as a formal costume (*kamishimo*).

Kawabiraki: A river festival celebrated with a fireworks display.

Kawagishi (riverbank): A low-class courtesan.

Kentō: The register guide marks consisting of the *kagi* and *hikitsuke* found on Japanese wood blocks.

Kesa: A priest's surplice.

Kiō: A yellow pigment compounded from sulfur and arsenic.

Kira: Mica.

Komabiki: An annual ceremony in which horses were brought to Kyoto and presented at the Imperial Palace.

Komochikōshi: An overall latticework textile design.

Komusō: A strolling *shakuhachi* player.

Kotatsu: A hearth covered with a quilt under which people keep warm.

Koto: A zither-like instrument.

Kotobuki: Felicitations; congratulations.

Kōzo: Broussonetia kazinoki; used in making paper for prints.

Kuchinashi: Gardenia jasminoides.

Kuro-bon: Popular mid-eighteenth-century novelettes bound with black covers and thus called "black books."

Kyōgen: Comic interludes interspersed in a Nō performance.

Kyōgō: The initial black-and-white impressions drawn from the key block which were used for making the color blocks.

Kyōka: Comic odes.

Maegashira: The lesser category of *sumō* wrestlers of the first-rank Eastern Group.

Manga: The sketchbooks of Hokusai published in fifteen volumes, the last ones posthumously.

Mawata: Floss silk; silk wadding.

Medaka: Killifish.

Mietasuki: A textile pattern of stacked diamond forms.

Minogami: A very sturdy paper of mulberry fibers which, in thin sheets, is used for *han-shita-e.*

Mitsu tomoe: A textile pattern consisting of three comma shapes in a circle.

Mitsumata: Edgeworthia papyrifera; used in making paper for prints.

Naga-hakama: Long pleated trousers worn by samurai. The trouser legs extended behind the wearer, making it appear that he was always kneeling and restricting his use of the sword.

Nanga: The southern school of painting that became popular in the eighteenth century. Nanga paintings were produced by scholars and literati painters and closely followed Chinese prototypes.

Nishiki-e: The full-color print, pioneered by Harunobu, in which many blocks were used. As the many colors made it resemble brocade (*nishiki*), the prints were named after it.

Nurioke: A lacquered support over which floss silk is shaped and dried.

Ōharame: A peasant maiden from Ōhara engaged in carrying faggots to Kyoto.

Oiran: A courtesan lower in class than the geisha.

Onnagata: A performer of female roles in the Kabuki theater.

Otokodate: A chivalrous commoner who aids the oppressed.

Rangakusha: Scholars of Dutch thought of the Edo period.

Rōnin: A masterless samurai.

Sambasō: The name traditionally given to an actor costumed as an old man, and to the dance he performs to open a theatrical season or performance.

Samisen: A three-stringed guitar-like instrument.

Samurai eboshi: A black-lacquered paper hat, worn by samurai, turned down from the crown into a tricornered shape.

Sayagata: An elaborate swastika-like textile pattern.

Sekiwake: The category of three champion *sumō* wrestlers of the first-rank Eastern Group.

Sembei: Rice cakes or crackers.

Shakkyō: The lion dance.

Shakuhachi: A flageolet-type instrument.

Shiō: Gamboge.

Shippō: Literally, "the seven precious things"; a textile pattern resembling a Chinese coin.

Shōchikubai: The so-called "three friends"—pine, bamboo, and plum—traditionally considered symbols of longevity.

Shoji: A paper sliding door.

Shunga: Literally, "spring pictures"; erotic prints and paintings.

Sumi: Ink made from lampblack or pine soot which, when combined with glue, was molded into small sticks.

Sumi-e: A print or painting executed in *sumi.*

Sumizuri-e: A print produced from a single block with *sumi.*

Sumō: A form of wrestling.

Suzuribako: An inkstone writing case.

Tachibana: A citrus plant.

Tai: Sea bream.

Tan: A pigment made of red lead, saltpeter, and sulfur.

Tan-e: A *sumi-e* hand colored with *tan.* The technique was commonly applied to primitive prints.

Tango: The Boys' Festival which falls on the fifth day of the fifth month.

Tatami: Mats made of rice straw.

Tate eboshi: A tall lacquered hat worn by samurai or noblemen.

Tatewaku: A striped textile pattern composed of two lines, one normally broader than the other.

Tengai: A basket-shaped rush hat.

Teppō: One of the lowest classes of courtesans.

Tokonoma: An ornamental alcove in a room used for displaying decorative objects.

Torii: A Shinto gate.

Tsuba: A sword guard.

Tsunokakushi: A cloth placed about the forehead of a bride to conceal the horns of jealousy.

Uchikake: A woman's ceremonial outer robe.

Uki-e: A perspective picture.

Ukiyo-e: The so-called "floating-world" school of painting, which arose in the Edo period and was devoted to scenes from everyday life, popular pleasures, and people of the age.

Ukiyo-e hanga: Wood-block prints of the *ukiyo-e* school.

Ukon: Saffron-colored pigment made from the tumeric plant *(Curcuma longa).*

Urei yo: The world of grief.

Urushi-e: A lacquer print; actually a *beni-e* embellished by the use of a lustrous black made up of *sumi* to which small quantities of glue or lacquer were added.

Wakashu: A homosexual or young dandy.

Yagura tokei: A tower-shaped clock based on a European prototype.

Yamato-e: The traditional style of Japanese painting which developed in the Heian period. Most of the great narrative handscrolls of the Heian and Kamakura periods were painted in *Yamato-e* style.

Yamazakura: Prunus serrulata.

Yotsume nanabishi: A textile pattern usually diamond-shaped and made up of stylized four-petaled flowers.

Yuiwata: Cotton cloth or skeins tied like sheaves.

Yukata: A thin cotton robe worn in the summer or for the bath.

PRINT SIZES

*It has been general practice, in Japan, to classify
prints according to size and shape. The following is a list
based on approximate sizes.*

	INCHES	CENTIMETERS
Chūban (medium-size print)	10 × 7 1/2	25.5 × 19
Hashira-e ("pillar picture," a long narrow print)	28 3/4 × 4 3/4	73 × 12
Hoso-e (a "narrow picture" same as *Hosoban*)	13 × 5 5/8	33 × 14.5
Kakemono-e (a "hanging picture")	30 × 9	76.5 × 23
Large panel	20 1/2 × 9	52 × 23
Ōban ("large print," actually the normal-size print)	15 × 10	38 × 25.5
Tanzaku (narrow strip print)	15 × 5	38 × 13

DATE CHART

This table of nengo *(dates of reigns) represents
the chronological subdivisions accepted in Japan
for the Edo period.*

Genna	1615–1624	Kanen	1748–1751
Kanei	1624–1644	Hōreki	1751–1764
Shōhō	1644–1648	Meiwa	1764–1772
Keian	1648–1652	Anei	1772–1781
Shōō	1652–1655	Temmei	1781–1789
Meireki	1655–1658	Kansei	1789–1801
Manji	1658–1661	Kyōwa	1801–1804
Kambun	1661–1673	Bunka	1804–1818
Empō	1673–1681	Bunsei	1818–1830
Tenwa	1681–1684	Tempō	1830–1844
Teikyō	1684–1688	Kōka	1844–1848
Genroku	1688–1704	Kaei	1848–1854
Hōei	1704–1711	Ansei	1854–1860
Shōtoku	1711–1716	Manen	1860–1861
Kyōhō	1716–1736	Bunkyū	1861–1864
Gembun	1736–1741	Ganji	1864–1865
Kanpō	1741–1744	Keiō	1865–1868
Enkyō	1744–1748		

BIBLIOGRAPHY

General Literature on the Japanese Print

BINYON, LAURENCE and SEXTON, J. J. O'BRIEN. *Japanese Color Prints.* C. Scribner's Sons, London, 1923.

FICKE, ARTHUR D. *Chats on Japanese Prints.* C. E. Tuttle Co., Tokyo and Rutland, Vt., 1958.

FUJIKAKE, SHIZUYA. *Japanese Wood-Block Prints.* Japan Travel Bureau, Tokyo, 1938.

————. *Ukiyo-e no Kenkyū* (Ukiyo-e Studies; in Japanese). 3 vols. Yūzankaku, Tokyo, 1943.

GOOKIN, FREDERICK W. *Japanese Colour-Prints and Their Designers.* The Japan Society, New York, 1913.

HEMPEL, ROSE. *Holzschnittkunst Japans; Landschaft, Mimen, Kurtisanen.* Belser Verlag, Stuttgart, 1963.

HILLIER, JACK R. *Japanese Masters of the Colour Print.* Phaidon Press, London, 1954.

————. *The Japanese Print: A New Approach.* G. Bell. London, 1960.

HONMA, MITSUNORI, compiler. *Shin Zōho Ukiyo-e Ruikō Gisakusha Ryakuden Hashigaki* (New Supplement to Notes on Ukiyo-e and Introduction to Brief Biographies of Novelists; in Japanese). Suwara Tetsuji, Tokyo, 1889.

INOUE, KAZUO. *Ukiyo-e-shi Den* (Biographies of Artists of the Ukiyo-e School; in Japanese). Watanabe Hangaten, Tokyo, 1931.

LANE, RICHARD D. *Masters of the Japanese Print.* Doubleday, Garden City, New York, 1962.

LEDOUX, LOUIS V. *An Essay on Japanese Prints.* The Japan Society, New York, 1938.

MICHENER, JAMES A. *The Floating World.* Random House, New York, 1954.

————. *Japanese Prints: From the Early Masters to the Modern.* C. E. Tuttle Co., Tokyo and Rutland, Vt., 1959.

NARASAKI, MUNESHIGE. *The Japanese Print: Its Evolution and Essence.* Kodansha International, Tokyo and Palo Alto, Calif., 1966.

———— and KONDŌ, ICHITARŌ. *Nihon Fūkei Hanga Shiron* (History of Japanese Landscape Prints; in Japanese). Tokyo, 1943.

Nihon Hanga Bijutsu Zenshū (The Art of the Japanese Print; in Japanese). 9 vols. Kodansha, Tokyo, 1960–62.

NOGUCHI, YONE. *The Ukiyo-e Primitives.* Ogata Yukio, printer, Tokyo, 1933.

ROBINSON, BASIL W., ed. *Japanese Landscape Prints of the Nineteenth Century.* Faber and Faber, London, 1957.

RUMPF, FRITZ. *Meister des Japanischen Farbenholzschnittes.* Walter de Gruyter & Co., Berlin and Leipzig, 1924.

SANTŌ, KYŌDEN, compiler. *Ukiyo-e Ruikō* (Notes on Ukiyo-e; in Japanese). Original manuscript compiled in late 1790s with annotations by Shikitei Samba.

————. *Ukiyo-e Furoku* (Supplement). 1800.

————. *Ukiyo-e Tsuikō* (Additional Supplement). 1802. The text and supplements were combined by Ōta Nampo in 1818.

SEIDLITZ, W. VON. *A History of Japanese Colour-Prints.* Heinemann, London, 1920.

STRANGE, EDWARD F. *The Colour-Prints of Japan.* A. Siegle, London, 1904.

SUZUKI, JŪZŌ. *Nihon Hanga Benran* (Handbook of Japanese Prints; in Japanese). Tokyo, 1962.

TAJIMA, SHIICHI, ed. *Masterpieces from the Ukiyo-e School.* 5 vols. Shimbi Shoin, Tokyo, 1906–9.

TAKAHASHI, SEIICHIRŌ. *The Evolution of Ukiyo-e: The Artistic, Economic and Social Significances of Japanese Woodblock Prints.* Yamagata Printing Co., Yokohama, 1955.

————. *The Japanese Wood-Block Prints through Two Hundred and Fifty Years.* Chūō-Kōron Bijutsu Shuppan, Tokyo, 1965.

————. *Ukiyo-e Zuisō* (Random Thoughts on Ukiyo-e; in Japanese). Chūō-Kōron Bijutsu Shuppan, Tokyo, 1966.

Ukiyo-e Taika Shūsei (A Compilation of Ukiyo-e by Great Masters; in Japanese). 20 vols. Taiho Kaku Shobō, Tokyo, 1931–32.

Ukiyo-e Taisei (The Complete Ukiyo-e; in Japanese). 12 vols. Tōhō Shoin, Tokyo, 1930–31.

Ukiyo-e Zenshū (The Complete Ukiyo-e; in Japanese). 6 vols. Kawade Shobō, Tokyo, 1956–58.

VOLKER, T. *Ukiyo-e Quartet: Publisher, Designer, Engraver and Printer.* E. J. Brill, Leiden, 1949.

WATERHOUSE, DAVID B. *Harunobu and His Age: Development of Colour Printing in Japan.* The Trustees of the British Museum, London, 1964.

YOSHIDA, TERUJI. *Ukiyo-e Jiten* (Ukiyo-e Dictionary; in Japanese). 2 vols. Ryokuen Shobō, Tokyo, 1965.

Book Illustration

BROWN, LOUISE N. *Block Printing and Book Illustration in Japan.* G. Routledge and Sons, Ltd., London, and E. P. Dutton and Co., New York, 1924.

HOLLOWAY, OWEN E. *Graphic Art of Japan: The Classical School.* A. Tiranti, London, 1957.

TODA, KENJI. *Descriptive Catalogue of Japanese and Chinese Illustrated Books in the Ryerson Library of the Art Institute of Chicago.* R. R. Donnelly and Sons Co., Chicago, 1931.

Works on Individual Artists

ADACHI, TOYOHISA, ed. *Sharaku: A Complete Collection* (Japanese and English text). 4 vols. Adachi Institute of Woodcut Prints, Tokyo, 1940ff.

FENELLOSA, ERNEST F. *Catalogue of the Exhibition of Paintings of Hokusai Held at the Japan Fine Art Association, Uyeno Park.* Kobayashi Bunshichi, Tokyo, 1901.

GONCOURT, EDMOND DE. *Hokusai.* Paris, 1896.

HENDERSON, HAROLD G. and LEDOUX, LOUIS V. *The Surviving Works of Sharaku.* E. Weyhe, New York, 1939.

HILLIER, JACK R. *Hokusai.* Phaidon Press, London, 1956.

———. *Utamaro: Colour Prints and Paintings.* New York Graphic Society, Greenwich, Conn., 1961.

HIRANO, CHIE. *Kiyonaga: A Study of His Life and Works.* Harvard University Press, Cambridge, Mass., 1939.

KONDŌ, ICHITARŌ. *Kitagawa Utamaro.* C. E. Tuttle Co., Tokyo and Rutland, Vt., 1956.

MATSUKI, KIHACHIRŌ. *Hiroshige Edo Fūkei Hangashū* (Hiroshige's Edo Landscape Prints; in Japanese). Iwanami, Tokyo, 1939.

NARASAKI, MUNESHIGE. *Hokusai Ron* (Study on Hokusai; in Japanese). Atorie Sha, Tokyo, 1944.

——— and KIKUCHI, SADAO. *Utamaro.* Kodansha International, Tokyo and Palo Alto, Calif., 1968.

NOGUCHI, YONE. *Harunobu.* Kegan Paul, Trench, Trubner and Co., London, and Yoshikawa, Yokohama, 1940.

———. *Hiroshige.* 2 vols. Maruzen Co., Ltd., Tokyo, 1940.

ROBINSON, BASIL W. *Kuniyoshi.* H. M. Stationery Office, London, 1961.

SHIBUI, KIYOSHI. "Utamaro," in *Ukiyo-e Zuten,* Vol. 13 (in Japanese). Kazama Shoten, Tokyo, 1964.

SUCCO, FRIEDRICH. *Utagawa Toyokuni und Seine Zeit.* 2 vols. R. Piper & Co., Munich, 1913.

SUZUKI, JŪZŌ, *Sharaku.* Kodansha International, Tokyo and Palo Alto, Calif., 1968.

TAKAHASHI, SEIICHIRŌ. *Harunobu.* Kodansha International, Tokyo and Palo Alto, Calif., 1968.

UCHIDA, MINORU. *Hiroshige* (in Japanese). Iwanami Shoten, Tokyo, 1930.

YOSHIDA, TERUJI. *Harunobu Zenshū* (The Complete Harunobu; in Japanese). Tokyo, 1942.

Catalogues of Collections

ART INSTITUTE OF CHICAGO. *The Clarence Buckingham Collection of Japanese Prints.* 2 vols. Chicago, 1955–65.

BINYON, LAURENCE. *A Catalogue of Japanese and Chinese Woodcuts Preserved in the Sub-Department of Oriental Prints in the British Museum.* The Trustees of the British Museum, London, 1916.

HIRAKI, SHINJI. *Hiraki Korekushon-Ukiyo-e* (Hiraki Collection: Ukiyo-e; in English and Japanese). 5 vols. Mainichi Shimbun, Tokyo, 1964–66.

LEDOUX, LOUIS V. *Japanese Prints in the Ledoux Collection.* 5 vols. Princeton University Press, Princeton, N.J., 1942–51.

Matsukata Ukiyo-e Hanga-shū (Ukiyo-e Prints in the Collection of Matsukata Kōjirō; in Japanese). Osaka, 1925.

Specialized Works

AZECHI, UMETARŌ. *Japanese Woodblock Prints: Their Technique and Appreciation.* Toto Shuppan Co., Tokyo, 1963.

ISHIDA, MOSAKU. *Japanese Buddhist Prints.* Harry N. Abrams, Inc., New York, 1964.

ISHII, KENDŌ. *Nishiki-e no Kai-in no Koshō* (Handbook of Censors' Seals; in Japanese). Isehin Shoten, Tokyo, 1920.

——— and HIROSE, KIKUO. *Jihon Nishiki-e Tonya-fu* (Index of Print and Book Publishers; in Japanese). Tokyo, 1920.

NARASAKI, MUNESHIGE. *Hiroshige: Famous Views*. Kodansha International, Tokyo and Palo Alto, Calif., 1968.

——. *Hokusai: The Thirty-Six Views of Mount Fuji*. Kodansha International, Tokyo and Palo Alto, Calif., 1968.

SCHRAUBSTADTER, CARL. *Care and Repair of Japanese Prints*. Idlewild Press, Cornwall-on-Hudson, N.Y., 1948.

SHIBUI, KIYOSHI. *Genroku Ko-hanga Shuei. Estampes érotiques primitives du Japon* (text in Japanese). 2 vols. Tokyo, 1926–28.

——. *Ukiyo-e Naishi: Old Documents Concerning Human Life Instincts and Emotions as Interpreted by Japanese Artists in the Eighteenth and Earlier Part of the Nineteenth Centuries* (in Japanese). 2 vols. Taihokaku Shobō, Tokyo, 1932–33.

STATLER, OLIVER. *Modern Japanese Prints: An Art Reborn*. C. E. Tuttle Co., Tokyo and Rutland, Vt., 1956.

STEWART, BASIL. *Subjects Portrayed in Japanese Colour-Prints*. Kegan Paul, Trench, Trubner and Co., London, 1922.

TOKUNO, T. *Japanese Wood-Cutting and Wood-Cut Printing* (from the *Report of the U.S. National Museum, 1892*). Government Printing Office, Washington, D.C., 1894.

VICTORIA AND ALBERT MUSEUM. *Tools and Materials Illustrating the Japanese Method of Colour-Printing*. London, 1913.

YŌSHIDA, TŌSHI and YUKI, REI. *Japanese Print-Making: A Handbook of Traditional and Modern Techniques*. C. E. Tuttle Co., Tokyo and Rutland, Vt., 1966.

Periodical Articles

FICKE, ARTHUR D. "The Prints of Kwaigetsudo," in *The Arts*, Vol. 4, No. 2, pp. 95–119. New York, 1923.

SHIBUI, KIYOSHI. "Masanobu no Sumi-e (Masanobu's Sumizuri-e Albums; in Japanese)," in *Ukiyo-e No Kenkyū*, Vol. 6, No. 3, p. 5 plus 66 plates.

Periodicals

Ukiyo-e. Tokyo, 1962ff.

Ukiyo-e Art (text in Japanese and English). Tokyo, 1962ff.

Ukiyo-e Geijutsu. Tokyo, 1932–35.

Ukiyo-e Kai. Tokyo, 1936–40.

Ukiyo-e Shi. Tokyo, 1929–31.

INDEX

Major references to artists are set in italics.

ACKNOWLEDGMENTS

The joyous time of thanking all of those who made this book possible is now at hand. The project owes its original impetus to the University of California at Los Angeles which, under the auspices of its then Chancellor, Dr. Franklin D. Murphy, purchased a large collection of Japanese woodcuts for the Grunwald Graphic Arts Foundation at UCLA. These prints were originally from the estate of the architect Frank Lloyd Wright. The Foundation contains the fine collection of Mr. and Mrs. Fred Grunwald and has grown under the able guidance of its Director, Dr. E. Maurice Bloch. The acquisition of the Wright prints in turn led to a comprehensive exhibition of *ukiyo-e hanga*, which was the occasion for this book.

The UCLA Art Council then entered the scene. It has sought to bring the best in art to the University, and through the years has done much to enrich the art climate of Southern California. It was the Art Council that invited me to undertake both the exhibition and this book. I was offered free reign and the most superb cooperation any scholar could desire. In this connection, I am especially grateful to Mr. Frederick S. Wight, Director of the UCLA Art Galleries; Dr. E. Maurice Bloch and his assistant, Paul Karlstrom; Mrs. Sidney F. Brody, Exhibitions Chairman, the Art Council and Mrs. Herman Weiner, Co-Chairman.

Once the project was decided upon the search for prints began.

I am deeply indebted to each collector and to the administrative, curatorial, educational, and photographic staff of each museum. The exhibition and book could not have been completed without the active assistance of the Far Eastern Department of The Metropolitan Museum of Art, which is represented by the largest number of reproductions and loans, and of Mr. Fong Chow and Miss Jean Schmitt of the Department staff. To the Directors and Trustees of each and all these institutions I am most grateful.

Adequate synonyms for thanks are few. I would have been helpless without the blessing and help of my own museum, the Freer Gallery of Art, and Dr. John A. Pope, its Director. Mr. Raymond A. Schwartz, our staff photographer, was responsible for most of the photography and traveled extensively with me for this purpose. I was ably assisted at the Gallery by Miss Ursula Pariser and Mr. James W. Riggs. Further appreciation is due Mrs. Virginia Westlake as personal secretary, and Mrs. Willa Moore and Miss Lola Beaver, all of whom were indefatigable. I am further indebted to Mrs. Priscilla Smith (Librarian of the Freer Gallery of Art) for undertaking the tedious chore of preparing the Index. Also consulted were Mr. Takashi Sugiura (Conservator of Far Eastern Painting at the Freer Gallery), about lesser-known Japanese customs and text, and Mr. Thomas Lawton of our staff, who listened daily to readings of the previous night's output.

One feels humble before the artists who created these beautiful prints and the generations who have loved and cared for them. All scholars working in the field of *ukiyo-e* are indebted to the scholars of the past. In like manner, I would like to express indebtedness to those of the present, Dr. Narazaki Muneshige; Mr. Yoshida Teruji; Dr. Shibui Kiyoshi; Dr. Richard Lane; the late Mr. Robert Treat Paine; Mr. Jack Hillier; Miss Margaret Gentles; and Mr. David Waterhouse, whose worthy contributions have been most helpful.

For many years factionalism has torn *ukiyo-e* studies. I wonder what we would do if we could say "without error"; such a statement could not apply to any publication or exhibition of the past, nor does this study presume to be final. I am sure that errors will come to light as our knowledge about these artists and their prints expands. Yet I hope that the publication of this book will mark a new era, and serve as a rallying point for us to join our forces in friendship. Then we may convene periodically, share our research, and get down to the serious business of further unraveling the story of *ukiyo-e*.

Harold P. Stern

An expression of deep appreciation is due the following museums and private collectors who have so generously allowed their prints to be reproduced herein:

Achenbach Foundation for Graphic Arts, California Palace of the Legion of Honor, San Francisco
Museum of Fine Arts, Boston · The Art Institute of Chicago
Miss Edith Ehrman, New York City · Mr. and Mrs. Richard P. Gale,
Mound, Minnesota · Mr. and Mrs. Edwin Grabhorn, San Francisco
Grunwald Graphic Arts Foundation, University of California at Los Angeles
The Metropolitan Museum of Art, New York City
Nelson-Atkins Gallery, Kansas City, Missouri
Philadelphia Museum of Art

Date Due

APR 18 '73			
MAR 13 '74			
NOV 22 '77			
NOV 5 '86			

CAT. NO. 23 233 PRINTED IN U.S.A.